6/4
E
12⁰⁰

W9-CJB-504

This catalog has been produced to describe the background and
way of life during the Shogun Age in Japan.
The catalog contains all the exhibits included in The Shogun Age Exhibition,
which will be displayed over three separate time periods.
The numbers affixed to the exhibits in the catalog are not sequential.
Please refer to the index at the end of the catalog.

THE SHOGUN AGE EXHIBITION EXECUTIVE COMMITTEE
THE TOKUGAWA ART MUSEUM

The exhibition schedule is as follows:

LOS ANGELES COUNTY MUSEUM OF ART, LOS ANGELES
DECEMBER 17, 1983—FEBRUARY 26, 1984

DALLAS MUSEUM OF ART, DALLAS
MARCH 17—MAY 27, 1984

HAUS DER KUNST, MUNICH
NOVEMBER 23, 1984—FEBRUARY 3, 1985

ESPACE PIERRE CARDIN, PARIS
MARCH 1—MAY 12, 1985

This traveling exhibition is supported by a grant
from Minolta Camera Co., Ltd., Japan.

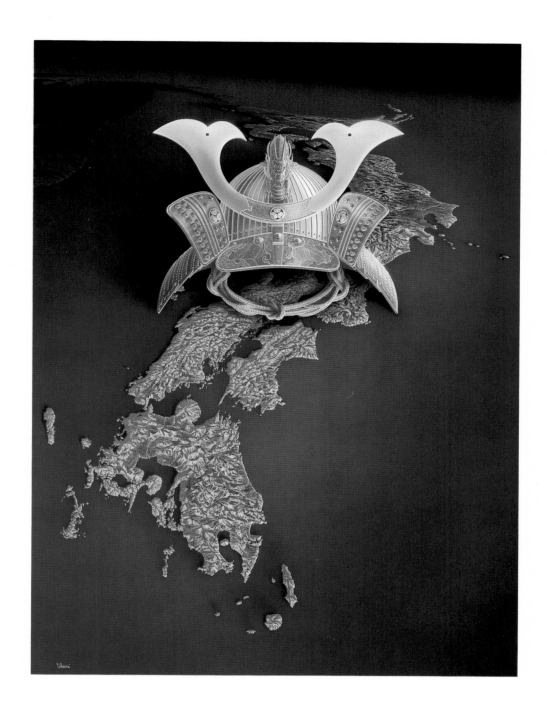

This illustration by Shusei Nagaoka symbolizes The Shogun Age Exhibition.

THE SHOGUN AGE EXHIBITION

From The TOKUGAWA ART MUSEUM, Japan

THE SHOGUN AGE EXHIBITION EXECUTIVE COMMITTEE

Essays by:	Yoshinobu Tokugawa (*Director of The Tokugawa Art Museum*) Shinzaburō Ōishi (*Dean of the Faculty of Economics, Gakushūin University*) Keizo Saito
Exhibit commentaries by:	(*Curators of The Tokugawa Art Museum*) Toyozo Sato Minoru Kinoshita Yasukazu Yamamoto Tomio Koike Fumihiko Shinagawa
Calligraphy titles by:	Sesshun Miyamoto (*International Calligraphers Association*)
Exhibit photographs by:	Ryoichi Takaku
Photographs and reference materials by courtesy of:	Nijō Castle Nagoya City Hall National Diet Library Tokyo Metropolitan Central Library Sekai Bunka-sha Co., Ltd. Sekai Bunka Photo Co., Ltd. Shogakukan Publishing Co., Ltd. Geishinsha Tatsuo Yoshikoshi The Moriya Family Bunji Kobayashi
Designed by:	Teruo Nakagawara
Edited by:	Kazuie Furuto Yoshiki Terashima Toru Noguchi Naotake Ohya Akira Mita Yoneo Haraguchi Chiyuki Kubo Akio Nakajima (Winds International Inc.) Masao Nakayama (″) Kyoko Muramoto (″)
Printed by:	Toppan Printing Co., Ltd.
Supervised by:	The Tokugawa Art Museum 1017 Tokugawa-cho, Higashi-ku Nagoya-shi, Aichi prefecture 461 Tel (052) 935-6262 The Tokugawa Reimeikai Foundation 3-8-11 Mejiro, Toshima-ku, Tokyo 171 Tel (03) 950-0111 Telegrams TOREFON TOKYO
Produced by:	Dentsu Incorporated
Published by:	The Shogun Age Exhibition Executive Committee 101 Dentsu Ginza Bldg. 7-4 Ginza, Chuo-ku, Tokyo 104

Copyright © The Shogun Age Exhibition Executive Committee 1983.
All rights reserved. No part of this publication may be reproduced, stored in
a retrieval system, or transmitted in any form or by any means, electronic,
mechanical, photocopy or otherwise, without the prior permission of the
copyright owner.

First published in December, 1983.
Printed in Japan

The installation for this exhibition was designed and executed by museum designer, Shuntaro Kunitomo.

CONTENTS

MEMBERS OF THE SHOGUN AGE EXHIBITION
EXECUTIVE COMMITTEE

Honorary Chairman:
>Yoshinobu Tokugawa
>*Executive Director of*
>*The Tokugawa Reimeikai Foundation,*
>*Director of The Tokugawa Art Museum*

Honorary Vice Chairman:
>Kazuo Tashima
>*Chairman of Minolta Camera Co., Ltd.*

Supreme Advisor:
>Seiichi Shirayanagi
>*Archbishop of Tokyo*

Special Advisors:
>Michael J. Mansfield
>*Ambassador of the United States of America to Japan*
>Edwin Reischauer
>*Former Ambassador of the United States of America to Japan*

Chairman:
>Hideo Tashima
>*President of Minolta Camera Co., Ltd.*

Vice Chairman:
>Setsuo Kubota
>*Director of 1st Account Service Division, Dentsu Inc.*

Members:
>Yujiro Shinoda
>Prof. Dr. Phil.,
>*Director of Socio-Economic Institute Tokyo*
>Shigeo Nagashima
>*Former Manager of Yomiuri Giants*
>Takashi Okada
>*Senior Executive Director of Minolta Camera Co., Ltd.*
>Naomi Fujita
>*Senior Executive Director of Minolta Camera Co., Ltd.*
>Ned G. Moro
>*General manager of Corporate Communications Division*
>*Minolta Camera Co., Ltd.*
>Reiji Takei
>*Director of 5th Account Service Division*
>*Osaka Regional Office, Dentsu Inc.*
>Hisashi Shinohara
>*Director of Sales Promotion Division, Dentsu Inc.*

Associate Members:
>Bunroku Yoshino
>*Former Ambassador of Japan to West Germany*
>Shoichi Watanabe
>*Professor of Sophia University*
>Hisao Sugawara
>*Director of the Nezu Institute of Fine Arts*
>Muneyoshi Tokugawa
>*President of the Japanese Association of Museums*
>Shusei Nagaoka
>*Illustrator*

MESSAGES

It has been approximately one hundred twenty years since Japanese works of art were first introduced to the West. During the first half of this period, such items as *ukiyo-e,* medicine cases (*inrō*), *netsuke,* and sword guards, which appeared foreign and exotic to the eyes of people in other countries, were extremely popular. It was in the latter half of this period that these people became genuinely interested in Japanese fine arts; and it is only recently that Japan's cultural history and traditional aesthetics have been included as subjects for study.

This exhibition is designed to indicate the nature of the works of art owned by the Tokugawa shoguns, who ruled the nation and maintained peace for three hundred years in the pre-modern age, and illustrate how they were used and appreciated as faithfully as possible using works in the possession of The Tokugawa Art Museum.

It is difficult to understand the traditional aesthetics and philosophy of another country. However, it would give me great pleasure if visitors to this exhibition derive some sense of what the Japanese have nurtured and maintained over the centuries. I should like to thanks all of the art museums which have made this exhibition possible.

Yoshinobu Tokugawa
Honorary Chairman
The Shogun Age Exhibition
Executive Committee
Director
The Tokugawa Art Museum

We at Minolta are glad to have been able to support the mounting of The Shogun Age Exhibition. This exhibition is an assemblage of cultural treasures representing Japan, most of which have never left our country before, and now we confidently present them to the people in the west.

Since its foundation, Minolta has been active, particularly in markets abroad. We have cooperated to mount this exhibition, which is said to be the first long-term traveling exhibition of its scope sent from The Tokugawa Art Museum, in hopes that it will help to impart a greater understanding of Japan's traditional culture among the American and European people who have generously welcomed Minolta products.

We are making our effort with a wish that people in the west would know more about Minolta's mother country. Also, we are trying our best to learn about the culture and history of the west and the world in order that we may offer ever more suitable Minolta products.

We sincerely wish that The Shogun Age Exhibition will serve as a bridge for mutual understanding between the Japanese and the people in the west, and that it will contribute to the peace and friendship between our nations.

Kazuo Tashima
Honorary Vice Chairman
The Shogun Age Exhibition
Executive Committee
Chairman
Minolta Camera Co., Ltd.

Most of the Japanese people share a constant wish that those of other nations, beginning with the United States and Europe, understand the "real Japan." It is our wish that Japanese history and culture, the national characteristics of the Japanese people, and Japan in its present state be understood.

The Shogun Age Exhibition is a large-scale, comprehensive exhibition of high quality which, when first announced here in Japan, met with enthusiastic requests that it be mounted in this country as well. We believe that presenting an exhibition of this type comprised of objects representing the tangible cultural heritage handed down for nearly three hundred years in the Tokugawa family— which performed a pivotal role in Japan's pre-modern history—is a singularly effective way of promoting the understanding of Japanese culture.

We believe that international cultural exchanges of this type will help to promote mutual understanding and contribute to the realization of a more peaceful and affluent international society.

Hideo Tashima
Chairman
The Shogun Age Exhibition
Executive Committee
President
Minolta Camera Co., Ltd.

Perhaps no aspect of the history of Japan has so captured the world imagination as the Tokugawa shoguns. The Los Angeles County Museum of Art is particularly honored to host this magnificient exhibition of art treasures of the Tokugawa family who ruled Japan during the Edo period. The three hundred works of art on loan from The Tokugawa Art Museum in Nagoya represent the finest artistic achievements of that period. These works, ranging from delicately painted screens and scrolls to swords and armorial work, as well as tea ceremony utensils and Nō theater costumes and masks, present the astonishing creations of Japanese artists over more than two centuries. The world has long been fascinated with the Tokugawa shoguns, but has never had the opportunity to actually see the exquisite art objects that adorned the Shogun's quarters, or that resulted from their generous patronage. The objects are stunning in their beauty and rich in their diversity and it is a special pleasure for the Los Angeles County Museum of Art to premiere this major and important international loan exhibition. I would like to take this opportunity to thank The Shogun Age Exhibition Executive Committee, in particular Mr. Yoshinobu Tokugawa and Mr. Kazuie Furuto, for their interest and willingness to have this exhibition at the Los Angeles County Museum of Art. Los Angeles, the West's largest city, has long had a distinguished tradition of association with Japan, a tradition which the city and Museum are both proud. We are particularly pleased to welcome the Tokugawa collection to Los Angeles.

Earl A. Powell III
Director
Los Angeles County Museum of Art

It is truly remarkable that a major traveling exhibition on "The Shogun Age" can be drawn from a single institution, The Tokugawa Art Museum. We are reminded how unique the Tokugawa family collection is in the modern world. As the exhibition begins its international tour, leaving its wonderfully intimate environment in Nagoya, Japan, for the enjoyment of art lovers throughout the United States and Europe, we wish to thank Yoshinobu Tokugawa and the officers of the Tokugawa Reimeikai Foundation for affording us the opportunity to admire treasured objects.

Inspiration for this exhibition grew out of a cooperative spirit for cultural exchange between The Tokugawa Art Museum, the exhibition's sponsor, Minolta Camera Co., Ltd., and the four other participating museums. We are grateful to The Shogun Age Exhibition Executive Committee for having conceived, organized, and implemented such a marvelous exhibition, and to the officers of The Tokugawa Art Museum and the people of Nagoya for sharing their incomparable art. We hope this international exhibition will deepen our understanding of "The Source of Traditional Japanese Beauty," and of the enlightened Tokugawa family that caused these works to be created during "The Shogun Age."

Harry S. Parker III
Director
Dallas Museum of Art

The Ausstellungsleitung Haus der Kunst München e.V. feels very proud to have the opportunity to present The Shogun Age Exhibition to the German public. We are pleased about this possibility of cooperation, for various reasons. The Shogun Age Exhibition does not only show art treasures of international importance, but it also reveals a cultural tradition. It informs us about the intellectual and historical background and the sources out of which not only these art treasures were created but with which the Japanese people still live today. This also means a contribution to a deeper understanding of both peoples, a consolidation of Japanese-German friendship and an underlining of the fact that Japan has not only made extremely important achievements in the eyes of nations in the field of industry and commerce but also — and especially — in the cultural field.

We would like to express our sincerest thanks to The Shogun Age Exhibition, especially to the Honorary Chairman Mr. Yoshinobu Tokugawa, Director of The Tokugawa Art Museum; the Honorary Vice Chairman Mr. Kazuo Tashima, Chairman of Minolta Camera Co., Ltd.; the Chairman of the Executive Committee Mr. Hideo Tashima, President of Minolta Camera Co., Ltd.; the Vice Chairman of the Executive Committee Mr. Setsuo Kubota, Dentsu Inc.; and to Prof. Dr. Phil. Yujiro Shinoda, Director of The Socio-Economic Institute Tokyo, as well as to Prof. Dr. Siegfried Wichmann and Dr. Hans Wichmann, for their excellent cooperation. We are already looking forward to The Shogun Age Exhibition as an event of great importance for the cultural life of Germany.

Dr. Hermann Kern
Director
Haus der Kunst

It is a great pleasure and honor to have this most extraordinary and marvelous collection — The Shogun Age Exhibition — from the Land of the Rising Sun with the kind cooperation of The Tokugawa Art Museum.

The Shogun Age Exhibition will be held at Espace Pierre Cardin in Paris from March 1 to May 12, 1985.

It is a great joy for myself personally as well as for Espace Pierre Cardin to be able to contribute in introducing Japanese culture to France as well as in strengthening the ties of culture and friendship between our two countries.

I sincerely hope for the great and real success of this "Shogun Age Exhibition."

Pierre Cardin
Owner
Espace Pierre Cardin

EDITORIAL NOTES

• This catalog has been developed and edited for the purpose of presenting in a readily comprehensible manner the contents and purport of "The Shogun Age Exhibition," which will be traveling to major cities in the United States and Europe. This catalog is not simply a list of the exhibits, but is intended to transmit a sense of the history, culture, and life of the great daimyo (feudal lords) of the Edo period through articles that had once constituted their possessions.

• All of the objects and documents exhibited belong to the collection of The Tokugawa Art Museum. Works owned by The Tokugawa Art Museum frequently possess historical documentation that concerns their commissioning, past history, and usage, as well as providing insight into the circumstances prevailing at the time. Documentary information of this nature has been included wherever possible.

• In each of the object entries, emphasis has been placed on their precise usage, historical background, and aesthetic qualities. In the text, the following editorial policies have been adopted:

• Japanese names have been rendered in the Japanese manner with the surname followed by the given name in the case of historical personages (example: Tokugawa Ieyasu); but in the case of contemporary individuals, the western practice of placing the surname last has been adopted.

• All ages of historical personages have been rendered in oriental count, in which a person is considered to be one at the time of birth and gaining a year with the advent of each subsequent New Year.

• When dates have been given according to the lunar calendar, the corresponding date in the western calendar has been provided in parentheses.

• In general, Japanese terms have been romanized in accordance with the practices followed in the 1954 edition of Kenkyūsha's *New Japanese-English Dictionary*, with the exception of well-known place names such as Tokyo and Kyoto, and such commonly used terms as "shogun" which have been rendered unitalicized and without macrons. All Chinese terms have been romanized according to the *pin-yin* system.

• The catalog numbers of the objects correspond to those affixed to the objects in the exhibition, but they have not necessarily been displayed in that order. In addition factors relating to space and conservation have necessitated a rotating of the exhibits, so that not all of the objects included in the catalog will be displayed at one time.

• The dimensions of the objects have been provided accompanied by the following abbreviations: l. (length), w. (width), h. (height), diam. (diameter). Dimensions provided without specifications have been given in the order of length, width, and height.

THE AGE OF THE SHOGUNS

Shinzaburō Ōishi

Dean of the Faculty of Economics, Gakushūin University

In the middle of the sixteenth century, during the era Japanese historians refer to as *Sengoku Jidai* or "Age of the Country at War," a provincial feudal lord named Oda Nobunaga marched into the capital city of Kyoto, intent on bringing the nation from anarchy to unity. Today the term *kinsei shakai* (pre-modern society) applies to the three centuries that followed: the thirty-five years of the Azuchi-Momoyama period when Oda Nobunaga and Toyotomi Hideyoshi were active, plus the two hundred sixty-five years of the Edo or Tokugawa period, from the establishment of a central military government by the great shogun Tokugawa Ieyasu in 1603 to the end of the family's reign in 1867.

This period is called "Edo" because the Tokugawa clan established the central military government and their residential seat in the town of Edo (now Tokyo). It is also called the Tokugawa period or the "age of the shoguns" because members of that clan ruled the country as shoguns during this period that lasted nearly three centuries. Presently, a need is perceived to see Japanese history as a part of world history, and not simply as a chorinicle of events of mere local interest. Therefore, it is justifiable to use the term "age of the shoguns" to symbolize this period, rather than to refer to it by the name of one city (Edo) or one family (Tokugawa).

> *Note.* The word "shogun" (general) is an abbreviation of the title *Sei-i-tai-shōgun* ("Barbarian-subduing Generalissimo"), conferred in the eighth century on officers of a force sent by Emperor Kammu to put down uprisings to the northeast of the capital. In the late twelfth century, the same title was bestowed upon Minamoto no Yoritomo, who established a military government in Kamakura, and at the time the title took on the sense of political administrator. In succeeding centuries it was held by members of the Ashikaga clan, who headed the Muromachi military government, but it was not until Tokugawa Ieyasu established his government in Edo that the shogun and the military government he headed wielded absolute political authority over all of Japan.

The Daimyo and the Castle Towns

The Tokugawa shoguns ruled with a system of parallel central and local administration which is designated presently by the term *bakuhan*. The *bakufu* or shogunate was the administrative authority which ruled the nation as a whole under the Tokugawa shogun, and the *han* were the domains that made up Japan and their administrative units, ruled by feudal lords called daimyo.

Turning first to an examination of the *han*, land holdings were measured in the number of *koku* (approximately five bushels) of rice they produced. Of the many local lords of the Edo period, those with holdings producing at least ten thousand *koku* were classified as daimyo, a title which afforded them special treatment and respect, both political and social.

Approximately two hundred seventy landowners held the title of daimyo in the Edo period, although there were slight variations in the number over the years. The records show that at the time of the downfall of the Tokugawa shogunate, sixty-two percent or one hundred sixty-six of the total of two hundred sixty-six daimyo households were categorized as lesser daimyo—that is, their holdings constituted less than fifty thousand *koku*.

The local lord built a castle at the center of his domain and a castle town around it, in which his loyal retainers lived, and he was responsible for the political and economic management of the area within the fief. There were, accordingly, as many of these castle towns as there were daimyo, and most were structured as follows:

(1) Political and economic considerations generally dictated that the castle town be located at the center of the fief, but the need to transport goods meant that many were actually built near the sea, a river, a lake, or even a canal. Road transportation was so difficult and inefficient in those days that shipments of any size had to be sent by boat.

(2) Castle towns were structured quite artificially, as a series of concentric circles around the castle. The first ring around the castle was the residence of the loyal retainers. Around that was the town itself, where arts and industry were conducted. On the outskirts were the precincts of the Buddhist temples and Shintō shrines.

Within the inner circle was located not only the castle itself, but also a watchtower or donjon (*tenshu-kaku*). In the early days this tower fulfilled a military function and signified the authority of the lord of the castle, by as time progressed the tower came to be seen as a symbol of the region.

In most cases, the connected castle buildings of the lord's personal residence and the administrative

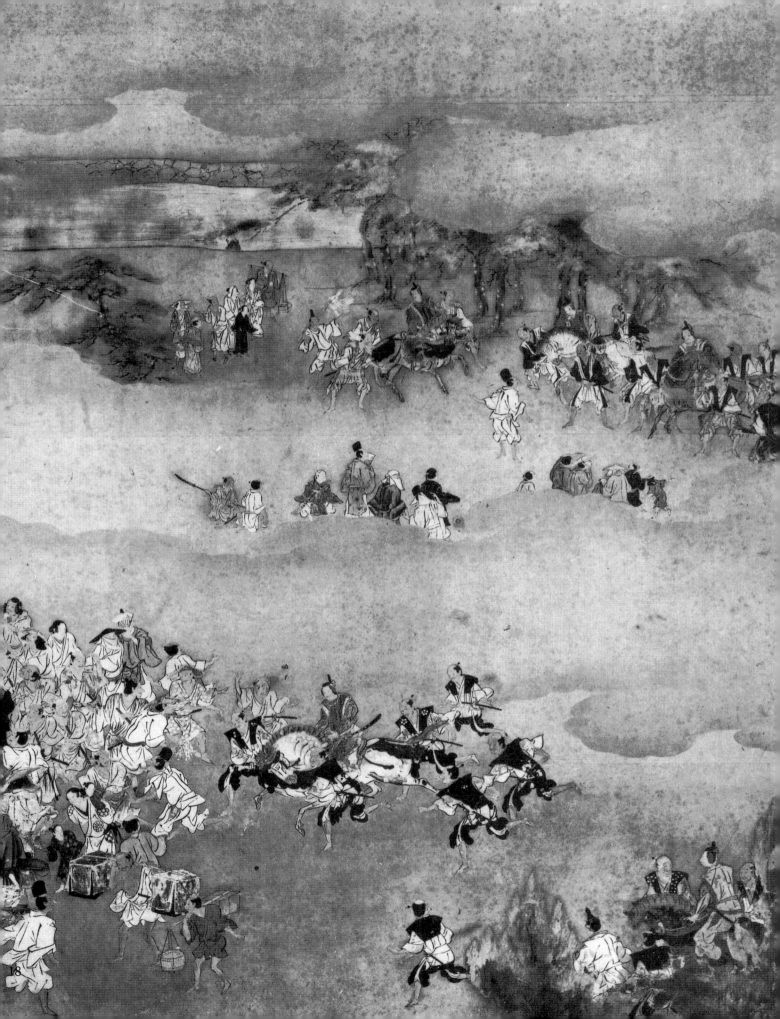

buildings of the *han* were found in the innermost circle (*hommaru*) and the watchtower in the second circle (*ni no maru*) immediately surrounding it.

When castle towns were first built, the shrines and temples on the outskirts played a role in the defense of the town and the castle, but with the long years of domestic peace in the Edo period, they came to be used more as sites for the recreation of the common people, as well as for religious practice.

The city of Edo was itself a castle town—both of the Tokugawa family, which was in fact just another, albeit the greatest, daimyo family, and of the immediate family of the Tokugawa shogun himself, who stood above the two hundred seventy daimyos and ruled the nation.

Edo was considerably larger than other castle towns. Within the inner circle was erected the palace, consisting of the official area (*omote*) and the private residence of the shogun and his family, and adjacent to the palace a five-story watchtower. The town of Edo surrounding the castle was correspondingly greater in scale: its population of approximately one million made it one of the largest cities in the world at that time.

Although the society of Japan of the Edo period is considered essentially an agricultural one, the fact that approximately ten percent of the population of each fief was concentrated not only in Edo but in all of the castle towns around the nation indicates that it was also an era of cities.

The Shogun and the Daimyo

The daimyo were categorized according to their relationship to the shogun into three classes: *shimpan*, *fudai*, and *tozama*.

The *shimpan*, or *han* of relatives, were directly related to the shogunal family. The *fudai* were hereditary daimyo vassals from other clans: their ancestors had been loyal to the Tokugawa clan before it had gained national power. The *tozama* were "outside lords," daimyo who had alleged loyalty to the Tokugawa clan only after the battle of Sekigahara, when Tokugawa Ieyasu became supreme ruler of the land.

Note. Tokugawa Ieyasu had twelve sons. Yoshinao (the ninth son) was dispatched to Owari (Nagoya), Yorinobu (the tenth) to Kii (Wakayama), and Yorifusa (the eleventh) to Hitachi (Mito). They enjoyed special privileges as the Three Houses (*Go-Sanke*), and it was understood that one of the houses would provide a successor should the main Tokugawa line in Edo die out. Thus the great fortune amassed by Tokugawa Ieyasu was not kept exclusively within the Edo branch but shared with the Three Houses. Many of the treasures in The Tokugawa Art Museum in Nagoya today were bequeathed by Ieyasu to the Owari branch of the family.

Over the decades the Tokugawa shogunate made a practice of trying to decrease the number of *tozama daimyō* and increase the number of the *shimpan* and *fudai*. By the end of the Tokugawa reign, sixty-three percent of the total of two hundred sixty-six daimyo families were of these latter two categories, direct relatives of the Tokugawa or descendants of traditionally loyal clans. The *tozama* families, although far smaller in numbers, usually had much greater land holdings. While the *fudai* and *shimpan* fiefs tended to be located around the Tokugawa holdings in Edo, hence near the center, the *tozama* domains were located in regions to the west or north or on the Japan Sea coast, remote from the central administrative seat.

Over the daimyo the shogun exercised absolute authority—the power of life and death—and a document certifying that he was indeed lord of his fief was issued to the individual daimyo, not to his family. It was revoked when he died without a direct heir, and restored to a foster son (adoption being a common practice at the time) only if certain conditions were met. Moreover, it was not the Tokugawa clan but each shogun in each generation who decided which person in which family would be recognized as lord of a domain.

The shogun also held the powers of attainder and transfer over the daimyo: he could confiscate, increase, decrease, or shift the location of a fief. The daily lives of the daimyo were regulated in a number of ways by a code (the *Buke Sho-Hatto*, see no. 60), which restricted the making of private marriage arrangements, the reconstruction or enlargement of a castle, and the building of ocean-going vessels, and by the policy of alternate attendance (*sankin-kōtai*), which obligated the daimyo to live in Edo in alternate years.

The administration and maintenance of order within each fief, however, including the collection of the land tax (in rice), were left completely to the daimyo. As

Location of the Three Tokugawa Houses and the Daimyos (1664)

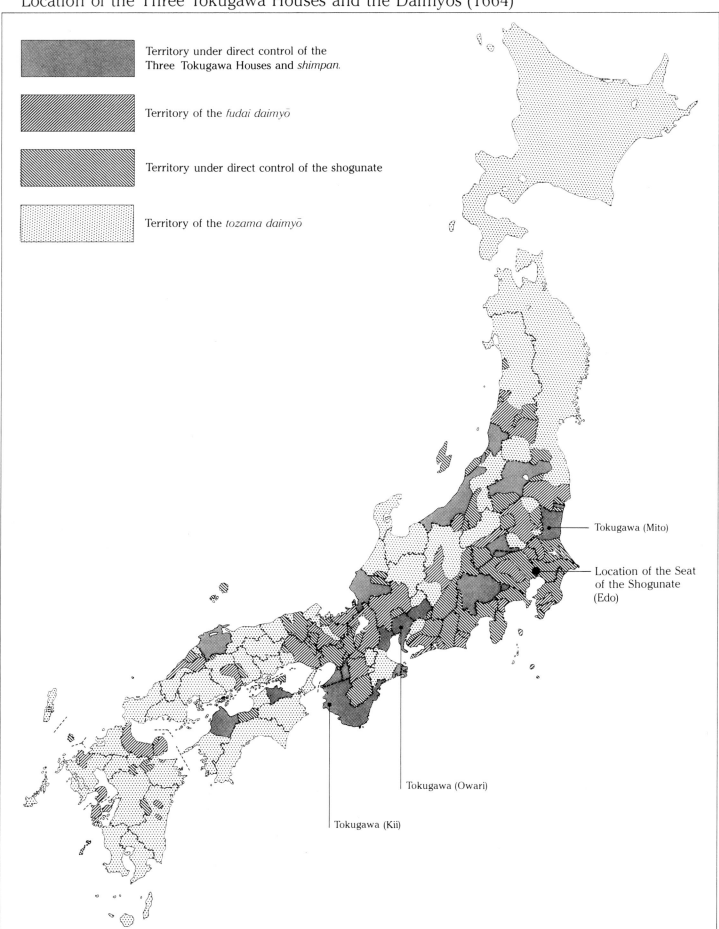

Territory under direct control of the
Three Tokugawa Houses and *shimpan*.

Territory of the *fudai daimyō*

Territory under direct control of the shogunate

Territory of the *tozama daimyō*

Tokugawa (Mito)

Location of the Seat
of the Shogunate
(Edo)

Tokugawa (Owari)

Tokugawa (Kii)

long as he refrained from political excesses so extreme as to make life in his domain unbearable for the peasants, the central government ceded local power to him.

The Tokugawa Family

The main branch of the Tokugawa family, in addition to being the clan of the shoguns who ruled the nation, was itself a feudal household, with lands and wealth far greater than that of any other. Its nationwide holdings, about seven million *koku*, were nearly seven times that of the next largest clan, the Maeda family of Kanazawa (on the Japan Sea coast), with one million twenty-five thousand *koku*. Even if we add the holdings of the next two most powerful families, the Shimazu of Kyūshū (728,000 *koku*) and Date of Mutsu (625,000), the total is still only about one-third that of the main branch of the Tokugawa clan.

The Tokugawa clan was served by about eighty thousand vassals, equivalent to a combination of forty households of greater daimyo (those with holdings of 100,000 *koku*).

Of their seven million *koku*, they distributed about three millions as fiefs to their *hatamoto* ("bannermen," retainers directly responsible to the Tokugawa clan) and managed the remaining four million directly. Their domains were not clustered in one area but scattered across the nation.

The Tokugawa clan was also the wealthiest. Although the income of most daimyo came only from the land tax collected on their domains, the Tokugawa revenues consisted not only of the taxes levied on their four million *koku* but also of profits from mines and exclusive rights on trade revenues.

From their revenues, however, the Tokugawa clan managed the administration of the central government. They collected from the daimyo not one grain of rice or gram of gold for that purpose. In fact, they frequently provided financial assistance to daimyo, in the form of loans or grants. During the two hundred sixty-five years of the Edo period there were many instances of daimyo households in financial trouble, but not one was destroyed by bankruptcy, thanks to direct or indirect aid and support from the Tokugawa clan.

This is not to say that the daimyo were without

duties or responsibilities to the shogunal family. Each daimyo was required to maintain a residence in Edo, where he had to leave his wife and children (in effect as hostages) and where he had to live himself in alternate years. He also had a number of duties that belonged to the category of military obligation. There was great variation, but in essence each daimyo was expected to maintain a force of two hundred warriors per ten thousand *koku* of rice. This force came under the command of the shogun and was expected to respond to his orders. In times of peace, they also followed the directives of the shogunate, engaging in such projects as constructing castles and building canals.

The Shogun and the Shogunate

The relationship of the shogunate (*bakufu*) to the local governments (*han*) was in some respects similar to that of the federal to state governments in the United States today.

The Tokugawa government held exclusive rights to the conduct of foreign diplomacy, and interchange took place only in Nagasaki under the control of the *bakufu*. Japan imported great quantities of silk in those days, but all profits from that trade were the perquisite of the shogunate. Trade was permitted only with China and Holland, and news of the outside world came in each year through the Dutch. In other words, the shogunate held exclusive rights not only to the profits from foreign trade, but also to information about the rest of the world. These reports from Holland, called the *Oranda Fūsetsusho*, were quite detailed, and reading through them provided the shogunate with considerable knowledge of conditions and events outside Japan. For example, they learned in detail about the British invasion of China in the Opium Wars of 1840: the report gave the names of vessels, number of cannon, and names of captains of the naval forces of Britain, the United States, and other nations located in the waters around China and in the eastern Indian Ocean.

The political activities of the shogunate proceeded under an extremely well-ordered administrative organization, which consisted of the shogun, *fudai daimyō*, and *hatamoto*. It was perhaps better ordered than the central government of almost any other feudal nation.

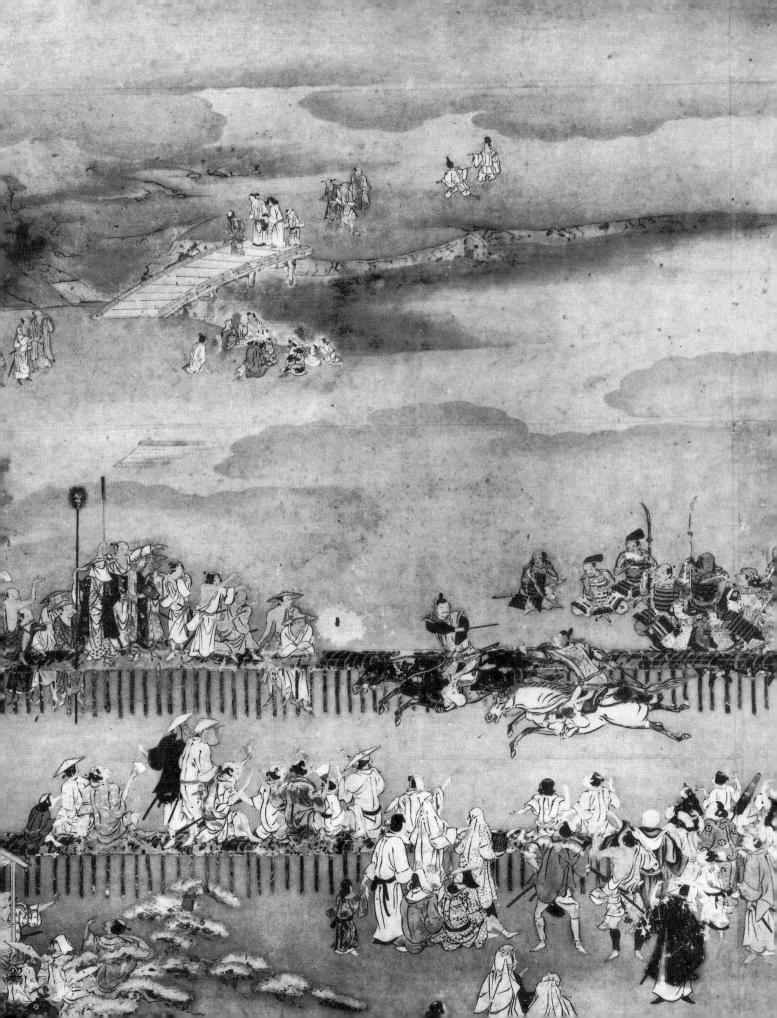

The shogun was the supreme ruler of the society, in every sense. Fifteen generations of Tokugawas served as shoguns during the Edo period, and among them were men whose natural inclinations, or perhaps illness, prevented their being forceful leaders. Yet even under those circumstances the authority of the shogun was unquestioned: whatever he willed took precedence over any other authority or law. This means that even though the society of the Edo period was one of strictly separated and regulated social classes, an individual of any rank, even the lowest, could rise to political power if he enjoyed the personal trust of the shogun. This reality, in tandem with the class structure, gave a measure of flexibility to a system that tended towards rigidity, and thereby helped to perpetuate it.

The trusted *fudai daimyō* usually filled the highest posts in the administration, the *tairō* (Great Elders), *rōjū* (Ministers), *wakadoshiyori* (Young Elders), Administrator of Kyoto, Governor of Osaka Castle, Superintendent of Temples and Shrines, and *sōjaban* (personal representatives of the shogun). Slightly more than half of the daimyo houses that existed at the end of the Tokugawa reign were *fudai*, and from among these about twenty promising young men were selected to serve as *sōjaban*.

The duties of the *sōjaban* were largely ceremonial: they acted as personal representatives of the shogun in receiving daimyo or lesser lords, making calls on daimyo who were ill, and the like. However these duties gave them the opportunity to observe at first hand the workings of daimyo society, and thus selection for the post was considered to be the first step towards the elite positions in the shogunate.

Within the administrative machinery of the Edo shogunate were many *bugyō* (commissioners), of whom three were especially important: the Commissioners of Shrines and Temples, the City of Edo, and Finance. In fact these three operated with responsibilities ranging across the shogunate as a whole, while other commissioners were responsible for limited areas. The Commissioner of Shrines and Temples was usually a *fudai daimyō*, and from that post he could move up through the posts of Osaka Castle Governor and Kyoto Administator to the highest rank in the shogunate, the *rōjū*. In other words, the elite of the young *fudai daimyō* became *sōjaban*, and the most capable of them could move to the post of Commissioner of Shrines and Temples to learn the ways of the shogunate. In addition to duties within the national government, of course, the Commissioner had to manage the temples and shrines around the country.

It was the responsibility of the Osaka Castle Governor to reside in Osaka and defend the castle and the city, and also oversee the activities of the daimyo in western Japan. The Administrator of Kyoto was responsible for the defense and well-being of the city, for the supervision of the court and nobility, and for all judicial matters in the provinces surrounding Kyoto. The highest officials in the government were the *rōjū* or Ministers, with duties much like those of the Prime Minister today.

Serving under these high officials was a large corps of officials the *hatamoto*, who conducted the actual business of administration. Direct vassals of the family of the shogun, the *hatamoto* possessed holdings of up to ten thousand *koku*. They numbered approximately five thousand three hundred households. There was considerable variation in income, but those with at least one thousand *koku* could rise up through the ranks of the bureaucracy, in posts appropriate to their ages, and *hatamoto* of outstanding ability could attain such responsible posts as Commissioner of the City of Edo, Commissioner of Finance, and Chief Inspector, to wield considerable power within the shogunate. *Hatamoto* with incomes of less than one thousand *koku* usually concerned themselves with family affairs, clan economy and finances, and the like. The *hatamoto* were bureaucrats loyal only to the shogunate, and the existence of this group of able officials is one main reason for the long span of the Tokugawa government. Moreover, the framework of disciplined, well-trained bureaucrats facilitated the smooth transition and leap to modernization even after the fall of the Tokugawa shogunate during the Meiji Restoration of 1868.

The age of the shoguns was one of a highly planned and structured society, both political and economic. During this period, the population lived in peace, free from domestic or foreign wars. Rarely in history has such a populous nation been able to maintain peace for nearly three centuries while also keeping alive a culture and identity to be passed down to succeeding generations. It was, in this sense, one of the most remarkable eras in the history of the world.

SHOGUN AND DAIMYO

Yoshinobu Tokugawa
Director of The Tokugawa Art Museum

Economic Policies of the Tokugawa Shogunate

Tokugawa Ieyasu, who was appointed *Sei-i-tai-shōgun* in 1603, implemented the following four economic policies in order to establish absolute command over the numerous daimyo in the new administration:

1) Land survey
2) The separation of soldier from farmer
3) Monopoly over the right to mint coinage
4) Monopoly over the right to trade

1) Land Survey

The total agricultural production of the country as a whole was measured in terms of rice yield (*kokudaka*). Using the village as the smallest unit, the total cultivated land area of the entire nation was surveyed using a standard unit of measure. Through these cadastral surveys, the total agricultural production of a daimyo's domain could be calculated, and the status of a daimyo was determined according to the officially fixed *kokudaka* of his fief. The *kokudaka* of a fief also determined the ratio of the military and public service burden that a daimyo was expected to bear for the shogunate. Under shogunal administration, the taxes imposed on newly developed farmlands were either reduced or exempted for the fixed period of one year; as a result, newly-tilled acreage increased by as much as eighty percent in the course of one century. The term "daimyo" was used to designate samurai in control of a domain whose total agricultural yield exceeded ten thousand *koku.*

2) The Separation of Soldier from Farmer

The farmers who were responsible for the agricultural production that constituted the bulk of national production were forbidden to bear arms and were made to reside on the land they tilled. Samurai were not permitted to own land and resided in the castle towns of the daimyo. This policy formed the basis of the social ranking system—consisting of samurai, farmer, artisan, and tradesman—which functioned to promote the development of cities, industry, and trade.

3) Monopoly over the Right to Mint Coinage

Gold and silver mines throughout Japan were placed under the direct administration of the shogunate. The circulation of ancient coinage, private coinage, and Chinese Ming coinage of non-standard weight and value was forbidden. Gold and silver coinage (see nos. 117 and 118),

with bronze coins as supplementary currency, were minted according to standardized weights, and an official exchange ratio was established for the different coinages. This measure enabled the controlling of prices according to a nationally unified standard and greatly quickened the development of a money economy, which encouraged commerce, the distribution of goods, the development of commercial capital, and even the establishment of industrial capital in some instances.

4) Monopoly over the Right to Trade

A steady supply of goods at stable prices was ensured by barring methods of accumulating wealth by the daimyos apart from agricultural production within their fiefs, strengthening commercial rights through the expansion of capital and forbidding the mainipulation of prices by foreign merchants. Not only did the shogunate profit from these policies, but more importantly they encouraged the stable development of domestic manufacturing industries and commercial industries.

The authority of the daimyo was thus greatly diminished, constituting mere administration of the domain that he had once owned outright; and the power lost by the daimyo was transferred to the shogunate. Since the establishment of the feudal system in the late twelfth century, ordering a daimyo to shift from fief to fief had been unthinkable, but it became possible for the Edo shogunate to command at will the transference of a daimyo with an income of one hundred thousand *koku* from his original fief one hundred kilometers north of Edo to one affording the same income five hundred kilometers south of Edo. The newly instituted system now enabled the shogun to order the daimyo or those retainers under direct shogunal command (*hatamoto*) to change fiefs, appoint them to fiefs of increased or decreased income, or even confiscate their fiefs entirely. The shogun could also order the daimyo to regulate his retainers in the same manner.

At the end of the sixteenth century, the domain of the daimyo consisted of lands either passed down from their forbears or those lands acquired through force. The land and its inhabitants were at that time the property of the daimyo, which he defended against the military aggression of other daimyos. The position of the daimyo under the Tokugawa shogunate, however, was of a completely different nature. Under shogunal administration, a daimyo could not even retain the domain that had been handed down

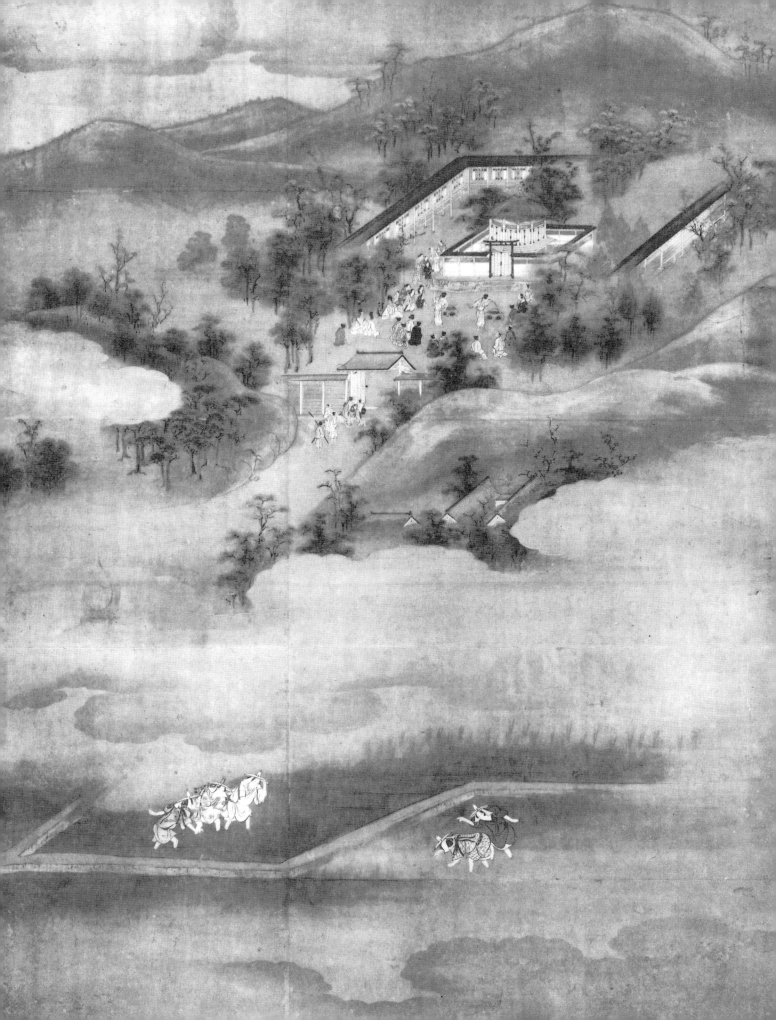

to him by his ancestors if he opposed the shogunate's dictates. He was subject to being transferred to another fief or even of forfeiting his fief entirely in extreme cases. A daimyo was strictly forbidden to wage war against another daimyo, and if he mobilized his warriors of his own accord, he was immediately subdued by the troops of other daimyos under the command of the shogunate.

When a daimyo was transferred to another fief, the samurai who served as his retainers were permitted to follow him, but the farmers and townspeople were not allowed to move. It can be said that the status and authority of a daimyo, to whom the shogunate granted administrative powers but not ownership rights, was closer to that of a colonial civil administrator, rather than that of a feudal prince.

The Civilian Administration of the Tokugawa Bakufu

The shogunate established absolute dominance over the daimyo through economic policies, and tended to seek to govern the nation through civilian administration. During the long, turbulent era of war that had preceded, the principal means by which a daimyo could protect his own territory was through military strength. In contrast to the concept of military might as the basis for justice and administration, the Tokugawa shogunate substituted the absolute authority and military resources of the shogun for the military strength of each individual daimyo. The "Great Peace of Edo" which lasted for two hundred sixty-five years (1603—1868), can be called the period of the *Pax Tokugawana,* the peace instituted by the Tokugawa shogun.

The concepts of right and administration implemented by Tokugawa Ieyasu in place of militray strength alone were morality and order, supported by the teachings of Shintō, Confucianism, and Buddhism, and the scholarship required to master these teachings. Ieyasu had assiduously applied himself to scholarship from his early boyhood; especially from 1592 onward, after he had passed the age of fifty, he strove to cultivate himself with the aim of holding the reins of the next administration—an aim that became a reality when he acquired the post of shogun in 1603. After he abdicated in 1605 at the age of sixty-four in favor of his third son Hidetada, he immersed himself in scholarship, collecting a vast

number of books, having them transcribed and printed using copperplate, and gathering together outstanding scholars to listen to their lectures and discussions. Needless to say, Ieyasu's enthusiasm for scholarship did not simply stem from a casual interest; instead, his propensity toward scholarly matters derived from his search for a set of national ethics and concepts of government that would be viable in the distant future and help to consolidate the foundation of the newly established Tokugawa shogunate.

Respect for Traditional Aesthetics

Ieyasu did not search for the foundations of the newly created system in scholarship alone. His letters and the many memoirs that he left indicate that, after he had reached the age of sixty, he would occasionally lecture to his retainers and their wives and children in easily understandable language on the daily practice and preparation required for them as members of the samurai class and as human beings, and would occasionally expound on profound philosophical principles. That Ieyasu was the possessor of a truly severe stoic philosophy in judging himself is clear from the fact that he unceasingly advocated patience, selflessness, forbearance, and self-control as the principal rules for those who, like the shogun and daimyo, were in a position to rule over others.

Ieyasu felt that the new administration centered on the person of the Tokugawa shogun necessarily required a new etiquette and standards of personal cultivation. He assiduously studied the ancient customs of the Ashikaga shoguns in the Muromachi period, and instituted a systematic mode of appreciation of the traditional arts, which had been on the verge of a state of confusion at the end of the sixteenth century. That is to say, he redressed the extravagance shown in receiving guests and also in daily life, which had become ostentatious and subject to the vagrances of fashion. He was a strong advocate of the samurai etiquette that had been established in the fifteenth century, and of the austerity of *wabi-cha,* one of the forms of the tea ceremony which embodied the new Japanese aesthetic that had emerged during the sixteenth century.

The fifteenth-century etiquette of the samurai for receiving guests included the display of a Song or Yuan period Chinese hanging scroll in the alcove with a Chinese flower vase, incense burner, and candle stand arranged in front

of the painting; displaying Chinese or Japanese lacquerware of the highest quality, such as tea caddies, incense containers, and tiered boxes on the staggered shelves; and adorning the desk alcove with writing implements. For the entertainment of the guests, a Nō drama was performed, to be appreciated while exchanging cups of *sake* and sharing an exquisitely prepared banquet.

On the other hand, *Sōan* tea, a form of tea etiquette that focused on the simple, austere spirit of *wabi* and was strongly influenced by the teachings of Zen Buddhism, attained sudden popularity among the merchant class from around the beginning of the sixteenth century. This etiquette was based on the concept of receiving a guest by sharing together a cup of tea, without regard to status, thereby transcending the notion of rank in the relationship of host and guest. This *Sōan* tea was altered by the great warlords Oda Nobunaga and Toyotomi Hideyoshi into a luxurious pastime in which individuals vied to outdo one another in splendor. Daimyos, samurai, and merchants all tended to compete in the sumptuousness of their accout-

rements for this basically simple "tea of the grass hut" (*suki no cha*). Ieyasu adopted the receiving etiquette that was the most positive aspect of this form of tea, and established as part of traditional culture the tea utensils that already reflected a fixed set of aesthetic values, adopting these values themselves in the process. On the other hand, he rejected the new, creative awareness of value judgment, which lay within the spirit of this form of tea, as a concept that would disrupt order.

In this manner the shogunate, headed by Tokugawa Ieyasu, created a new etiquette, suited to the new administrative order and regulated by both the samurai etiquette of the fifteenth century Ashikaga shogunate and the conventions of *suki no cha* developed during the latter half of the sixteenth century. The daimyos of the Tokugawa clan, led by the Owari Tokugawa, as well as the other daimyos, adopted these forms of etiquette, thereby consolidating the foundation of the culture of the samurai and the daimyo, who formed the ruling stratum during the Edo period.

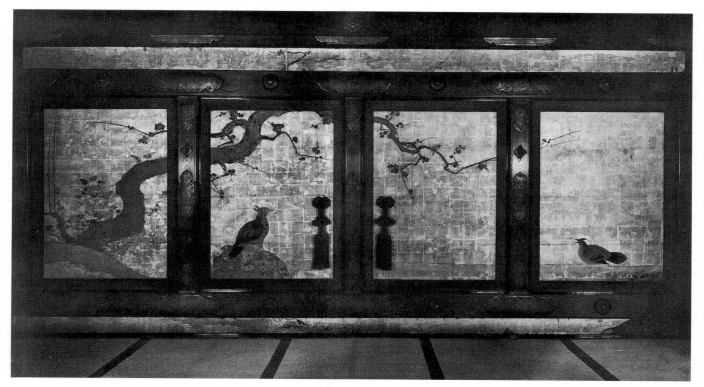

A DAIMYO'S POSSESSIONS

Yoshinobu Tokugawa

A daimyo is, of course, a samurai and a military leader. Preceding the Edo period, that is to say, until the battle of Sekigahara in 1600, a daimyo acquired and maintained his status primarily through force, relying on the fighting ability of the retainers under his command.

However, with the appointment of Tokugawa Ieyasu as *Sei-i-tai-shōgun* in 1603 and the establishment of the shogunate in Edo, daimyos were no longer able to use armed force on their own initiative without the consent of the shogun. In the new order, if a daimyo disobeyed the shogun's commands in this respect, he would be forced to relinquish his fief and lose his status as a daimyo. The two hundred sixty-five years of peace that continued until 1868 was maintained through the absolute authority of the Tokugawa shogun.

The foundations for this two and a half centuries of peace were laid by Ieyasu who, in the opening articles of his last instructions addressed to the daimyos, admonished them to endeavor in both the literary and military arts. With the advent of peace, a daimyo was no longer simply a military commander, it was also demanded that he be a competent administrator. Thus Ieyasu intended that they should apply themselves not only to the military arts, but also to the various scholarly fields that would serve as the basis for their administrative duties. It can be said with justification that not even the slightest threat of war marred this long period of peace—a period in which the daimyo followed the dictates of the age, and the emphasis was placed on the literary rather than the military arts.

Once the duties of the Edo period daimyo were regulated in this manner, and literary pursuits took precedence over military matters in daily administration and self-cultivation, changes occurred in the types of articles accumulated for daily use and for display during official functions and their relative importance. Taking into account the altered role and character of the daimyo in the Edo period, the articles in his possession can be surveyed in the following manner.

A daimyo's possessions are divided into the two principal categories of *omote-dōgu* (official articles) and *oku-dōgu* (private articles). The *omote-dōgu* consisted of arms and armor kept in readiness in accordance with the income and status of the lord of the fief, and books and accoutrements for actual use or for the ornamentation required on formal occasions. The *oku-dōgu* consisted of articles used in the private life and pastimes of the daimyo himself, as well as the members of his household.

I. *OMOTE-DŌGU*

A. Arms and Armor

1. Sword blades such as *tachi, katana, wakizashi, ko-gatana* and sword fittings; and other weaponry including spears, halberds, firearms, and cannon

Swords were called the "Soul of the Samurai," and the high spiritual and aesthetic qualities suffused by the master swordsmith into these blades were respected highly. Even among the vast variety of articles included in a daimyo's possessions, swords were decidedly of the first rank, and were the most highly regarded gifts exchanged between shogun, daimyo, and their retainers. In terms of destructive capability as a weapon of war, swords were less effective than spears which had been in use since the fourteenth century. Moreover, it is readily apparent that they were also inferior in this respect to muskets and cannon that were introduced in the latter half of the sixteenth century. However, these forms of weaponry were ranked only as functional arms, while the sword had occupied the highest status from ancient times because of its outstanding spiritual qualities. Components of the sword mounting, such as the scabbard and hilt, sword guard, decorative *menuki, kōgai,* and *ko-gatana* were frequently produced using the highest standards of craftsmanship, befitting the accoutrements of an article of such exalted status.

2. Armor, battle standards, tents, riding capes, conches, military leader's batons and fans, and battle drums and gongs

The defensive armor was, of course, worn, and the other military equipment listed above was used to adorn the headquarters or temporary residence of the commander as manifestations of his might. However, it was not considered sufficient for armor to be functional alone, and armor worn by daimyo were especially outstanding examples of craftsmanship that were beautiful to behold and skilfully created to manifest the true spirit of the warriors who wore them. For this reason, even with the advent of a peaceful society, every year on the eleventh day of the first lunar month, a celebration was held in which a suit of armor was displayed in the *shoin* of a daimyo household and battle standards were erected in the garden to pray for success in military matters in the coming year.

3. Horse trappings, falconry accessories, et cetera

Horses were of prime importance during military engagements, and defensive armor and equipment were provided for the mount. In peacetime, too, horses were always maintained in readiness, and saddles and stirrups in keeping with a daimyo's status were also kept at hand. Grand hunts and falconry were not simply undertaken for the pleasure of the hunt or sport, but were performed with the aim of military training and inspection of the condition of the populace in times of peace.

B. Decorative Implements

1. Implements for Decorating the *Shoin*

Since the advent of the feudal period in Japan, rooms ranging from the *dai-shoin* to reception rooms of various sizes were provided within the residence for official receptions given by the daimyo. In each of these rooms, an alcove (*tokonoma*), staggered shelves (*chigai-dana*), tripartite shelves (*seirō-dana*), and desk alcove (*shoin-dana*) were provided along with specialized spaces reserved for the arrangement of ornamental implements. In the residences of the the families of the shogun, the Three Tokugawa Houses, and the most influential daimyos, the traditional ornamentation based on the ancient customs of the Ashikaga shoguns during the Muromachi period served as the standard. In the large alcove of the *shoin,* a Chinese monochrome ink painting triptych was hung, in front of which were displayed the *mitsu-gusoku* or offering set consisting of three objects, namely a bronze incense burner, candle stand, and flower vase arranged on a base. To the side were placed a pair of flower vases in which flowers of a pale color were arranged in the *shin* manner. On the *chigai-dana* and *seirō-dana* to the side of the large alcove were placed incense instruments, *Temmoku* tea bowls, tea caddies, incense containers, and nested boxes all set on trays or stands, with trays and basins placed on the lower levels. A set of *daisu-kazari,* or utensils for the preparation and serving of powdered tea, was also provided among the ornaments in the receiving area. In the waiting room, a kettle and brazier were placed with writing implements such as an inkstone, ink stick, brushes, and scrolls arranged decoratively in the desk alcove.

2. Utensils for Decorating the Tea Hut (*Sukiya*)

The etiquette of austere *wabi* tea, which governed the partaking of tea in a small room, was widely practiced during functions in a daimyo household and called *o-sukiya.* In a room only nine feet to a side, the daimyo as host and a single guest accompanied by one to three attendants were the only participants, who enjoyed tea and conversation in serene calm, removing even the *wakizashi* short sword before entering. In the small alcove were displayed a calligraphic scroll of an honored Zen monk along with flowers. The kettle was placed upon the brazier, and the daimyo as host himself prepared the tea and offered it to the guests, using such utensils as old Chinese tea caddies and incense containers, Korean tea bowls of the Yi period, ceramic water containers from Southeast Asia, and bamboo ladles and tea scoops— all seemingly humble and austere utensils of *wabi* tea. It was considered an essential part of a daimyo's education that he possess the knowledge necessary to be able to appreciate, both from the standpoint of host as well as guest, the hidden spirituality, the aesthetic of *wabi,* and the ancient and honored lineage of these utensils, which may at first have seemed almost coarse and of little value.

3. The Accoutrements of the Nō Drama

In the grand audience hall of the *shoin,* the official reception commenced with the ceremonial exchange of *sake* cups called *shiki-sankon,* and numerous gifts were presented, beginning with swords and gold. As many as three trays burdened with unusual and elaborate dishes of food were brought in succession. In conjunction with these proceedings, performances of Nō and Kyōgen were offered, accompanied by flutes, hand drums, stick drums, and chanting, on a specially-constructed Nō stage located just across a small garden from the audience room. The plays to be performed were selected to suit the particular reception. The actors performed before the host and his guests wearing exquisite costumes kept for this purpose in the daimyo household. The daimyo was naturally expected to possess a profound knowledge of the plays, modes of performance, dances, costumes, and masks used in these Nō performances, and if asked to do so, needed to be able to chant, beat the drum, and dance himself. For the above reasons, the accoutrements of Nō were required to be on hand at all times in a daimyo household. In addition, Nō actors were either always in the employ of or received stipends from the daimyo.

4. The Library

Apart from the reading material which was kept for daily

reading or ornamental purposes, a vast number of books were kept on hand for the daimyo's learning and cultivation. The library contained tomes on Japanese and Chinese history; the teachings of Confucianism, Buddhism, and Shintō; books on the military arts, strategy, geography, astronomy, and production; medical tomes; and countless volumes of classical literature. This library was provided for the scholarly pursuits of the daimyo and the members of his household, and was also made widely available to the scholars in his employ and his retainers. There were not a few daimyo who themselves edited volumes on history, philosophy, and economics, and ordered the scholars and retainers under his command to compile a variety of studies such as topographical treatises, genealogies, and the like, at times having them published and presented to the public.

II. OKU-DŌGU

A. Household Furnishings

It goes without saying that furniture and personal effects of myriad varieties were used in the daily life of a daimyo household. Although the actual objects used in day to day life necessarily suffered from wear and no longer exist today, some of the articles owned by Tokugawa Ieyasu and the wedding trousseaux of the wives of the successive daimyos were not subjected to constant use and have been carefully preserved in an almost perfect state. These household articles can be categorized in the following manner.

1. Shelf Ornaments

These consist of the incense instruments, various types of boxes, letter cases, scrolls, and books placed as ornaments on the so-called "three shelves," consisting of *zushi-dana, kuro-dana,* and *sho-dana* (see no. 273).

2. Personal Effects

This category includes small household furnishings: toiletry articles such as the dressing table, cosmetic cases, basins, latticed box on which to drape a garment for perfuming with incense, and a rack for hanging a *kimono*; special cosmetic boxes, portable dressing tables, and tea utensils for use when traveling; and such light furniture as armrests, which were always placed on one's right.

3. Pastimes and Amusements

These include articles used in such pastimes as Japanese chess, *go,* backgammon, the incense-identifying game, shell-matching game, and card games. Although these were amusements, the boxes containing the shells used in the shell-matching game were considered the foremost among articles included in the wedding trousseau, and the articles for the incense-identifying game could at times also be used to decorate the shelves, thus being prized more as symbols of rank rather than as practical objects.

B. Clothing

While clothing was a necessary part of daily life and served the function of keeping one warm, it was also, of course, a form of personal ornament which indicated one's status. It therefore goes without saying that there were prescribed types of clothing for the daimyo as lord of the fief and the members of his family. Since clothing suffered greatly from wear, garments worn frequently in daily life rarely survive. Ieyasu's clothing, however, was carefully preserved even after his death, and are unusual examples of everyday garments that survive today.

Apart from daily wear, garments for specific occasions and ceremonial functions were worn infrequently and carefully preserved, so that many examples in this category exist today. Nō costumes are, of course, not garments for daily use, and are theatrical costumes reserved for official performances of Nō. They are therefore classified under the *omote-dōgu* and carefully preserved to the present day.

C. Medicines and Medical Instruments

This category consists of medicines and the implements used to prepare them.

D. Paintings

1. Yamato-e

Illustrated handscrolls of the Heian and Kamakura periods such as the Tale of Genji Scroll (*Genji Monogatari Emaki,* of which fragments constituting slightly more than three scrolls exist in the collection of The Tokugawa Art Museum) and scrolls relating the legendary origins of a shrine or temple (*engi-emaki*) are well-known today and are frequently registered as National Treasures or Important Cultural Properties. In the daimyo household, however, such scrolls were considered part of the *oku-dōgu,* and not articles that could be used as *omote-dōgu*

for official occasions. They were considered rather as objects for the private amusement and personal cultivation in the lives of the daimyo and his family.

2. Ukiyo-e

Ukiyo-e paintings, such as the folding screens depicting the Aoi festival, amusements, or genre scenes produced in the early seventeenth century, and the *Uneme Kabuki* scroll (see no. 205), were strictly confined to use as articles for the private amusement of the members of the household, and it was unthinkable to display them as official ornaments in the *shoin* or in the tea-room. Nonetheless, since the early Edo period, *ukiyo-e* paintings were highly regarded and preserved accordingly. *Ukiyo-e* prints were not considered important, however, though they had probably provided a source of amusement for the household; and not having been preserved, none remain in the collection of The Tokugawa Art Museum today.

3. Paintings by Members of the Household

Tokugawa Ieyasu and the daimyo and their families in the Edo period practiced painting as a hobby and amusement, but more importantly as an accomplishment and a means of self-cultivation. Among these painting practitioners of high social rank, there are quite a few who actually became professional painters or whose talent rivalled that of professional painters. Paintings executed by the daimyo or members of his family were considered private *oku-dōgu,* unsuitable for official display as long as they remained in the family. If the paintings were presented to retainers or temples and shrines, however, they were treated as objects of an official nature that lent honor to the recipient.

Chinese paintings and monochrome ink paintings, bird-and-flower screens, works of the Chinese-influenced Kanō or Unkoku Schools, and wall paintings in the native Japanese traditional modes practiced by the Tosa and Sumiyoshi Schools may occasionally have been used in the private quarters, but they were interpreted as *omote* articles that could at the same time be displayed on official occasions.

E. Calligraphy

The calligraphy of a Zen master, the Japanese poems written on decorative paper, such as *kaishi, shikishi,* or *tanzaku,* by a famous poet or calligrapher, warrior, or tea master of note,

and occasionally documents, were mounted as hanging scrolls and served as *omote-dōgu* used to adorn the alcoves of the tea room and *shoin.* When calligraphy of this type was mounted together to form an album or on a folding screen, they were counted among the official articles. The calligraphy albums, however, were not only considered as articles for official decoration, they were also part of the wedding trousseau and used for personal enjoyment as an *oku-dōgu.* The daimyo and his family studied calligraphy as a matter of course from the time they were small. This was not simply to learn how to read and write, for they were required to be able to write beautiful, accomplished calligraphy. Among daimyos and their families are counted numerous talented calligraphers of great fame whose work had been highly regarded even during their lifetimes. Calligraphic studies and works produced within the family were preserved in the private quarters, where they were prized and appreciated as works of art. Like paintings, such examples of calligraphy were considered *oku-dōgu* while in the possession of the family, but were treated as official articles by the recipients once they were presented to retainers or temples.

Since *omote-dōgu* were embodiments of rank used on official occasions, there were rules and regulations governing them in line with the status of the particular daimyo. In contrast, however, since the *oku-dōgu* were used as private effects, there were no rules governing them and they varied greatly from family to family. Although these private articles were used largely for amusement and to further one's attainments, they also indicated the status of the family that used them in the same way as the official articles, and were a tangible manifestation of the accomplishments and scholarly pursuits of the daimyo and his family.

THE TOKUGAWA ART MUSEUM

The Tokugawa Art Museum is a repository of the family treasures of twenty generations of the Owari Tokugawa family, established by Ieyasu, the founder of the Tokugawa shogunate, as one of the three main branches from which his successors might be chosen. The first lord of the Owari Tokugawa family was his ninth son, Yoshinao,. who was granted a fief of 620,000 *koku*—that is, an estate yielding some three million bushels of rice; the seat of his domain was Nagoya Castle. The Tokugawa Art Museum collection is, in a word, the household property of Yoshinao and his descendants.

In the century since the Meiji Restoration, and especially during the economic hardships of World War II and the immediate post-war period, the descendants of many of the three hundred feudal lords of the Edo shogunate have had to sell the treasures that had been handed down in their families for generations, and precious collections have been scattered and lost. Marquis Yoshichika, the nineteenth lord of the Owari Tokugawa family, however, decided in 1931 to establish a foundation—the Owari Tokugawa Reimeikai—to preserve the treasures of his family as an important cultural asset, and make them available for both scholarly research and public appreciation. He donated to the Foundation the entire Owari Tokugawa collection of paintings, books, objects of art, and documents.

The headquarters of the Tokugawa Reimeikai Foundation are at Mejiro, in Tokyo, where a library and research center were built to house the books and documents. The materials in the library are open to outside scholars. The Owari Tokugawa collection itself is housed in a museum built on a part of what was formerly the family estates in Nagoya; the museum was opened to the public in 1935.

In 1945, the building suffered extensive bomb damage. Fortunately, however, the collection itself was unharmed. Until this time, the Foundation's sole source of income

was its holdings in the Manchurian Railway, which were confiscated after the war. The postwar period was thus one of enormous difficulties in the administration of the museum and the repair of the building. In 1953, a new Museum Law was enacted by the Japanese government; to meet the provisions of the law, and to accommodate an increasing number of visitors, the museum was obliged to improve and expand its facilities. It was decided in 1964 to double the existing space, but only a part of that plan has been completed; the museum at present has a floor area of some 2,500 square meters.

Unlike museum collections that reflect an official policy, or the personal tastes of an individual collector, the works preserved here embody the culture and way of life of a feudal aristocracy that ruled Japan for nearly three hundred years. There are over 20,000 items in the collection; surviving with them are the historical records that enable us to know where they came from, how they were made and used, and what part they played in the lives of the people who owned and appreciated them.

THE ROAD TO THE SHOGUNATE

The first Tokugawa shogun, Ieyasu, was born in 1542 in Okazaki, Mikawa (present-day Aichi Prefecture), as the eldest son of the lesser daimyo, Matsudaira Hirotada. Having lost his father at an early age, he spent most of his youth as a hostage to the Oda clan at Atsuta and the Imagawa clan of Suruga (modern Shizuoka). At one point he was on the verge of losing his domain, but after the death and defeat of Imagawa Yoshimoto at the battle of Okehazama in 1560, he was released from hostage after thirteen years of confinement and returned to Okazaki. At the age of nineteen, he was once again fully reinstated as an independent daimyo.

In 1561, Ieyasu formed an alliance with Oda Nobunaga (1534—1582), and strengthened his own position in Mikawa, where he subdued the Ikkō sectarian uprising. He succeeded in unifying practically the entire province of Mikawa, and he was granted permission by the court to use the family name of Tokugawa in 1566. Subsequently, beginning with the conquest of Enshū (Shizuoka), the battles

After the death of Nobunaga, Ieyasu moved his residence to Sumpu and in 1584, he fought against Toyotomi Hideyoshi (1536—1598) in the battles of Komaki and Nagakute. After having emerged victorious in both battles, he concluded peace with Hideyoshi. These two battles had also been waged on the diplomatic, intelligence, and economic, as well as military fronts, and they served as a turning point, for Ieyasu was no longer solely a general but a statesman and administrator as well.

In 1590, Ieyasu was made to withdraw to the Kantō provinces and entered the castle at Edo. During this time he devoted himself to administering his domain: dividing his fief among retainers, consolidating those lands under his direct control, and developing the town of Edo. Through these activities, he progressively organized the administrative system of the Kantō region, which would eventually serve as the model for the shogunal administration. In addition to military power, he built up a corps of talented retainers, amassed great wealth, and

of Anegawa and Nagashino, he extended his domain to include the provinces of Tōtōmi and Suruga (both in Shizuoka), Kai (Yamanashi), and Shinano (Nagano). In 1570, he transferred his residence to Hamamatsu. By the time of Nobunaga's assassination at Honnō-ji in 1582, Ieyasu had become one of the most powerful daimyo in the entire country.

At the battle of Mikatagahara, Ieyasu's troops had suffered a crushing defeat at the hands of the Takeda forces and their cavalry strategy. In this battle, however, his bold and determined fighting earned him the reputation of "First Archer of the Kaidō," and became one of the most outstanding achievements of his career. Also, during the battle of Nagashino, the strength of the firearms of the combined Oda-Tokugawa forces was fully demonstrated, resulting in a great victory and impressing upon Ieyasu the need to procure supplies of this new weapon and strengthen the mobility of his forces.

improved the information-gathering ability of his forces, thereby buttressing his strength to become the most powerful daimyo during the period of Toyotomi rule.

After the death of Hideyoshi, Ieyasu was the principal member of the five-member Council of Regency. In 1600, after emerging victorious in the battle of Sekigahara, he became *de facto* ruler of Japan. In 1603, upon his appointment as shogun by the emperor and thus having been granted the authority to rule the country, he established the shogunate in Edo.

Ieyasu was a brave general as well as an able statesman and knowledgeable entrepreneur. His keys to success were patience and forbearance. However, before attaining power, he had already prepared a detailed blueprint to ensure peace and tranquillity. With his broad knowledge, acute powers of judgment, and outstanding ability, Tokugawa Ieyasu embodied that rare combination of talents: intellect with an ability to act.

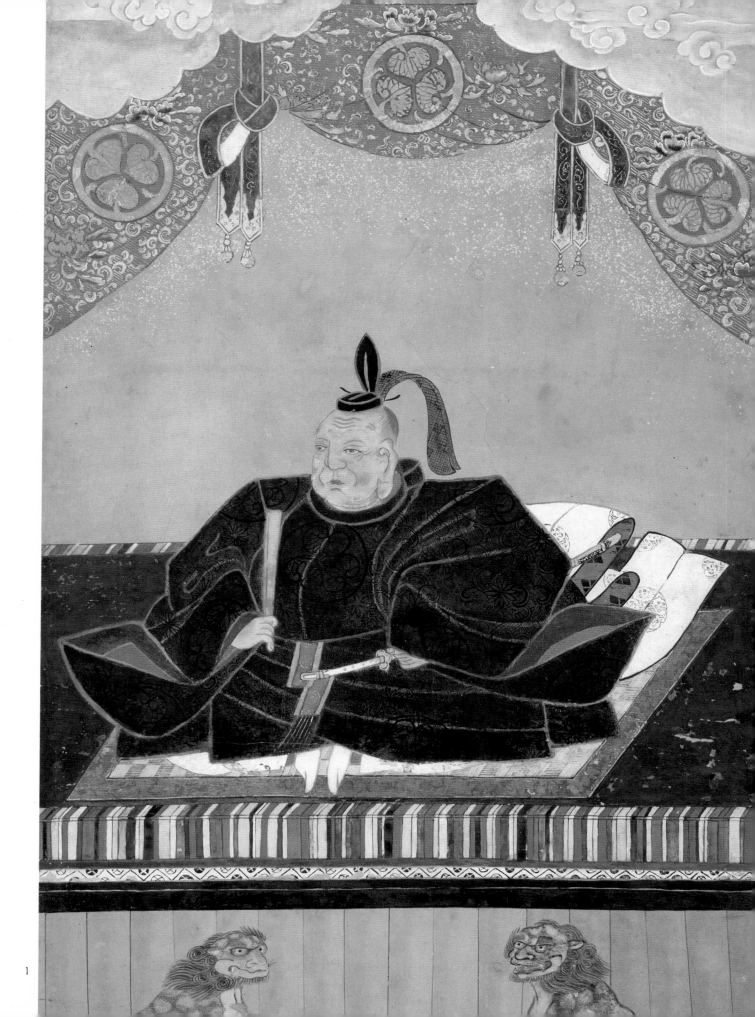

1

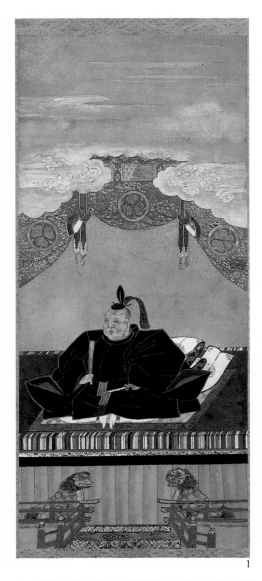

1

1. PORTRAIT OF TOKUGAWA IEYASU

Kanō Tan'yū (1602—1674)
Hanging scroll, ink, colors, gold pigment, and
gold and silver leaf on paper; 89.7 × 38.8cm.
Edo period, 17th century

In 1603 Tokugawa Ieyasu was appointed
Sei-i-tai-shōgun ("Barbarian-subduing
Generalissimo"), abbreviated shogun, a
title designating the apex of political power
in the military administration of the country.
Originally, this post had been an inter-
mittently sanctioned imperial commission
to a military commander charged with the
responsibility of subjugating offending
"barbarians" (which, at the time, meant
the indigenous people of eastern Japan).
From the Kamakura period (1185—1333)
onward, however, when the military class
seized the reigns of government, the status

of shogun came to manifest supreme
authority in all affairs of state—political
and economic, as well as military.

Ieyasu was born in troublous times,
when the country was torn by civil war
among rival regional lords defending their
local authority. By virtue of his personal
qualities and with force of arms, he gained
the office of shogun through a succession
of victories in this fierce struggle for power.

Sixty-two years old when he procured his
appointment as shogun, Ieyasu died of
illness thirteen years later at the age of
seventy-five. Even after his death, peace
and stability continued for two and a half
centuries under Tokugawa administration.
A harmonious culture flourished through-

out the Edo period (1603—1868), which
derives its name from the seat of the
Tokugawa regime in Edo (the present
capital Tokyo).

Ieyasu was posthumously honored as the
founder of the Edo period and Tokugawa
rule; his person and his great exploits were
even raised to the level of a religious cult.

The style of this portrait is based on an
iconic type of painted Shintō image.
Represented in old age, Ieyasu is depicted
as a deity. Portraits of him of this type are
said to have been painted by Kanō Tan'yū
(1602—1674), the foremost among the
artists officially attached to the Tokugawa
shogunate.

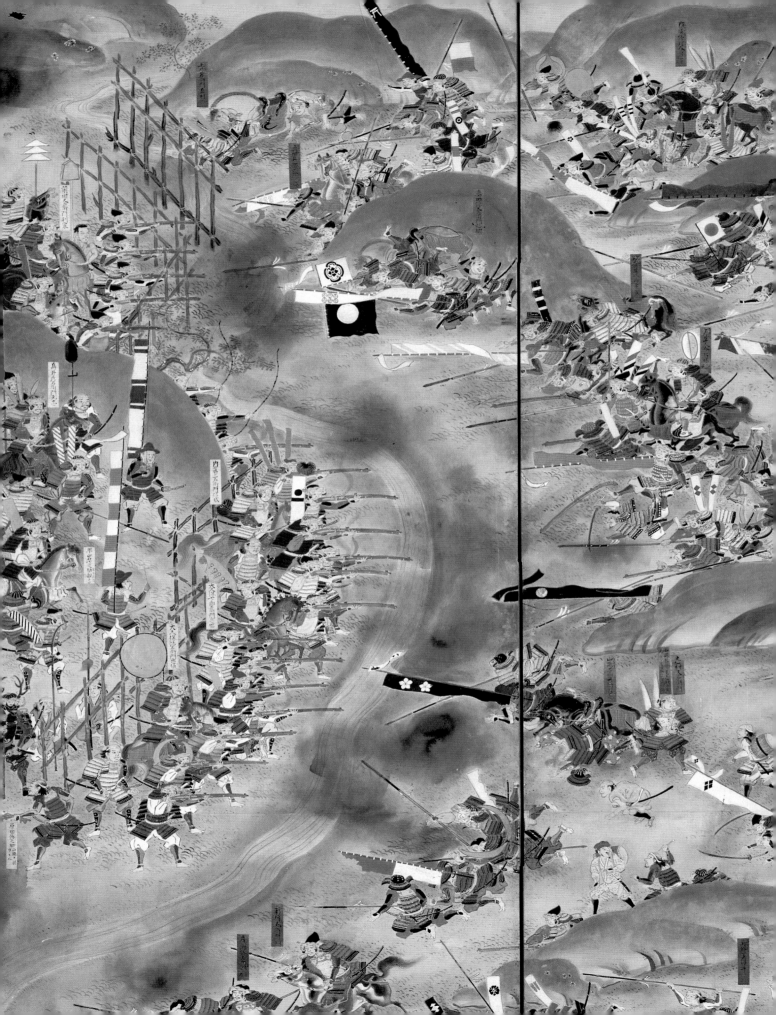

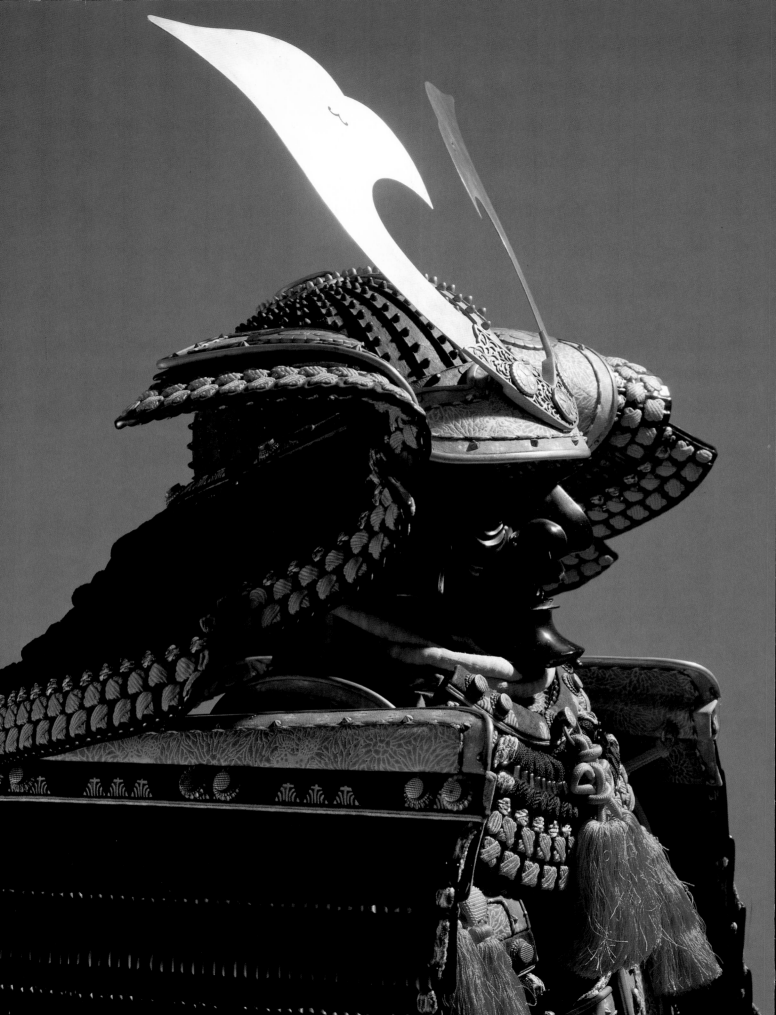

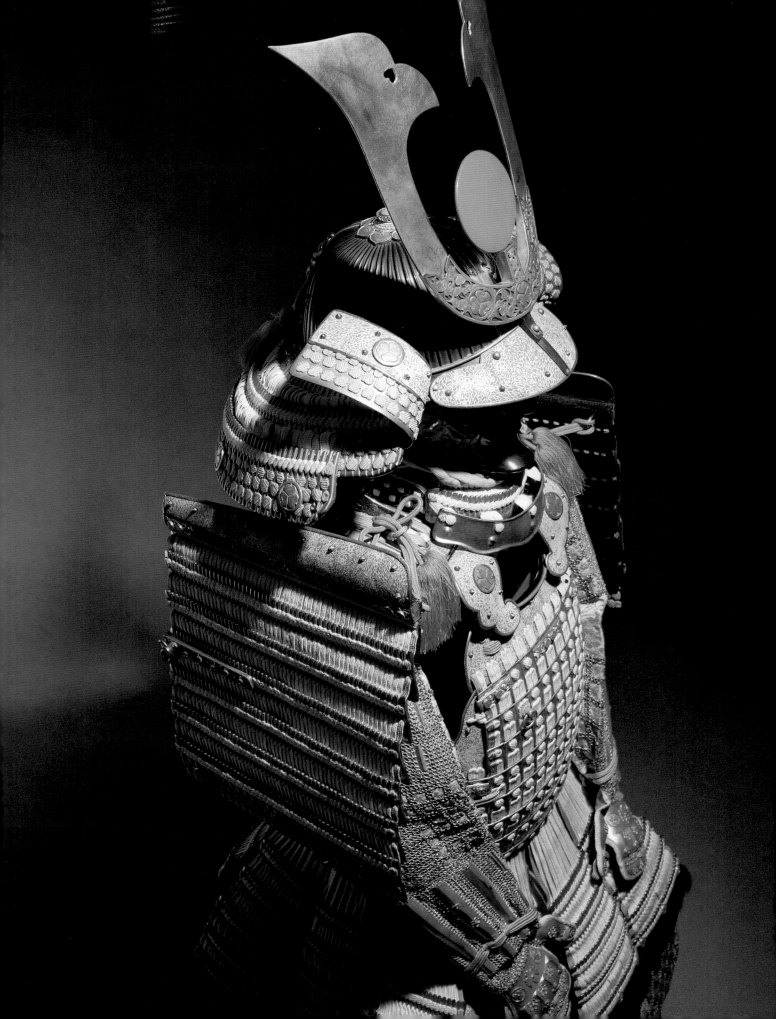

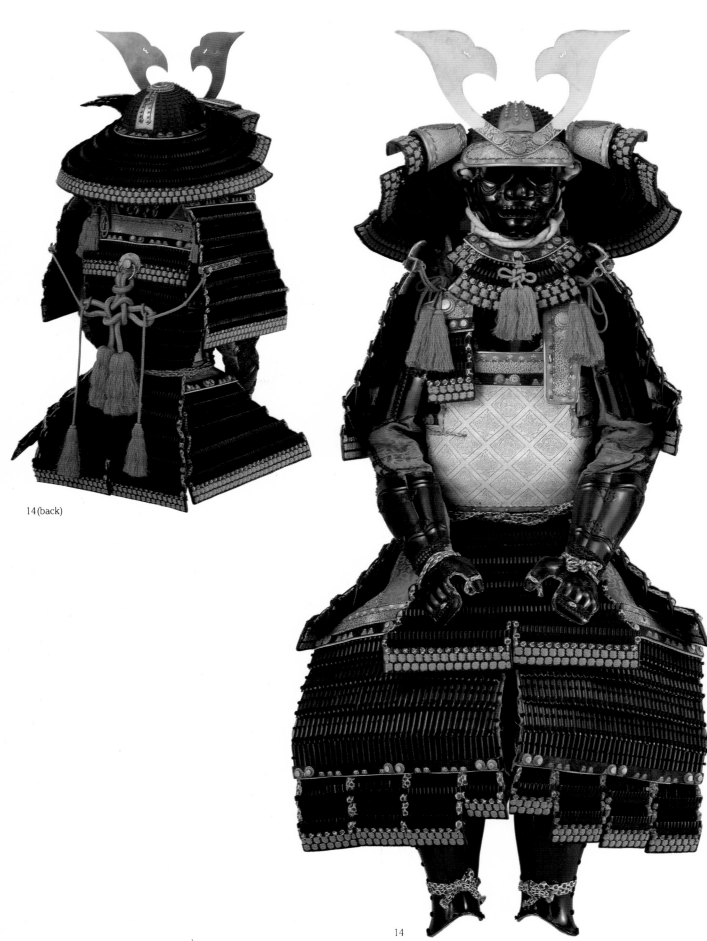

14(back)

◄ 14 (detail), 10 (detail)

14

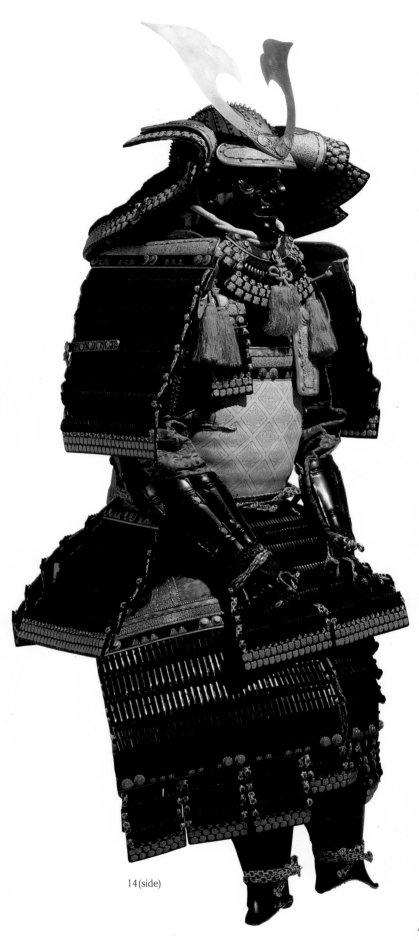

14. SUIT OF ARMOR IN Ō-YOROI STYLE

Black-lacquered iron plates with black silk lacing;
h. with stand 165.0cm.
Edo period, 18th century

This suit of armor is made in the ō-yoroi
style, which is the most formal type of
armor for high-ranking samurai. Used for
actual combat purposes from the middle of
the Heian period through the late Muromachi
period (from the tenth through the fifteenth
centuries), ō-yoroi were used for cere-
monial purposes in later periods. This set
of decorative armor was produced to be
worn on ceremonial occasions by Matsudaira
Katsunaga, who was the sixth son of
Munekatsu, eighth lord of Owari.

14 (side)

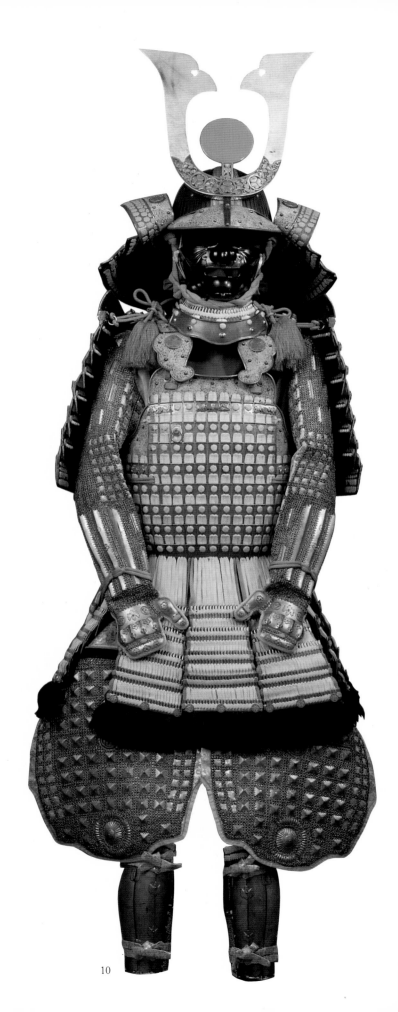

10. SUIT OF ARMOR IN *GUSOKU* STYLE

Silver-lacquered iron plates with white silk lacing;
h. with stand 170.5cm.
Edo period, 17th century

This suit of armor is in *gusoku* (or, more
properly, *tōsei-gusoku* or "modern
equipment") style. Of the different types of
Japanese defensive armor, the *gusoku*
style is the most recent, having been
developed during the Momoyama period
(sixteenth century). Drawing from ex-
perience derived over a period of prolonged
warfare, *gusoku* are characterized by
lightness and flexibility, in addition to afford-
ing strong protection.

This armor was made to be worn by
Tokugawa Yoshinao, first lord of Owari.
Of the many suits of armor owned by
Yoshinao, this one is said to have been
his favorite.

44

10

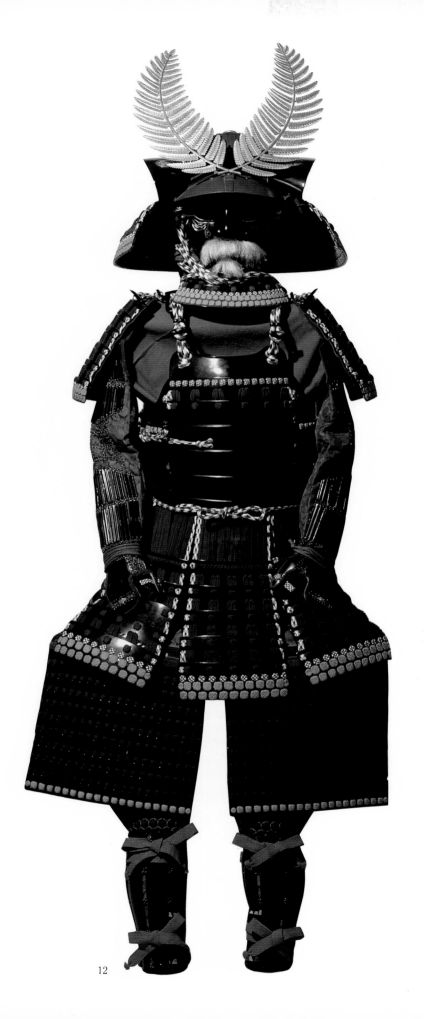

12. SUIT OF ARMOR IN *GUSOKU* STYLE

Black-lacquered iron plates with dark-blue silk
lacing; h. with stand 160.0 cm.
Edo period, 1849

This suif of armor is in the *gusoku* style.
It was made in 1849, toward the close of
the Edo period, to be worn by Tokugawa
Yoshikatsu, fourteenth lord of Owari.
In 1864, when Mōri of the Chōshū clan led
an uprising against the shogunate,
Yoshikatsu served as commander-in-chief
of the shogunate's forces, drawn from many
fiefs, and departed for the field wearing
this suit of armor.

11. SUIT OF ARMOR IN *GUSOKU* STYLE

Gold-foiled leather plates with black silk lacing;
h. with stand 160.0cm.
Edo period, 18th century

This suit of armor is also in the *tōsei-gusoku* style. The principal characteristic of a *tōsei-gusoku* consists of a cuirass composed usually of two hinged iron plates that open on the left side of the wearer, with the right side laced together. The cuirass of Japanese armor is basically made by tying together small plates of iron or leather with colored lacing. Unusual exceptions in armor of the *gusoku* type are cuirasses consisting of a single iron plate, produced under European influence during the sixteenth century and later.

This suit of armor consists of small leather plates covered with gold foil tied together with black silk lacing. It was worn by Matsudaira Katsunaga, who was the sixth son of Munekatsu, eighth lord of Owari.

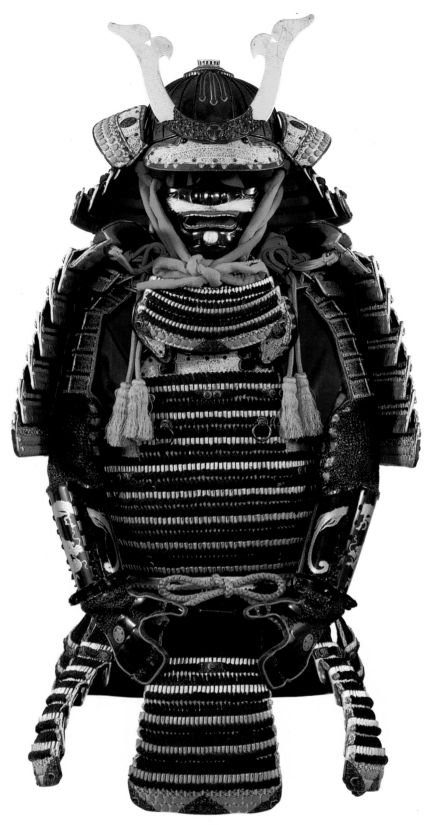

11

13. SUIT OF ARMOR IN *GUSOKU* STYLE

Silver-foiled leather plates with white silk lacing;
h. with stand 155.0 cm.
Edo period, 18th century

Made in the *tōsei-gusoku* style, this suit of armor consists of a cuirass, designed to protect the trunk of the wearer, composed of small leather plates covered with silver foil and tied together with white silk lacing. Over the years, silver usually oxidizes and blackens, but the excellent state of preservation of this suit of armor is evidenced by the attractive silver color it retains. Portions of the white silk lacing have been restored in later years. The overall white and silver color scheme is sumptuous, and portions have been accented with gold instead of silver leaf.

This suit of armor was worn by Michimasa, nineteenth among the children of Tsunanari, third lord of Owari.

15. SUIT OF ARMOR IN *GUSOKU* STYLE

Black-lacquered leather plates with white silk lacing; h. with stand 155.0 cm.
Edo period, 19th century

This suit of armor is also made in the *tōsei-gusoku* style, which was popular during the Edo period. The principal components of Japanese armor were composed of small lacquered iron or leather plates tied together with colored silk lacing. During the tranquil Edo period, the function of armor became largely ceremonial, and many sets were made using small joined leather plates, like the present example, rather than the heavier, stronger iron plates.

The leather plates of this suit of armor have been coated with black lacquer and joined with white silk lacing. In addition to this white lacing, vermilion and multi-colored plaited lacing has been used for the borders. Lacing of this type could only be used by samurai of high rank.

This suit of armor was worn by Tokugawa Yoshinori, sixteenth lord of Owari.

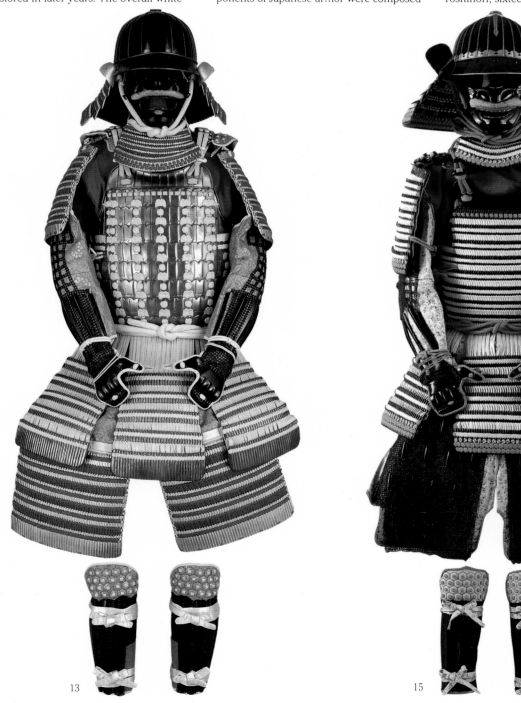

13

15

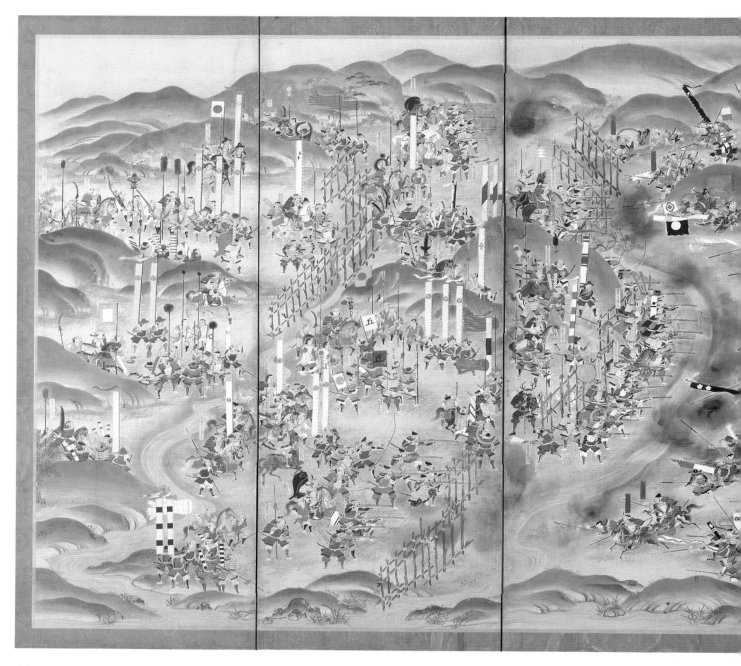

8A.　THE BATTLE AT NAGASHINO

Six-fold screen, ink and colors on paper;
157.9 × 366.0 cm.
Edo period, 17th century

Paintings of famous battle scenes executed in the large-scale format of the folding screen were created for the victors and their descendants to memorialize triumphs in warfare. The production of screens of this type seems to have begun in the early 17th century, and later, there appear many paintings that were copied from these earlier works. In his pictorial treatment of an actual battle, the artist presents us with a single painting surface that at once incorporates a multitude of incidents that were in fact separated by temporal intervals; there is a degree of idealization in the

rendering and a selectively exaggerated or abbreviated handling of the details. Thus what we see was not intended necessarily to maintain fidelity in every respect to the corpus of historical facts.

This screen painting depicts the confrontation that took place at Nagashino (present Aichi Prefecture) in 1575, on the twenty-first day of the fifth month (June 29, 1575, by the western calendar). To the left, the allied armies of Oda Nobunaga and Tokugawa Ieyasu have taken up their positions. Squads of musketeers are shown firing their matchlock weapons in volleys

from amidst the alignment of wooden palisades erected along the banks of the river. In the opposite field to the right is arrayed the cavalry of the Takeda (Katsuyori) clan, whose army was reputedly invincible in its day.

In this battle, the allied Oda-Tokugawa forces sent into action a newly organized company of 3,000 musket-bearing foot-soldiers, the factor that in large measure ensured their overwhelming victory on that day. The battle at Nagashino was an epoch-making event in Japanese history: tested in an actual large-scale military engagement,

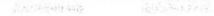

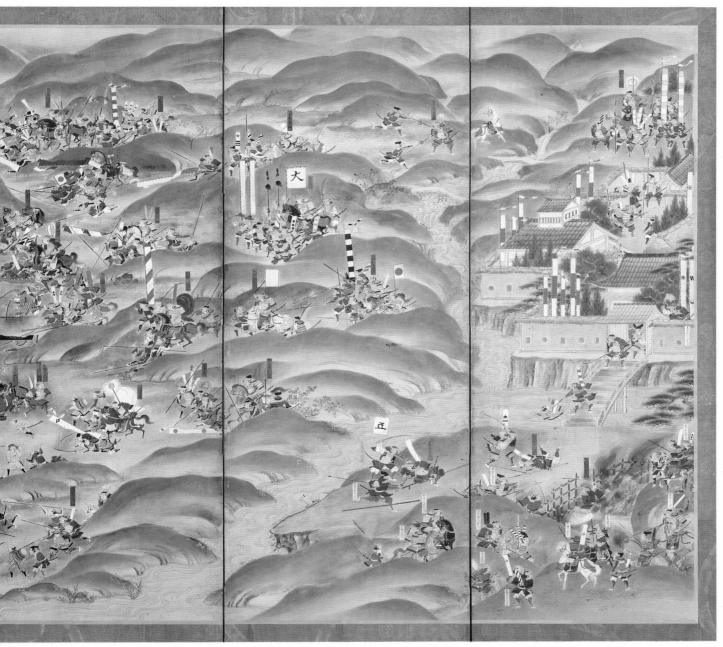

the superior might of firearms, which had only recently been introduced to Japan from Europe, became fully evident against the old-style method of attack by mounted warriors.

In the aftermath of the battle, the Takeda clan was left to face its imminent downfall; meanwhile, the Oda and Tokugawa clans had taken still another step forward toward domination of the whole country. The estimate of the strength of the military forces that met at Nagashino places 17 to 18,000 men under the allied Oda-Tokugawa banners to the 6,000 who rallied to the

Takeda colors. In the center of the painting, the artist has shown the very moment when a line of crouching musketeers has discharged their guns; each has his left eye shut as he takes aim, and black smoke rises from the muzzles. The represention is extremely abbreviated in terms of the number of soldiers depicted. Nevertheless, the artist has managed to capture admirably the vivid sense of an actual battle.

8B. THE BATTLE AT NAGAKUTE

Six-fold screen, ink and colors on paper;
157.9 × 366.0cm.
Edo period, 17th century

This screen painting shows the battle that was fought in 1584, on the ninth day of the fourth month (May 18, 1584), at Nagakute (in the present suburbs of Nagoya). The battle was one local engagement in the course of a single, continuous struggle waged over a nine-month period, from the third to the eleventh month of that year. Centered in the region of the feudal province of Owari, the conflict pitted the forces of Tokugawa Ieyasu against the army of Toyotomi Hideyoshi.

The number of men fighting in the battle is estimated at 6,800 on the Tokugawa side, and the supporters who served under the command of Hideyoshi's two generals at 17,000 strong. In spite of being vastly out-numbered, Ieyasu, by the use of superior tactics, struck a devastating blow, taking in the battle the lives of the two Toyotomi generals. Still, after nine-months' warfare had failed to give either side a decisive victory in the conflict, a stalemate ensued. In the following year, the two men made peace. At this time, Hideyoshi wielded the greatest power in Japan, and eventually he succeeded in completing the unification of the entire country under his sole domina-tion. By his victory at Nagakute, however, Tokugawa Ieyasu secured his own reputation as far as Hideyoshi was concerned; there-after, he cooperated in the latter's campaign toward unification.

The battle at Nagakute took place nine years after the one at Nagashino depicted in the companion screen (no. 8A). Both of these battles played a vital role in the course of the establishment of Tokugawa supre-macy; hence, it was natural that these

victories should be memorialized. Thought to be the work of the same artist, the two screens form a pair which has been handed down in the Owari branch of the Tokugawa family.

9. THE BATTLE AT NAGASHINO

Eight-fold screen, ink and colors on paper;
76.6 × 380.0cm.
Edo period, 17th century

The subject of this screen painting is, like number 8A, the battle at Nagashino. In the scene depicted and in composition the two screens correspond closely, although the format of the present example is an eight-panel folding screen (instead of six-panel) of considerably less height.

One feature displayed here that is common to painted screens of great battles is the affixing of cartouches (oblong strips of paper) in which are inscribed the names of principal characters. Some of these illustrate, as well, the practice of inserting a sentence that describes the action of a figure. It is estimated that this screen was painted about a century after the time when the actual battle occurred, dating it to the same period as number 8A. When it was painted, the artist probably gathered together a great deal of documentary literature and sifted through orally transmitted accounts perti-nent to the production of the work. The artist then presented in pictorial form the results of his investigations.

Together with the previous pair of battle screens (nos. 8A and 8B), this one was handed down in the Owari Tokugawa family, in which successive generations have regarded it as a memorial to the victory won by their ancestors. In bequeathing to descendants and future retainers a pictorial record of the actual conditions that attended the Tokugawa victories, screens such as

these were intended to sympathetically evoke the exultation of triumph.

As room furnishings which when folded up are capable of being easily moved about, screens were utilized as interior partitions. Depictions of battle scenes were counted among the most appropriate subjects for painting on the large-scale, panoramic surface afforded by this format.

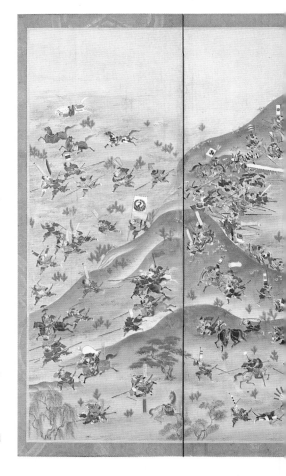

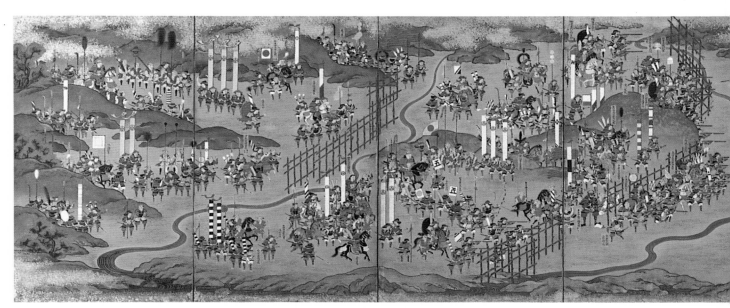

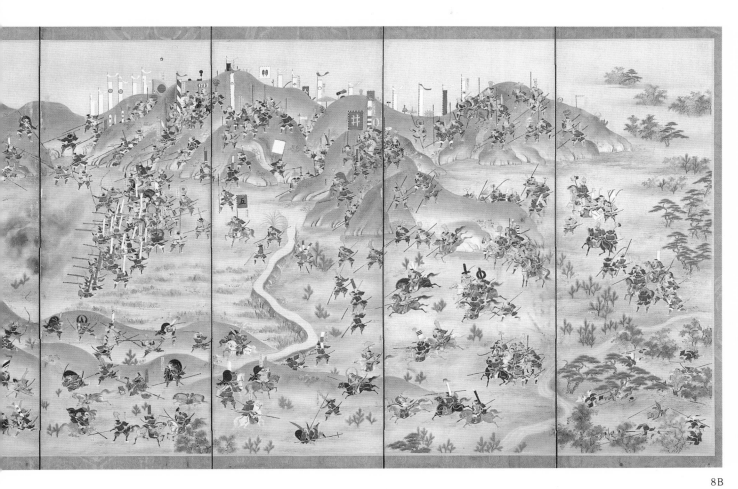

8B

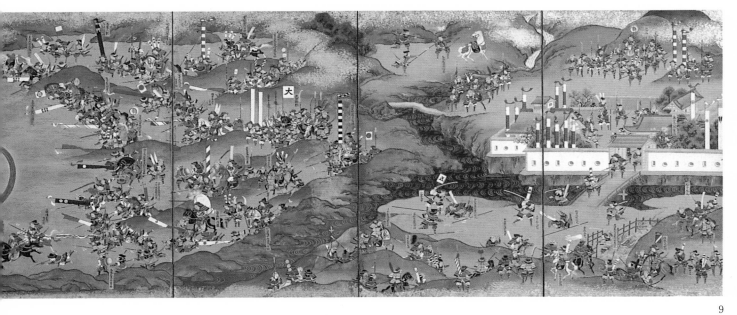

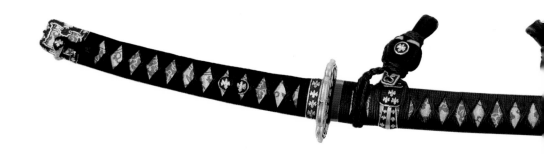

16. *JIMBAORI*

White *ro* (gauze-weave) ground with a design of waves and *aoi* crests; 87.2 × 66.0cm.
Edo period, 19th century

17. *JIMBAORI*

Umber *ro* ground with a *tatewaku* (undulating vertical line) motif and floral design in gold brocade; 90.6 × 61.2cm.
Edo period, 18th century

18. *JIMBAORI*

White *rasha* (wool gauze-weave) ground with an *aoi* crest; 98.2 × 50.0cm.
Edo period, 19th century

Jimbaori were worn by warriors in the field as campaign vests over their armor since the beginning of the Sengoku period (1482—1558). During that period, the armor itself was light and functional, and *gusoku*-style armor was widely worn. This soldier's equipage was not only utilitarian, but distinctive in its use of vivid colors and bold designs. The warriors sought to present an imposing appearance on the battlefield, and steeled their courage when facing death by adorning themselves brilliantly.

The early *jimbaori* were made of highly water resistant *rasha* (wool gauze-weave) or fur to provide the greatest protection against the cold and inclement weather.

These materials were imported from overseas.

During the peaceful Edo period, the need for the *jimbaori* as an outer garment over armor was greatly reduced, and its role was transformed to that of formal wear for outdoor occasions. Elaborate ornamentation was emphasized, and a differentiation was made between summer and winter wear.

Numbers 16 and 17 are for summer use, and cool, refreshing-looking fabrics have been used. Number 18 is for winter use.

Number 17 was worn by the ninth lord of Owari, Tokugawa Munechika.

Numbers 16 and 18 were worn by the fourteenth lord, Yoshikatsu.

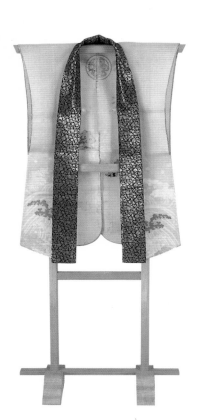

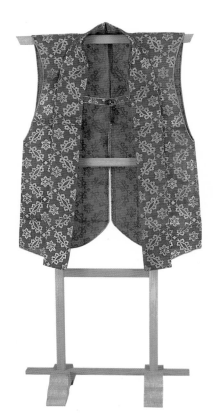

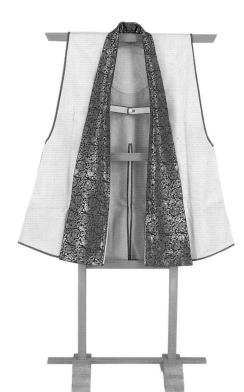

16 17 18

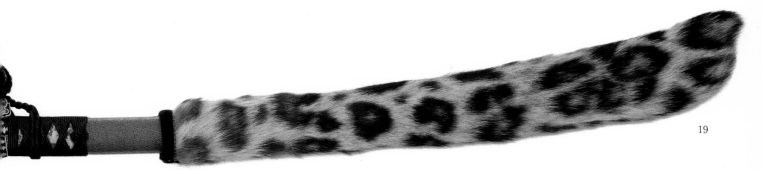

19

19. *TACHI* MOUNTING

Aventurine lacquer ground with thread-wrapped scabbard and leopardskin sheath; total l. 104.2, leopardskin l. 53.0cm.
Edo period, 18th century

This type of mounting was produced for the *tachi,* a long curved sword whose blade exceeded sixty centimeters in length and was worn slung from the left side of the sash with the cutting edge facing downward. The thread-wrapped *tachi* mounting, or *itomaki-no-tachi,* was a type of *tachi* mounting which had been widely used since the late Kamakura period, and derived

its name from the fact that not only the hilt, but also the upper part of the scabbard was wrapped with silk braid. Originally worn in actual combat, the wrapping was provided to facilitate the drawing of the blade. The present mounting is shown here as a *shirizaya-no-tachi* in which a removable fur sheath was provided for the scabbard to protect it from the weather. The type of fur used was determined by the rank of the wearer, and deer, wild boar, or bear skins were commonly used for this purpose. This example, however, is presently provided

with a sheath made of imported leopardskin, reserved for samurai of especially high rank.

The metal fittings for this mounting are made of an alloy of copper and gold called *shakudō* with detailed gold and silver inlay on a *nanako* ground (literally "fish-roe" ground, exhibiting granulation produced using a round-headed chisel). The high quality of all of the components of this mounting is in keeping with the exalted rank of the lords of Owari.

20. MILITARY LEADER'S FAN

Wickerwork with *tame-nuri* (cinnabar) and black lacquer; 64.5 × 32.1cm.
Edo period, 17th century

21. BATON WITH TUFT OF YAK'S HAIR

Black-lacquered rod; l. of rod 36.4, l. of tuft 60.2cm.
Edo period, 17th century

22. MILITARY LEADER'S FOLDING FAN

Wheel of the law pattern in gold and silver pigment; 36.2 × 57.2cm.
Edo period, 17th century

Combat during the medieval period in Japan was largely hand-to-hand. From around the end of the Muromachi period, however, combat strategies altered in favor of military formations using spear and firearm battalions. For this reason, many different types of instruments to be used by the commander to direct the movement of his troops were ingeniously devised. Signal calls with gongs, drums, and conches were used effectively to command a large body of troops. There were also instruments, however, resembling a baton of command, that were used as symbols to indicate the rank of the supreme commander of the army.

The implement in number 20 resembles

a round, flat fan in shape, while number 22 takes the form of a folding fan. Number 21 consists of a rod with a tuft of white yak's hair attached at one end. Since the yak is indigenous to high altitude areas in Tibet and northern India, its hair was, of course, imported, and Japanese of the time believed it to be the fur of a white bear. Since the bear had a widespread reputation for ferocity, this fur was highly prized as decoration for armor and weaponry.

Number 20 was used by Tokugawa Tsunanari, third lord of Owari, while numbers 21 and 22 were used by Yoshinao, first lord of Owari.

53

27. BOW

Wood and bamboo wrapped with lacquered
wisteria vines; l. 222.7cm.
Edo period, 18th century

28. QUIVER WITH FIVE ARROWS

Wild boar hide, with design of dragonflies and
aoi crests made of ivory; 16.6 × 18.l × 41.8cm.
Edo period, 18th century

The bow was used as a combat weapon in
Japan from ancient times, and through the
Kamakura period mounted archery was a
requisite skill for all high-ranking warriors.
From the end of the Muromachi period,
however, large units of foot soldiers bearing
firearms and spears were found to be
superior to mounted archers, who were
relegated to secondary importance.

In spite of this, archery was not completely
forgotten, and the once-powerful weapon of
the ancient warrior remained part of the
martial training of high-ranking samurai
even in the Edo period.

Number 27 is a bow made of both
wood for tension and bamboo for flexibility.
This composite core was wrapped with
several layers of wisteria vines, which
imparted additional strength. The most
unusual feature of Japanese bows is that the
grip is below center, in contrast to most
other bows which employ center grips.

The use of the raw hide of a wild boar as
part of the decoration of the quiver (no.
28) was quite rare in the Edo period.
Because of their lightness and malleability,
animal hides were popular as bases for
lacquer objects in the Nara period, but were
later replaced by cheaper and more
abundant wood.

Both the bow and quiver were owned by
Tokugawa Munechika, the ninth lord
of Owari.

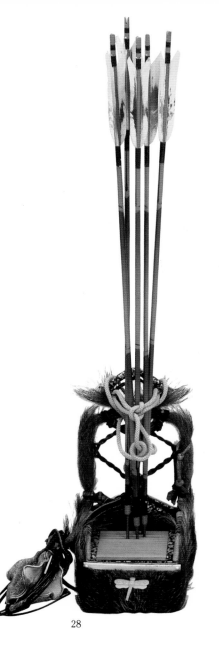

28

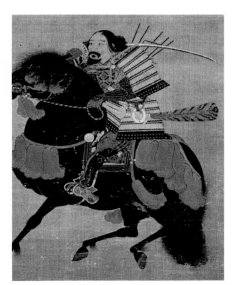

Figure of a warrior on horseback.

27

26

23. MATCHLOCK

Inscribed: *Keichō 16-nen 10-gatsu kichijitsu Nihon
Seigyō (kaō)* (Keichō 16th year [1611], 10th
month, fortunate day, Nihon Seigyō [monogram])
Barrel for 13.125 gram lead shot; l. 148.2cm.
Edo period, 1611

24. MATCHLOCK

Inscribed: *Shibatsuji Riemon Sukenobu (kaō)*
Barrel for 13.125 gram lead shot; l. 119.7cm.
Edo period, 17th century

According to the *Teppō-ki* ("Record of
Fire-arms"), compiled in 1606, a Portuguese
ship drifted onto the shores of Tanegashima,
a small island south of Kyushu in 1593
and introduced firearms to Japan for the first
time. Until that time, the only projectile
weapons used by the Japanese were bows and

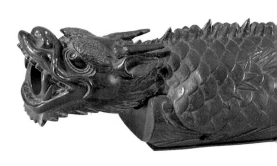

26. SPEAR

Inscribed: *Mino no Kami, Fujiwara no Masatsune*
(Fujiwara no Masatsune, Governor of Mino)
Steel-tipped spear with wooden shaft coated with
black lacquer and inlaid with mother-of-pearl;
overall l. 384.0cm., steel tip l. 15.3cm.
Edo period, 18th-19th century

During the turbulent decades of civil war
that preceded the long peace of the Edo
period the spear was, after firearms, the
most effective offensive weapon and was,

arrows, and stone catapults. Once firearms came into use, they revolutionized military strategy and castle-building methods. Soon after their introduction, firearm production and gunpowder mixing techniques rapidly spread throughout Japan, so that many of the principal cities were able to produce firearms. Domestic production was easily accomplished, firstly because of the large demand for powerful weaponry from rival warlords during this period of incessant strife, and secondly because Japanese smiths were already masters of metalworking and casting techniques through their experience in producing sword blades, sword guards, and armor.

Matchlocks are a form of musket in which the shot and gunpowder are inserted, then fired by lighting a fuse. The gun barrel is not rifled as in modern examples. The effective range of the matchlock is usually about two hundred meters, and it is said that a well-trained soldier could fire four shots per minute at the most.

These two matchlocks are of fairly narrow bore, and used lead shot weighing 13.125 grams. The barrel of number 23 is inscribed with the name of the gunsmith and the date of its production. The smith, Noda Seigyō, was in the exclusive employ of Tokugawa Ieyasu and was originally a swordsmith.

The barrel of number 24 is decorated with *aoi* crests symbolizing the Tokugawa family, and was specially commissioned by the Owari Tokugawa. The smith named in the inscription on the barrel is known to have been a resident of Sakai (near Osaka), but details of his career are unclear. During the sixteenth century, Sakai was a free commercial city, somewhat like medieval Venice, and was a major center of firearm production in Japan. Sakai was also an important port for the importation of saltpeter, the raw material for gunpowder, until it began to be domestically produced in the seventeenth century.

23

24

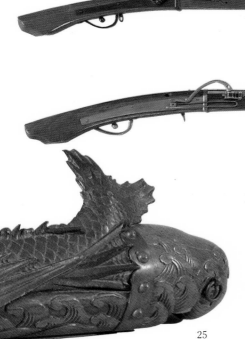

25

25. CANNON IN THE SHAPE OF A DRAGON

Bronze, l. 77.2cm.
Momoyama period, 16th century

Cannon were imported into Japan from Portugal and Spain in the sixteenth century. It is said that, at that time, cannon were employed in Japanese warfare principally to threaten the adversary with the thundering noise and smoke that it produced. Domestic imitations were manufactured, but cannon were not rapidly produced or

deployed in the same way as firearms.

This bronze cannon is of striking design, with a dragon-shaped head whose gaping mouth corresponds to the muzzle of the cannon. The upturned tail and fins resemble those of a fish, and it was apparently made to represent a *shachi,* an imaginary marine animal. The support is carved out of oak and bears a wave pattern in relief; a brass strap riveted in place stabilizes the barrel. This unusual cannon is believed to have belonged to Tokugawa Ieyasu.

in fact, the most useful weapon in hand-to-hand combat. In battle, recognition was given to of the warrior who first crossed spears with the enemy, and he was designated "Ichiban-yari" ("first spear"), the highest battlefield honor a foot-soldier could receive.

The spear is said to have been first used in the Muromachi period (fourteenth century), and by the sixteenth and seventeenth centuries it proved to be an extremely valuable weapon when used in

concert by large groups of foot soldiers. In general, spears were heavily damaged in the course of battle, so that while numerous swords survive from the Heian and Kamakura periods, examples of spears from these periods are rare.

The shaft of this spear is decorated with *raden,* in which broken fragments of iridescent shell are inlaid on a black lacquer ground. The artisan who produced the blade for this spear was a smith named Masatsune, who worked exclusively for the lord of

Owari province. Since the fifteenth century, Masatsune's family had been swordsmiths belonging to the Seki School of Mino province, (present-day Gifu Prefecture), but with the establishment of the Owari fief in the early seventeenth century, they moved to the castle town of Nagoya and continued for successive generations to produce weaponry in the service of the Owari Tokugawa family.

YŪSO

VALOR

PART I.
VALOR

The three men who had managed to impose their authority over the scattered daimyo were Oda Nobunaga, Toyotomi Hideyoshi, and Tokugawa Ieyasu. Hideyoshi carried out a great national land survey that began in 1583 and continued for a decade. This survey was intended to create a uniform structure for rural society. He also instituted a system of strict social categorization of warrior, merchant, and farmer, forbade the shifting from one class to another, and denied farmers the right to own or bear arms. The purpose of this policy was to prevent riots and armed uprisings by the rural population and force them to concentrate on farming. At the time these were revolutionary measures in establishing feudal rule by the samurai class. Ieyasu also administered thorough cadastral surveys and confiscated weaponry from non-warriors, sharpening the distinction between farmer and samurai and forcing them to reside in separate areas. In the Edo period, only samurai were allowed to bear arms. Among the different types of weaponry, the sword was the symbol of the samurai, and each samurai strove to own swords that accurately reflected his rank and status, wearing them at all times in public. Even with the advent of a peaceful era, the society continued to be permeated with a military atmosphere, and samurai of all ranks, including the shogun and members of the Three Houses of the Tokugawa clan, continued to retain the militant characteristics of the turbulent period of constant wars that had preceded. However, this atmosphere lasted only until the rule of the third shogun Iemitsu (r. 1623—1651), when changes began to appear. In the course of a half century, the shogunate systematized the policy of requiring alternate residency for the daimyo (*sankin-kōtai*), who were then mandated to reside half the time in the capital of Edo; implemented the policy of isolation; and forbade the practice of Christianity. The Tokugawa shogunate thus consolidated the foundations of their national rule, and established a governing system of unprecedented rigidity. The shogun and daimyo were of the military class, and they had gained their status by means of force. Even after the consolidation of the system of Tokugawa rule, they continued to store vast amounts of weaponry, relentlessly maintaining their guard. From the long period of war through the period of peace and stability, the courageous spirit of the samurai continued to span the ages.

THE SYMBOL OF THE SAMURAI

For the shogun and the daimyo, swords and other weaponry were an important means by which to represent their status. Among these, swords were considered the soul of the samurai; they were worn thrust into the sash in public, decorated the alcove in the residence, and were a samurai's most prized possession. Even during Ieyasu's lifetime, once firearms began to be widely produced from the latter half of the sixteenth century onward, swords had ceased to be the foremost weapon of war. Nonetheless they continued to serve as ceremonial objects of primary importance, and even after the advent of peace, swords retained their significance as formal gifts exchanged between shogun and daimyo. *Tachi* ranked highest among swords, followed by *katana* and *wakizashi*. The sword blades were fitted with appropriate mountings: decorative *tachi* mountings for ceremonial court occasions, and more utilitarian mountings for *katana* and *wakizashi*, whose accessories nonetheless reflected a high level of technical accomplishment in crafts such as metalwork and lacquer. Mountings of outstanding quality were also offered as official gifts to accompany famous blades. Strictly utilitarian weaponry such as halberds and spears were never presented formally.

The upper echelons of the warrior class, such as the shogun and daimyo, vied with one another in collecting swords of the finest artistic quality from the Heian and Kamakura periods. Not only did they treasure the blades themselves, they also commissioned elaborate mountings to house them. The demand for high quality sword mounts during the Edo period resulted in the development of an extremely high standard of metal craftsmanship, including detailed fine line engraving, inlay, and other elaborate techniques with which to ornament the surface of these sword fittings.

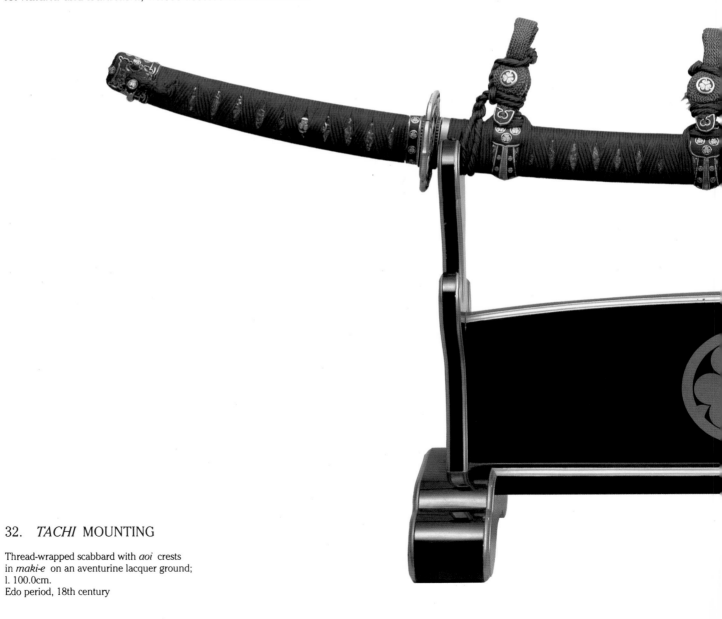

32. *TACHI* MOUNTING

Thread-wrapped scabbard with *aoi* crests
in *maki-e* on an aventurine lacquer ground;
l. 100.0cm.
Edo period, 18th century

58

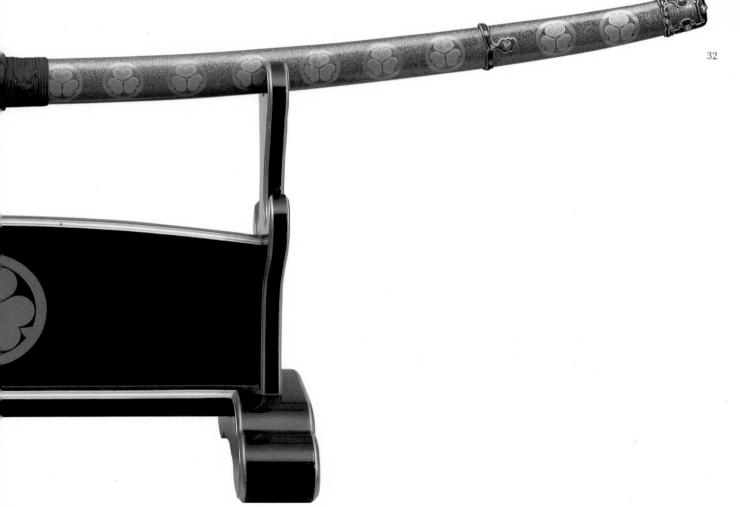

32

33. *TACHI* MOUNTING

Ceremonial court mounting with gold fittings;
l. 103.7cm.
Edo period, 17th century (modern restoration)

34. *TACHI* MOUNTING

Kenuki-type with gold fittings; l. 90.5cm.
Edo period, 18th century

Tachi mountings meant to be worn
suspended from the sash with a cord so that
the cutting edge faced downward were
popular from the Heian through
Muromachi periods. Toward the end
of the Muromachi period, however,
it became preferred practice to thrust
the sword into the sash with cutting
edge upward to facilitate drawing and
striking. During the Edo period, *tachi*
fell largely into disuse among the
majority of samurai, and this form
of mounting was relegated to formal
use by the shogun, daimyo, and court nobility.
 Number 32 belongs to the *itomaki-no-tachi*
type (see no. 19), and was produced to
serve as the mounting for the blade in

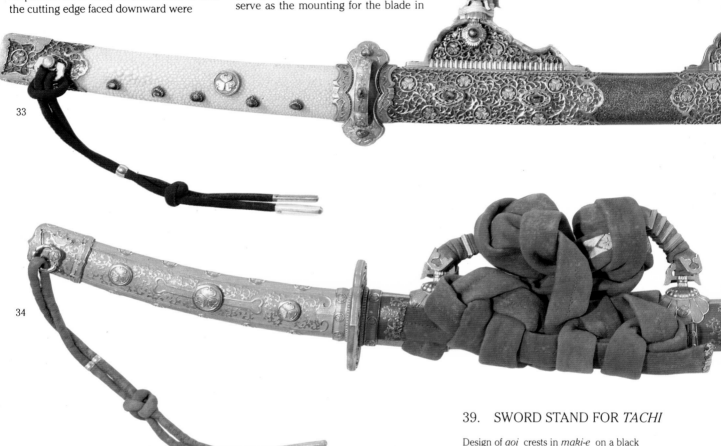

33

34

entry Number 29 (*tachi* engraved with
a chrysanthemum crest, named "Kiku Go-
saku"). Part of the scabbard and the hilt
of this mounting are wrapped with blue
silk cord. In 1713, Tokugawa Gorōta, fifth
lord of Owari, dedicated this mounting to
the mausoleum of the previous lord, his
father Yoshimichi.
 Number 33 represents the most formal
type of ceremonial *tachi* worn by those of
the highest rank. This court *tachi* is provided
with lavishly carved gold and silver
fittings set with brightly colored gemstones.
This mounting was found among the
tomb furniture during the 1953 renovation
of the grave site of Tokugawa Mitsutomo,
second lord of Owari, who died in 1700.
The blade and the scabbard had deteriorated
almost completely, but the gold fittings
survived intact. The entire mounting was
later restored, including the *maki-e* of the
scabbard, the cord, and the hilt.
 Number 34 belongs to the *kenuki-tachi*
type, so-called because of the decorative
metal fittings on both sides of the hilt that
resemble tweezers ("kenuki"). Gold has
been lavishly used throughout this
sumptuous mounting, which was worn by
successive generations of Tokugawa
shoguns.

39. SWORD STAND FOR *TACHI*

Design of *aoi* crests in *maki-e* on a black
lacquer ground; 17.6 × 50.9 × 28.0cm.
Edo period, 19th century

41. SWORD STAND FOR *KATANA*

Same as no. 39; 18.6 × 49.0 × 33.0cm.
Edo period, 19th century

40. SWORD STAND FOR *KATANA*

Design of *aoi* crests in *maki-e* on a
mulberry wood ground; 2 pieces, 18.5 × 54.0 × 30.9cm. each
Edo period, 19th century

42. SWORD STAND FOR *WAKIZASHI*

Same as no. 40; 16.9 × 28.9 × 20.9
Edo period, 19th century

 Whenever a member of the samurai class
went out in public, he always wore a pair of

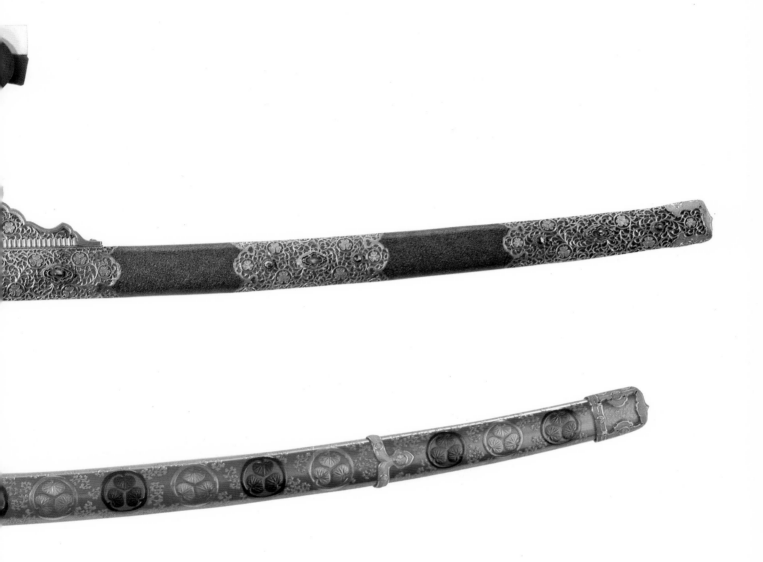

swords called a *daishō*, composed of a long sword (*katana*) and a short sword (*wakizashi*), thrust through his waistband. When indoors, he wore only the smaller *wakizashi*. The only times when even the *wakizashi* was not worn were: while sleeping, when bathing, and when entering a tearoom. Yet even during these times the sword was kept in a specific spot nearby.

In order for this symbol of the warrior to be handled and displayed with the proper respect, the sword was placed on a stand like those in numbers 39 through 42 whenever it was removed from the warrior's side. Numbers 39 and 41 have their wooden bases completely covered with black lacquer, while numbers 40 and 42 are made of mulberry wood and decorated

using the *kiji-maki-e* technique, in which *maki-e* lacquer is applied on a plain wood ground. Each of the latter group of stands also has four small perforations in the shape of a single *aoi* leaf. Both groups are further decorated with the trifoliate *aoi* crest of the Tokugawa family executed in gold *maki-e*.

41 39 42 40

36. *KATANA* MOUNTING OF *DAISHŌ* PAIR

Wood coated with flat black lacquer and inlaid
with fish bone; l. 95.5cm.
Edo period, 1857

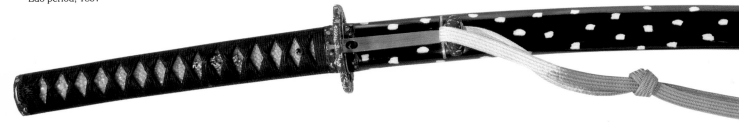

38. *WAKIZASHI* MOUNTING OF *DAISHŌ* PAIR

Wood coated with flat black lacquer and inlaid
with fish bone; l. 55.0cm.
Edo period, 1857

It was both the right and privilege of
samurai of the Edo period to wear a pair of
swords thrust into the sash. The pair was
called a *daishō* (literally, "large and small"),
consisting of a *katana* and a *wakizashi*,
and was the symbol of the samurai.

This *daishō* set of sword mountings was
produced in 1857 to be used by Tokugawa
Yoshikatsu, fourteenth lord of Owari.
The scabbard of each mounting has been
coated with black lacquer and inlaid with
bits of fish bone to produce a leopard-spot
pattern. The accompanying metal fittings are
all uniformly ornamented with a delicate
pattern of autumn grasses. These fittings
were not produced specially for this pair of
mountings; instead, fittings that were already
one to two centuries old were taken and
attached to these mountings.

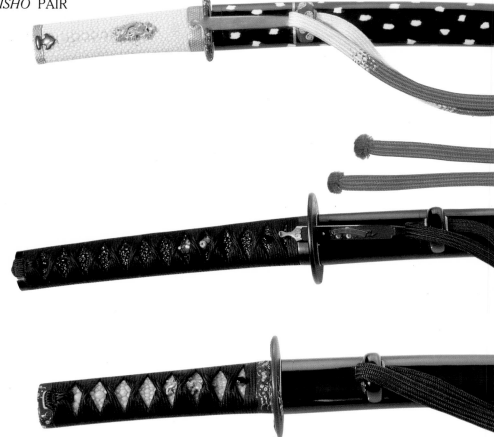

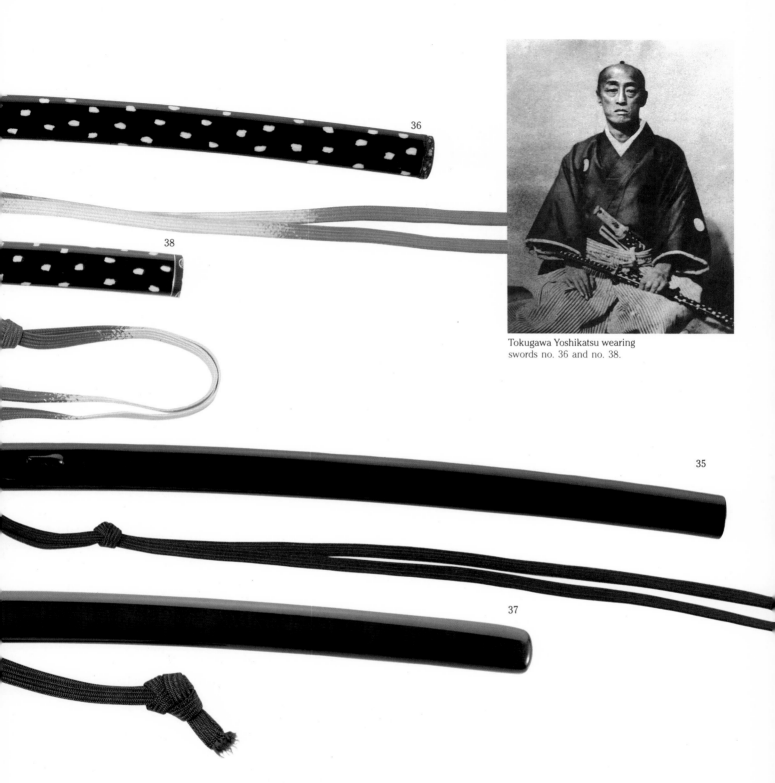

Tokugawa Yoshikatsu wearing
swords no. 36 and no. 38.

35. *KATANA* MOUNTING OF *DAISHŌ* PAIR

Lustrous black-lacquered scabbard; l. 92.4cm.
Edo period, 17th century

37. *WAKIZASHI* MOUNTING OF *DAISHŌ* PAIR

Lustrous black-lacquered scabbard; l. 66.7cm.
Edo period, 17th century

This *daishō* pair of mountings was pro-
duced for a daimyo, utilizing the highest
standards of technique and materials
available at the time.

The metal fittings of number 35 bear
a pattern of stemmed chrysanthemums and
calligraphy cartouches in gold inlay and
relief carving. The calligraphy cartouches
are engraved with delicately written poems
reminiscent of autumn. This design motif
derives its origin from the theme of
chrysanthemums used in aristocratic poetry

contests popular during the Heian period.

The metal fittings provided for number
37 bear a lion and autumn grasses design
lavishly executed in gold and silver on
a blue-black copper alloy ground (*shakudō*).
The harmonious juxtaposition of the con-
trasting elements of the ferocious lion and
gentle autumn grasses is indicative of the
character and aesthetic inclinations of the
daimyo of the Edo period.

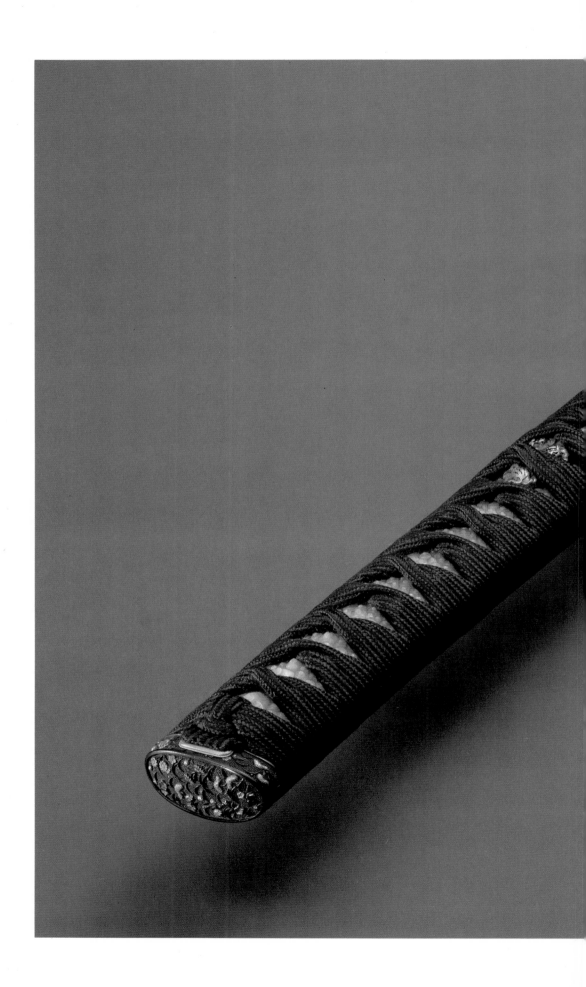

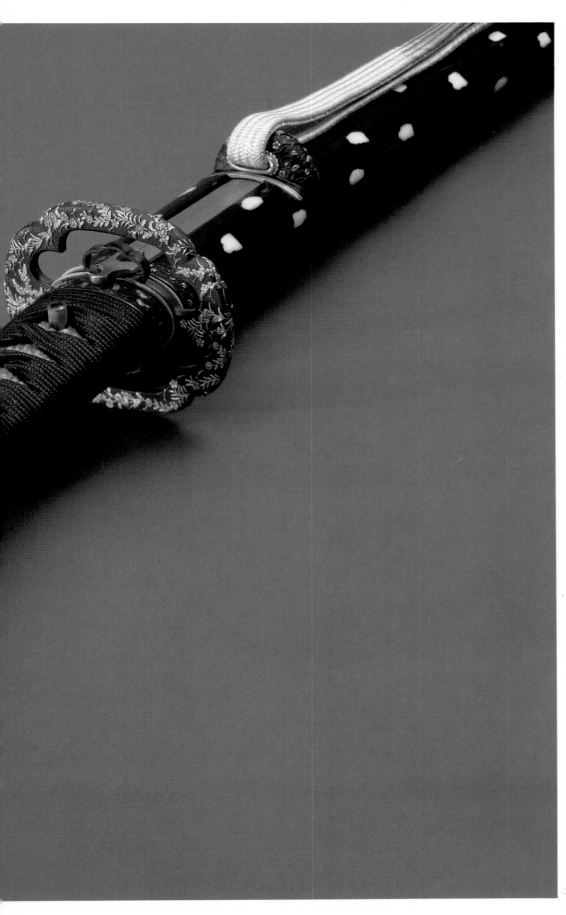

36 (detail)

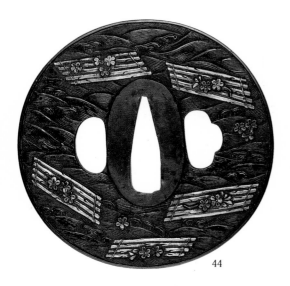

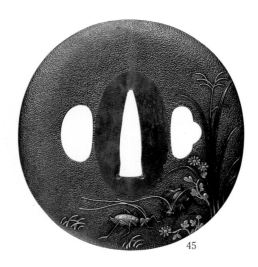

44

45

44. RIMMED *TSUBA*

Design of waves, cherry blossoms, and rafts in *iro-e* on a *shakudō* ground; diam. 7.7cm.
Edo period, 17th century

45. *TSUBA*

Design of autumn grasses and insects in *iro-e* on a *shakudō* ground with a stippled, stone-like surface; longest diam. 7.1, shortest diam. 6.7cm.
Edo period, 18th century

43. *DAISHŌ* PAIR OF *TSUBA*

Inscribed: *Inshū-jū Ichijū* (Ichijū, residing in Inaba province)

Design of an aged plum tree in bloom carved in relief with gold inlay on an iron ground; large: longest diam. 7.7, shortest diam. 7.3cm.; small: longest diam. 7.2, shortest diam. 6.9cm.
Edo period, 17th century

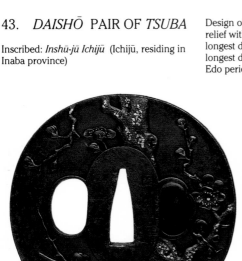

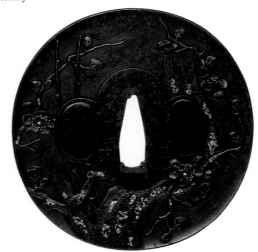

43

The main purpose of the *tsuba* or sword-guard was to protect the hand and to maintain the overall balance of the sword. During the Edo period, however, the decorative characteristics of the *tsuba* took precedence over its practical qualities, and detailed carving techniques, variegated designs, and alloy techniques developed markedly.

The pair of iron-ground *tsuba* in number 43 bears a design of an aged plum tree sending forth new branches and blossoms, executed in relief carving and gold inlay. This design not only signifies the spring, in the orient it also symbolizes the breath of new life, for the plum is the first among the withered winter trees to send forth blossoms each year.

Numbers 44 and 45 display finely executed carving and gold and silver inlay on a blue-black *shakudō* ground. Number 44 bears a design of rafts floating on the surface of a river scattered with cherry blossoms. The elements of the changing seasons form an integral part of the Japanese artistic consciousness. Cherry blossoms are the objects of special appreciation, for these evanescent flowers bloom in such great profusion that an entire mountainside will adopt a pink hue, but they are soon scattered by the unpredictable spring weather. Their singular beauty and evanescent quality appealed greatly to the aesthetic sense of the Japanese. The design motif that appears

on this *tsuba* was originally conceived as cherry blossom petals scattered on the river surface like a string of floating rafts. Later the idea of floating rafts was transformed into the concrete depiction of rafts incorporated into the design.

Number 45 is executed in the same technique as number 44, and bears a design of insects singing among the autumn grasses. This motif developed from the Japanese attachment to the sound of insects in the autumn night, heard only briefly before the onset of winter and tinged with a sense of loneliness.

Three types of sword fittings, the *kozuka*, *kōgai*, and *menuki*, form a set called *mi-tokoro-mono*. As a rule, the entire set is executed by a single artisan and bears the same motif. A *kozuka* is the handle of a small knife whose blade measures about 12 centimeters in length. A *kōgai* is shaped like a paper knife and is not provided with a tempered blade; it was originally used as an implement to arrange the hair. These two fittings were inserted into two openings provided in the sword guard to fasten them flush against the scabbard, one on each side. Since the swords of a *daishō* pair were always thrust into the sash with the cutting edge upward, the *kōgai* was placed on the outside of the sheath away from the wearer, and the *kozuka* on the inside. *Menuki* are decorations affixed on both sides of the hilt. One or two pegs pass through the hilt to secure the blade, and their heads became increasingly decorative. In time, the functional pegs and the ornamental heads were separated, thus resulting in the *menuki*.

These three types of sword fittings served almost no functional purpose and were largely decorative. During the Edo period; mountings fully equipped with *mi-tokoro-mono* were worn by samurai of high rank. Furthermore, correctly fitted mountings used by the shogun, daimyo, and *hatamoto* (literally, "bannermen," lesser vassals directly responsible to the shogun) customarily used *mi-tokoro-mono* produced by the Gotō family of metalworkers.

Succesive generations of Gotō metalworkers, exclusive producers of sword furniture, had served the families of both the Ashikaga and Tokugawa shoguns. None of these three sets of sword fittings are inscribed by the artisan himself, but all display the distinctive Gotō style using blue-black *shakudō* finished with granular *nanako*, and Edo period descendants of the Gotō family have identified the metalsmith responsible for each set.

Both numbers 46 and 47 bear designs of autumn wildflowers, a motif that has long been cherished by the Japanese and is often used in the applied arts. The design of paired mandarin ducks appearing in number 48 is interpreted as symbolizing conjugal happiness. Also, the attractive plumage of the male has made the mandarin duck a popular subject in both painting and the applied arts.

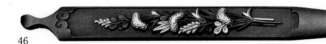

46

46. SET OF SWORD FITTINGS

Uninscribed, attributed to Sōjō

Design of autumn grasses on a *shakudō* ground finished with *nanako; kozuka*, 9.6 × 1.4cm.; *kōgai*, 21.0 × 1.2cm.; *menuki*, l. 4.0cm. each
Muromachi period, 16th century

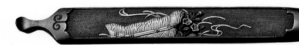

47

47. SET OF SWORD FITTINGS

Uninscribed, attributed to Kōjō

Design of Chinese bellflowers and fence by the sandbank of a stream in *iro-e* on a *shakudō* ground finished with *nanako; kozuka*, 9.7 × 1.9cm.; *kōgai*, 21.2 × 1.2cm.: *menuki*. l. 3.6cm. each
Edo period, early 17th century

48

48. SET OF SWORD FITTINGS

Uninscribed, attributed to Tokujō

Design of mandarin ducks in *iro-e* on a *shakudō* ground finished with *nanako* and backed with gold; *kozuka*, 9.7 × 1.9cm.; *kōgai*, 21.2 × 1.2cm.; *menuki*, l. 2.5cm. each
Edo period, early 17th century

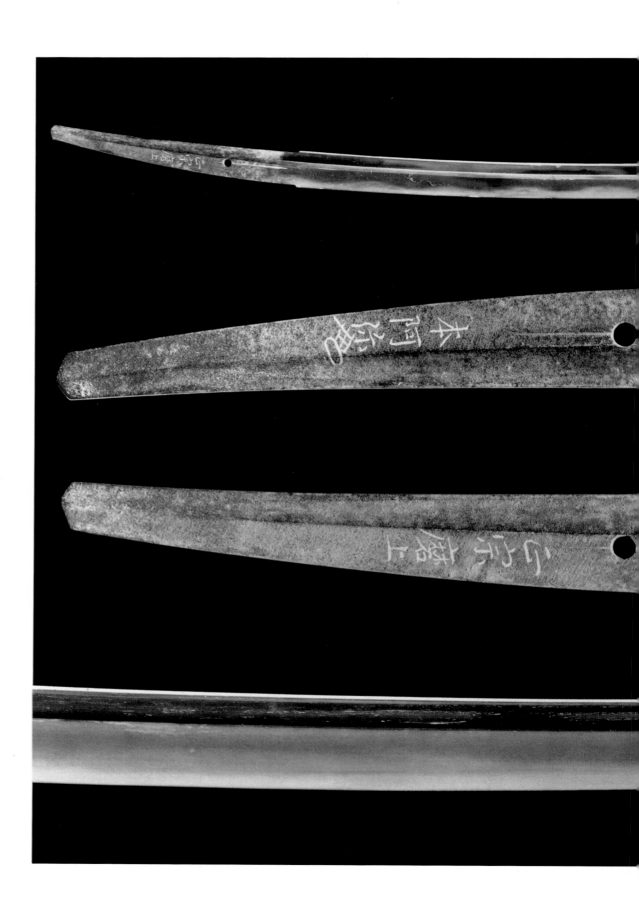

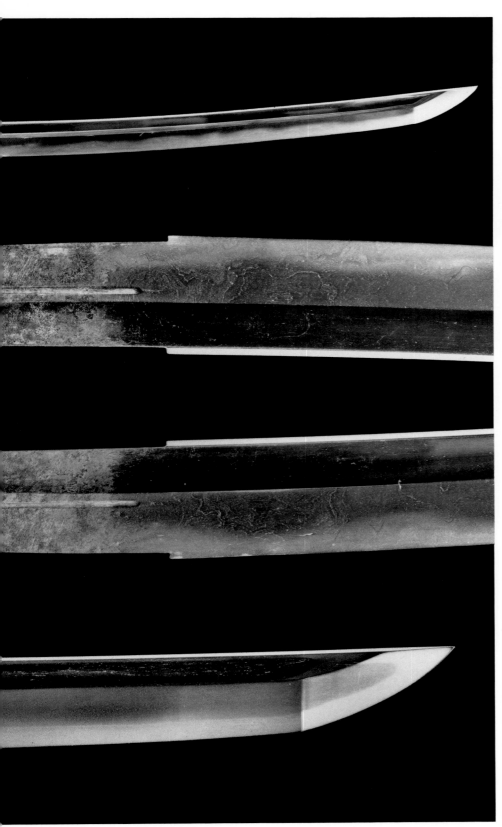

30. *KATANA*, NAMED "IKEDA MASAMUNE"

Inscription in gold inlay: *Masamune suri-age, Hon'ami (kaō)* (Shortened Masamune, Hon'ami [monogram])
l. 86.6 cm.
Kamakura period, 14th century

30

29. *TACHI,* NAMED "KIKU GO-SAKU"

Attributed to Emperior Go-Toba
Carved chrystanthemum crest; 1. 85.7cm.
Kamakura period, 13th century

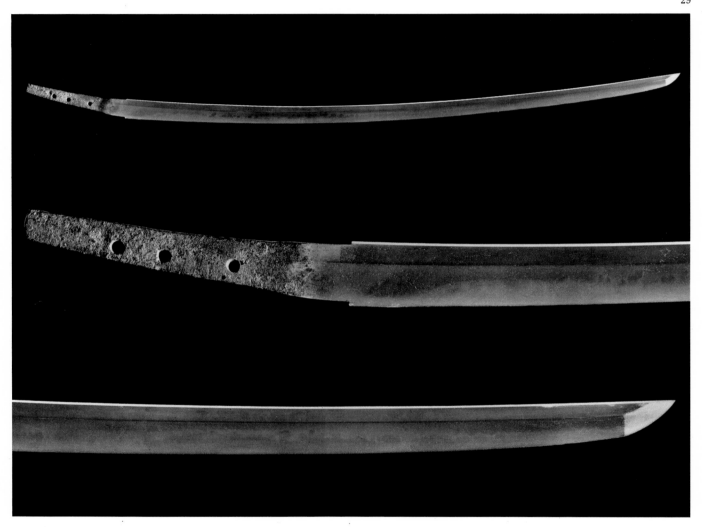

In armored combat, arrows and spears were more effective than swords. Later, firearms became the foremost offensive weapon once they came into widespread use. Among the numerous types of weaponry, however, swords had for centuries symbolized the samurai, and they were also recognized as works of art. During the Edo period, swords ranked highest among the gifts exchanged between daimyos, or between the shogun and a daimyo.

The Heian and Kamakura periods are said to represent the golden age of the Japanese sword, when the finest works were produced. The Japanese sword

ingeniously combined the qualities of unbreakability, unbendability, and cutting prowess—qualities that seemed to be contradictory in a single sword—thereby exhibiting an effectiveness unrivalled in the history of the world's metalwork. More-over, the efficiency of the Japanese sword is manifested in its functional beauty. The shape, temper pattern, and quality of the ground metal are the essential points in appreciating a sword as a work of art. The nomenclature of curved, single-edged swords is determined by the length of the blade. Both *tantō* and *katana* measure over sixty centimeters in length, and their strict categorization derives from the

manner in which they are mounted, either with the cutting edge facing downward and slung from the sash for the *tachi,* or with cutting edge upward to be worn thrust into the sash in the case of the *katana.* An unmounted long blade can only be categorized if it is inscribed, for the inscription is always placed on the side that is meant to face outward when worn. Short, curved blades measuring between thirty and sixty centimeters in length are called *wakizashi* and resemble a smaller version of the *katana.*

Number 29 is a *tachi* presented by the second son of the second shogun, Hidetada, to Tokugawa Yoshinao, first lord

31. *WAKIZASHI,* NAMED "NAMAZUO YOSHIMITSU"

Inscribed: *Yoshimitsu* l. 48.2cm.
Kamakura period, 13th century

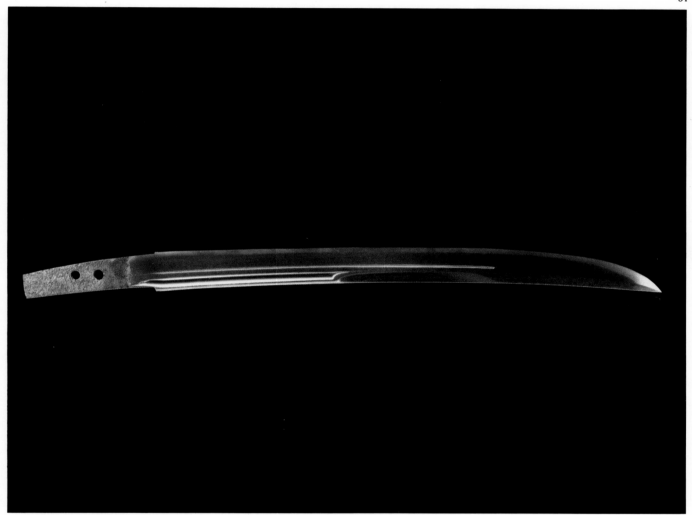

of Owari, and is said to be the work of Emperor Go-Toba (1180—1239; r. 1184—1198). Emperor Go-Toba was an avid admirer of swords, and it said that he himself forged swords in the company of famed swordsmiths gathered from throughout Japan. On this *tachi,* the imperial chrysanthemum crest appears in fine-line engraving below the blade notch, lending credence to the imperial attribution.

Number 30 is ascribed to Masamune, who is generally regarded as the greatest Japanese swordsmith. Like most of Masamune's works, this *katana* lacks an inscription by the smith himself; instead,

the well-known Momoyama period connoisseur, Hon'ami Kōtoku, identified this blade as a Masamune that had been later shortened to its present length, and an inscription to this effect was inlaid in gold on the tang (see also no. 35). This *katana* was named "Ikeda Masamune" after the general Ikeda Nagayoshi who once owned it, and it was presented to Tokugawa Yoshinao by the third shogun Iemitsu when he visited Yoshinao's residence in 1636.

Number 31 is a *wakizashi* (see also no. 37), fashioned in later times from a blade by Yoshimitsu that was originally a *naginata* —a halberd-like weapon composed of a wide,

single-edged blade attached to a long handle. It differs, therefore, from the usual *wakizashi* shape. Since its broad surface resembles the tail of a catfish, it was given the name "Namazuo Yoshimitsu," literally, "catfish-tail Yoshimitsu." One of Japan's foremost swordsmiths, Yoshimitsu was the leading smith of the Awataguchi School in Kyoto.

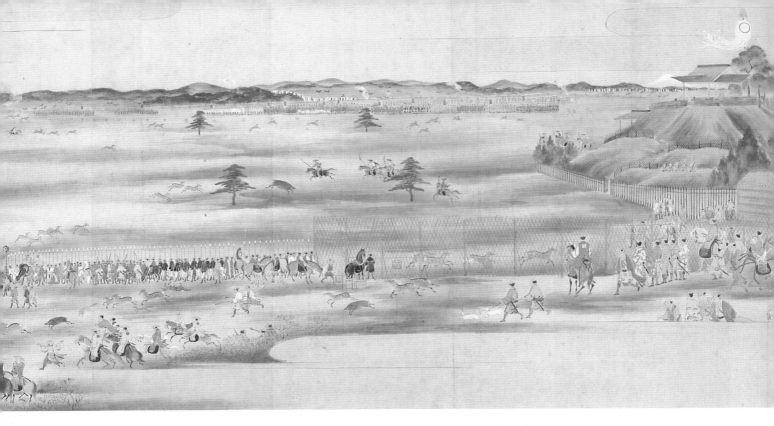

PURSUITS OF A MILITARY NATURE

After the two sieges conducted against Osaka Castle in 1614 and 1615, Tokugawa Ieyasu succeeded in destroying the Toyotomi clan, thus managing to subdue the remnants of opposition, and unified the country. After the final siege, no other military campaigns of any consequence occurred to mar the peace, and a tranquil era that lasted for two and a half centuries was initiated.

However, the ruling samurai never relinquished their warrior character, and maintained military readiness even in times of peace. In the fields in the vicinity of the castle, large areas for falconry and hunting were marked out. These activities were conducted with the aim of sharpening the combat skills of the lord and his retainers, as well as providing amusement, so that they possessed not only the character of sport, but also simulated large-scale military excercises. In addition, these hunts were organized to inspect conditions in the surrounding areas,

thus contriubting to the effective control of the rural provinces. The first shogun Ieyasu was especially fond of falconry, and the third shogun Iemitsu also engaged frequency in bird and game hunting.

The shogun, daimyo, and their retainers all practiced the military arts in keeping with their status. One of the characteristics of the Edo period is the emergence of masters in the fields of swordsmanship, horsemanship, archery, the arts of the spear, halberd, and musket, as well as swimming, and the subsequent development of different schools and theories. As a result of the participation of the shogun and daimyo in these military arts, frequent competitions were held. When the retired shogun Hidetada and the third shougn Iemitsu traveled to Kyoto in 1626 to demonstrate the might of the shogunate, an impressive horsemanship competition took place upon the emperior's progress to Nijō Castle.

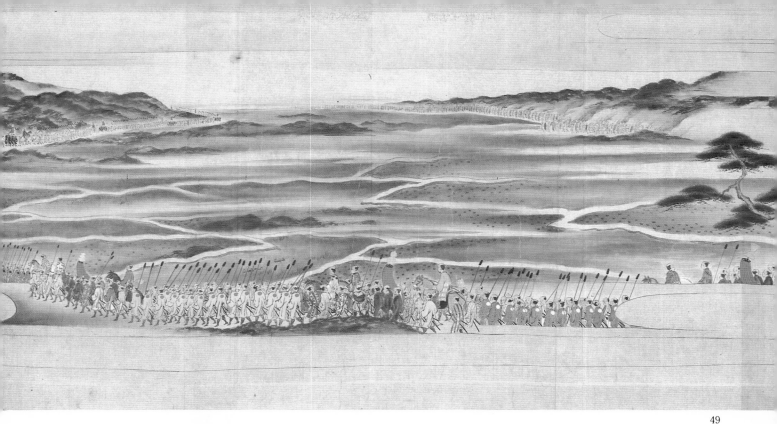

49. SHOGUNAL HUNT AT KOGANEGAHARA

Hanging scroll, ink and colors on paper;
122.3 × 140.3cm.
Edo period, 19th century

Takagari (falconry and hawking) and *shishigari* (hunting of deer, wild boar, and other kinds of prey) were types of hunting indulged in for sport by high-ranking samurai of the Edo period. In their objectives, however, neither pursuit was confined to the simple concept of sport. The Edo period was a peaceful era, and the hunt provided an opportunity for military training and an excuse for inspecting conditions among the general population.

In the *shishigari* type of hunt, a multitude of beaters were used to drive the deer, wild boar, and other game into a prescribed area where they would be brought down by mounted archers. Four

times during the Edo period shogunal hunts, such as the one shown here, were carried out on a grand scale on lands under the direct control of the shogun at Koganegahara (in present Chiba Prefecture).

The number of peasants who were enlisted as beaters for the *shishigari* held in 1795 is reckoned to be more than 72,000; for the list of 1849, the count is upward of 62,000 men. Similarly remarkable figures are likewise recorded for the number of shogunal retainers who disported themselves in these hunts: more than 15,000 in 1795 and over 23,500 in the later event. On both occasions, close to 100,000 men were mobilized for the hunt. A large-scale military exercise being their principal purpose, such shogunal hunts involving extraordinarily massive turnouts were

further intended as intimidating demonstrations of the authority of the shogun.

In the upper right of the painting is an artificial hillock at the top of which a standard has been raised to mark the position of the shogun. From within his hilltop pavilion the shogun overlooks the activities of the hunt spread out in the plain below. Each of his retainers engaged in the hunt has on a brilliantly colored *jimbaori*, or campaign jacket (see nos. 16-18), distinctive in its combination of color and design so as to enable individuals to be identified and their units discriminated.

52. ILLUSTRATIONS OF THE BATTLE FLAGS USED BY THE OWARI TOKUGAWA

Two folding books, ink and colors on paper;
A: 42.0 × 24.2cm., overall length 484.0cm.
B: 42.1 × 24.2cm., overall length 1546.8cm.
Edo period, 18th century

Battle flags functioned both as the symbol of a troop and to regulate troop formations. These flags came to be used in the late Heian period from about the 11th century with the rise of the warrior class.

Illustrations of the battle flags used by the army of the Owari Tokugawa are here accurately and colorfully depicted and then bound in the form of two folding books.

52 A

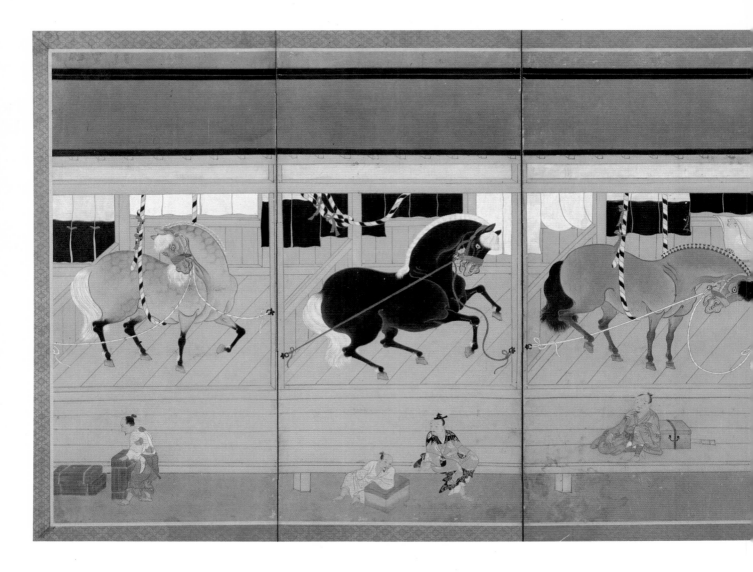

50A,B. HORSES IN A STABLE

Pair of six-fold screens, ink and colors on paper;
99.7 × 288.0cm. each
Edo period, 18th century

A 16th century European visitor to Japan noted that "when one compares the horses of Japan with those of Europe, the physique of the former is found to be diminutive and unsightly; moreover, their training leaves something to be desired." And yet, in contrast, another observation moved him to admire the way "the horses are exceedingly prized. At the mansions of samurai they are kept in handsome stables whose wooden planks are kept immaculately clean."

The ownership of fine horses was a source of great prestige among members of the warrior class. Paintings having horses as their principal subject matter were produced from the late Muromachi through the early Edo period, and the folding-screen format was especially favored.

This pair of six-fold screens depicts

twelve horses tethered in a stable, one horse appearing in each of the six panels. The individual characteristics of coat and conformation are minutely depicted. Paintings of stabled horses can generally be divided into two types: one in which the picture is limited to a frieze of posed horses alone, and another in which the horses' grooms and a variety of genre elements surrounding the stable appear. This pair of screens belongs to the second category, and both the dress of the figures and the genre elements are characteristic of the late Muromachi through Momoyama periods. Stylistically, however, these screens belong to the Edo period, and it appears that the painter produced these screens according to the traditional conventions governing paintings of stabled horses, without having been familiar with the actual scene.

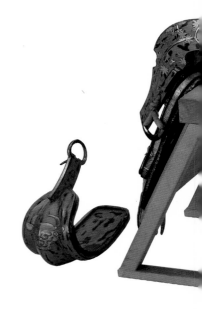

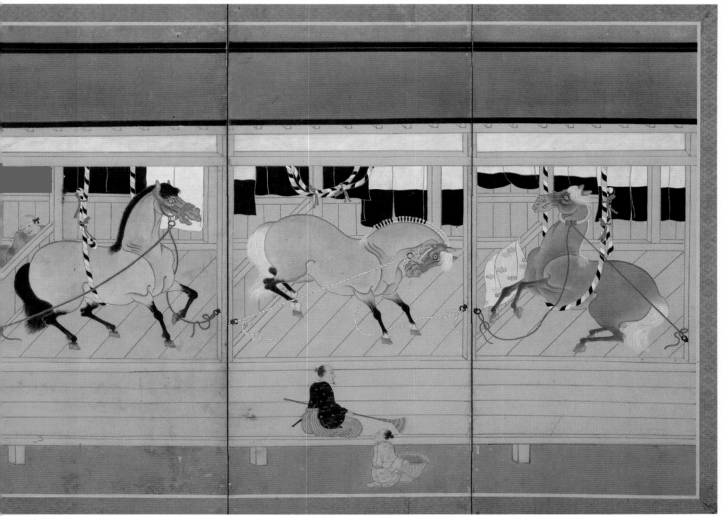

54. SADDLE AND STIRRUPS

Design of the Legend of Tatsuta and *aoi* crests
in *maki-e* and inlaid mother-of-pearl on a
cinnabar and black lacquer ground;
saddle: h. with stand 63.5, 1. 42.0, w. 41.0cm.;
stirrups: 30.8 × 13.3 × 27.2cm.
Edo period, 18th century

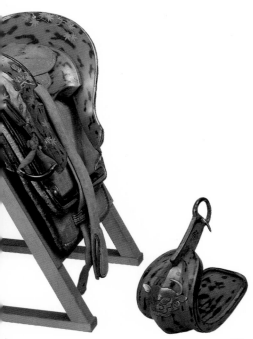

This set of horse trappings includes a
saddle, a pair of stirrups, and their fittings.
A soft, thick pad made of cloth or tanned
deer hide was spread on the back of the
horse to cushion the weight and sharp
edges of the hardwood saddle. While
riding horses was a privilege granted only
to warriors of upper and middle rank in
the Edo period, it was also an obligatory
part of their military preparedness. In
order to display their elevated status, these
samurai vied with each other in capa-
risoning their horses with lavish,
elaborately worked equipment.

The design of this saddle features a
trifoliate *aoi* crest of the Tokugawa family
executed in gold *maki-e* prominently
placed in the center of the front rim of the
pommel. Extending across both the
pommel and cantle of the saddle are the

leafy branches of a maple tree depicted
primarily in gold *maki-e* with a scattering
of leaves inlaid in iridescent blue shell
(*raden*). The ground is completely covered
with a monochrome cinnabar lacquer that
has been deliberately worn away in spots to
reveal the undercoat of black lacquer. The
stirrups are lacquered using the same
decorative techniques, but the design has
been reduced to a single demonic mask in
maki-e on the front of each stirrup.

An inscription by the craftsman inked
on the underside of the saddle indicates
that it was made in the eleventh month of
1590 by Yoshihisa. In the Edo period, old
saddles were prized, and they were often
decorated anew with *maki-e* lacquer (see
also no. 53).

54

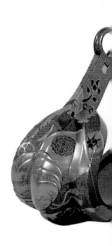

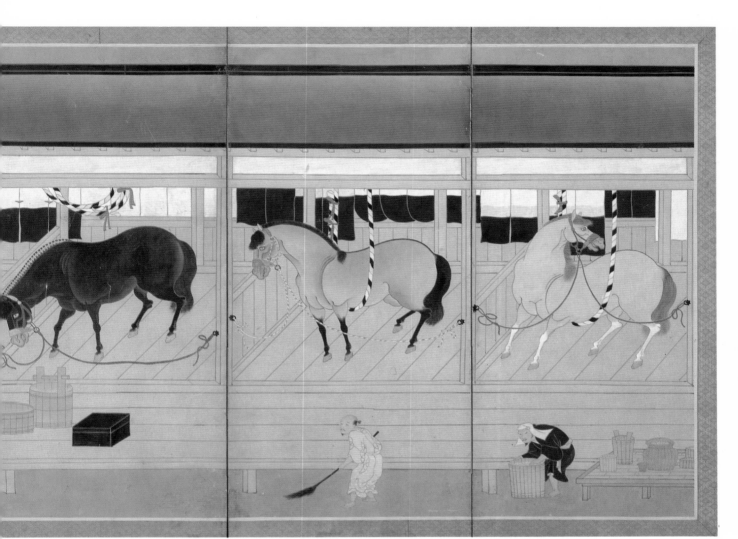

50B

53. SADDLE AND STIRRUPS

Design of military accoutrements in *maki-e* on
an aventurine lacquer ground;
saddle: 41.0 × 27.0 × 39.0cm.
stirrups: 30.0 × 13.0 × 26.0cm. each
Edo period, 19th century

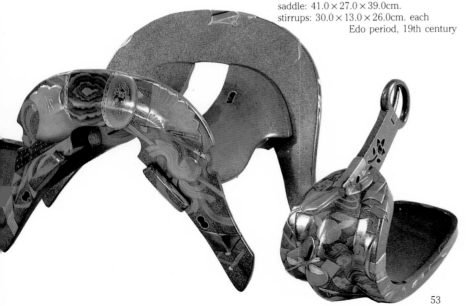

In the Edo period only samurai of
middle or high rank were permitted to
possess their own riding horses. Of these
the warriors of the highest status such as
the shogun, daimyo, and *hatamoto* used
riding equipment ornamented in a manner
appropriate to their social position.

Japanese saddles were usually made of
hard woods such as oak or maple and
were decorated with lacquer. Stirrups, on
the other hand, were primarily made of
steel. The decoration of this saddle and
stirrup set is executed in high relief, or
taka-maki-e, and depicts various kinds of
military hardware such as swords, bows
and arrows, firearms, flags, whips, and
fans. According to the carved inscription
on the underside of the saddle, the
wooden body was fashioned in the fifth
month of 1507. Redecorated in the 19th
century, this set was presented as a gift to
the fourteenth lord of Owari by Emperor
Kōmei (r. 1847—1866) shortly before the
fall of the Tokugawa regime.

53

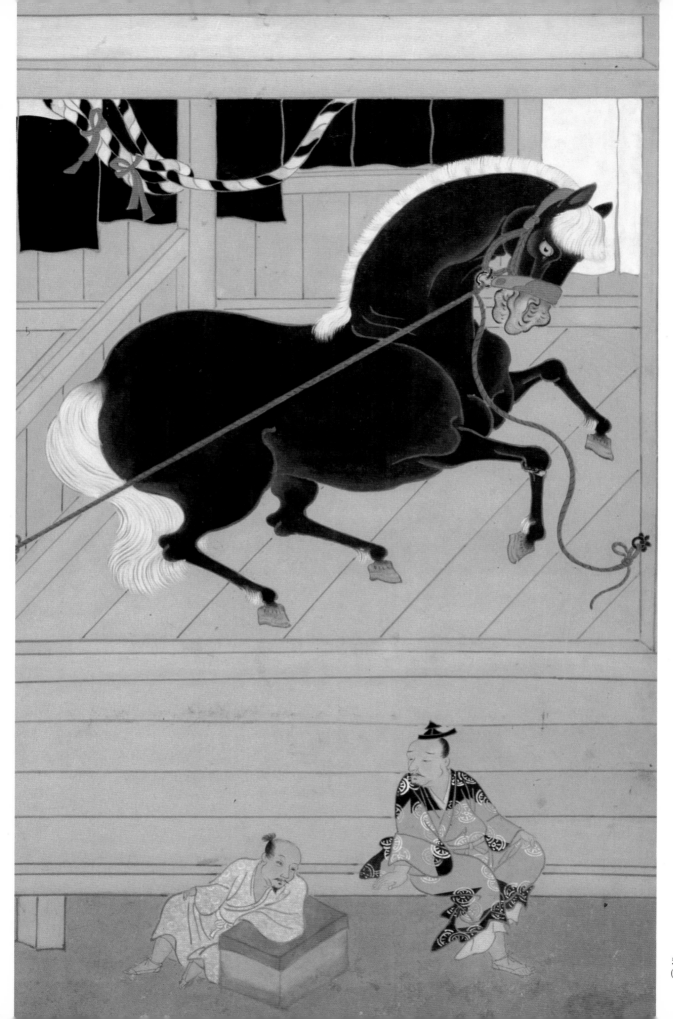

50A
(detail)

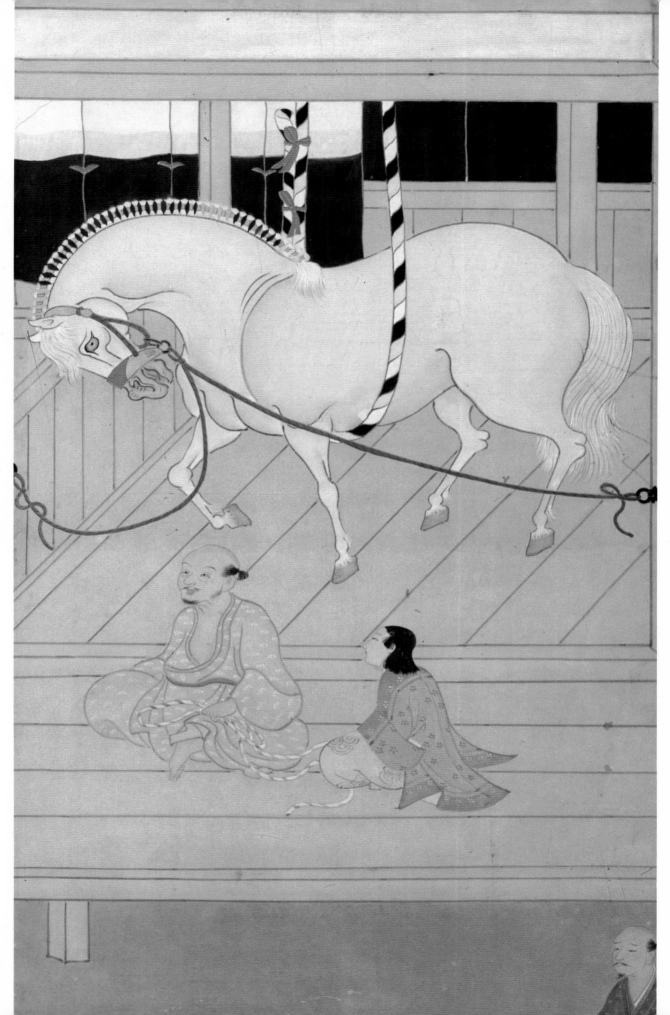

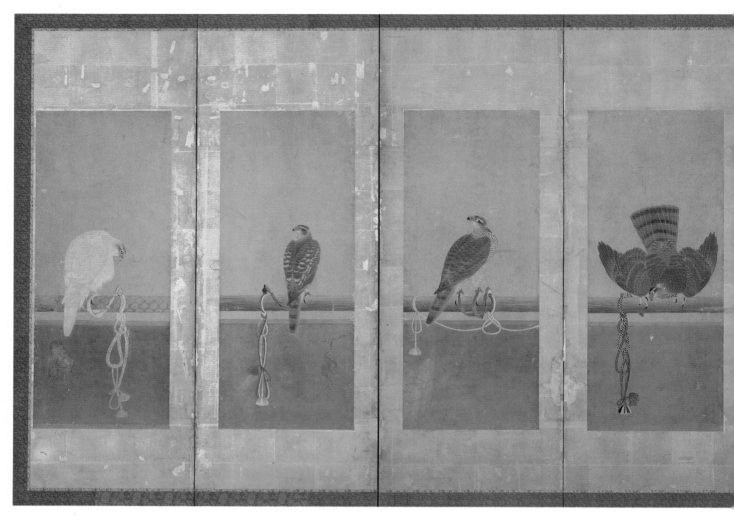

51. HAWKS

Kamiya Haruzane
Eight-fold screen (one of a pair), colors on paper;
each painting, 91.5 × 37.4cm.
Edo period, 19th century

The eight hawks depicted on this screen were for *takagari* ("hawking"), a kind of hunting in which domesticated hawks (also peregrines) were set loose to catch cranes, wild geese, and other wild fowl. The custom had a long tradition, developing since the 14th and 15th centuries as a sport of the military class. While pursued as a recreational activity,

hawking also bore the purpose of a small-scale military exercise. Riding about the countryside hardened warriors with physical training, while also permitting inspection of the fief, both its territory and the condition of the poipulace.

To collect and maintain fine hawks constituted a status symbol of the warrior class. Samurai found in the brave and daring nature of these birds a congenial expression of their ideals, and hawks became a preferred theme in painting from about the 14th or 15th century.

Tokugawa Ieyasu's enthusiasm for hawking is said to have been unequaled, and nearly all the successive shoguns

down through the Edo period shared his keen interest. Beginning with samurai who specialized in the training of hawks, a system to provide the kind of organization necessary for hawking was established.

Kamiya Haruzane (flourished ca. 1830—1844), who painted this screen, was a late Edo period artist of the Kanō school officially attached to the Owari fief. It appears likely that Haruzane had not painted from actual observation of his patron's aviary, but rather had copied these hawks from an older painting.

55C

55B

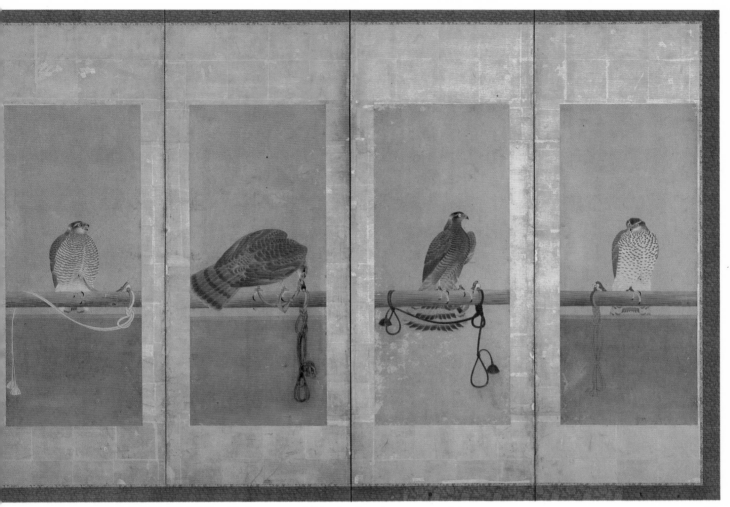

51

55. FALCONRY ACCESSORIES

A: Water bottle of worm-eaten wood inlaid on a
black lacquer ground; h. 16.3 w. 7.8cm.
B: Feed box and pouch with design of eggplants
Mt. Fuji, and fans in gold *maki-e* on a black
lacquer ground; 11.4×7.6cm.
C: Feed box with design of *aoi* crest in gold
maki-e on a black lacquer ground; 12.3×8.1cm.
Edo period, 19th century

Falconry and hawking were favorite
forms of hunting for the samurai class in
the Edo period (see also nos. 49 and 51).
High-ranking warriors were particularly
extravagant, as was appropriate for their
social standing, in the procurement,
training, and care of the birds used in this
sport. This lavishness is exhibited even in
the minor accessories exhibited here.

On both sides of 55A, which is a bird's
water bottle, are inlaid pieces of worm-
eaten wild mulberry wood on a black
lacquer ground. In spite of, or perhaps
because of, its imperfections, the surface of
this wood creates a lively, successful
pattern. The use of such humble wood
as the principal ornamentation of a luxury
item that employed the finest quality
lacquer craftsmanship and materials is a

prime example of the refined aesthetic
consciousness of the Japanese. On the
shoulder of the bottle is attached a fitting to
allow it to be hung from the belt at the waist.

55B and C are small containers to hold
the insects and small pieces of meat used
in feeding the birds. 55B was placed in a
small pouch with a short cord so it could
be suspended from the waist much like an
inrō, the small medicine cases that were
extremely popular in the Edo period. Both
boxes were coated with black lacquer and
then further decorated on the cover with a
design executed in gold *maki-e*. The
ornamentation of 55C is limited to a single
aoi crest, but 55B employs a more
elaborate decoration of eggplants and
several folding fans, one of which displays
eggplants and a landscape of Mt. Fuji. This
motif is based upon the proverb, "One
Fuji, two hawks, three eggplants," all said
to be famous products of Suruga province
where Tokugawa Ieyasu spent his final
years. Furthermore, it is thought to be a
good omen if any of these three things
appears in one's dreams.

55 A

81

THE CONSOLIDATION OF
THE SYSTEM

The system of Tokugawa rule was placed on a firm foundation as the office of shogun passed from the first shogun Ieyasu to the second and third shoguns, Hidetada and Iemitsu. During the rule of Iemitsu, the process of consolidation was largely completed.

In 1615, the regulations concerning the various Buddhist sects and their head temples were compiled, and the principles governing the conduct of the emperor, nobility, and samurai (see no. 60) were finalized. With the promulgation of these regulations, the system of controlling the temples and shrines, the court, the aristocracy, and the daimyo was thoroughly consolidated, thus creating for the shogunate a solid foundation for its civil administration.

During the rule of Iemitsu, the system of years in alternate residence was established for the daimyo. According to this system, not only were the daimyo required to spend alternate years in the shogunal capital of Edo, their wives and children were also required to reside in Edo at all times.

As a result of these measures, the samurai, while largely retaining their original military character, gradually adopted the characteristics of supervisors, whose duties had become largely administrative, legal, and regulatory. The shogun was at the head of the central administration, and the daimyo and those retainers under direct shogunal control functioned as administrators.

The relative status of the members of the samurai class was determined by the extent of the domains they controlled, since the fundamental economic structure of the entire system rested on the rice yield. The production of a samurai's domain was manifested in terms of *koku*, the basic unit of measurement for rice. The deed for a fief or estate served as documentary evidence of the income of the recipient (see nos. 57 and 58).

The social order was divided into four classes: samurai, farmer, artisan, and merchant, in descending order. Although under this system farmers were ostensibly ranked higher than artisan or merchant, they were subject to the severest restraints. Supported by a feudal system of land ownership, the social ranks were established and a strict lord-and-vassal relationship was instituted for the samurai, thus consolidating the system of Tokugawa rule.

Drawing depicting the payment of land taxes in rice.

57. DEED TO OWARI PROVINCE (presented to Tokugawa Yoshinao, first lord of Owari, by Tokugawa Hidetada, the second Tokugawa shogun)

Handscroll, ink on paper;
45.1 × 61.6cm.
Edo period, dated Keichō 13th year, 8th month,
25th day (October 3, 1608)

This document was sent by Tokugawa Hidetada, the second shogun, to Tokugawa Yoshinao, the first lord of Owari, and instructs Yoshinao to take control of Owari province, which was officially granted to him at that time.

For the Owari Tokugawa family, this document was of the utmost importance, since it provided the very basis for the existence of the Owari fief. This letter is dated the 25th day of the 8th month of the 13th year of the Keichō era (October 3, 1608), and corresponds to the period when the social structure of the shogunate was in the process of consolidation. Beneath the date appears the written seal of Shogun Hidetada in black ink. Whenever the shogun sent a document of this nature to a member of the imperial family or to a daimyo with an income exceeding one hundred thousand *koku,* he wrote his own seal as seen here. If the same kind of document was issued to lesser daimyos, temples or shrines, or the nobility, he merely affixed a red stamped seal, which was a simpler, abbreviated manner of placing one's signature than using brush and ink.

56. MAP OF THE LAND CONTROLLED BY THE OWARI TOKUGAWA FAMILY

Hanging scroll, ink and colors on paper,
171.5 × 122.5cm.
Edo period, dated in accordance with 1698

This is a map of the land possessed by the Owari Tokugawa, which included all of Owari province and a part of Mino province. The lord of Owari had total control over the administration, adjudication, and taxation of this territory.

The *gun* (counties or major administrative sub-divisions of the provinces) are distinguished by color with the names of the villages and major roads recorded in black ink. Agriculture was the basis of the economy during the Edo period with rice being the main crop. Rice was so important to the diet and economy of Edo society that the output of a piece of land, even if it was used to produce other crops, was expressed in terms of rice. The

information in this map is based upon a cadastral survey taken in 1698. According to that survey, there were over 1,800 villages within this domain and an annual yield of over 645,000 *koku* of rice (or about 110,000 kiloliters) in that year. The number of villages within an area was a particularly important figure since the village was the basic unit by which the output of an entire province was measured. Due to such factors as 250 years of unbroken peace, advances in and diffusion of agricultural technology, and the development of new farmland, agricultural output in the Edo period increased significantly. During the Edo period, the administration of frequent and accurate cadastral surveys to evaluate the production level of each village was one of the most important duties of feudal lords.

56

57

58

58. ESTATE DEED

Unmounted sheet, ink on paper;
41.4 × 55.5cm.
Edo period, dated Shōho 4th year, 9th month, 14th day (October 11, 1647)

This document is the deed for the granting of land from the lord of Owari to one of his retainers. The person issuing the deed was Yoshinao, the first lord of Owari. The recipient was an Owari retainer of middle rank named Ueda Gohei.

This deed awards to Ueda taxation rights to approximately two hundred *koku* (1 *koku* = about 180 liters) of the rice

produced by the two villages of Tamba and Hachisuka in Owari province. The tax rates levied on this two hundred *koku* were not necessarily the same every year, but usually about forty to fifty percent. In a year when the tax rate rose to sixty percent, Ueda received an income of 2,160 liters of rice, with the remaining 1,440 liters becoming the share of the farmers who produced the crop. The portion of rice that Ueda received annually and did not use to feed his family and dependents would be sold and converted into money for his own use.

This document not only has the function of being a clear statement of the yearly stipend of a retainer, but also fixes the

status of the recipient within the hierarchy of the fief and regulates the military obligations that he would be expected to bear in times of warfare. As a result, it serves to establish the basis for the very existence of the Ueda family within the feudal hierarchy.

In the Owari domain, there were some 1,200 to 1,300 families that were provided with deeds of this kind in the course of the Edo period. Such documents were issued in the event of the accession of a new lord or a change in the succession in the household of the recipient, as well as when the recipient rose or fell in status.

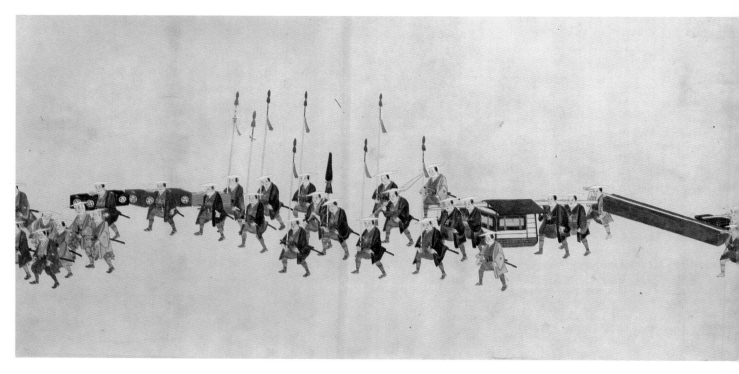

61. THE PROCESSION OF A DAIMYO TO EDO

Odagiri Shunkō
Handscroll, ink and colors on paper;
28.9 × 2,588.2cm.
Edo period, 19th century

The feudal lords, or daimyos, of the Edo period were required to maintain two households, one in their native domain and another in the capital city of Edo. Under a shogunal decree they were obliged to spend alternate years at their Edo residence (*sankin-kōtai*). Moreover, when a daimyo returned to his provincial lands he was compelled to leave behind his wife and children as virtual hostages of the shogunate. This system was instituted in order to ensure that daimyos enfeoffed far from the capital would be unlikely to instigate a rebellion against the shogun.

Thus throughout the Edo period there were approximately 260 to 270 daimyos every year who made the round-trip journey between their own provincial domains and the capital. The makeup of a processional retinue was strictly regulated by sumptuary laws so as to be commensurate with a daimyo's standing and the size of his fief. Its basic character was that of a military parade, including in its ranks the various detachments of lancers, musketeers, and archers, in addition to units for transporting stores of food and sundry provisions and furnishings to meet the necessities of daily life. Eager to make a display of their might, the daimyo organized colorful processions of considerable pomp and splendor. Comprised at the very least of one hundred men, they are often reported to have numbered several thousand.

Residents along the route swept the highway at the daimyo procession's approach and prostrated themselves at the roadside, waiting until it had passed. These were occasions for the rural population not only to truly witness the power of the daimyo, but also to experience indirectly the authority of the shogun, the master of these regional lords who were constantly coming and going in processions over the highways. The daimyos were constrained to accept annually the tremendous drain on their purses caused by this frequent travel. Clearly, the custom was but one expedient measure by which the shogun was able to exercise his control over powerful provincial lords.

With the growing number of travelers bound for or returning from Edo created by these processions, the highways and facilities at post towns were expanded and consolidated. These travelers also promoted the dissemination of Edo culture throughout the provices.

This handscroll depicts the Owari Tokugawa family procession headed toward Edo from Nagoya, the clan seat. Tradition ascribes the work to Odagiri Shunkō (1810—1880), a middle-ranking retainer known also as a painter.

60. *BUKE SHO-HATTO* (RULES FOR THE MILITARY HOUSES)

Unmounted sheet, ink on paper;
45.8 × 315.0cm.
Edo period, dated Ansei 6th year, 9th month, 25th day (October 20, 1859)

The *Buke Sho-Hatto* is a set of approximately fifteen fundamental laws promulgated by the shogun for the regulation of the conduct of daimyos and the perpetuation of Tokugawa suzerainty. They were first issued by Tokugawa Ieyasu in 1615, the year of the fall of Osaka Castle which ended all organized resistance to Tokugawa rule and was the final step in the unification of the country. Afterwards, each of the succeeding fourteen shoguns, at the time of their succession, would summon the daimyo throughout the land to gather at his official residence, Edo Castle, where the regulations would be read publicly, and the daimyo would pledge absolute submission and obedience to the new military ruler. This edition of the *Buke Sho-Hatto* was one of the last ever issued. Dated on the twenty-fifth day of the ninth month of the sixth year of Ansei (October 20, 1859), it was presented at that time to the Owari Tokugawa family by the fourteenth shogun, Tokugawa Iemochi (ruled 1858-1866).

Among its provisions, which varied somewhat from edition to edition, the *Buke Sho-Hatto* exhorted the daimyo to excel in both the martial and literary arts. There were prohibitions on all new castle construction, and castle renovation was also restricted. Daimyo were forbidden to form leagues, and all marriages between

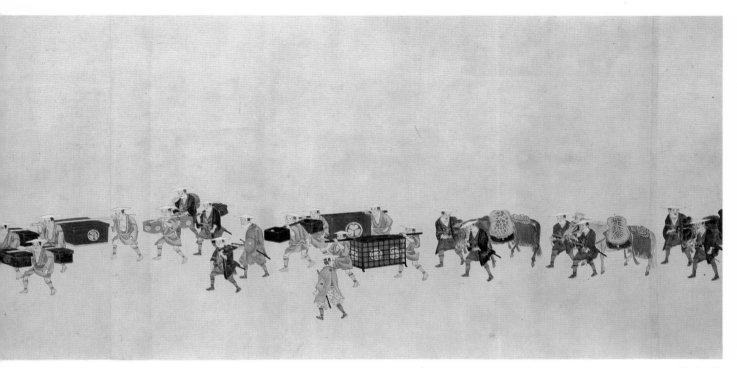

61 (detail)

their families required official sanction. The rules governing the *sankin-kōtai* system in which daimyo were required to spend alternate years at their Edo residence were made explicit. Daimyo who breached any of these rules would face severe punishment and the dissolution of his family.

Besides the *Buke Sho-Hatto* which were aimed at the daimyo, the shogun drew up another set of laws for those retainers under his direct control and yet another for the benefit of the emperor and nobility. This latter group known as the *Kinchū Kuge Sho-Hatto* (Rules for the Palace and Court) was also first published in 1615. The fact that these three sets of ordinances were strictly observed by the groups for which they were intended gives some indication of the enormity of the authority of the shogun.

60

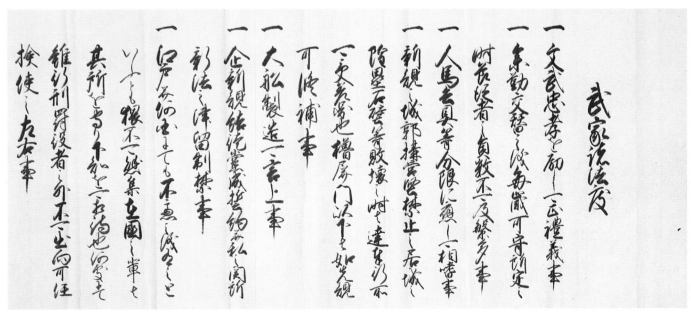

武家諸法度

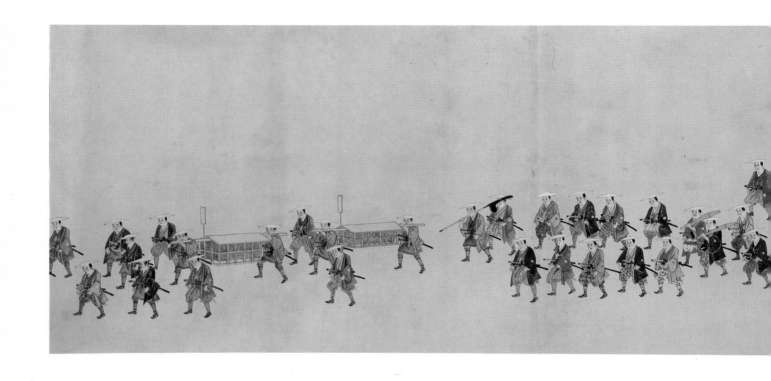

59 B

59 C

59. IMPERIAL APPOINTMENT OF TOKUGAWA YOSHINAO TO THE RANK OF *JŪNI-I*

A: Court rank certificate of the promotion of Tokugawa Yoshinao to Junior Second Rank (*Juni-i*): handscroll, ink on indigo paper; 26.7 × 156.7cm.

B: Imperial appointment to the office of Provisional Major Counsellor (*Gon-dainagon*): unmounted sheet, ink on paper; 34.6 × 48.0cm.

C: Proposal for the oral statement of the Provisional Major Counsellor: unmounted sheet, ink on paper; 38.2 × 59.5cm.

Edo period, dated Kan'ei 3rd year, 8th month, 19th day (October 9, 1626)

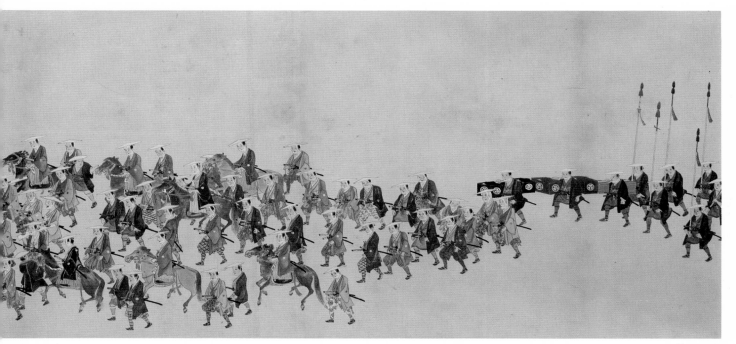

61 (detail)

These three documents are the formal imperial certificates that describe the court rank and office that were bestowed upon Tokugawa Yoshinao, the first lord of Owari, by Emperor Go-Mizunoo (r. 1611—1629). All three are dated in accordance with October 9, 1626. 59A is the document that concerns his rank of *Jūni-i*, or Junior Second Rank, the fourth highest court rank for officials. The document in 59B conferred upon Yoshinao the post of *Gon-dainagon*, or Provisional Major Counsellor, while the draft in 59C was a supplementary document to the former and was written on remanufactured paper that is light grey in color.

For samurai, it was an honor to receive court rank and office, although largely ceremonial and not attended by the actual performance of specific duties. In the Edo period, the emperor and his court in Kyoto were completely bereft of economic and political power, and accepted the shogun's protection and support. Following the instructions of the shoguns, the emperors continued throughout the Edo period to issue documents and appointments of this nature as a formality, preserving the traditions and procedures which had been both the prerogative and responsibility of the court since the seventh century. This manipulation by the shogun of the ancient and revered, but largely ceremonial, authority of the emperor as a means of consolidating his supremacy is an excellent example of the consummate political skills of Tokugawa Ieyasu, who not only succeeded in unifying Japan after a long period of civil war, but was also able to fashion a system of regulation and control which perpetuated that rule for more than two and a half centuries.

59A

KENRAN

FLAMBOYANCE

PART II.
FLAMBOYANCE

The residences of the shogun and daimyo were the great castles. Castle-building styles developed in reaction to changes in methods of warfare, such as the introduction of firearms, and they were planned primarily with military considerations in mind. They also served to manifest the power and dignity of the ruler. In scale, the largest of the castles were: Azuchi, built by Oda Nobunaga; Osaka and Fushimi Castles, constructed by Toyotomi Hideyoshi; and Tokugawa Ieyasu's Edo Castle. None of these edifices remain standing in their original form today. Edo Castle had been impressive in size, covering 33,100 meters of floor space, a magnificent, luxurious structure suitable for the ruler of the land. All of the buildings within the precincts of the castle were constructed of plain wood in the *shoin* style of residential architecture. The central buildings were large and separated into three principal sections: *omote* (for official functions), *naka-oku* (for the performance of administrative duties), and the *oku* (private quarters for the ladies of the household). The *omote* was also called the *goten*, and large, *tatami* -floored rooms, such as the audience hall, reception room, and assembly room, were reserved for ceremonial functions. Each of these rooms was provided with furnishings and decor appropriate to their function, consisting of suitable implements and objects to ornament the alcoves and shelves of the principal rooms. These furnishings were considered *omote-dōgu,* or accessories for the official halls, and were carefully maintained under the supervision of a specially appointed official. In keeping with the status of their families, the shogun and daimyo collected and commissioned such furnishings as befitted their means. To this end, by supporting the development of gold and silver mines in Sado, Iwami, and other locations and encouraging trade, Ieyasu managed to accumulate a vast amount of wealth. Although normally frugal, Ieyasu was unstinting with his resources when the time and place demanded it. By reconstructing the atmosphere of their private residences, it can be seen how these men of status, power, and wealth conducted their lives: how they dressed, the nature of the atmosphere in which they lived, and with what sorts of implements they conducted their official affairs.

THE CASTLE

Once a daimyo's fief was established, a permanent castle was constructed in the center of his domain. Just outside the perimeters of the castle were grouped the residences of his retainers, merchants, and artisans, which formed the castle town.

When Ieyasu was appointed shogun in 1603, he undertook the expansion of Edo Castle in order to demonstrate the authority of the shogunate. At the same time as the construction of Edo Castle, Ieyasu ordered the daimyo of the seven provinces neighboring on the Kinki district to build Nijō Castle as his temporary residence in Kyoto (he entered the city in 1603 for its "protection") as well as building Hikone Castle in Ōmi in 1604 because of its strategic location. In 1612, Ieyasu constructed Sumpu Castle, and in 1615 he ordered the building of Nagoya Castle.

Because of the system of alternate residence, all of the daimyos were required to maintain a mansion in the shogunal capital of Edo, apart from their own castles in their respective fiefs. The location of daimyo residences in Edo directly mirrored the manner in which the shogunate had

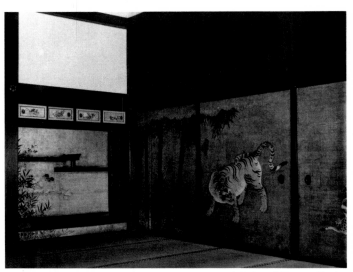

Interior of Nagoya Castle.

distributed their fiefs, deftly arranging them according to their status as one of the Three Tokugawa Houses, a *fudai* daimyo belonging to one of the hereditary fiefs, a *tozama* daimyo whose domain was not a hereditary feudatory, or the daimyo of a newly created fief. During the early part of the period, Edo daimyo residences were redistributed on a number of occasions.

62. MAP OF NAGOYA CASTLE AND ITS SURROUNDING TOWN

Hanging scroll, ink and colors on paper;
89.3 × 103.0cm.
Edo period, 19th century

This diagram of Nagoya Castle and the surrounding city depicts the home of the Owari Tokugawa clan, which ranked second only to the shogun himself. The castle and its supporting town were planned and built under the supervision of the first shogun, Ieyasu, from 1610 to 1612.

The two most important considerations in the planning for castle towns of the Edo period were the psychological element, for the majestic presence of the castle exerted a powerful influence over the general populace, and the practical factor of defensive capability in times of unrest. These considerations were manifested in the scale of the castle enclosure, the placement of the residences of the samurai, connections provided by the moats for overland and water transport, location of the temples, and the special arrangements of roads and pathways. Another significant consideration was the promotion of the town's economic prosperity through the concentration of commercial and industrial activities in the town precincts. The city of Nagoya was planned and constructed with the aim of fulfilling the above requirements, and it ranked as the second largest

castle town in Japan, outranked only by the shogunal capital of Edo.

In this map, samurai residences, temples, and the merchants' sector are distinguished by different colors, enabling the viewer to perceive readily the characteristics of the separate sectors.

62

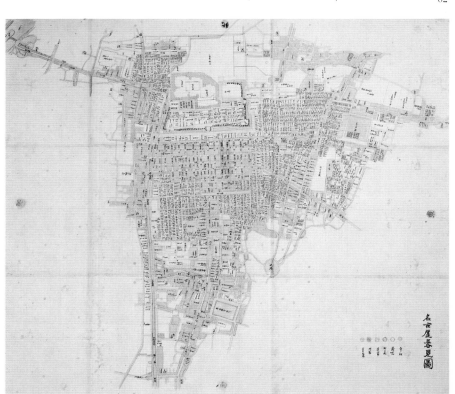

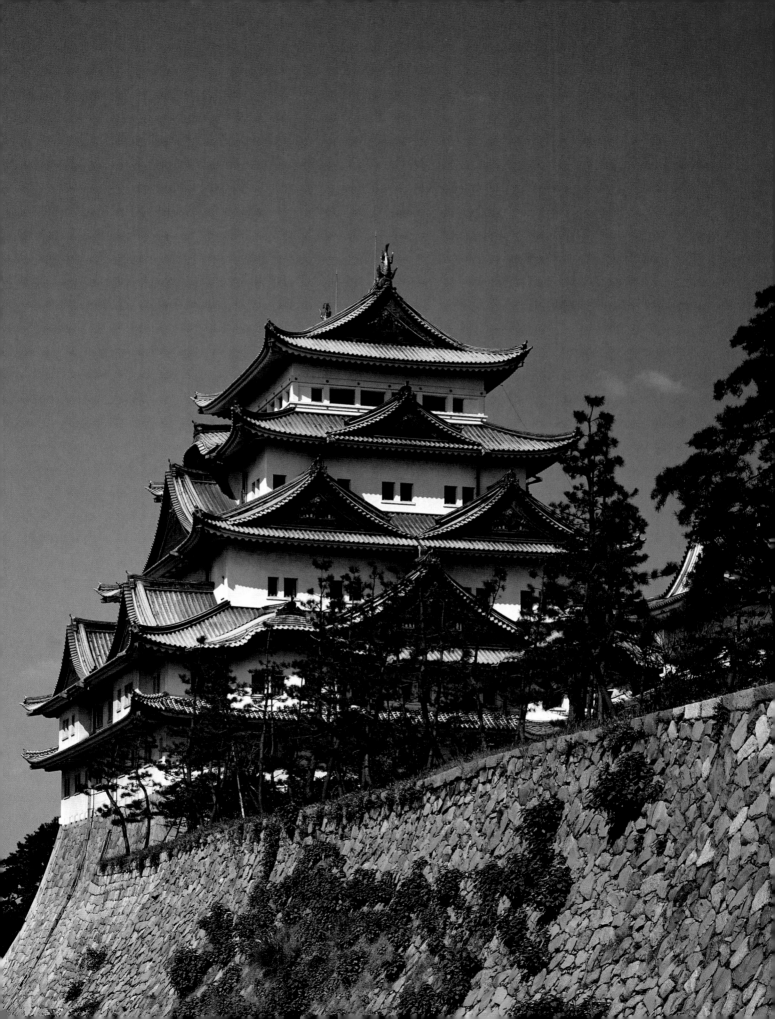

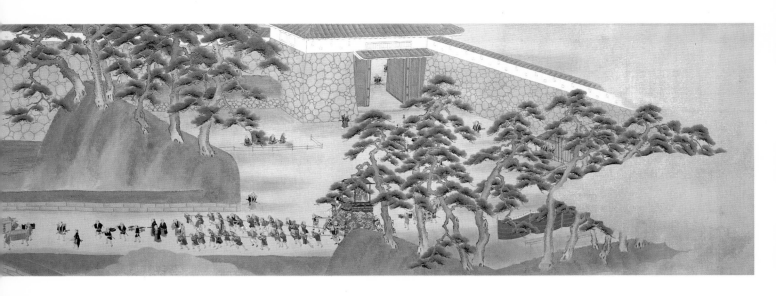

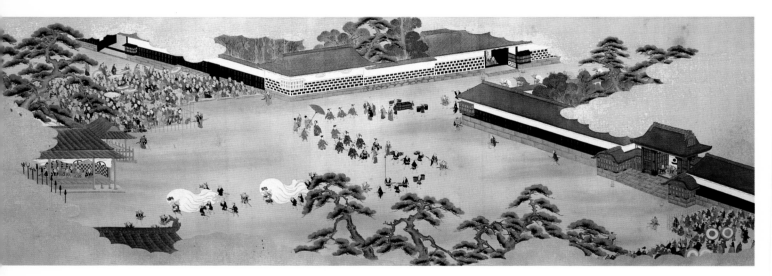

64. FESTIVAL OF THE NAGOYA TŌSHŌ-GŪ SHRINE

Mori Takamasa
Handscroll (one of nine), ink colors, gold
pigment, and gold leaf on silk;
34.5 × 1,234.0cm.
Edo period, 19th century

After the death of the first Tokugawa shogun Ieyasu, on the seventeenth day of the fourth month of the second year of Genna (June 1, 1616), he was deified and Shintō shrines dedicated to him, called Tōshō-gū, were erected in various parts of Japan. Ieyasu's son, Yoshinao, the first lord of Owari also established a magnificent Tōshō-gū shrine within the precincts of his residence at Nagoya Castle. Every year, on the anniversary of Ieyasu's death, he held a festival there marked by pomp and

splendor. Celebrated throughout the Edo period, this festival consisted of two observances, a formal ceremony and a more lighthearted procession. The former rite was held at the shrine within the castle grounds, while the procession, originating at the shrine, was sent forth into the streets of the town. The procession was joined in by the local merchants. Split into their neighborhood units, they paraded through the streets in all manner of guise, with their elaborately conceived festival floats displaying each

unit's originality.

The painting depicts the progress of a well-organized procession as it marches through the castle town. Greeting the procession along the route are the tradesmen, each of whom has made a decorative display of his family's most treasured folding-screens in the front room of his shop.

Mori Takamasa (1790—1864), who painted this scroll, was an artist in the service of the Owari Tokugawa family.

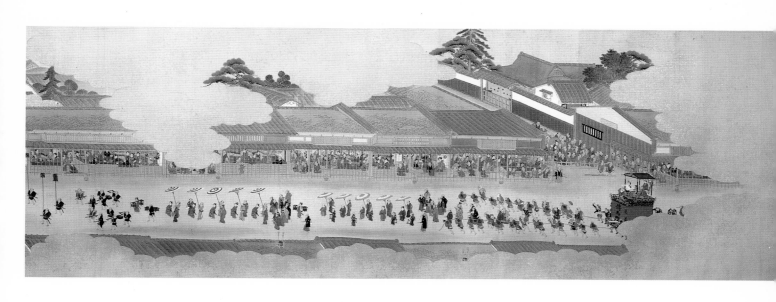

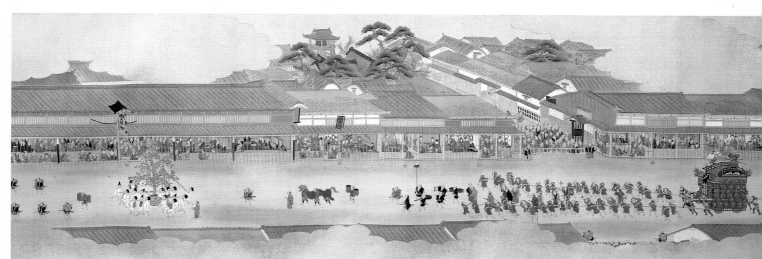

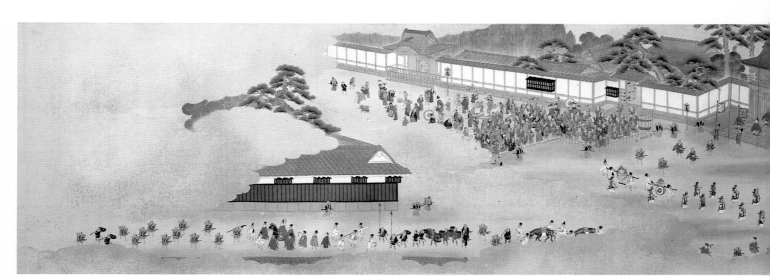

64 (detail)

Edo residence of the Owari Tokugawa located at Ichigaya.

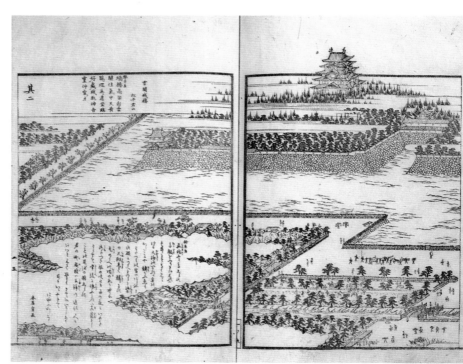

63 (detail) Nagoya Castle

63. BOOKS OF FAMOUS PLACES IN OWARI PROVINCE

Seven printed books, ink on paper;
26.2 × 19.0cm. each
Edo period, 19th century

These books contain about six hundred illustrations and descriptions of famous places and objects found in Owari province, centering on the castle town of Nagoya, the seat of the Owari Tokugawa family. Besides temples, shrines, and sites of historical interest, these books list interesting old legends and local customs, as well as antiques handed down over generations and rare natural phenomena such as trees and rocks of unusual size of shape.

This work was compiled by Kōriki Tanenobu (1755—1831), a middle-ranking retainer of the Owari clan. These books provide insight into the extent of the economic and cultural activity of Owari province during the Edo period.

63

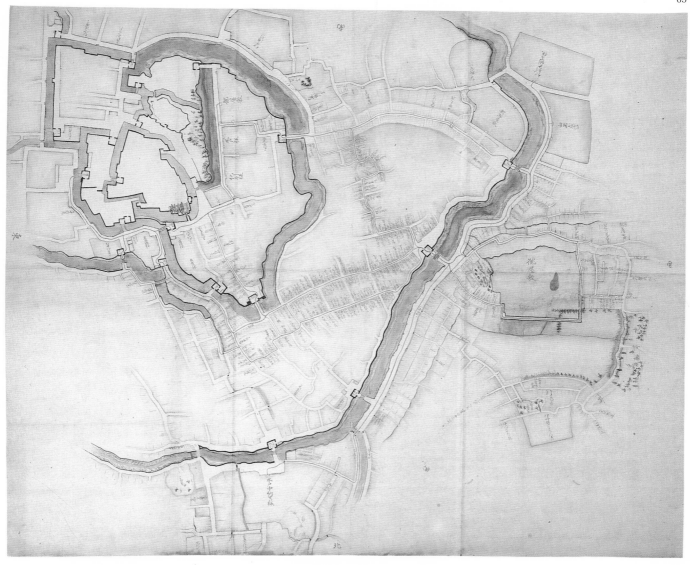

65. MAP OF THE APPROVED PROCESSIONAL ROUTES FROM THE VARIOUS EDO RESIDENCES OF THE OWARI TOKUGAWA TO EDO CASTLE

Hanging scroll, ink and colors on paper;
90.2 × 108.0cm.
Edo period, 17th century

During the Edo period daimyos in every region of Japan had an obligation to reside in the city of Edo, the seat of the shogun, for a specified period of time, and to present himself before the shogun at Edo Castle, in a largely ceremonial expression of fealty and submission.

The daimyos were thus required to maintain a large residence in Edo to serve as their headquarters there, as well as several detached residences. The routes by which the daimyos were permitted to proceed from their Edo residences to Edo Castle when paying homage to the shogun were strictly regulated. This map illustrates the set routes from the various Edo residences of the Owari Tokugawa clan to Edo Castle.

THE CHARACTER OF A
DAIMYO RESIDENCE

Within the castle precincts, the residence of the lord of the castle was built in the *shoin* manner of residential architecture that had first appeared during the Muromachi period. In this structure, the daimyo issued orders to his retainers, received guests, and attended to his administrative duties. Here various official and ceremonial functions occurred, including banquets.

The large surfaces, such as the walls and sliding screens, of these buildings were lavishly decorated with paintings, and the carefully arranged rooms were provided with elaborately ornamented implements and furnishings that manifested

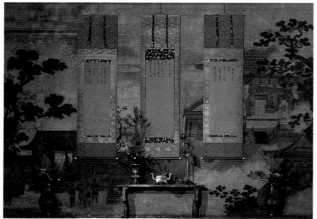

Tokonoma of the Shiroshoin of Nishi Hongan-ji ornamented with objects included in this section of the catalog.

the status and authority of the lord of the castle. Also, in order to intensify this effect, a raised platform area physically divided the room into two levels, and the raised space intended for the lord of the castle was provided with a large alcove, *shoin* or desk alcove, and staggered shelves, which were then ornamented according to strict rules. The customs

governing the layout and ornamentation of a reception room were based on the methods of arrangement practiced by the Ashikaga shoguns. For this reason, the objects most desirable for this purpose were precious articles and implements once owned by the Ashikaga rulers. In the alcove were displayed hanging scrolls of high quality with incense burners and vases placed before them. The staggered shelves to the side of the alcove were arranged with such objects as precious Chinese ceramic ware, incense burners, *sake* cups, nested food boxes, incense instruments, and tea ceremony utensils. In the writing alcove were displayed writing implements, including brushes, inkstones, ink sticks, and inkstone screens. Many of these objects were of Chinese manufacture, dating to the Song, Yuan, and Ming periods, in techniques such as celadon, carved lacquer, and cast bronze.

In this way, the articles and utensils used to adorn a room for official functions were frequently Chinese art objects. On the other hand, sumptuous examples of Japanese lacquerware were also used in this manner.

74. PAIR OF *HU*-SHAPED VASES

Bronze; each h. 33.9, diam. 19.5cm.
Chinese, Ming period, 15th century

The ultimate origin of the shapes of Chinese and Japanese flower vessels can frequently be found in ancient Chinese ritual bronzes of the Shang and Zhou periods (ca. 1776—221 B.C.). These vases are in the shape of a bronze wine jar called a *hu*, a type that was widely produced during the Late Eastern Zhou (ca. 650—221 B.C.), and are decorated with a *tao-tie* mask, the stylized rendering of the mask of a mythological monster that formed one of the principal motifs on ancient Chinese bronze vessels.

Flowers were arranged in these two vessels to form a symmetrical composition.

74

View of the Shiroshoin of Nishi Hongan-ji showing the location of the *tokonoma*, staggered shelves, and writing alcove.

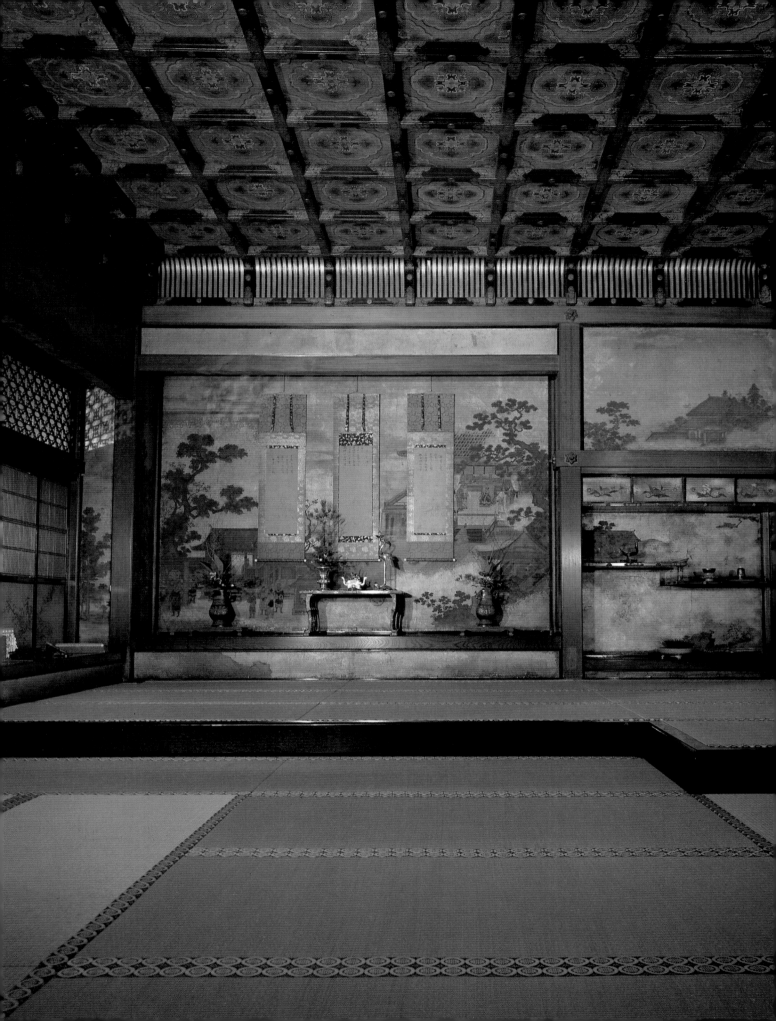

66. BODHIDHARMA, ZHENG HUANGNIU AND YU SHANZHU

Wuzhun Shifan
3 hanging scrolls (triptych), ink on paper;
Bodhidharma, 89.1 × 32.0cm. and two flanking
paintings, 84.1 × 30.0cm. each
Chinese, Southern Song period, 13th century

From the fourteenth through the fifteenth centuries, the aesthetic interest of Zen Buddhist monks and members of the cultivated ruling class in Japan turned enthusiastically in the direction of China, resulting in the importation of large quantities of Chinese articles. Of these, it was ink paintings of the Song and Yuan periods that were most highly valued, and they came to be regarded as treasures in their Japanese context. It was an age in which Zen (Chinese: Chan) Buddhism enjoyed great prestige, and consequently Zen-related themes in painting and works produced by Zen monks were all the more highly prized.

The three paintings of this triptych were executed by the Song period Chan prelate, Wuzhun Shifan (1179—1249). In the upper portion of each painting is a poem referring to the motif below and the signature of the artist Wuzhun.

The subject of each painting is a Chan Buddhist monk. Celebrated as the founder of the Chan school of Buddhism in the sixth century, Bodhidharma, is renowned as the Indian monk who transmitted the teachings to China. A single reed is shown at his feet, which alludes to the legend that he traveled to China from India riding on a reed. (For another interpretation of this iconography, see no. 210.)

Placed in either the left or right lower corner of each painting is the same square relief seal, read "Dō-yū." The presence of this *kanzō-in* ("connoisseur-collector's seal") denotes that these paintings were once a part of the collection of Ashikaga Yoshimitsu (r. 1368—1394), the third Ashikaga shogun of the Muromachi period. From the fifteenth century onward in Japan, paintings bearing this seal have been regarded in the first rank of art works, and prized accordingly.

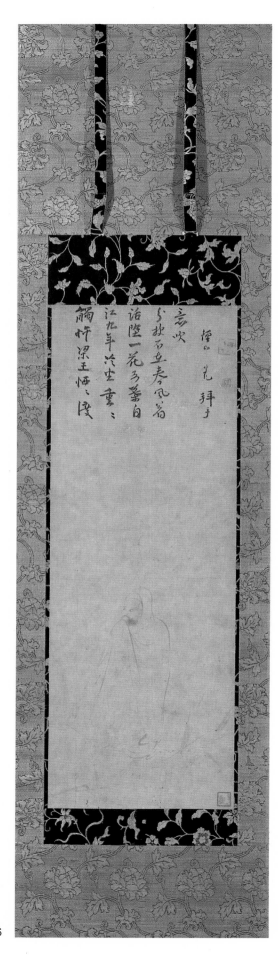

66

67. JURŌJIN, THE GOD OF LONGEVITY, WITH BIRD-AND-FLOWER SUBJECTS

Kanō Tan'yū
3 hanging scrolls (triptych), ink and light colors on silk;
121.6 × 50.6cm. each
Edo period, 17th century (dated in accordance with 1672)

A legendary Chinese character putatively of the Song period (960—1279), Jurōjin (Chinese: Shou Laoren) is revered in Japan as one of the *Shichi-fukujin*, or Seven Gods of Happiness and Good Fortune. As an auspicious subject signifying long life, he has long been shown in paintings, often with a congratulatory connotation. He is usually represented under a great pine tree as a white-haired and bearded old man, carrying a tall staff and accompanied by a deer—all symbols of the blessing of longevity.

The artist of this triptych, Kanō Tan'yū (1602—1674), is one of the foremost artists of the Edo period. From his position as the leading official painter to the Tokugawa shogunate (*goyō-eshi*), he dominated the field of painting during his lifetime.

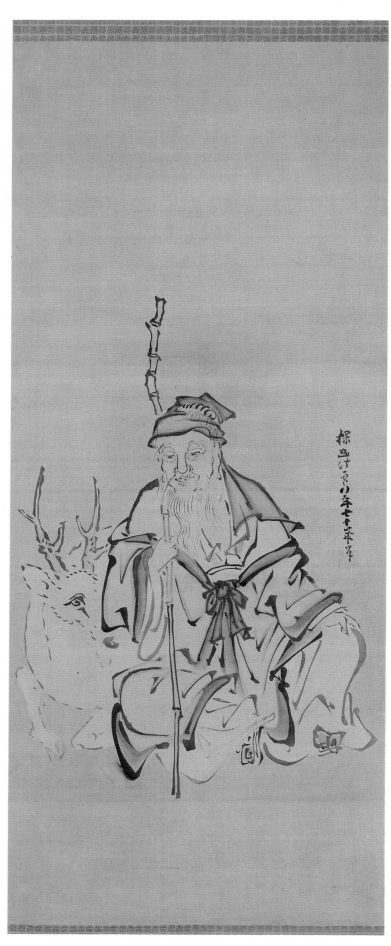

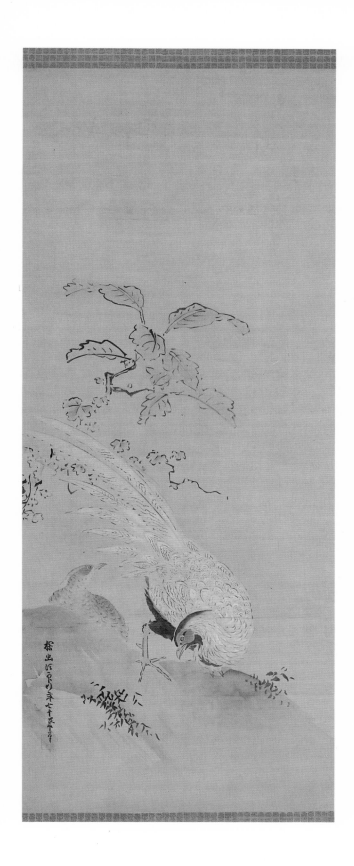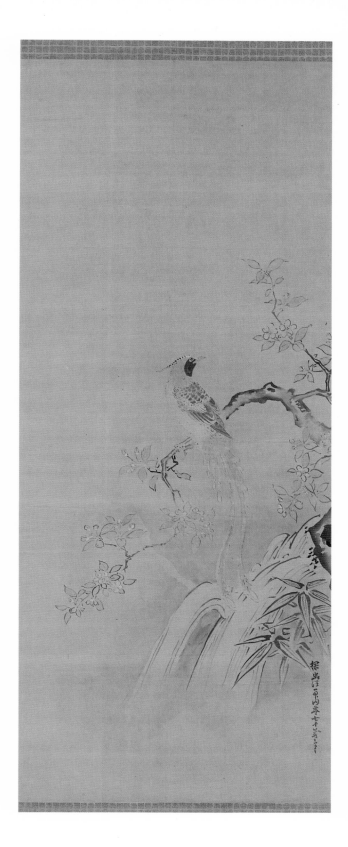

68. SHŌKI, THE DEMON-QUELLER, AND DRAGONS IN BILLOWING WAVES

Kanō Tsunenobu
3 hanging scrolls (triptych), ink and light colors
on paper;
113.0 × 51.2cm. each
Edo period, 17th-18th century

Shōki (Chinese: Zhong kuei) is a
Chinese deity who routs demons and
malignant spirits and drives away
pestilence and plague, which accounts for
the frightful appearance of his painted
image in the form of a truculent Chinese
warrior. According to one legend, the Tang
emperor, Xuanzong (r. 712—756; also
called Ming huang), was suffering from a
fever and in a dream saw Shōki
subjugating and destroying fiends. When
he awakened, the fever had left him.
Thereupon, recounts the tale, the emperor
ordered a court painter to draw the figure
of Shōki as he had appeared in his dream.
Traditionally, this painting, brushed by Wu
Daozi, is said to be the "original" depiction
of Shōki. Wu Daozi is famous as the
originator of the traditional art of
monochrome ink painting.

In Japan, together with his role as a god
who controls and stamps out epidemics
and pestilence, Shōki has been painted as
a symbol of military power. This triptych
was executed by Kanō Tsunenobu
(1636—1713), an official painter in the
employ of the Tokugawa shogun
(goyō-eshi), and a leading artist of the late
17th and early 18th centuries.

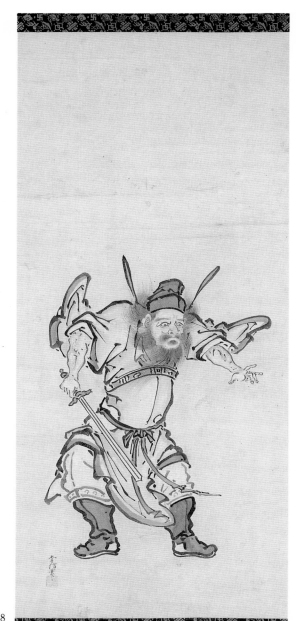

68

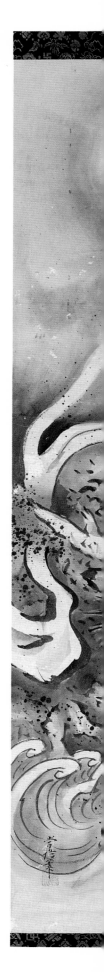

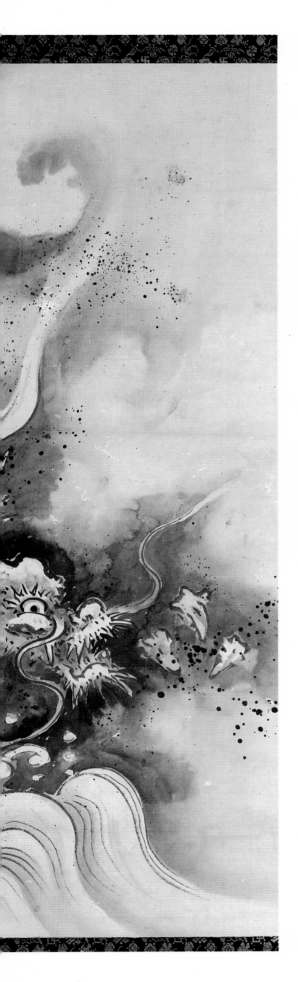
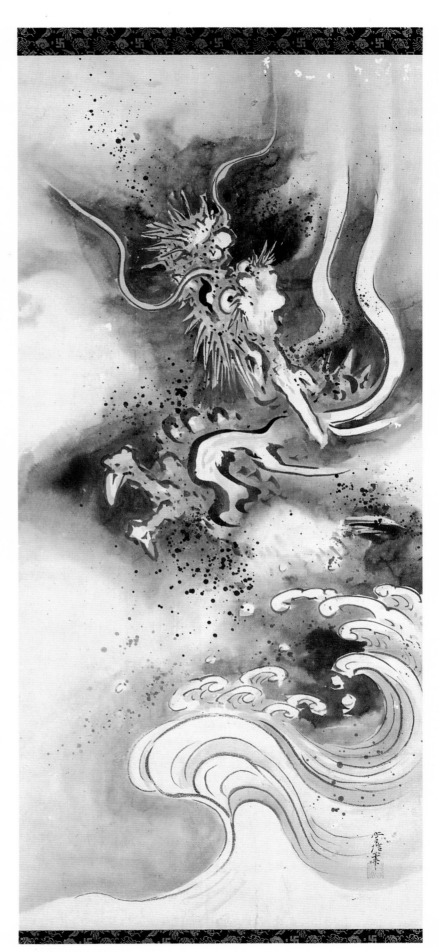

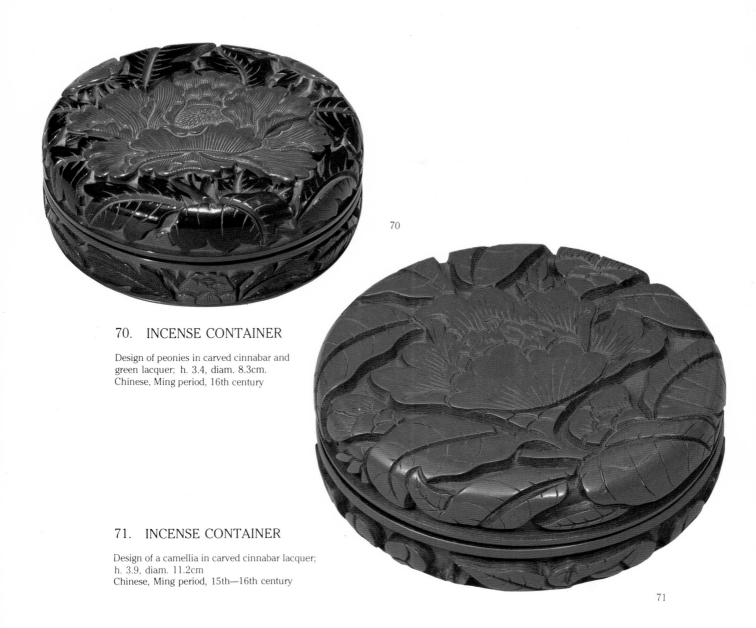

70

70. INCENSE CONTAINER

Design of peonies in carved cinnabar and green lacquer; h. 3.4, diam. 8.3cm.
Chinese, Ming period, 16th century

71. INCENSE CONTAINER

Design of a camellia in carved cinnabar lacquer; h. 3.9, diam. 11.2cm
Chinese, Ming period, 15th—16th century

71

These utensils were placed before the hanging scrolls, numbering either three or five, that filled the *tokonoma* alcove in the formal reception room of the residences of the shogun and daimyo. Flowers, incense, and candles are the three basic offerings placed before Buddhist altars, and the adoption of this religious format served to impart dignity to the paintings displayed in this manner.

Numerous rules governed the size and varieties of flowers that were arranged in the vases thus displayed, for the status and character of the master of the residence was expressed in the shape and composition of these flowers. The traditional Japanese art of flower arrangement (*ikebana*) traces its origins to the practice of devising floral compositions in this manner.

The incense used in the incense burners was stored in containers such as those seen in numbers 70 through 72. All are circular with flush-fitting lids and are executed in deep relief-carved lacquer, whose specific nomenclature derives from the color of the lacquer used. Numbers 71 and 72 are called *tsuishu* (literally, "piled-up cinnabar"), while number 70 is known as *kōka-ryokuyō* ("red flowers, green leaves"), because these two colors of lacquer were used to differentiate the blossom from the foliage. Carved lacquer developed in China during the Song and Yuan periods, and objects made by these techniques were extremely popular in Japan among tea ceremony practitioners.

104

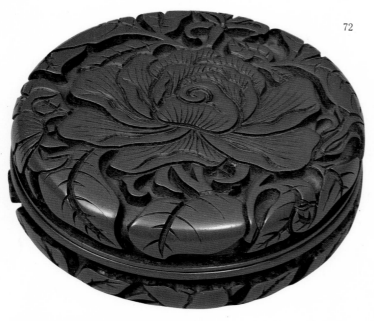

72. INCENSE CONTAINER

Design of peonies in carved cinnabar lacquer;
h. 3.9, diam. 9.8cm.
Chinese, Ming period, 15th-16th century

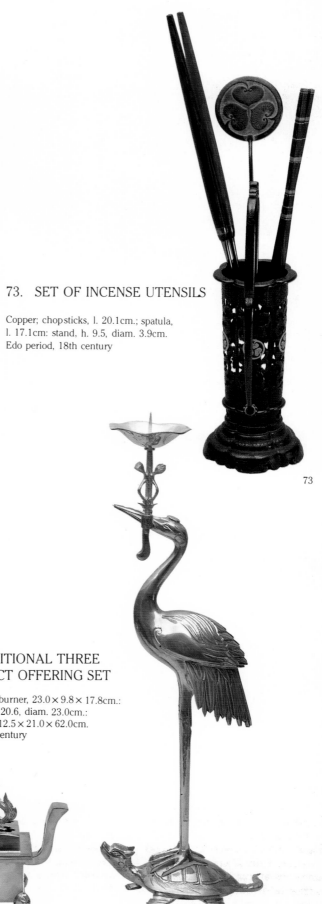

73. SET OF INCENSE UTENSILS

Copper; chopsticks, l. 20.1cm.; spatula,
l. 17.1cm: stand, h. 9.5, diam. 3.9cm.
Edo period, 18th century

73

69. TRADITIONAL THREE OBJECT OFFERING SET

Brass; incense burner, 23.0 × 9.8 × 17.8cm.:
flower vase, h. 20.6, diam. 23.0cm.:
candle holder, 12.5 × 21.0 × 62.0cm.
Modern, 20th century

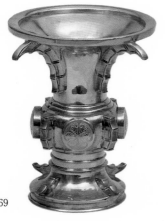

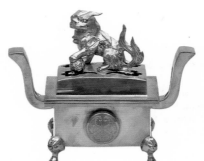

69

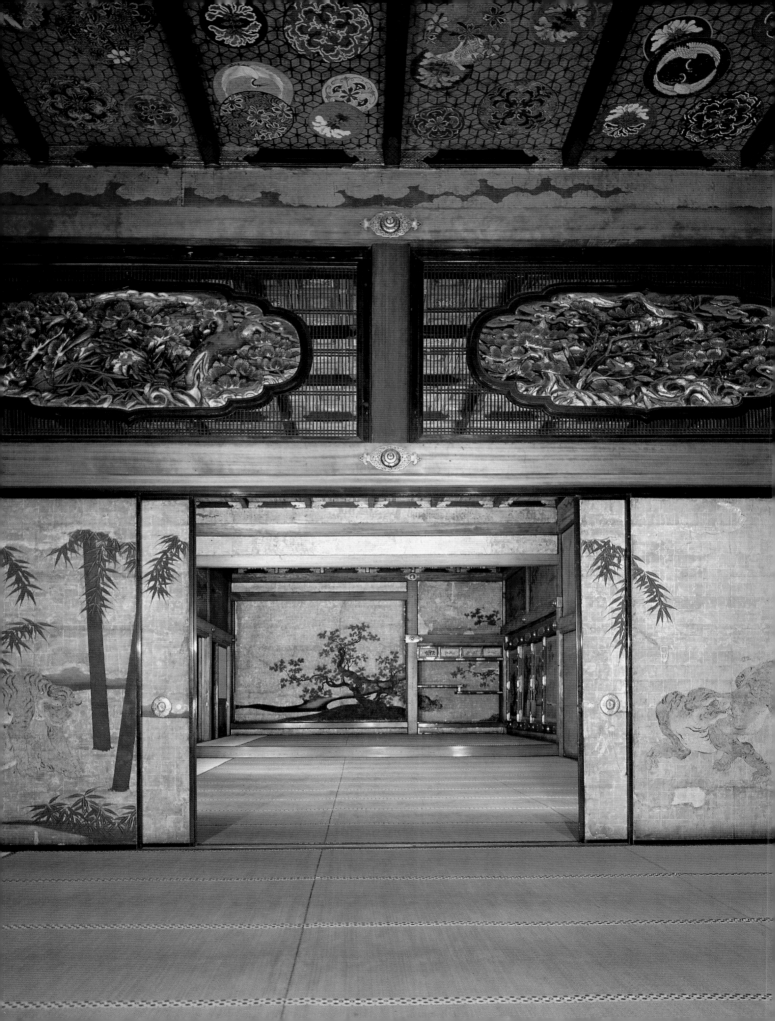

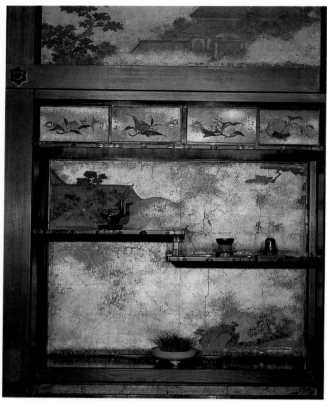

Objects included in this section shown displayed on the staggered shelves of the Shiroshoin of Nishi Hongan-ji.

75. INCENSE BURNER IN THE SHAPE OF A DUCK

Bronze, h. 24.5, w. 20.3cm.
Chinese, Ming period, 14th-15th century

Large numbers of Chinese animal-shaped incense burners were imported into Japan during the Muromachi period. These were indispensable as ornamentation for the reception rooms of a daimyo's residence. These incense burners were not merely for display, however, for the incense emanating from the burner lent the rooms a more sumptuous and dignified atmosphere.

This incense burner is made in the form of a duck, and is placed on a stand cast with a pattern of swirling waves. The body of the duck serves as the burning chamber, and the smoke and fragrance emanate from the bill. This example ranks among the finest of the incense burners of this type imported into Japan.

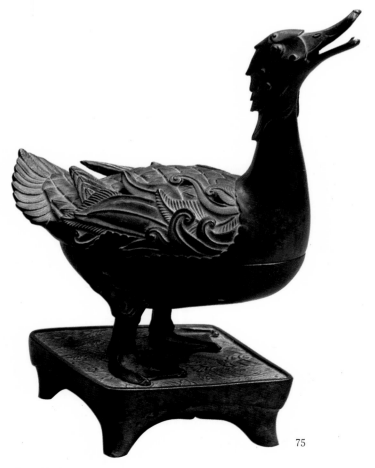

75

Location of the *tokonoma* and staggered shelves in the Imperial Messenger's Chamber of Nijō Castle.

76. TEA BOWL

Kensan Temmoku with hare's-fur effect;
h. 6.6, diam. 12.1cm.
Chinese, Southern Song period, 12th-13th century

The practice of drinking powdered green tea whipped in boiling water became prevalent in China during the Song period. Jian ware tea bowls (called *kensan* in Japan) came to be considered the most suitable for drinking tea in this manner. The term *kensan* is the Japanese transliteration for the Chinese characters meaning "small, shallow bowl from Jian," indicating ware produced at the Jian kilns in the Chinese province, Fujian.

When this method of drinking powdered green tea was introduced into Japan, *kensan* bowls were imported in large quantities for use as tea bowls. At the same time, certain bowls considered to be superior in quality were selected from among those imported, which came to be viewed not simply as ordinary tea bowls, but as treasured objects. The selection of such bowls was made on the basis of their form and the quality of the glaze, with particular consideration given to the mottled glaze effect. Generally categorized as *Temmoku* in Japan, these lustrous black-glazed stoneware bowls derive their name from the Tian-mu mountains in Zhejiang province in China, which is supposed to have been the source of the first such bowl brought back to Japan by a Buddhist monk during the Kamakura period.

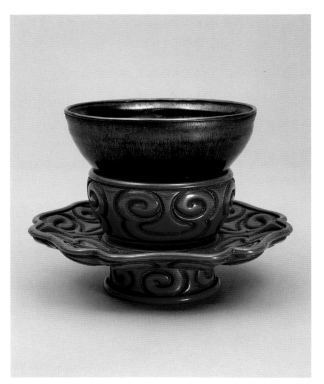

76 and 77

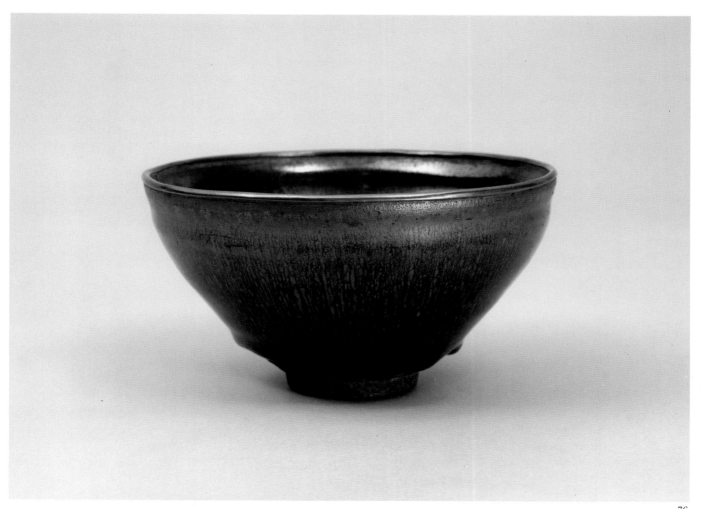

76

77. STAND FOR *TEMMOKU* TEA BOWL

Design of *guri* spirals in carved cinnabar lacquer; h. 8.2, diam. 16.8 cm.
Chinese, Ming period, 15-16th century

78. STAND FOR *TEMMOKU* TEA BOWL

Carved inscription: *Yang Mao zao* (Made by Yang Mao)
Design of chrysanthemums and peonies in carved cinnabar lacquer: h. 6.8, diam. 15.9 cm.
Chinese, Ming period, 15th-16th century

79. STAND FOR *TEMMOKU* TEA BOWL

Design of peonies and gardenias in carved cinnabar and green lacquer; h. 7.9, diam. 16.1cm.
Chinese, Ming period, 16th century

Tea-bowl stands are usually made of wood coated with lacquer and ornamented, primarily with carved designs *(chōshitsu)* or inlaid mother-of-pearl. The many carved lacquer techniques consist of applying numerous layers of lacquer, sometimes of different colors, such as black, red, yellow, and green, to a thickness of three to seven millimeters, and carving a design into the lacquer at an angle to expose the different layers.

These three stands are examples of different carved lacquer techniques: number 77 exhibits a spiral pattern *(guri)* consisting of stylized swirls of water or clouds executed in carved red lacquer; number 78 bears a chrysanthemum and peony design in carved red lacquer; and number 79 displays a design of peonies and gardenias, with the blossoms in red lacquer and the surrounding foliage in green lacquer. Number 78 is inscribed with the name "Yang Mao," a leading Chinese carved-lacquer craftsman of the thirteenth century during the Yuan period. It is believed that the stand is the work of a fifteenth century Ming artisan, who inscribed the piece with the name of his illustrious predecessor in homage to the excellence of early carved lacquer.

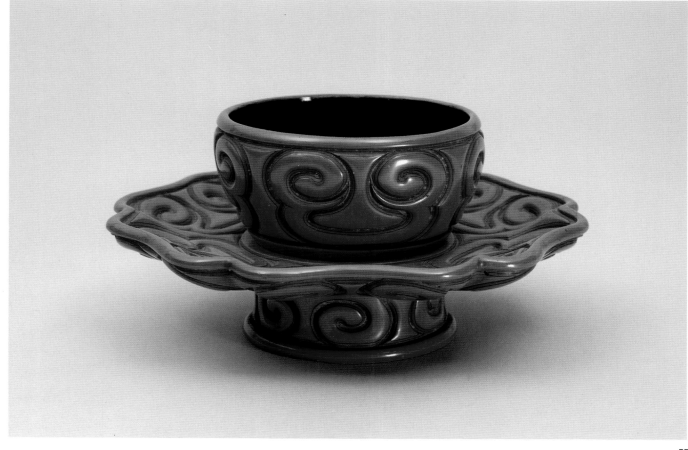

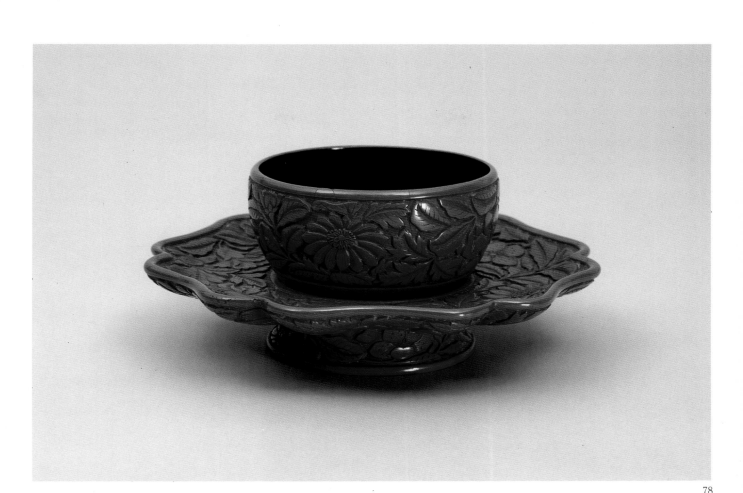

78

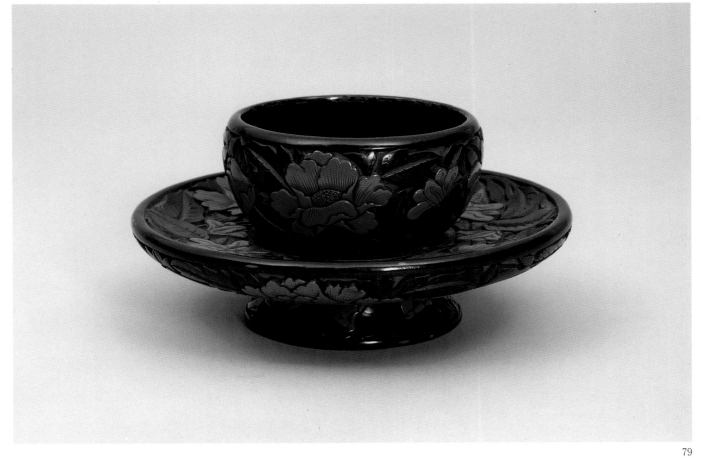

79

80. TEA CADDY, NAMED "HON'AMI"

Seto ware; h. 12.5, diam. 4.3 cm.
Muromachi period, 15th-16th century

This ceramic tea caddy or *cha-ire* serves as a container for the powdered tea used in the tea ceremony. It is provided with an ivory lid and is classified as a *kata-tsuki*, or square-shouldered type. The tea caddy was long considered to be among the most important utensils for the tea ceremony. It was even believed that certain exceptional pieces were as valuable as an entire province.

The name of this tea caddy, "Hon'ami," originates with the Hon'ami family, who were known as influential sword connoisseurs. Hon'ami Kōetsu (1558—1637), a man of the same family name who lived during the Momoyama period when the tea ceremony was flourishing, is well known not only as the most cultivated individual of his day, but also as an avid devotee of the tea ceremony.

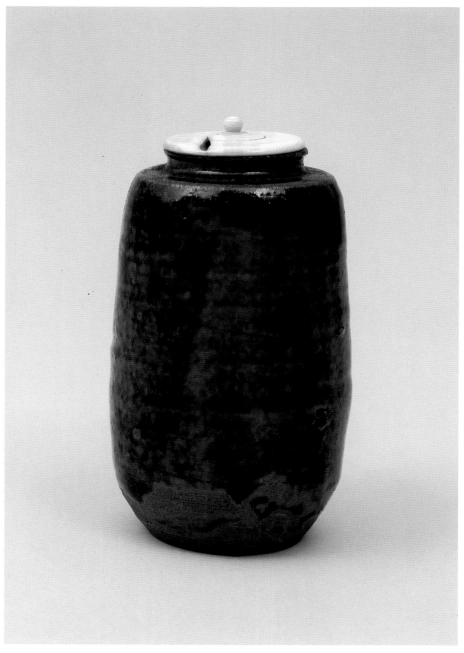

80

81. TRAY

Cinnabar lacquer; 19.7 × 19.7 × 1.8cm.
Chinese, Ming period, 16th century

82. TRAY

Cinnabar lacquer; 18.6 × 18.6 × 2.4cm.
Chinese, Ming period, 16th century

83. TRAY

Cinnabar lacquer; 20.9 × 20.9 × 2.1cm.
Chinese, Ming period, 16th century

These are square trays for displaying tea caddies *(cha-ire)*, small lacquer or ceramic jars for holding powdered tea used in the tea ceremony. Each tray is made of wood and coated with cinnabar lacquer on the obverse and black lacquer on the reverse. Because of the simplicity of their shape and decoration, the value of lacquer as a decorative technique can be appreciated in trays such as these: the luster, smoothness of surface, and richness of color. Similarly, the shapes of these trays take on a greater significance; subtleties in height, the angles at which the borders join the base, and the outlines of the rim here command one's full attention.

84. BOWL

Celadon with design of Eight Divinatory Diagrams and embossed peony motif, h.9.5, diam. 32.4 cm.
Chinese, Ming period, 14th-15th century

This three-footed celadon bowl was produced at the Longquan kilns in China. The outer surface is decorated with the Eight Divinatory Diagrams (*Ba gua*), representing natural and cosmic forces whose interaction is said to have formed and sustained the universe. A peony-shaped pattern is embossed on the unglazed portion of the inner surface, and the feet are shaped like the heads of mythical animals.

In Japan, *sekishō* or sweet rush, a kind of grass that was thought to help eliminate the oily smoke of candles, was placed in such bowls which were then used as part of the decor of reception rooms.

81

82

83

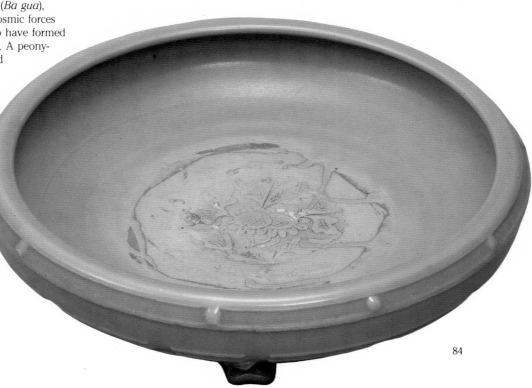

84

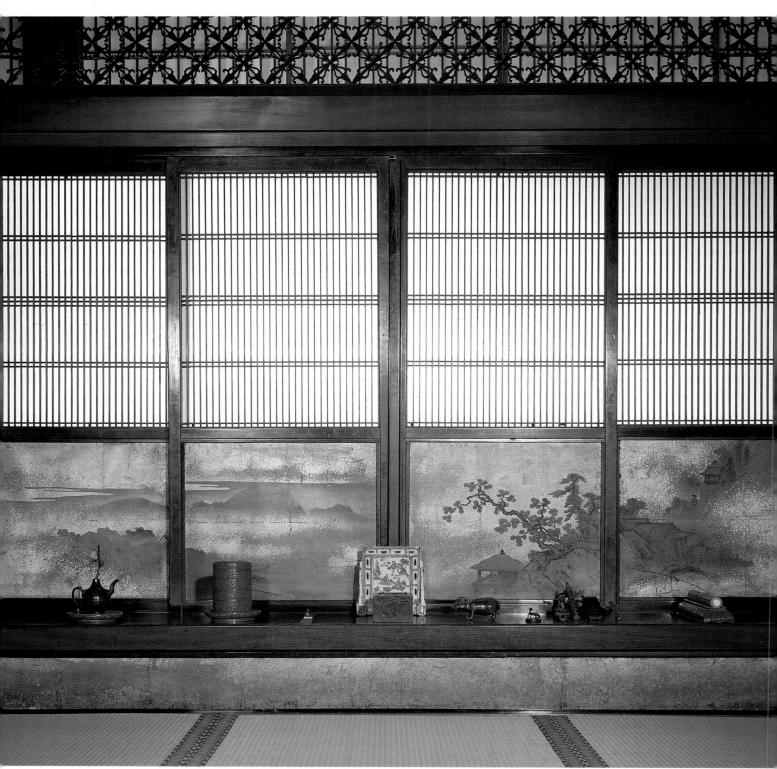

Writing alcove of the Shiroshoin of Nishi Hongan-ji ornamented with objects in this section.

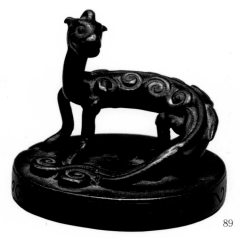

89

89. PAPERWEIGHT IN THE SHAPE OF A DRAGON

Bronze; h. 4.4 diam. 4.8cm.
Chinese, Ming period, 16th century

Paperweights produced in China were made either of metals such as bronze and iron, or of ceramic, stone, or other materials. This bronze paperweight is made in the form of the ancient mythical beast, the dragon, coiled to conform to the shape of the round base.

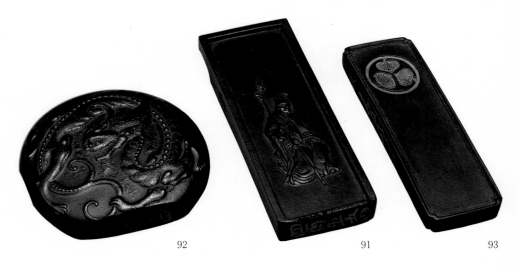

92 91 93

91. INK STICK

Inscribed: *Wu Shenbo zhi* (Produced by Wu Shenbo)
Design of seated figure; 4.6 × 1.5 × 12.7cm.
Chinese, Ming period, 16th-17th century

92. INK STICK

Inscribed: *Cheng Junfang*
Design of a dragon; h. 2.0, diam. 9.0cm.
Chinese, Ming period, 16th-17th century

93. INK STICK

Design of an *aoi* crest; 3.8 × 1.0 × 12.1cm.
Edo period, 18th century

Ink was made by first burning vegetable oil or pine resin, which yielded a high grade of soot that was then mixed thoroughly with glue and aromatics. This mixture was put into a mold, which often bore one of a great variety of designs or Chinese characters. Chinese ink sticks were not merely utilitarian objects whose sole function was the production of liquid ink for writing. The sticks themselves with the various designs and characters that enlivened their surfaces were appreciated and collected as objects of considerable aesthetic value. Consequently, ink stick makers devoted much time and attention to the creation of designs and the carving of their molds. The names of the craftsmen of two of the ink sticks shown here are known to us. Number 91 with a design of a seated sage holding a staff was produced by Wu Shenbo, while Cheng Junfang produced the rounded dragon ink stick in number 92. Both were leading ink stick craftsmen of the late Ming period.

Number 93 was a Chinese ink stick that was reshaped in Japan where the *aoi* crest of the Tokugawa family was applied as its decoration.

97. BRUSH STAND IN THE SHAPE OF A DRAGON

Bronze, 6.0 × 21.8 × 8.9cm.
Chinese, Ming period, 16th century

This bronze object modelled in the shape of a dragon turning back its head serves as a brush stand. Such stands are usually made of metals, stone, or ceramic, and are shaped either like animals or a series of mountains. Of these types, the dragon-shaped brush stands were used by men of rank, for in China the dragon was honored as the most sacred of imaginary animals.

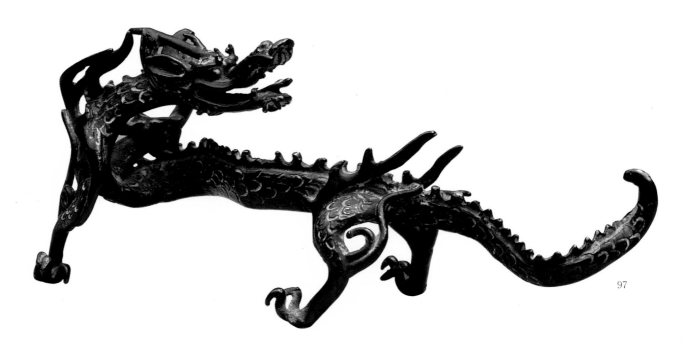

97

94. DECORATIVE INK BRUSH AND CAP

Inscribed: *Da Ming Wan-li nian zhi* (Produced during the Wan-li era of Great Ming)
Design of dragons in gold leaf on a black lacquer ground; l. 24.5cm.
Chinese, Ming period, Wan-li era (1573—1615)

95. DECORATIVE INK BRUSH AND CAP

Design of plum blossoms in carved cinnabar and green lacquer; l. 27.3 cm.
Chinese, Ming period, 16th century

96. DECORATIVE INK BRUSH AND CAP

Design of dragons amid clouds in carved cinnabar lacquer; l. 26.2cm.
Chinese, Ming period, 16th century

Writing brushes for actual use had a tightly-bound tuft of animal hair inserted into the tip of a slender tube of bamboo. In contrast to the rather plain, strictly utilitarian brushes, there were highly decorative ones made expressly to ornament a gentleman's study. Carved ivory or porcelain techniques including *aka-e* (overglaze red or other colors) and *sometsuke* (underglaze blue) were used in creating the handles of decorative brushes, and the full range of decorative lacquer techniques was also employed to produce sumptuous brushes.

In number 94, dragons writhing amid surging waves, crags, and small tufts of scudding clouds are depicted in gold leaf on a black lacquer ground. The same technique is used for the inscription in the cartouche at the base of this brush, which

reads in translation: "Produced during the Wan-li era of Great Ming" (from 1573 to 1615).

Number 95 bears a design of blossoming plum branches carved in deep relief in cinnabar and green lacquer.

Number 96 is decorated with a design of dragons among clouds in carved cinnabar lacquer. All three brushes have been provided with matching caps which are functional as well as decorative.

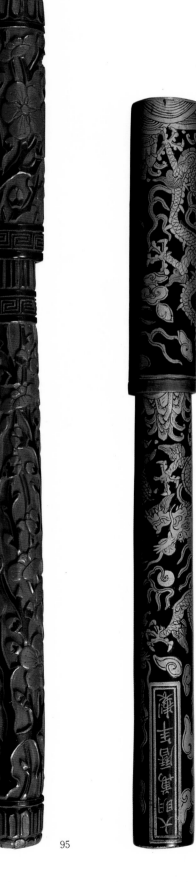

96 95 94 117

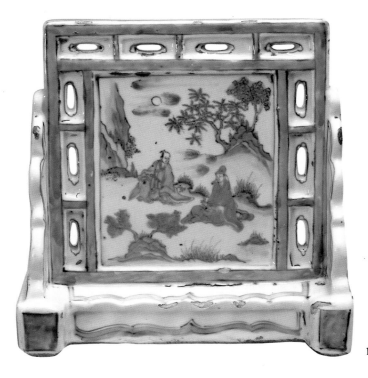

100

100. INKSTONE SCREEN

Design of two figures gazing at the moon in underglaze blue porcelain; 9.8 × 22.2 × 22.5cm. Chinese, Ming period, 17th century

This screen was meant to be placed at the upper edge of an inkstone to prevent dust or other extraneous matter from entering the inkstone and sullying the ink. A wide variety of materials including metal, wood, lacquer, and ceramic was used in the production of Chinese inkstone screens with the full range of decorative techniques employed to enliven them. This particular screen is made of underglaze blue porcelain with a design of two bibulous scholars reciting verses outdoors by the light of the full moon.

99. INKSTONE

Design of grazing horses in carved shale; 21.4 × 12.0 × 8.4 cm. Chinese, Song period, 13th century

The inkstone (*suzuri*) is used for making and storing liquid ink. After pouring a small amount of water into the depression of the stone, the ink stick is rubbed along the stone's abrasive surface while being mixed with water. The inkstone is the most important of the stationery tools found in the study, and of the so-called "four treasures" used in writing (paper, ink, brush, and inkstone), the inkstone is the most valued because of its permanence.

Inkstones are made of a variety of hard materials such as porcelain, metal, tile, or stone. The most common material, however, is shale, especially the *she* stone from Anhui Province and *duan* stone from Guangdong Province, both in China. Furthermore, the quality of these stones is determined by the texture and pattern of the stratification of the rock crag from which it was cut. Chinese poems extolling the qualities of superior inkstones are carved in intaglio along the upper rim of this stone, while a scene of eight horses frolicking beneath trees in an open meadow is carved in relief along the sides of the stone.

99

98. WATER DROPPER IN THE SHAPE OF A COMPOSITE BEAST

Bronze, 16.3 × 7.6 × 7.3cm.
Chinese, Ming period, 16th century

A water dropper was used to hold water needed when grinding an ink stick to produce liquid ink. Chinese Ming period water droppers made of bronze are frequently modelled in the shape of birds or animals. In Japan, the type of water dropper represented by this example has long been identified as a "water buffalo." The actual shape of this water dropper, however, reflects that of the zoomorphic *zun*, an ancient Chinese ritual bronze vessel.

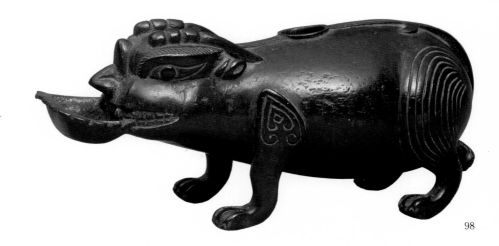

98

119

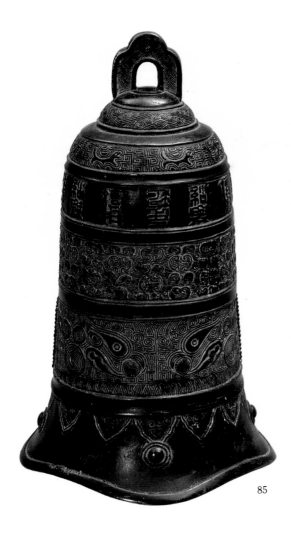

85. SUMMONING BELL WITH MALLET

Bell: bronze, h. 23.1, diam. 13.4 cm.
Mallet: wood, 83.5 × 12.3cm.
Chinese, Ming period, 15th century

Originally these bells were used by the master of the house when sequestered in his study to summon an attendant. Later, however, these bells served as ornamentation for the formalized study. Unlike western bells, Chinese bells are sounded by striking a wooden mallet on the exterior, The shape of this bell originates in ancient Chinese ritual bells, and on its surface are cast *tao-tie* masks and Chinese characters.

90. PAPER KNIFE

Design of hare's-foot ferns in gold *maki-e* on a plain wood ground; l. 19.2cm.
Edo period, 18th century

A paper knife was an essential instrument to be placed on the desk in the study. The mounting of this knife is of a type that was popular in Japan about 1,300 years ago during the Nara period. The sheath and handle of the knife are made of rosewood upon which a design of hare's-foot ferns is applied in gold using the technique of *kiji-maki-e*.

85

90

101

101. PAPERWEIGHT

Design of stylized spirals in cloisonne on brass; 3.3 × 35.9 × 3.1cm.
Chinese, Ming period, 15th century

This implement was used both as a ruler for drawing straight lines and as a paperweight. Paperweights were a very necessary part of the tools needed when writing with a brush. Besides holding the paper still while the actual writing was in progress, paperweights also kept the paper flat and secure while it dried.

The technique of cloisonne (Japanese:

shippō) is used to decorate this piece. Briefly stated, this technique involves the filling of numerous cavities on a metal plate (usually gold, silver, copper, or brass) with transparent or opaque varicolored enamel glazes, which is then baked at high temperatures. This paperweight was imported from China where the technique had been known since the Han period

(2nd century B.C.—2nd century A.D.). Cloisonne achieved its highest level of development in China during the Jing-tai reign era (1450—1457) of the Ming period, and this object was made according to the techniques perfected at that time. The knob is in the shape of a little seated Chinese boy.

87

87. HANDSCROLL TRAY

Design of birds and flowers in gold foil on
cinnabar lacquered wood with bamboo;
35.0 × 14.4 × 4.5cm.
Chinese, Ming period, 16th century

86. HANDSCROLL TRAY

Design of *guri* spirals in carved black lacquer;
33.3 × 4.3 × 1.1cm.
Chinese, Ming period, 15th century

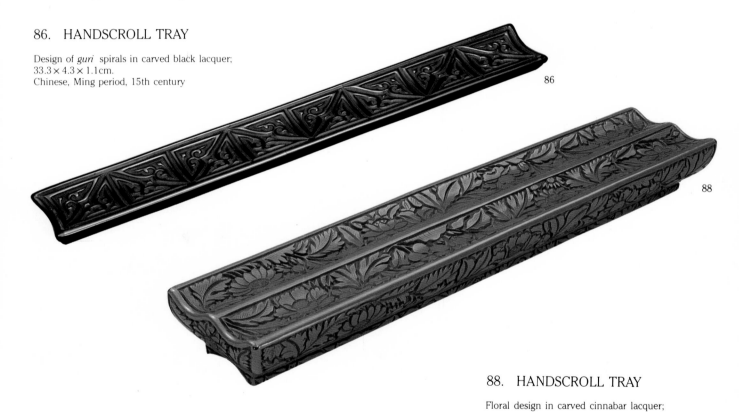

86

88

88. HANDSCROLL TRAY

Floral design in carved cinnabar lacquer;
47.0 × 9.0 × 5.0cm.
Chinese, Ming period, 15th century

In both China and Japan, the cal-
ligraphy and paintings of historically
significant figures were highly revered.
These works were not merely prized as art
objects or antiquities but were regarded as
valuable objects that gave later generations
insight into the personal qualities of these
illustrious figures and the nature of their
times. They were further employed as
models of painting and calligraphy for
others to emulate. Thus these works were

often made into handscrolls, and at times
used to decorate the interior of a room.
When used as ornamentation, these scrolls
were placed on trays such as those seen
here, and arranged on a shelf or stand.

The tray in number 86 is decorated with
guri spirals representing stylized water or
clouds carved in low relief on a black
lacquer surface (*tsuikoku*). Number 87 has
a flat bottom coated with red lacquer upon
which very thin gold foil was applied to

produce a design of birds and flowers.
Attached to the perimeter of this board are
delicately woven bamboo borders fitted
into curved black lacquer rims. The deeply
carved floral pattern of number 88 has
been executed in carved cinnabar lacquer
(*tsuishu*), and this tray has been devised to
accommodate either one or two scrolls,
depending upon which side faces upward.

121

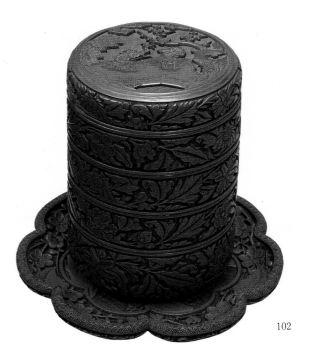

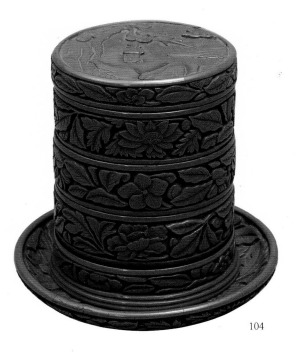

102

104

102. TIERED SEAL BOX AND TRAY

Seal box: design of scholars viewing plum blossoms in carved cinnabar lacquer; h. 17.3, diam. 11.9 cm.
Tray: design of scholars playing the zither under trees in carved cinnabar lacquer; h. 3.2, diam. 18.9 cm.
Chinese, Ming period, 15th century

103. TIERED SEAL BOX AND TRAY

Seal box: design of figures among pavilions in inlaid mother-of-pearl on black lacquer; 14.0 × 14.0 × 19.1cm.
Tray: design of figures on bridge in inlaid mother-of-pearl on black lacquer; 22.2 × 22.2 × 4.7cm.
Chinese, Ming period, 16th century

104. TIERED SEAL BOX AND TRAY

Seal box: design of scholar beneath tree in carved cinnabar lacquer; h.13.4 diam, 10.0 cm.
Tray: design of peony and Chinese flowers in carved cinnabar lacquer; h. 3.0, diam. 12.0 cm.
Chinese, Ming period, 15th century

103 (tray)

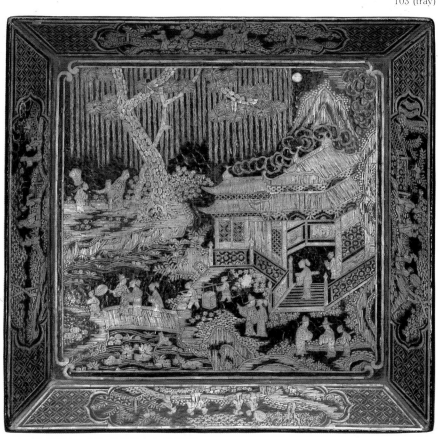

In both China and Japan, in addition to handwritten signatures, seals were used like signatures to indicate one's person. These valuable seals were stored in cases called *inrō* ("seal caddies"), which were often lacquer objects of outstanding workmanship and considerable aesthetic value. Seal cases were usually divided into three or four tiers. Each tier would house the seals, seal inks (usually red and black) and paste.

Numbers 102 and 104 are executed in carved cinnabar lacquer (*tsuishu*), while number 103 is decorated with bits of mother-of-pearl (*raden*) inlaid onto the black lacquer ground.

122

103

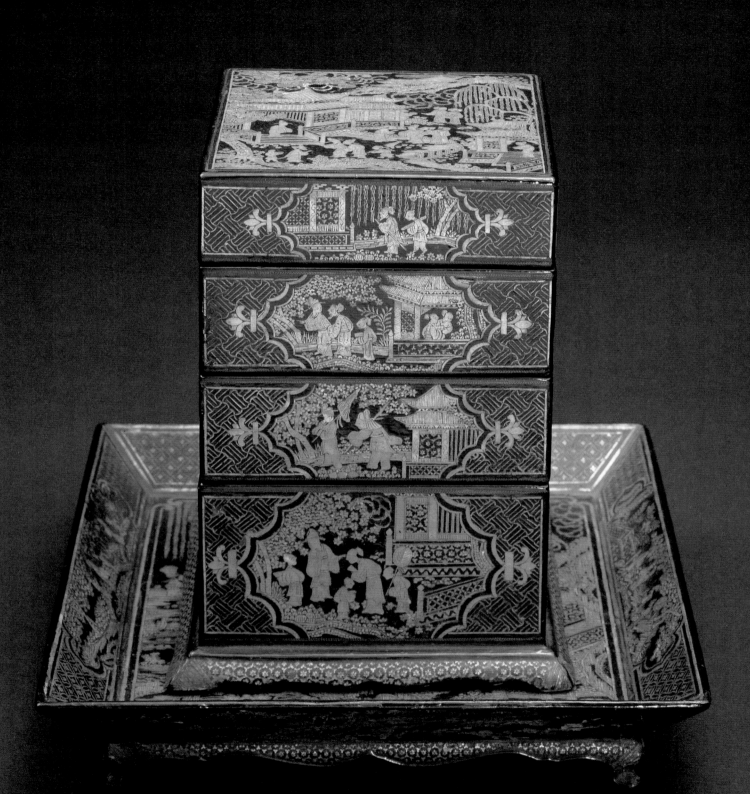

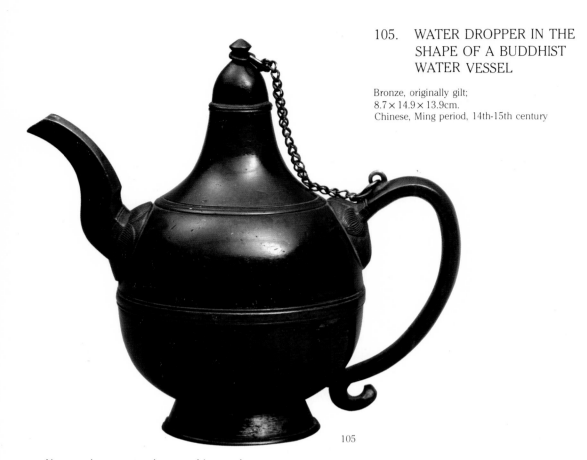

105. WATER DROPPER IN THE SHAPE OF A BUDDHIST WATER VESSEL

Bronze, originally gilt;
8.7 × 14.9 × 13.9cm.
Chinese, Ming period, 14th-15th century

105

Now used as a water dropper, this vessel derives its shape from a Buddhist water vessel of the *fusatsu* (Chinese, *bu-sa*; Sanskrit, *posadha*) type, used in Buddhist assemblies held every fifteen days to expound the precepts. Although the present vessel is provided with a handle, which is not a feature of *fusatsu* type water vessels, the tall foot, treatment of the rounded body circumscribed by a single band, and disitinctive shape of the spout with a stylized lotus at its base are all characteristics of Buddhist water vessels of this type. Bronze *fusatsu* type water vessels were widely produced in Japan during the Kamakura period, almost contemporaneous with the present Chinese early Ming vessel.

As a water dropper, this vessel was used to hold the water necessary when grinding the ink stick into liquid ink. Another of its specialized usages is as a vase to hold a single spray of flowers when formally decorating the alcove of a reception room.

Made of cast bronze, this vessel was originally gilt, but very little gilding remains today. Austere to the point of severity, the only decorative motif present is the lotus at the base of the spout and handle.

106. TRAY

Design of lotus arabesque in carved cinnabar lacquer; h. 2.4, diam. 16.8 cm.
Chinese Ming period, 15th century

106

107

107. TRAY

Design of Chinese character *shou* (long life)
surrounded by peonies in carved cinnabar and
green lacquer;
h. 2.1, diam. 20.0 cm.
Chinese, Ming period, 16th century

108

108. TRAY

Floral design in carved cinnabar
lacquer;
h. 2.9, diam. 14.8 cm.
Chinese Ming period, 15th century

These are trays upon which the water
vessel (no. 105) would be displayed. The
deliberate placing of this vessel on such
elaborate trays was intended to create the
visual impression that the water vessel was
even more exquisite than the underlying
trays. To heighten this effect, the trays
selected here are made of imported
Chinese carved lacquer of superior quality
and aesthetic value.

Number 106 bears a design of peony
blossoms and foliage deftly formalized to
create a floral arabesque. Number 107, on
the other hand, is a six-sided foliate tray
dominated by the Chinese character for
long life (*shou*), surrounded by flowers and
foliage in cinnabar and green carved
lacquer.

Number 108 displays a design of flowers
and foliage in carved cinnabar lacquer.

GARMENTS FOR OFFICIAL FUNCTIONS

In large part, the official garments worn by the shogun and daimyo were patterned after the clothing of the court nobility. Since the upper echelons of the warrior class also held court titles, their official garments were in keeping with their rank. For example, the white *nōshi* (see no. 112) was reserved for the shogun, members of the Three Tokugawa Houses, and high-ranking daimyos as formal wear intended for appearances at the imperial court, while the white *kosode* was restricted to daimyos, commissioners, and stewards. In formal wear, the *kariginu* (see no. 130) was limited to members of the Council of Elders and daimyos in control of a province; garments bearing large family crests were permitted for all daimyos; the *naga-kamishimo* (see no. 109) was allotted to samurai of middle and upper rank; and lower-ranking samurai wore *kataginu* with short trousers. Clothing was thus strictly regulated, and those who did not conform were subject to sanctions.

The official garment of the samurai of the Edo period was the *kamishimo,* with the sleeveless upper garment tucked into the lower garment, whose trouser legs were either ankle-length or longer. The longer trousers were reserved for samurai of the upper ranks, while the ankle-length ones were used for the daily official wear of lower-ranking samurai. Worn by a samurai while performing official duties and while paying informal visits or receiving guests informally, this garment was not permitted for use by farmers, artisans, or tradesmen. When donning a *kamishimo,* an undergarment and inner garment were worn under the two pieces of the outer garment and tied with a sash, and the outfit was completed by the addition of a folding fan, folded tissue paper, and a pair of swords. Headgear was not included, and the samurai went bare-headed when clothed in this manner. In the first half of the Edo period, the color of this type of garment was not regulated, but from the middle of the period onward, indigo, deep brown, and light brown hemp cloth *kamishimo* adorned with small white family crests were most commonly worn.

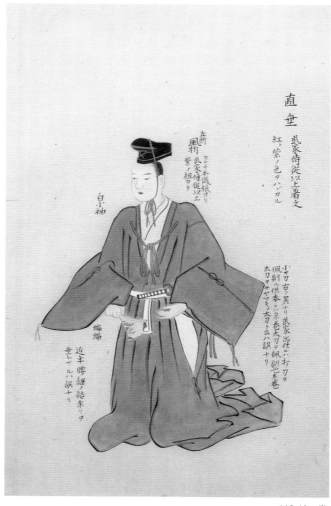

113 (detail)

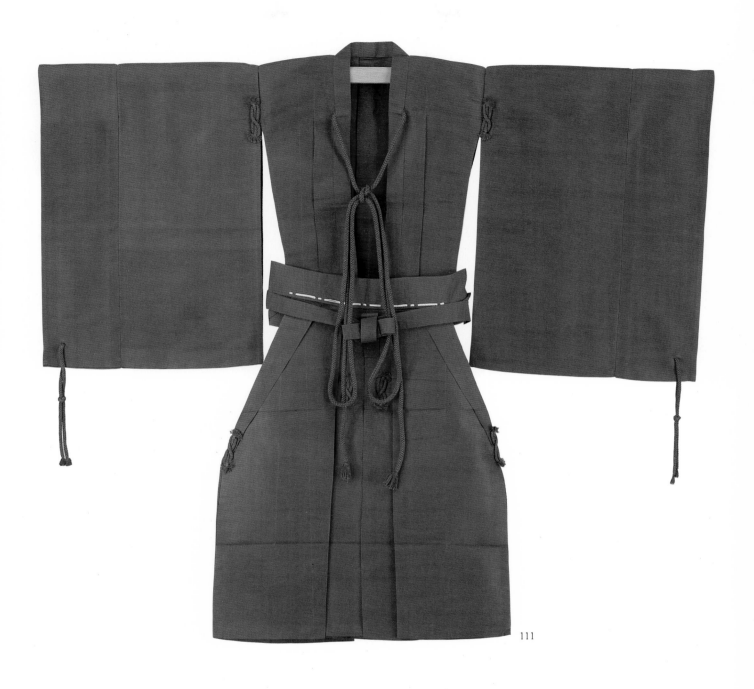

111

111. *HITATARE*

Formal wear of heavy plain-weave purple silk;
upper garment, 70.6 × 147.2cm.;trousers, l. 78.7cm.
Edo period, 19th century

This is an example of the formal wear
reserved for the highest echelons of the
warrior class such as the shogun or
influential daimyo. While number 109, the
kamishimo, was considered abbreviated
formal dress for personages of rank, the
hitatare was the formal garment for
ceremonial occasions.

For the sake of creating a sumptuous
effect, the sleeves of the upper garment are
narrow and it was worn with a cord
attached at the chest looped across the front.
The lower garment is a *hakama* (trousers).
Both the upper and lower portions of the
garment are of heavy silk. A *noshime,*
such as number 110, would be worn under
the *hitatare.*
Tokugawa Yoshikatsu is said to have
worn this garment.

110. *NOSHIME*

Inner robe with a splash-pattern (*kasuri*) dyed design of well cribs decorating a horizontal band, and *aoi* crests on a dark blue silk ground; 129.0 × 120.2cm.
Edo period, 19th century

This garment is one of the components of the formal wear of the warrior class and would be worn as the inner robe with a *kamishimo* (no. 109) or *hitatare* (no. 111). It might be compared to a dress shirt worn with a tuxedo or morning coat in Western society.

The fabric is dark blue plain-weave silk, with the band below the sleeves at the waist bearing a *kasuri* (splash-pattern) design of well cribs, or parallel crosses on a white ground.

This *noshime* was worn by Tokugawa Yoshikatsu.

112. *NŌSHI*

Jacket with a float-weave design of chrysan-themum medallions on a white twill ground; 104.0 × 215.0cm.
Edo period, 19th century

The *nōshi* was designated men's formal wear for the emperor and upper class nobles in the 11th century, and later aristocracy followed that tradition. Retainers, who were members of the warrior class, were not allowed to wear this costume when serving at court without the special permission of the emperor. In the Edo period, however,

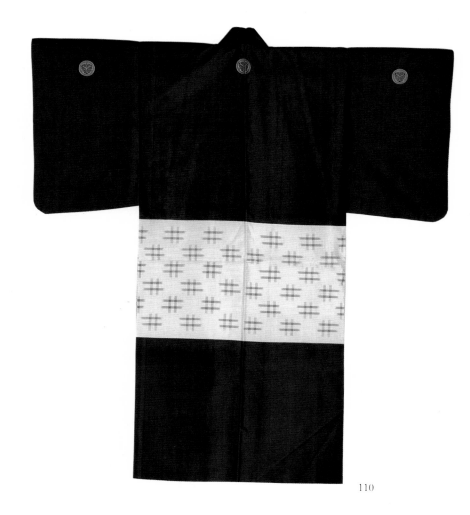

110

the shogun or influential daimyo also assumed elevated court ranks and were permitted to wear the *nōshi* when participating in traditional court rituals or ceremonies.

Depending on the age and status of the wearer, and the season, there were subtle and complex regulations as to the color and type of fabric which might be worn. This *nōshi* is a winter costume for a mature man, and the fabric used is a white twill ground with the weft threads floated to create a motif of chrysanthemum medallions. This garment was worn by Tokugawa Yoshikatsu.

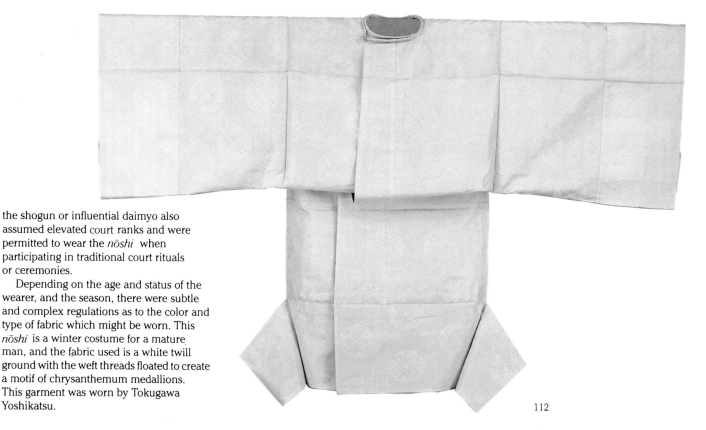

112

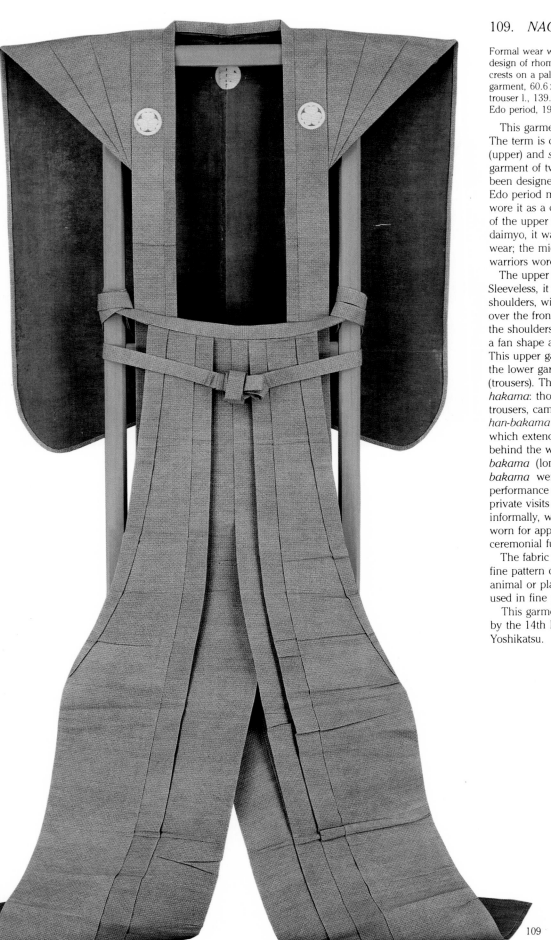

109. NAGA-KAMISHIMO

Formal wear with a dyed fine pattern (ko-mon)
design of rhombus shapes, decorated with aoi
crests on a pale blue hemp (asa) ground; upper
garment, 60.6 × 75.2cm.
trouser l., 139.4 cm.
Edo period, 19th century

This garment is called a kamishimo.
The term is derived from the words kami
(upper) and shimo (lower) and describes a
garment of two such parts which have
been designed to be worn together. In the
Edo period members of the warrior class
wore it as a ceremonial garment. For those
of the upper ranks, such as the shogun or
daimyo, it was worn as simplified formal
wear; the middle and lower ranking
warriors wore it as their full-dress costume.

The upper garment is called a kataginu.
Sleeveless, it is worn draped over the
shoulders, with narrow panels coming
over the front of the body, while toward
the shoulders the garment opens out into
a fan shape and hangs down the back.
This upper garment is worn tucked into
the lower garment called a hakama
(trousers). There were two types of
hakama: those which, like modern
trousers, came to the ankles were called
han-bakama (half-trousers); and those
which extended beyond the feet to trail
behind the wearer were called naga-
bakama (long trousers). The han-
bakama were used during the
performance of daily official duties, such as
private visits or the receiving of guests
informally, while the naga-bakama were
worn for appearances at important
ceremonial functions.

The fabric is a rough hemp dyed in a
fine pattern of rhombus shapes. Felicitous
animal or plant designs were most often
used in fine patterns.

This garment is said to have been worn
by the 14th lord of Owari, Tokugawa
Yoshikatsu.

109

113. ILLUSTRATIONS OF PROPER DRESS FOR A SAMURAI FAMILY

Two volumes; 38.4 × 25.2cm.; 37.8 × 25.2cm.
Edo period, 18th-19th century

As well as controlling the warrior class, the shogun and daimyo were retainers of the emperor, who remained at the apex of the ancient institution of the aristocratic court. Thus they preserved the traditional culture of the nobility and the court at the same time that they developed and maintained their own culture. To this end there were functions and ceremonies at the public level for both groups, which were kept strictly separate, each having its own meticulous rules of manners and of dress. These were subtle regulations which governed what might be worn according to a warrior's age, birth, rank, and the season. These two volumes contain illustrations of the proper dress for a family of the shogun or daimyo class for different social occasions.

THE ESTATE

In addition to possessing power and authority, the shogun and daimyo were men of considerable wealth. After the death of Tokugawa Ieyasu on the seventeenth day of the fourth month of Genna second year (June 1, 1616), at the age of seventy-five, the estate remaining at Sumpu was divided among four of his sons: Hidetada, who had become the second shogun; the ninth son Yoshinao, who was the first lord of Owari; the tenth son Yorinobu, first lord of Kii; and the eleventh son Yorifusa, first lord of Mito.

Yoshinao traveled several times to Sumpu to collect his portion of the estate, which was duly recorded in two documents preserved in The Tokugawa Art Museum, the *Kunō On-kura Kin-gin Uketori-chō* and the *Sumpu On-wakemono-chō* (see no. 119). The extent of the portion of the estate recorded in these documents is staggering. Listed within are gold and silver, swords and other military equipment, tea ceremony utensils, incense utensils, Nō accoutrements, clothing, and furnishings, encompassing a wide range of categories. Even a cursory reading reveals entries such as one million gold *koban* coins, six hundred white *kosode* garments, and five hundred *kan* (about 1,800

kilograms) of cotton. Yoshinao inherited around 19,745 kilograms of gold coinage, and 320,205 kilograms of silver coins, countless articles of clothing, and huge amounts of thread and cotton.

However, ninety-nine per cent of Ieyasu's estate consisted of coinage and goods for consumption, and in the three hundred years that have passed since his death, these articles have been depleted and no longer remain today. Over half of the total number of swords, tea ceremony utensils, paintings, and calligraphy that had been highly prized at the time are still preserved in The Tokugawa Art Museum. Numbering some five hundred in all, they actually comprised only one per cent of the estate. Judging from documentary evidence and objects still in existence today, it is likely that Ieyasu's total estate had originally comprised hundreds of times the number of objects now housed in The Tokugawa Art Museum.

This present exhibition includes coinage and articles made of gold from Ieyasu's bequest, thus giving some idea of the prodigious extent of the wealth of the first shogun.

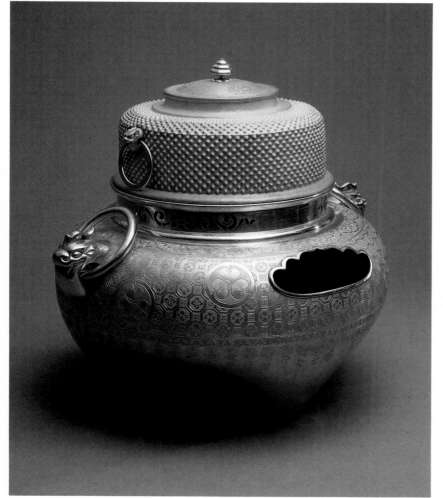

116

116. TEA KETTLE WITH BRAZIER

Gold; brazier, h. 24.6, diam. 34.5 cm.; kettle, h. 18.6, diam. 23.0 cm.
Edo period, 17th century

In the tea ceremony, according to the place, occasion, and purpose, several levels of etiquette were prescribed, such as the presentation of tea upon the arrival of an especially high-ranking personage, a tea-gathering held with a group of acquaintances, or offering tea to a close friend who happened to be visiting. In each of these cases, the varying levels of etiquette demanded different tea utensils.

These tea ceremony utensils made of pure gold were commissioned as the personal property of the first Tokugawa shogun, Ieyasu. This kettle and brazier used to boil water for tea are made of 3.15 and 7.013 kilograms of gold, respectively, and belong to a set of twelve utensils used in the special etiquette reserved for personages of high rank.

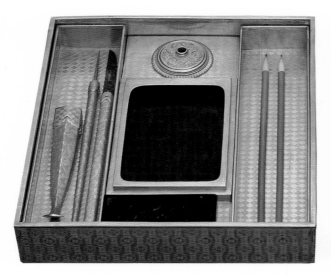

114. INKSTONE BOX

Design of *aoi* crests in gold sheet over a wooden base;
22.8 × 20.8 × 4.8cm.
Edo period, early 17th century

This is a box called a *suzuribako* (literally, "inkstone box") for the implements needed for writing with a brush. The middle section contains the water dropper, the inkstone, and the inkstick. The small removable tray (*kakego*) to the right holds two brushes, while that to the left has a paper knife, an awl for punching holes in paper, and an inkstick holder used when making ink.

The box itself has a wooden core over which is fitted gold alloy sheet. This sheet has a number of large *aoi* crests scattered upon a grid of smaller repeating propitious motifs. Apart from the sections (like the tip of the knife, the brushes, the ink stick, and the abrasive surface of the stone) where gold would be completely inappropriate, the accessories stored in this box are all made of gold alloy. Since, its contents are functional, it is thought that this box was not merely a decorative piece or impractical luxury item, but was originally produced to be actually used as a writing box. Tokugawa Ieyasu, the first shogun, is said to have commissioned this box for his personal use.

118

117. *ŌBAN* GOLD COIN OF THE KEICHŌ ERA

Gold; 14.3 × 9.0 cm.
Momoyama period, Keichō era (1596—1614)

118. *KOBAN* GOLD COIN OF THE KYŌHŌ ERA

Gold; 6.8 × 3.9 cm
Edo period, Kyōhō era (1716—1736)

In 1600, Tokugawa Ieyasu revised the currency system, which had previously been in a state of confusion as a result of decades of constant warfare, and instituted a unified system of currency based on newly minted, standardized gold and silver coins. A unified currency was a prerequisite for the establishment of a firm foundation for the Tokugawa shogunate, as well as for the well-being of the populace at large.

The newly established standard was the *ōban*, which was the world's largest gold coin, weighing a full 165 grams. This coin was much too large, however, for general commercial transactions, and was primarily used for rewards, presentations, and the storage of wealth by the shogun and the daimyos. The gold coin that was more commonly circulated was the *koban*, which weighed 18 grams.

Both the *ōban* and *koban* differed qualitatively depending on the period in which they were produced. The *ōban* in number 117 and the *koban* in number 118 are coins of the highest quality, containing 86% gold and 14% silver.

Tokugawa Ieyasu was able to mint such coins because the latter half of the sixteenth century through the seventeenth century was for Japan a period of great mineral discoveries. Records of the time state that "throughout Japan, gold and silver gushed forth from the earth like a fountain." Moreover, these mines were almost all monopolized by the Tokugawa shogunate.

117

115. SET OF INCENSE UTENSILS AND TRAY

Design of *aoi* crests scattered over a landscape in gold alloy and gold sheet over wood: tray, 26.8 × 36.9 × 3.9cm.; incense burner with attached cover, h. 8.3, diam. 7.3cm.; incense container. h. 7.1, diam. 4.8cm.
Incense instruments: chopsticks, l. 17.1cm.; spatula, l. 14.5cm.; stand, h. 10.2, diam. 5.1cm.
Edo period, early 17th century

Throughout history, exotic fragrances have been prized by people in Japan and in the West. But while Westerners primarily used liquid perfumes, Japanese preferred fragrant woods which released their aroma when burned. The tools seen here are the basic ones used in burning these aromatic woods or incense.

This tray has a wooden core over which gold sheet has been fashioned. The remaining implements and tools are made completely of gold alloy. This metal was at one time thought to be solid gold, but it has now been determined that the metal used here and in number 114 are only about 22% gold. This set was also commissioned by Tokugawa Ieyasu, the first shogun.

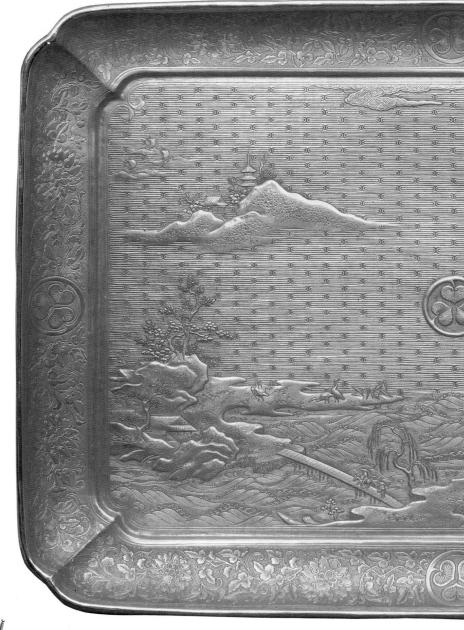

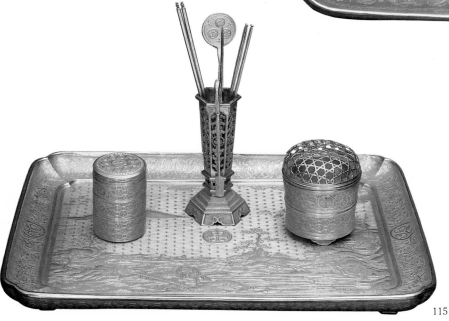

115

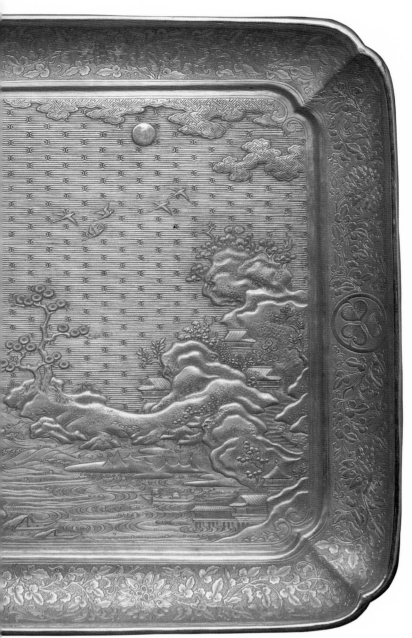

115 (tray)

119

119. *SUMPU ONWAKEMONO-CHŌ*

Record of the Property Bequeathed to Tokugawa Yoshinao from Tokugawa Ieyasu;
three books, ink on paper;
28.3 × 21.8 cm. each
Edo period, 1616—1618

These books form a catalog of the property that Tokugawa Yoshinao, the first lord of Owari, inherited from his father, Ieyasu, the first Tokugawa shogun. In 1605, only two years after he had received the title of shogun from the emperor, Ieyasu turned over that position to his son, Hidetada, and retired to Sumpu Castle in Suruga (present day Shizuoka Prefecture). Ieyasu died there on the seventeenth day of the fourth month of Genna second year (June 1, 1616), at the age of 75. Following his death the property that remained in that castle was divided among four of his surviving five sons: Hidetada, the second shogun; Yorinobu, the first lord of Kii; Yorifusa, the first lord of Mito; and Yoshinao, his ninth son. From the 11th month of 1616 to the same month in 1618, members of the Owari Tokugawa family journeyed several times from their castle in Nagoya to Sumpu Castle to receive their inheritance. This three-volume estate list was drawn up at that time; the entire catalog of Ieyasu's bequest comprised eleven volumes. Along with gold and silver, the inheritance of the Owari Tokugawa included such diverse items as swords and other weapons, suits of armor, tea ceremony utensils, Nō drama properties, clothing, furniture, art objects such as paintings and calligraphy, and precious imported textiles and medicines. Yet more impressive than the range of luxury goods that are usually associated with bequests is the magnitude of the inheritance. Large-scale single entries, such as 600 white *kosode* garments, 1,800 kilograms of raw cotton (500 *kan*), and 1,000,000 gold *koban* coins, can readily be spotted among the listings, and vividly illustrate Ieyasu's vast wealth, thus providing tangible evidence of the political and military power and authority of the first shogun.

A large number of the art objects recorded in this catalog survive today, with twenty of them included in the present exhibition.

GASHU

TASTE

PART III.
TASTE

By 1630, Edo was firmly established as the capital of the warrior class, and became the center of a culture formed around the samurai. This culture of the new samurai rulers flourished in fields ranging from the sciences, fine arts, and performing arts to the martial arts—a culture that could only have developed in the shogunal seat of Edo. The official drama of the warrior class was Nō, which developed as the performing art of the warrior class in the latter half of the fourteenth century under the patronage of the third Ashikaga shogun, Yoshimitsu (r. 1368—1394). Both Toyotomi Hideyoshi and Tokugawa Ieyasu were devotees of Nō. Once Ieyasu, who possessed great interest in the culture of the Ashikaga shogunate, became shogun himself, the Nō drama was adopted as the official music-drama of the shogunate, as well as being a performing art to be enjoyed. For the daimyo, with the adoption of the system of alternate years in residence, the principal setting for their activities shifted to Edo. They vied with one another in collecting accoutrements for the Nō drama and kept Nō actors in their employ in preparation for official visits by the shogun or other daimyo. In Edo Castle itself, there were frequent ceremonial performances of Nō. The tea ceremony also developed as one of the social rituals of the warrior class since the establishment of the forms and etiquette of tea during the rule of the eighth Ashikaga shogun, Yoshimasa (r. 1449—1473). After the tea ceremony reached its culmination in the forms developed by Sen no Rikyū (1522—1591), frequent tea gatherings were held, often serving as the setting for political or commercial discussions. The leading tea masters formed schools of tea that transmitted their teachings to later generations. Just as Nō became the official music-drama of the shogunate, the tea ceremony became a form of official social interaction indispensable to the warrior class. The arts and ceremonies attending the official protocol of receptions adopted by the shogun and daimyo are here represented by the following objects selected for this exhibition.

THE NŌ DRAMA AND ITS ACCOUTREMENTS

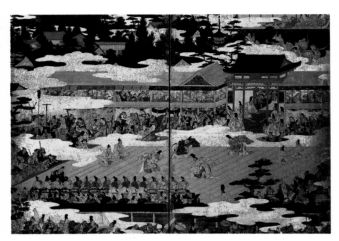

Hōkoku Shrine Festival

The Nō drama is a masked music-drama—the only highly refined masked drama of its kind in the world—performed on a specially constructed stage. In its widest meaning, the term also encompasses the comic drama Kyōgen, as well as the serious Nō. Nō itself, which incorporates music and dance, developed during the Kamakura period from *Sarugaku,* which had existed since the Heian period, while Kyōgen developed from the comic nature of early *Sarugaku* into a drama form in which the actors speak their lines. Although the term *Sarugaku* had originally encompassed both the serious and comic forms, this term which literally means "monkey music" was dropped during the Meiji period for the preferred appellation, "Nō-gaku."

Since the time that the third Ashikaga shogun Yoshimitsu had patronized Kan'ami (1333—1384) and his son Zeami (1363—1443), Nō enjoyed great popularity among the members of the warrior class. It came to occupy an official ceremonial function during formal receptions, and was performed as a rule on the occasion of a shogunal visit.

The triumvirate that had succeeded in unifying Japan in the latter half of the sixteenth century, Oda Nobunaga, Toyotomi Hideyoshi, and Tokugawa Ieyasu, were all enthusiastic supporters of Nō, and many of the great generals were adept enough in the form to perform themselves.

The Tokugawa shogunate continued to patronize this traditional performing art, and just as *Bugaku* served as the official ceremonial music of the court nobility, Nō served this purpose for the warrior class. As the Nō drama became a required part of the formal etiquette for receptions hosted by the shogun and daimyo, its accoutrements were an essential component of the *omote-dōgu* that comprised the official implements of the daimyo household. It was considered part of a ranking samurai's cultivation to be able to chant Nō verses. Moreover, the fifth shogun, Tsunayoshi (r. 1680—1709) performed Nō dances himself, and urged the other daimyos to do the same.

Every daimyo household was required to maintain a full set of accoutrements for the performance of a range of Nō plays. The Owari Tokugawa family has managed to preserve around four hundred Nō costumes, nearly one hundred masks, and over three hundred other accoutrements. All are objects of surpassing quality, suited to the exalted status of the family itself.

"Eguchi" by Kan'ami. Kanai Akira performing, costumed in a *karaori* robe and *Zō* mask.

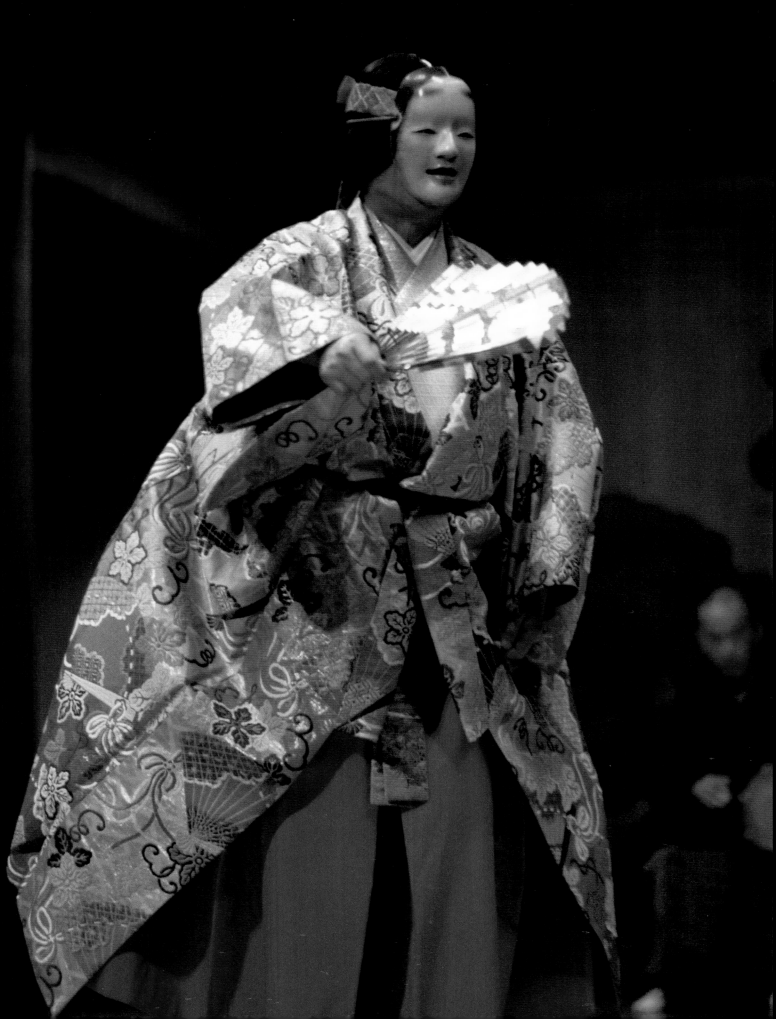

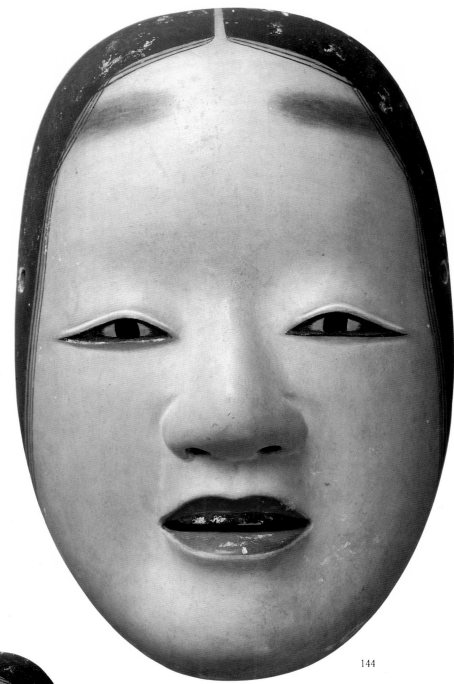

144

144. *KO-OMOTE*

Nō mask of painted Japanese cypress;
21.1 × 13.8cm.
Edo period, 18th century

The definitive young woman's mask is the *ko-omote*. The forehead is wide, the chin long, the eyes, nose, and mouth tending to cluster toward the center of the countenance; the flesh is full, the line of the eyes long, the eyebrows located high on the brow, the lips scarlet, the teeth blackened—all rendered with masterly painting techniques to create a most impressive work of art. The features are an idealization of those of a high-born lady of marriageable age of the twelfth or thirteenth century. At that time it was the custom for all young women who were of age, whether they were married or not, to pluck their eyebrows and draw them on at a higher point with *mayuzumi* (eyebrow blackener), and to stain their teeth with *o-haguro* (tooth stain). The hair was worn parted in the center, hanging evenly on the left and right. Two or three nearly parallel strands of hair are usually drawn on the *ko-omote* mask in a naturally flowing manner along the hairline. In this mask, however, the loose strands form intersecting arcs more typical of a *Zō* (see no. 146) or *Waka-onna* mask. Nonetheless, records handed down in the Owari Tokugawa family indicate that this mask was used as a *ko-omote* in actual Nō performances during the Edo period.

144 (3/4 view)

140

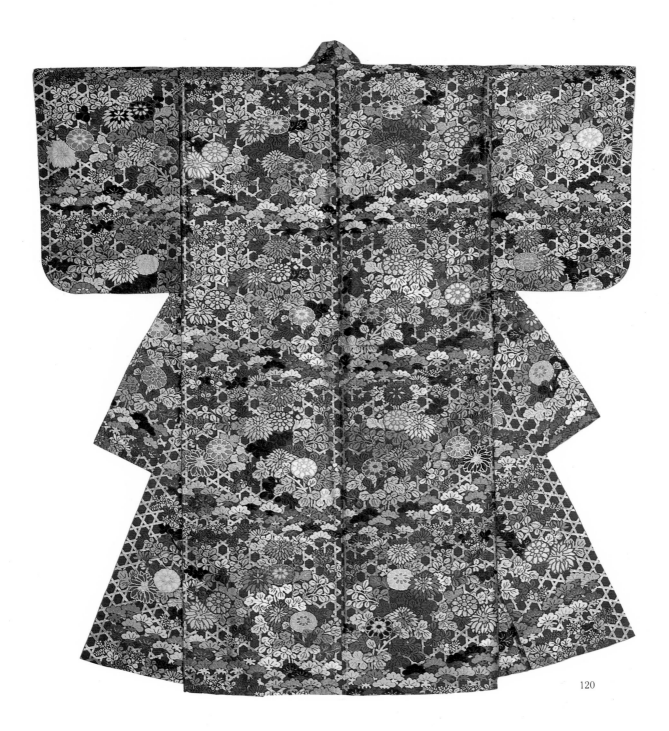

120

120. *KARAORI*

Outer robe with a design of pine,
chrysanthemums, and bush clover blossoms
worked on a woven bamboo basket pattern on
a black-red twill-weave ground;
151.5 × 142.4cm.
Edo period, 18th century

Karaori is not only the name of one
type of Nō costume, but also describes
a type of fabric. Because of the high level
of craft demonstrated in its weaving, this
fabric was chosen to create the most
gorgeous and elaborate of the Nō costumes.

In this type of fabric a design is produced
on a three-harness twill ground by floating a
number of colored weft threads, and then
fastened down with gold or silver foiled
threads, forming beautiful patterns on
the surface of the fabric. The designs are
of such intricacy and delicacy as to seem
embroidered. This sumptuous cloth was

originally of Chinese
manufacture, but from the beginning of
the sixteenth century it was woven in
Japan using techniques learned from the
Chinese.

At the time Nō was becoming estab-
lished in the fourteenth century, it was a
treasured cloth whose use was strictly
limited to the upper classes. The great
prestige enjoyed by Nō is demonstrated by
the choice of the precious *karaori* for use
in Nō costuming.

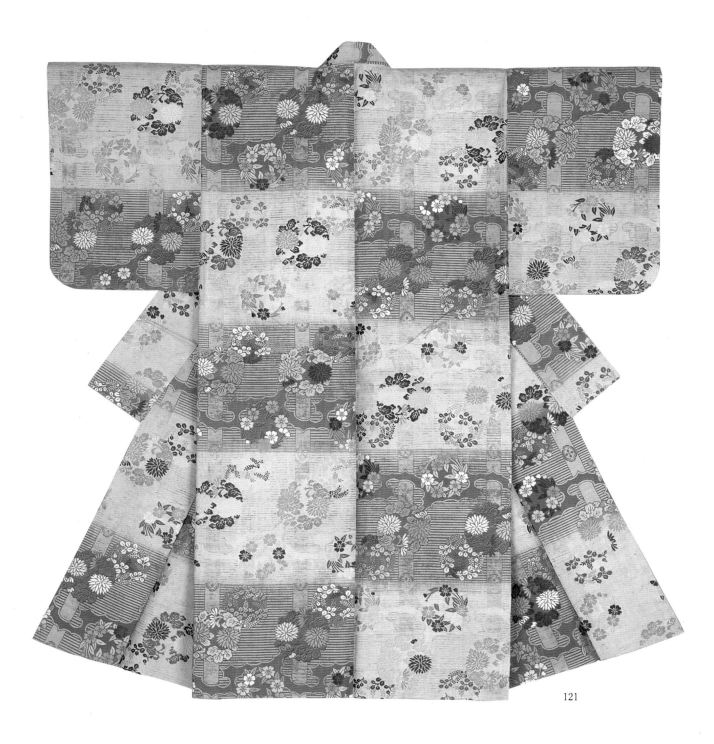

121

As a Nō costume *karaori* have been almost always used as an outer robe in women's roles. Exceptions are made, however, and it may be used for the role of a child or young boy, or as an inner robe in a young man's role to indicate particular splendor. The color red was incorporated in the design of a robe for the role of a young woman, while women of middle age or older were clothed in costumes lacking that color.

In number 120, a woven bamboo basket motif is brocaded in gold on a black-red ground which has been further embellished with an overall design of pines, chrysanthemums, and bush clover blossoms worked in threads of around twelve colors. The line of pines which starts the design sequence cuts the pattern into horizontal blocks, but the richness of the colors used is such that the striped effect is not strongly felt, and the impression is one of overall sumptuousness.

Red, with a hint of black, and white, alternating in rungs, is enhanced by an overall design of reed screens worked in silver thread in number 121. Over a pattern of clouds which compliments the space are woven gorgeous medallions of flowers of the four seasons.

The costume in number 122 was tailored to be worn by a child actor. The flowering grasses of an autumn field have been richly worked on a white ground by the use of eleven different colored threads in the weaving. The composition of the autumn grasses in layered horizontal bands imparts a broad, spreading impression, so that the effect produced is that of a vast field of flowers blooming in clusters.

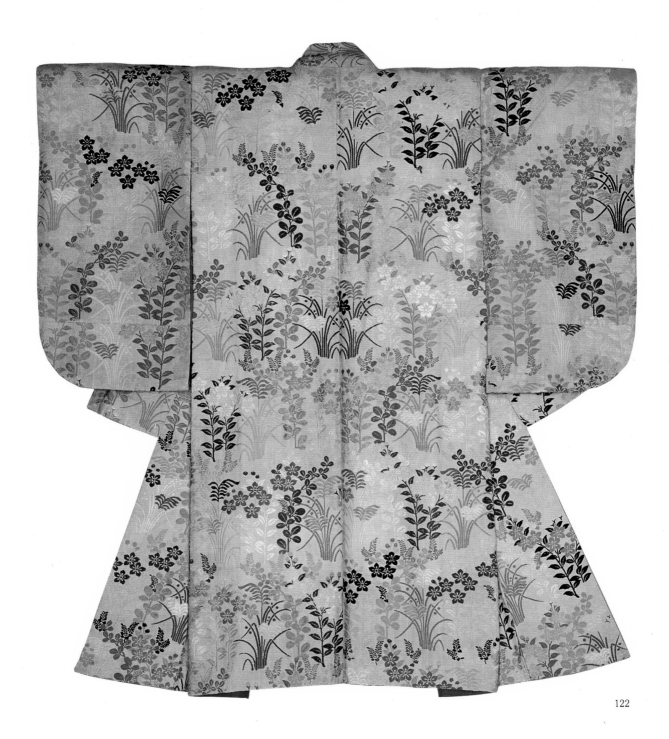

122

121. *KARAORI*

Outer robe decorated with a reed-screen back
and flower medallion design on a red and white
rung-dyed twill-weave ground;
151.5×142.4 cm
Edo period, 18th century

122. *KARAORI*

Outer robe with a design of autumn plants on a
white twill-weave ground;
125.7×121.4 cm.
Edo period, 17th century

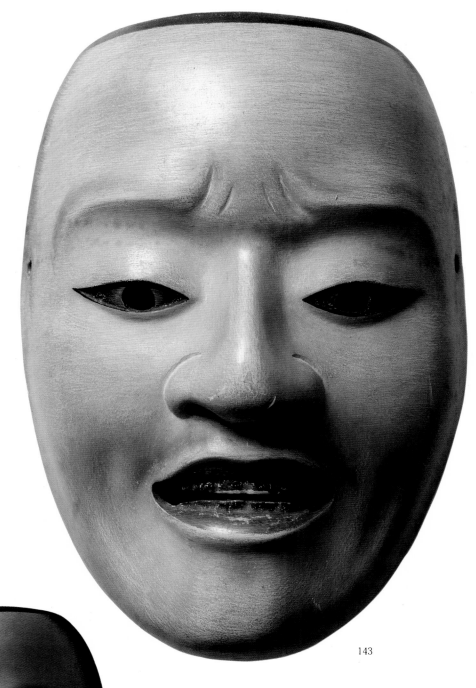

143

143. *KANTAN-OTOKO*

Nō mask of painted Japanese cypress;
19.8 × 14.2cm.
Edo period, 18th century

This mask is used for the title role in the Nō play *Kantan*. The character is that of a young man of philosophical bent who inquires into the illusions of life. Thus the features of the mask must contain both an air of melancholy and skepticism, and the clear look of someone who has just awakened from a dream into an enlightened state.

In order that these two very different emotions may be shown effectively on stage, the eyes and mouth have been sculpted in the manner of a typical young man's or woman's mask, with an ambiguous quality that can change to either expression.

143 (3/4 view)

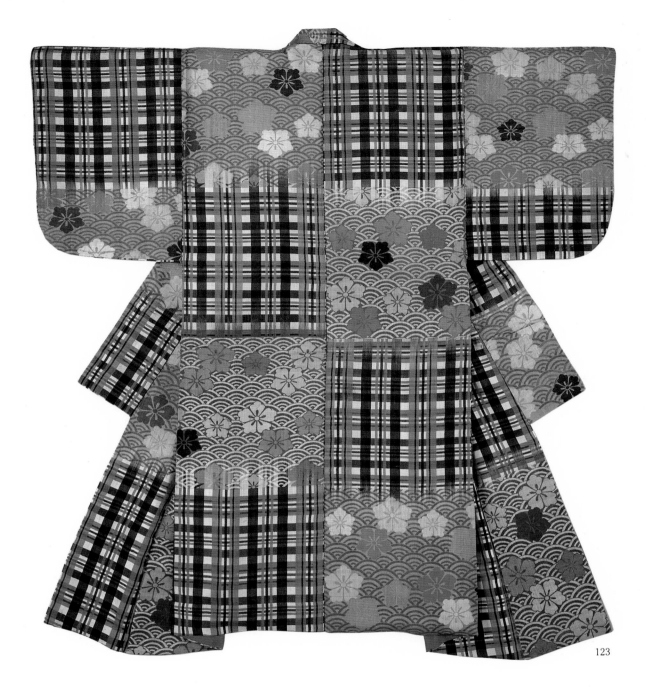

123

123. *ATSUITA*

Outer robe with a brocade design of blue waves
and Chinese flowers on a twill-weave ground
rung-dyed in red and light green;
145.4 × 142.4cm.
Edo period, 17th century

Atsuita, like *karaori*, is used today as
the name of a fabric as well as a
type of Nō costume. Originally, *atsuita*
was used as a generic term for thick
fabrics in contrast to such thin stuffs as
donsu (satin damask) or *rinzu* (figured
satin). At present, the word is used to
describe a plain-weave ground in which
design weft threads or gold and silver
foiled threads are fastened down with the
ground threads to create a brocade design.
The fabrics used to create the *atsuita* Nō
costume include the *atsuita* and *karaori*
fabrics, and also *nishiki* (brocade), *ayaori*
(twill), and *ukiori* (relief brocade).

While the costume called the *karaori* is
primarily used for women's roles, the
atsuita is used chiefly for men's roles. On

special occasions there are instances where
the character of an old woman of humble
birth will wear an *atsuita*.

In number 123, a bold plaid of broad
and narrow widths of brown and blue has
been worked on a white ground
alternating with a red and light green
rung-dyed ground, which is decorated with
a design of waves and Chinese flowers.
The Chinese flowers are worked in threads
of seven different colors, but because the
design threads are not floated as in
karaori weaving, the color of the ground
warp threads can be seen over the weft
design threads, so that more colors seem
to have been used than have actually
been employed.

On the dark blue ground of number 124,

145

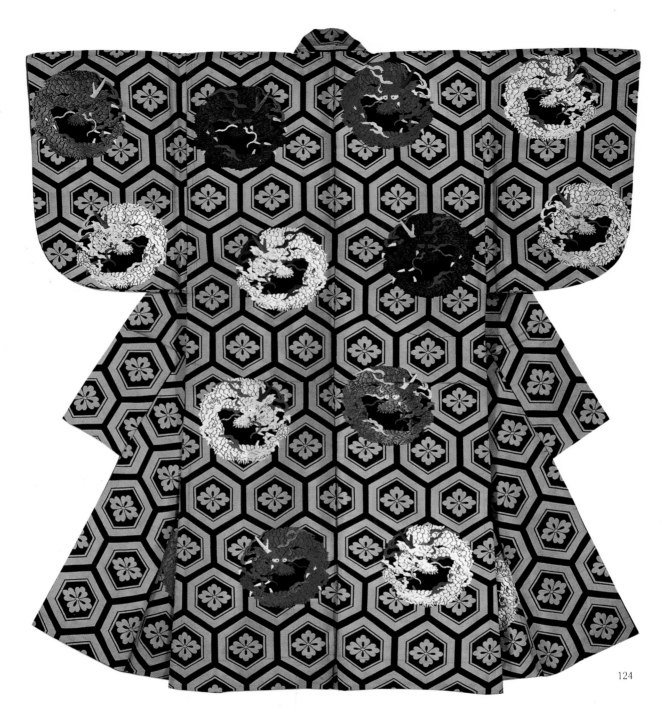

124

an overall hexagonal tortoise-shell pattern has been woven in a three-harness twill in a straw color. Over this a *karaori*-style floated design of dragon medallions has been magnificently wrought in red, blue, white, yellow, and light green threads.

In number 125, a four-blossom rhombus design has been woven in floated-weft relief in white, yellow, and gold over the entire surface of the red ground. The four-blossom rhombus is one of the traditional aristocratic designs used since the Heian period. It was most often appropriated as a design in the *jūni-hitoe,* the formal costume consisting of numerous layers of unlined robes worn by high-ranking women of the imperial court.

124. *ATSUITA*

Outer robe with a brocade hexagonal tortoise-shell motif and dragon medallions on a dark blue twill-weave ground;
148.5 × 139.4 cm.
Edo period, 18th-19th century

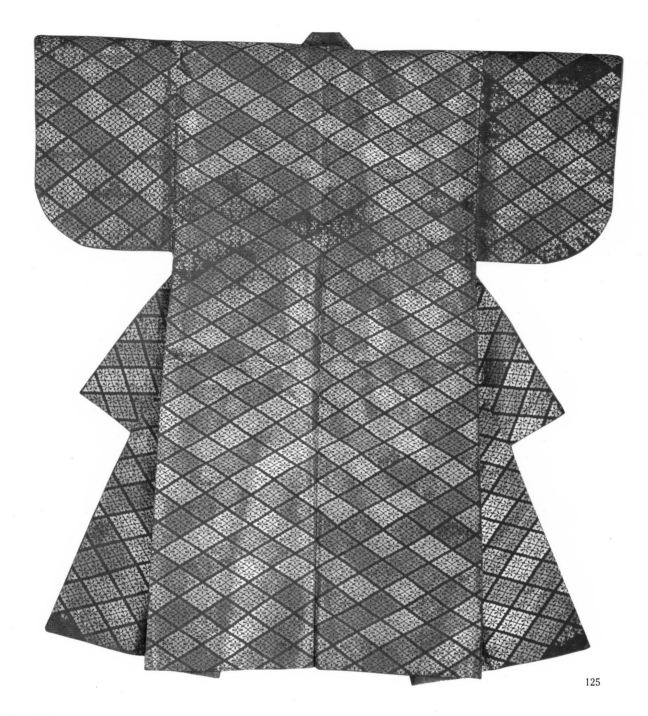

125

125. *ATSUITA*

Outer robe with an overall design of four-
blossom rhombuses on a red twill-weave
ground;
154.5 × 136.4cm.
Edo period, 18th-19th century

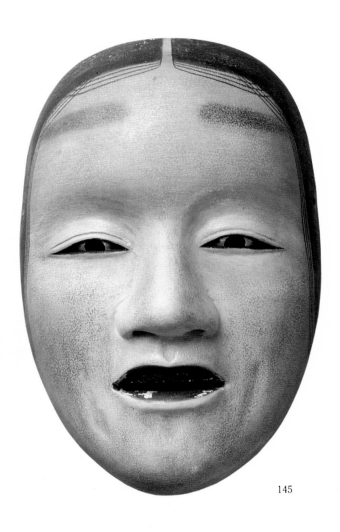

145

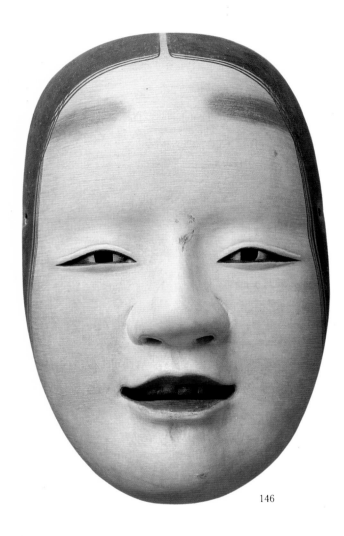

146

145. *FUKAI*

Nō mask of painted Japanese cypress;
20.9 × 13.6cm.
Edo period, 18th century

This is a mask depicting a middle-aged woman. The evidence of her age are her narrow, sunken eyes, and the sagging flesh of her cheeks. The insightful, subdued expression shows the depth of feeling and compassion of one who has experienced the grief and bitterness of hardship.

146. *ZŌ*

Nō mask of painted Japanese cypress;
21.2 × 13.8cm.
Edo period, 18th century

Zōami, a Nō actor active in the early years of the fifteenth century, is said to have created this type of young woman's mask. It is a mask with classical features, brimming with a fresh purity and nobility. The long, narrow eyes and slightly parted lips also give the mask an expression of alluring feminine charm.

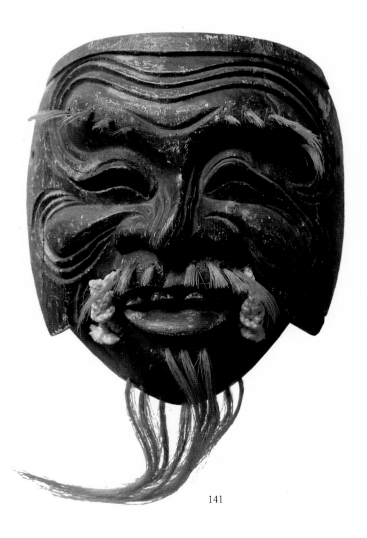

141

142

141. *KOKUSHIKI*

Nō mask of painted Japanese cypress;
16.7 × 13.8cm.
Edo period, 17th century

When an official Nō performance was held, the first work performed was always the one called *Okina*. It is a ritualistic piece performed to purify the performance area and to offer a prayer of thanksgiving and celebration for the peace and tranquillity of the nation. In *Okina* the god appears in the form of three old men who perform dances. The *Kokushiki* mask is used in the dance by the third old man: a dance to celebrate abundant harvests. The expression of the darkly finished features of this old man gives the impression of an aged tiller of the soil who has been elevated to godhood.

142. *KOJŌ*

Nō mask of painted Japanese cypress;
24.2 × 16.1cm.
Edo period, 18th century

This is an old man's mask. The old men in Nō plays are not simply aged persons, but are gods in a transformed state, or the god himself. Therefore the old men's masks are filled with a graceful nobility and authority, displaying a spiritual quality as well as the dignified air of a patriarchal figure. Among old men's masks the *Kojō* has a particular quality of nobility. Many old men's masks have both upper and lower teeth sculpted, but the *Kojō* mask has upper teeth only, and the moustache is painted in rather than being composed of slender tufts of hair embedded in the wood.

149

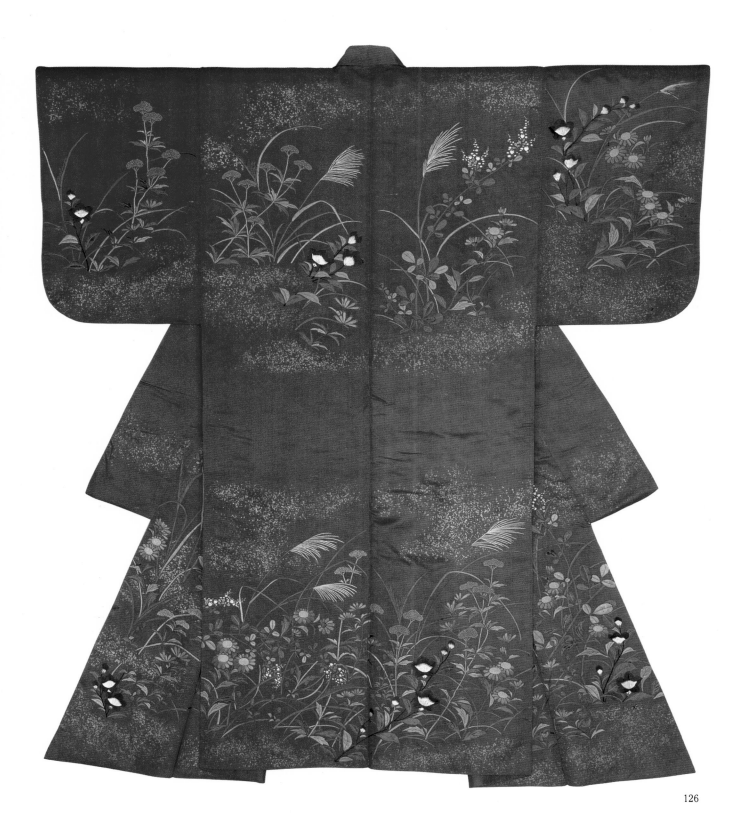

126

126. *NUIHAKU*

Inner robe with an autumn field design in
embroidery and gold foil powder on a red silk
ground;
148.4 × 136.2 çm.
Edo period, 19th century

Nuihaku is the term used for a Nō
costume on which embroidery and gold or
silver foil have been employed to work
rich and stunning designs. Although it is
chiefly used for female roles, there are also
instances when the *nuihaku* may be used
for male roles. Its use is then limited to
the roles of an emperor, upper-rank
nobility, or a youth.

Leaving the waist area free, a design of
autumn grasses has been embroidered in a
painterly style on the rich, deep red of the
ground fabric. The space around the
grasses has been sprinkled with gold foil
powder. In composition, this robe seems
more like a *kosode* (see nos. 244, 247,
and 253) than a Nō costume.

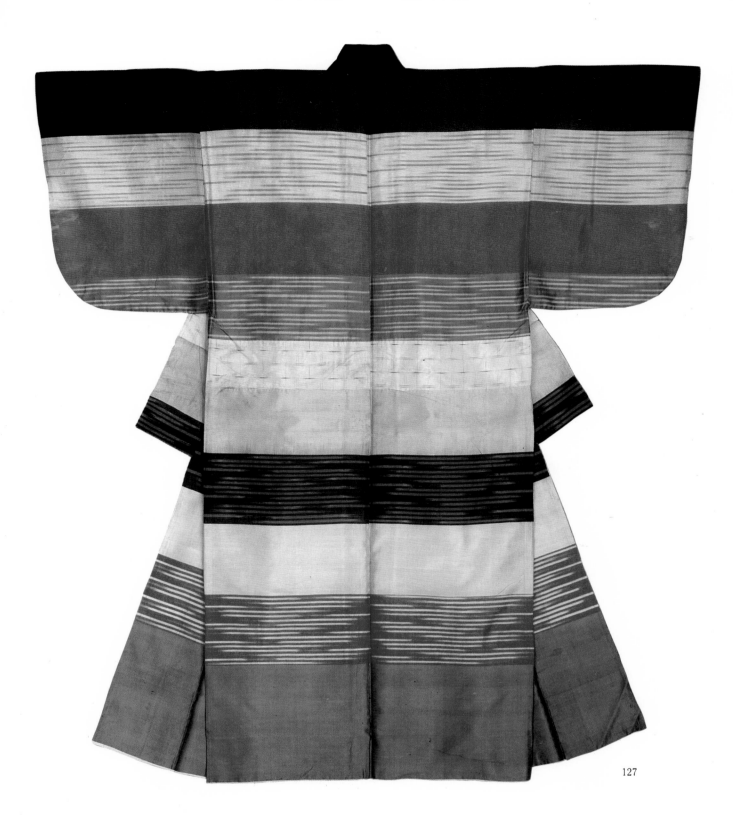

127

127. *DAN-NOSHIME*

Inner robe with bands of blue, white, red, and light green incorporating splash-pattern (*kasuri*) dyeing;
143.9 × 130.2 cm.
Edo period, 18th century

The Nō costume called the *noshime* is used for the roles of males who are warriors of low rank, monks, and commoners. On rare occasions it might be used to costume the character of a middle-aged woman of humble birth. In any case, it is never used as an outer garment, but only as an inner robe. The types of *noshime* are the *muji* (plain), *shima* (striped), and *dan* (broad-banded).

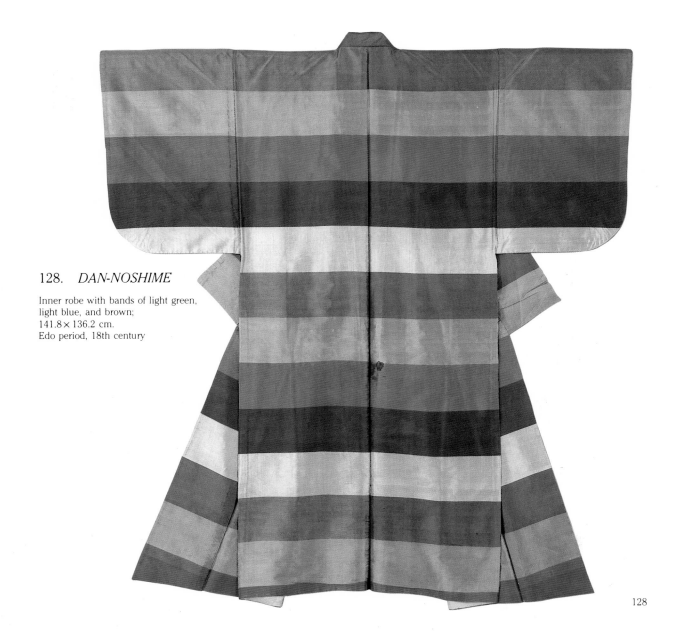

128. *DAN-NOSHIME*

Inner robe with bands of light green,
light blue, and brown;
141.8 × 136.2 cm.
Edo period, 18th century

128

129

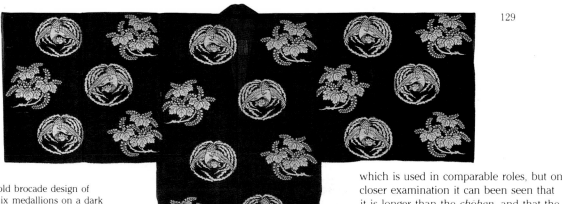

129. *MAIGINU*

Outer jacket with a gold brocade design of
paulownia and phoenix medallions on a dark
blue silk gauze-weave (*ro*) ground;
137.9 × 218.2 cm.
Edo period, 17th-18th century

This is one of the robes which is worn
only by a female character who will
perform a dance in the course of the Nō
play. It is similar to the *chōken*, no. 131

which is used in comparable roles, but on
closer examination it can been seen that
it is longer than the *chōken*, and that the
sides have been sewn closed. On stage it
is worn belted at the waist.

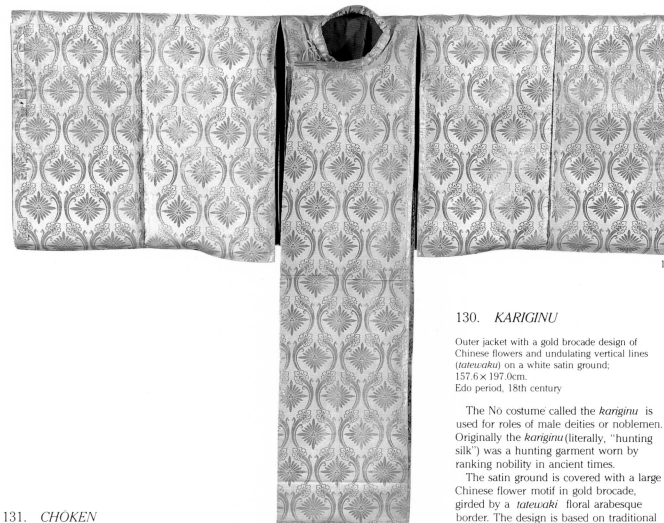

130

130. *KARIGINU*

Outer jacket with a gold brocade design of
Chinese flowers and undulating vertical lines
(*tatewaku*) on a white satin ground;
157.6 × 197.0cm.
Edo period, 18th century

The Nō costume called the *kariginu* is
used for roles of male deities or noblemen.
Originally the *kariginu* (literally, "hunting
silk") was a hunting garment worn by
ranking nobility in ancient times.

The satin ground is covered with a large
Chinese flower motif in gold brocade,
girded by a *tatewaki* floral arabesque
border. The design is based on traditional
aristocratic motifs.

131. *CHŌKEN*

Outer jacket with a major motif of fans with
arrowroot arabesques, and a secondary motif of
butterflies in brocade on a blue-gray gauze-
weave ground;
109.0 × 197.0cm.
Edo period, 18th century

131

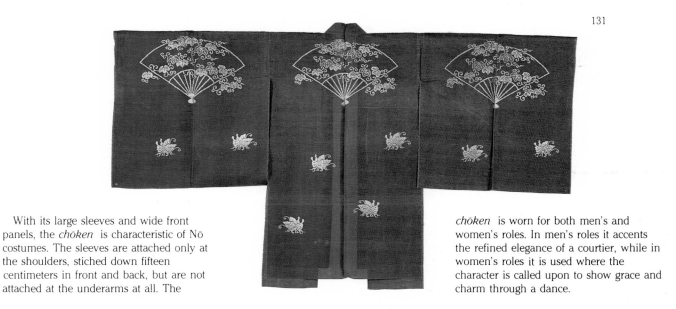

With its large sleeves and wide front
panels, the *chōken* is characteristic of Nō
costumes. The sleeves are attached only at
the shoulders, stiched down fifteen
centimeters in front and back, but are not
attached at the underarms at all. The

chōken is worn for both men's and
women's roles. In men's roles it accents
the refined elegance of a courtier, while in
women's roles it is used where the
character is called upon to show grace and
charm through a dance.

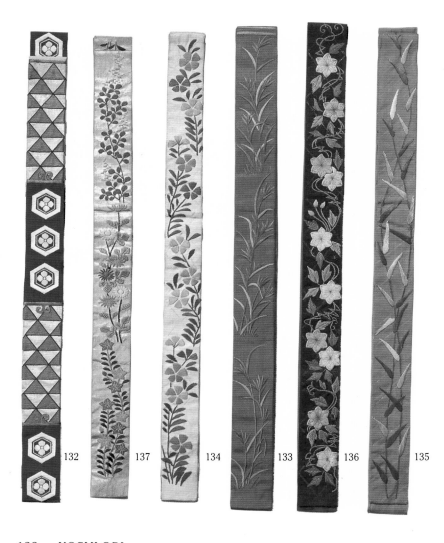

132 137 134 133 136 135

132. *KAZURA-OBI*

Headband of gold foil and embroidery on satin; a hexagonal tortoise-shell pattern in white on a blue ground, a serpent-scale design in gold foil and red silk embroidery

133. *KAZURA-OBI*

Headband with a design of cut miscanthus reeds embroidered on a brown silk ground

134. *KAZURA-OBI*

Headband with a design of wild-pink flowers on a white satin ground

135. *KAZURA-OBI*

Headband with a design of rushes embroidered on a red satin ground

136. *KAZURA-OBI*

Headband with a design of clematis flowers and vines embroidered on a dark blue satin ground

137. *KAZURA-OBI*

Headband with a design of Chinese bellflowers, chrysanthemums, and flowering bush clover embellished with gold foil embroidered on a white satin ground;
245.5 × 4.0cm. each
Edo period, 17th-18th century

The *kazura-obi* is a highly ornamented headband worn, in women's roles, under the mask to hold down the *kazura* (wig). For this accessory, thin strips of satin were embroidered with well-known designs and patterns, and sometimes further embellished with gold or silver foil. This ornamentation did not, however, cover the entire surface of the headband. Only an area of about forty-five centimeters at the center and both ends of the band was decorated.

138. *KOSHI-OBI*

Belt with gold foil and a design of chrysanthemums embroidered on a white satin ground

139. *KOSHI-OBI*

Belt with gold foil and an autumn field design embroidered on a red satin ground

140. *KOSHI-OBI*

Belt with gold foil and a hexagonal tortoise-shell motif embroidered on a pale blue satin ground;
268.0 × 6.8cm. each
Edo period, 18th century

The Nō costume accessory called the *koshi-obi* originally served the utilitarian purpose of allowing the wearer to adjust the length of an outer robe by folding the robe over the belt at the waist, so that the edge would not trail on the ground. Later, more importance was attached to it as an ornamental belt. The ornamentation, which was done solely in embroidery or also embellished with gold or silver foil, was worked on ground fabrics of *donsu* (damask), *shusu* (satin), or *kinran* (brocade), and was only applied for about thirty centimeters at the center and at each end.

138

140 139

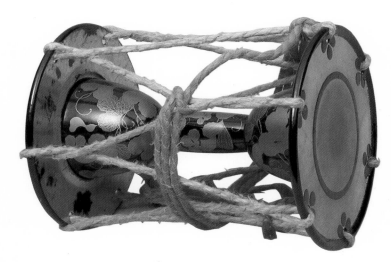

Hand-drum no. 152 with a stretched hide.

150. *TSUZUMI*

Hand-drum body with a design of turnips in *maki-e* on an aventurine lacquer ground; l. 25.0, diam. 10.0cm.
Edo period, 18th century

151. *TSUZUMI*

Hand-drum body with a design of circular crests on a back fret-pattern motif in *maki-e* on a black lacquer ground; l. 25.3, diam. 10.0cm.
Edo period, 18th century

152. *TSUZUMI*

Hand-drum body with a design of bottle gourd flowers and vines in *maki-e* on a black lacquer ground; l. 25.0, diam. 10.0cm.
Edo period, 18th century

In the Nō drama, which is a dance drama as well as being a masked drama, musical accompaniment is provided by an ensemble made up of the *Nō-kan* (transverse flute), *tsuzumi* (hand-drum), *ō-kawa* (hip-drum), and *taiko* (stick drum). The *tsuzumi* is a percussion instrument that is played by striking a skin made of horse hide. The drum is formed by pressing a pair of skins, which have been stretched, stitched, and lacquered onto metal rings, over an hour-glass shaped drum body of cherry wood, and attaching the skins by hemp cords. The *tsuzumi* is held by the cords gathered in the left hand and held against the right shoulder. It is struck by the palm and fingers of the right hand, and the left hand increases and relaxes tension on the drumhead cords by squeezing them lightly to control the pitch of the sound.

The drum bodies are decorated with designs using the traditional art of *maki-e* lacquer. As instruments used in the dignified art of Nō, it was required that drums such as these exhibit the highest artistic craftsmanship.

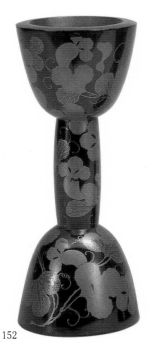

152

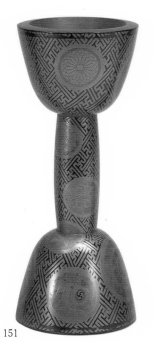

151

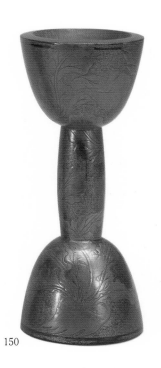

150

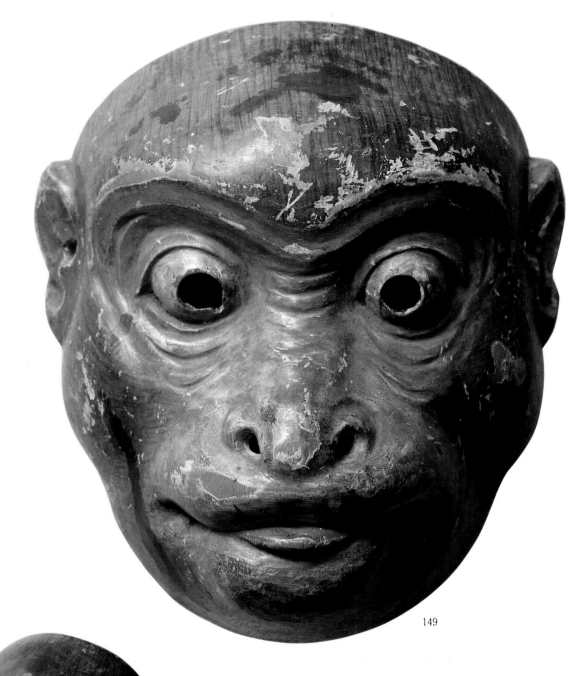

149

149. *SARU*

Kyōgen monkey mask of painted Japanese
cypress;
17.9 × 15.2cm.
Edo period, 18th century

There are a number of Kyōgen plays in
which animals play the central role, and
the monkey is the animal which appears
most frequently in these plays. The
Japanese feel an affinity for monkeys
because of their seemingly human
qualities. When portrayed in plays,
they are, therefore, modeled on human
beings, and the different types include a
Monkey Woman, Monkey Man, Monkey
Bridegroom, and a Monkey Father-in-law.
Because of the wrinkles on the bridge of
its nose, this mask is identified as the
Monkey Father-in-law.

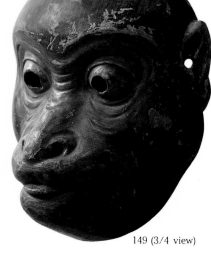 149 (3/4 view)

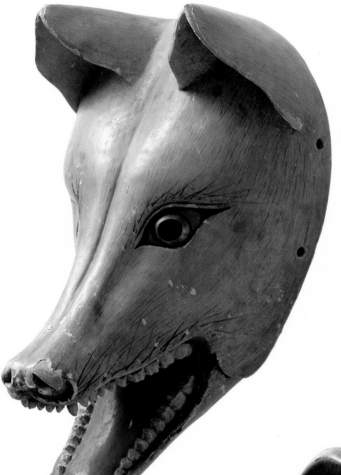

147

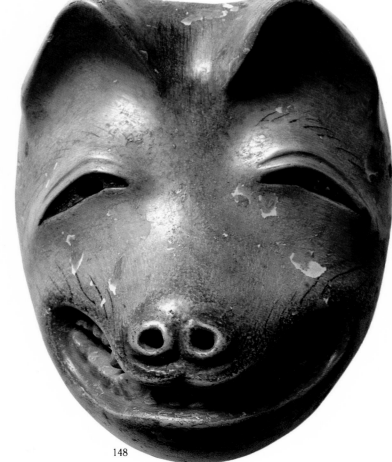

148

148. *TANUKI*

Kyōgen badger mask of painted Japanese cypress;
18.2 × 15.2cm.
Edo period, 18th century

This Kyōgen mask represents a badger, an animal with which Japanese people feel a familiarity along with the monkey and fox. There are many folk legends of badgers, as well as foxes, disguising themselves as human beings and playing pranks on people.

This badger mask is used only in the Kyōgen play entitled *Tanuki no Hara-tsuzumi,* or "The Badger's Belly-drum," a play based on the folk tradition that badgers play on their bellies as though they were drums.

147. *TSURIGITSUNE*

Kyōgen fox mask of painted Japanese cypress;
19.7 × 13.2cm.
Edo period, 18th century

In contrast with the spiritual, philosophical art of Nō, Kyōgen is a drama of comedy and farce, where the leading characters may even be animals such as the fox, monkey, badger, or kite, although the number of plays featuring these animals is actually quite small.

This fox mask was made to be used exclusively in the Kyōgen play *Tsurigitsune.* In summary, a trapper has been catching fox after fox of a particular fox clan, until finally only one old fox is left, and he, too, fears for his life. The fox disguises himself as the uncle of the trapper who happens to be a Buddhist monk. He then meets with the trapper and tries to persuade him to give up trapping animals for the good of his soul. However, during this meeting the trapper sees through the old fox's disguise, and the fox is forced to flee.

TEA CEREMONY UTENSILS

The tea ceremony began its development in the Kamakura period with the introduction of the practice of drinking whisked powdered green tea from Song China. From the Nambokuchō through the Muromachi period, the form of amusement called *tō-cha,* in which the contestants competed in guessing the type and source of different varieties of tea, was popular among the warrior class. From *tō-cha* competitions developed the tea gatherings held in the *shoin,* and it is said that the etiquette governing tea presented in the *shoin* was established during the rule of the Ashikaga shogun Yoshimasa (r. 1449—1473). With this development, the first step toward the development of the Way of Tea was taken in the tea ceremony performed in the official residence.

From this form of the tea ceremony performed in the reception rooms of the Ashikaga shoguns, the etiquette of tea drinking further developed into the *Sōan* tea enjoyed by the general populace, and the austere form known as *wabi* tea perfected by Sen no Rikyū (1522—1591).

In the course of its development, the tea ceremony was transformed from being a method for simply enjoying tea into an official part of formal functions sponsored by the samurai and daimyo, and became an accomplishment that was considered essential by the great warlords. It is well-known that Oda Nobunaga and Toyotomi Hideyoshi were avid devotees of the tea ceremony. Tokugawa Ieyasu was also an enthusiast of the tea ceremony, as is apparent from the utensils, such as the tea caddies, tea bowls, hanging scrolls, and vases, that were originally in his possession. The famed tea master and connoisseur Furuta Oribe served as tea master to the second shogun Hidetada (r. 1605—1623), who frequently received official guests according to the etiquette of the humble tea house (*sukiya no o-nari*). Traditionally, official guests were received within the main audience hall of the residence, but instead of serving tea in the audience hall according to the corresponding formal etiquette *(denchū cha no yu),* many elements from the method of serving tea in the small, humble tea room were adopted.

In order to prepare for official visits, daimyo collected numerous tea ceremony utensils, and the most coveted objects were those that had once belonged to the Ashikaga shoguns, while the next most preferred were those that had formerly belonged to the great tea masters such as Murata Jukō, Takeno Jōō, Sen no Rikyū, and Furuta Oribe. In addition, the utensils, such as the tea bowl, kettle, tea scoop, tea-leaf jar, and articles with which to ornament the tea room, including the hanging scrolls and flower vases, were all selected with the aim of subtly manifesting the status of the owner.

Utensils used in the tea ceremony.

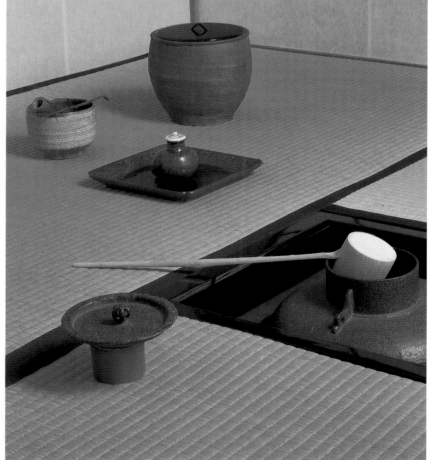

The *tokonoma* in a tea-room.

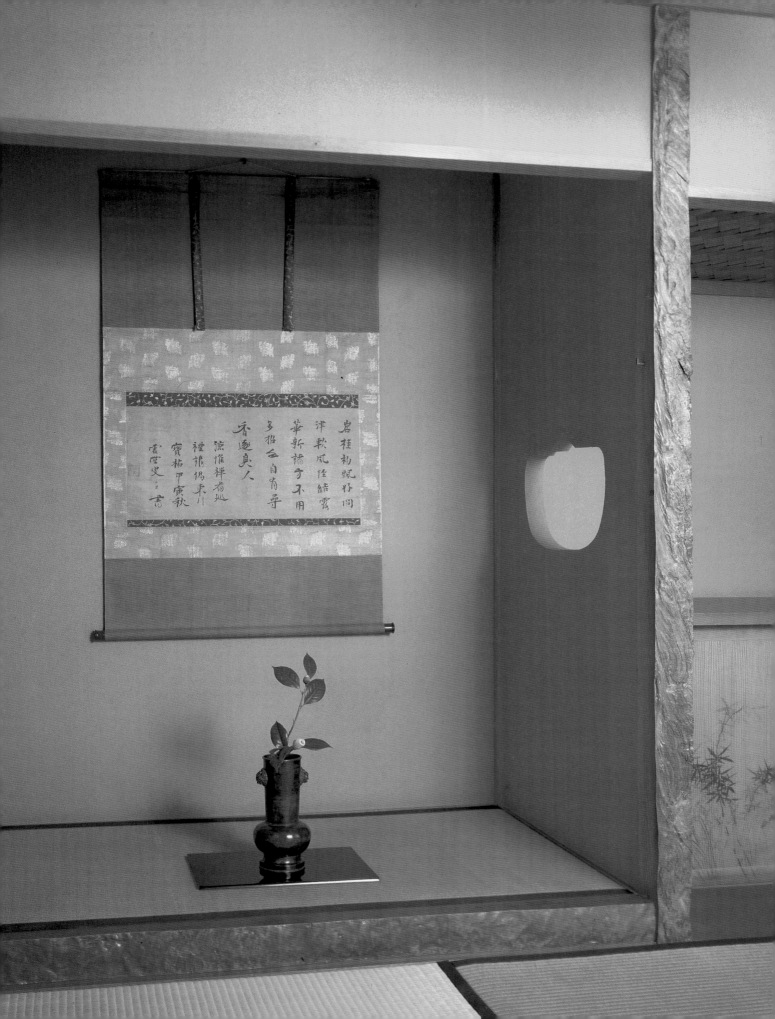

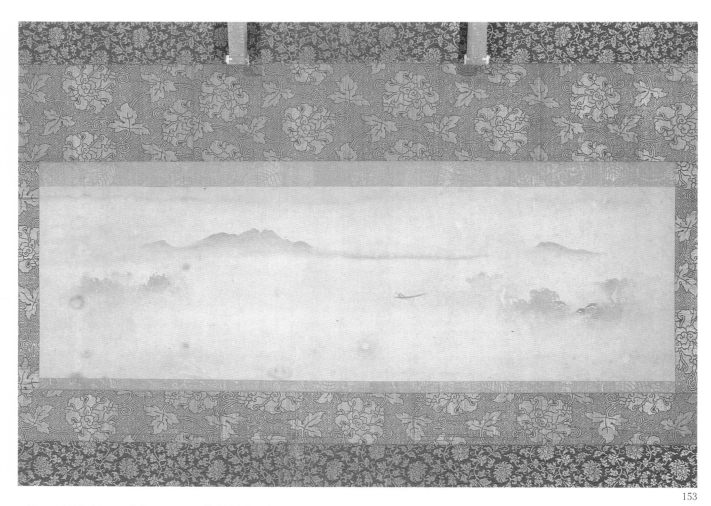

153. AUTUMN MOON OVER DONGTING LAKE

Attributed to Mu qi (d. between 1264—1274)
Hanging scroll, ink on paper;
29.4 × 93.1cm.
Chinese, Southern Song period, 13th century

The region in Hunan Province in China where the confluence of the Xiao and Xiang rivers flows into Dongting Lake, an area which abounds in extremely variable atmospheric conditions, is celebrated for the picturesque, natural beauty of its landscape. Taking delight in this scenery, Chinese ink painters adopted eight selected themes based on the landscape as favorite subjects for their compositions. Arranged in order, these eight motifs were named collectively the "Eight Views of the Xiao and Xiang." The subject of the present painting, "Autumn Moon over Dongting Lake," is one of them.

The painting is suffused with a softness that is almost unthinkable as the product of the tip of a brush. Represented impressionistically, the whole lake appears blurred in the evening mist.

Although many points in his biography remain obscure, Mu qi, the artist to whom this painting is traditionally attributed, was presumably a Chan monk-painter who came from Sichuan Province and lived at the end of the Southern Song. In China, his paintings were, from a later historical viewpoint, not regarded highly; whereas in Japan, where they were respected as an inspirational wellspring for monochrome ink painting (suiboku-ga), they had great significance.

154. FRAGMENT OF THE *OGURA HYAKUNIN ISSHU* POETRY ANTHOLOGY

Fujiwara no Teika (1162—1241)
Decorative paper (*shikishi*) mounted as a
hanging scroll, ink, gold, and silver on
decorative paper;
18.5 × 15.3cm.
Kamakura period, 13th century

Poet, scholar, and calligrapher, Fujiwara no Teika (1162—1241) was one of the major literary figures in Japanese history. Among his honors was being named one of the editors of the eighth imperial poetry anthology, the *Shinkokinwakashu* ("The New Collection of Ancient and Modern Poetry"), completed in 1216. As a scholar, Teika copied or edited many of the works from early periods that survive today. He also created a distinctive calligraphic style.

The work shown here is part of an anthology of one hundred poems, one each by one hundred different aristocratic poets (*Hyakunin Isshu*). The poems were written on separate, specially prepared pieces of decorative paper called *shikishi* and were used to adorn the walls of Teika's villa on Mt. Ogura outside Kyoto. For this reason they are called the *Ogura shikishi*.

This *shikishi* displays a love poem by Mibu no Tadami, a poet of the lesser aristocracy, composed at a poetry competition held at the imperial palace in 960 (Tentoku 4) during the reign of Emperor Murakami (r. 946—967). Three pieces of colored paper of differing widths were joined together to produce this *shikishi*. The grey-colored middle sheet is

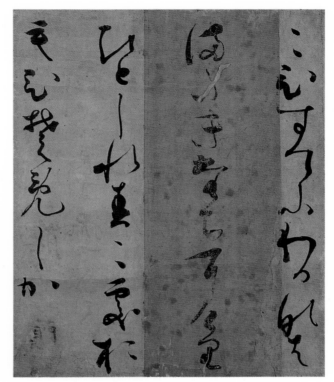

154

sprinkled with bits of cut silver leaf.

Teika's calligraphic style was considered unorthodox during his lifetime, but from the fifteenth to the seventeenth centuries it was the subject of universal praise, especially among practitioners of the tea ceremony who valued it especially for the hanging scrolls that adorned the alcove. Tokugawa Ieyasu, the first shogun, owned several specimens of Teika's work, including this example, and studied Teika's calligraphic style.

155

155. CALLIGRAPHY

Xu-tang Ji-yu (1185—1269)
Hanging scroll, ink on paper;
30.6 × 62.7cm.
Chinese, Southern Song period, dated in
accordance with autumn, 1254

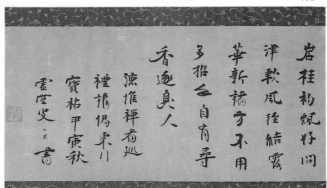

Xu-tang Ji-yu (in Japanese, Kidō Chigu or Sokkō) was a distinguished Chan monk of the Southern Song period. He entered the priesthood at the age of fifteen and rose to be the abbot of the great monastery on Mt. A-yu-wang. In addition, he was regarded as one of the master calligraphers of his time.

A number of Japanese Zen monks at this time journeyed to China to study under distinguished monks there.

This example of Xu's calligraphy was a gift to a Japanese monk named Tokui who had gone to China to study. Because the tea ceremony sought its spiritual foundations in the Zen teachings, the writings of Zen

monks, known as *bokuseki* ("ink traces") were particularly prized and often mounted as hanging scrolls to adorn the tea room. Among these *bokuseki*, the calligraphy of Xu was the most highly prized, not only for its inherent aesthetic qualities, but because he is considered the spiritual forefather of a considerable

segment of the Japanese Zen community.

This work was a gift of Tokugawa Tsunanari, the third lord of Owari, to his heir, Yoshimichi, the fourth lord. Yoshimichi, in turn, presented it to the sixth shogun, Ienobu (r. 1709—1712). It was returned to Yoshimichi as part of the bequest of Ienobu in 1712.

161

156. VASE IN THE SHAPE OF A FULLING BLOCK, NAMED "KINE-NO-ORE"

Bronze; h. 25.8, diam. 10.5cm.
Chinese, Southern Song period,
12th-13th century

This Chinese Southern Song period bronze vase is one of the most famous flower vases associated with the tea ceremony in Japan, and its value is commensurate with its fame. It is said that this vase was named "Kine-no-ore" because its shape resembles that of a pestle broken in half. In the tea ceremony, unadorned vases are preferred over highly ornamented ones, and are valued for their very simplicity. Apart from the animal masks placed symmetrically on either side of the upper part of the neck of this vase, it is largely unadorned.

In the long and eventful history of this prized vase, one episode that emerges is its presentation to Tokugawa Ieyasu by the vanquished general Ishiko Ujikatsu, who, after suffering defeat in a battle in the year 1600, escaped execution by offering this vase to the victor, Ieyasu.

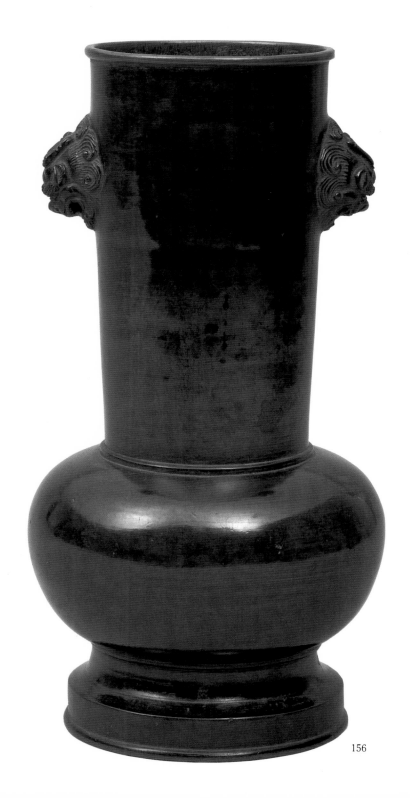

156

160. TEA CADDY, NAMED "KARA-MARUTSUBO"

Ceramic; h. 6.4, diam. 7.0 cm.
Chinese, Southern Song period, 12th-13th
century

This Chinese ceramic tea caddy served as a container for the powdered tea used in the tea ceremony, but was originally made for use as a spice jar. The literal meaning of *kara-marutsubo* is "Chinese round-bodied jar."

The Japanese were quick to perceive the profound beauty of such simple, ordinary ceramic objects, which soon came to be treasured as the most important of tea ceremony utensils. This type of ceramic tea caddy is used only at the most distinguished tea gatherings.

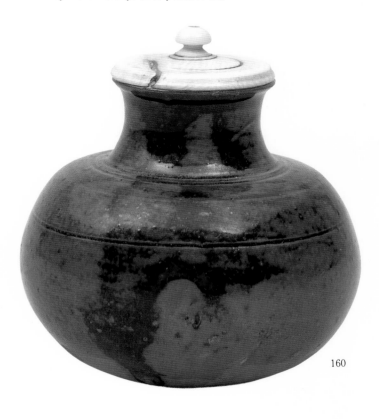

160

161

162

163

161. TRAY

Design of peony arabesque in carved cinnabar lacquer and black-lacquered wood;
20.5 × 20.9 × 2.4 cm.
Chinese, Ming period, 16th century

162. TRAY

Design of Chinese flowers in carved cinnabar and green lacquer;
20.0 × 20.0 × 2.4 cm.
Chinese, Ming period, 16th century

163. TRAY

Design of Chinese flowers in carved cinnabar and green lacquer;
17.4 × 17.4 × 2.6 cm.
Chinese, Ming period,16th century

These are trays upon which tea caddies were placed during the tea ceremony. Although tea caddies were an essential part of every tea gathering, they were not necessarily always displayed on trays. This occurred only on special occasions when a prominent guest was invited, and on such occasions only the finest tea caddies would be used.

All three of these trays are square with rather elaborate carved lacquer decoration. Number 161 employs a peony scroll around its entire border with a glossy black-lacquered central section.

Number 162 displays the same basic border composition, but here the design comprises four different types of flowers, one for each side. Also, the central section is far more elaborate with four separate items such as a fan and a gourd occupying the four inner corners. The cinnabar-lacquered center is delicately carved with two long-tailed birds on a floral background.

Number 163 is similar to number162 in terms of its cinnabar and green carved lacquer technique and its border composition. The square corners of the central plain black-lacquered section contrast with the rounded edges of the tray itself.

163

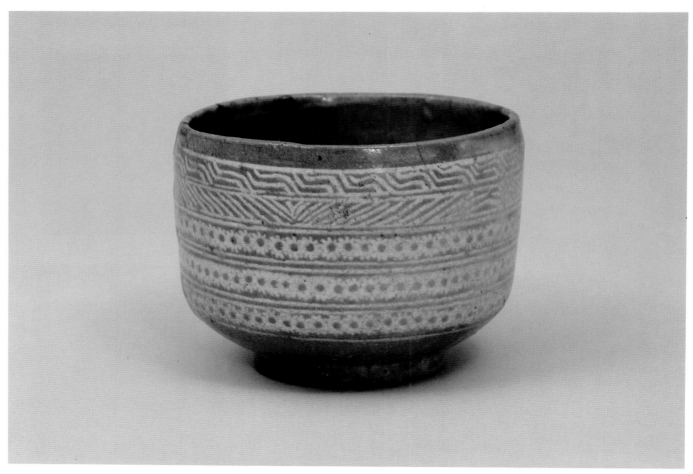

159. TEA BOWL, NAMED "MISHIMA-OKE"

Ceramic, Mishima type;
h. 8.9, diam. 11.3 cm.
Korean, Yi period, 16th century

With white slip inlaid in patterns in the grey-colored body, this piece is representative of what are generally known in Japan as "Mishima" tea bowls.
Known as *Punch'ŏng* in the country of its origin, Korea, this type of ware developed during the early Yi period (1392—1910) from inlaid celadons of the Koryŏ period (918—1392).

A document written by the warlord and tea ceremony devotee, Hosokawa Tadaoki (1563—1645), has been handed down with this tea bowl. In it Hosokawa praises this bowl highly with the words, "There is not another equal to it on earth," indicating that this bowl had been highly coveted among tea ceremony enthusiasts of the time.

164. TEA SCOOP, NAMED "MUSHIKUI" (WITH CASE)

Attributed to Sen no Rikyū, (1522—1591).
Bamboo; l. 17.3 cm.
Momoyama period, 16th century

165. TEA SCOOP (WITH CASE)

Attributed to Sen no Rikyū.
Bamboo; l. 17.6 cm.
Momoyama period, 16th century

166. TEA SCOOP (WITH CASE)

Attributed to Sen no Rikyū.
Bamboo; l. 17.3 cm.
Momoyama period. 16th century

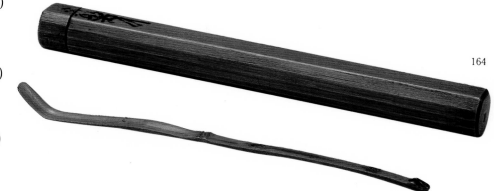

164

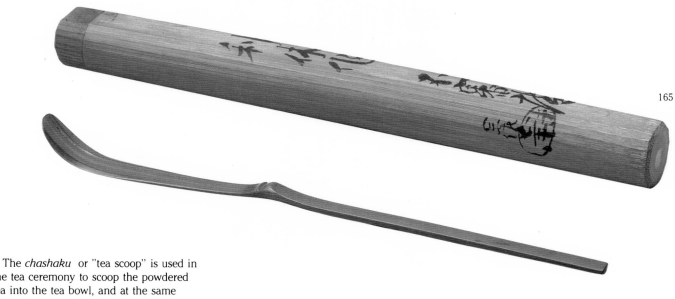

165

The *chashaku* or "tea scoop" is used in the tea ceremony to scoop the powdered tea into the tea bowl, and at the same time is appreciated as an object of art. Moreover, as bamboo tea scoops were made by the tea masters themselves rather than by craftsmen, they came to be highly valued as expressions of each master's creative skill in evoking the natural quality of the material to produce an object of formal beauty.

The tea scoop in number 164 is named "Mushikui" or "Worm-eaten," and all three of these tea scoops are attributed to the great tea master Sen no Rikyū, who developed the "wabi" style of tea.

166

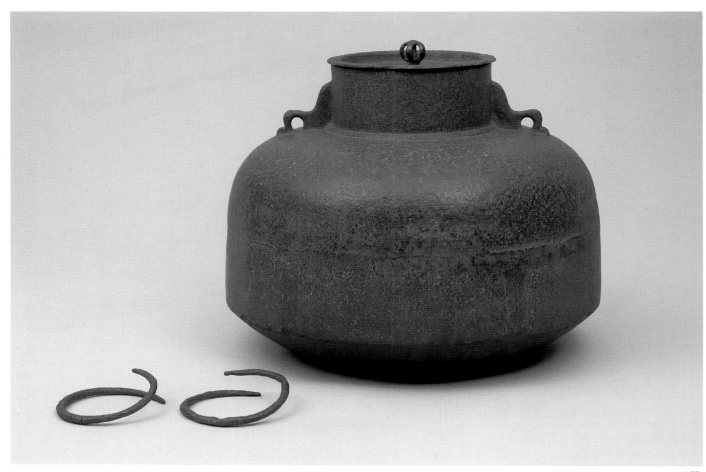

157. KETTLE, NAMED "KAJI"

Iron; h. 21.7, diam. 27.0 cm.
Muromachi period, 14th-15th century

This cast-iron kettle is used to boil water used in the tea ceremony. In the context of the tea ceremony, the kettle is both a practical item, as well as an object worthy of artistic appreciation. In judging the aesthetic qualities of a kettle, the elements of shape, surface texture, and pattern are the principal elements of appreciation. This particular kettle is noted for its stable, balanced shape and its distinctive rough surface texture. It was cast in Temmyō, of Sano in present-day Tochigi Prefecture, one of the two major centers producing kettles during the Muromachi period. Its name, "Kaji," can mean either oar, rudder, or paper mulberry. First owned by Furuta Oribe (d. 1615), favored pupil of the great tea master Sen no Rikyū (d. 1591), this kettle subsequently came into the possession of the first Tokugawa shogun, Ieyasu.

158

158. WATER JAR, NAMED "IMO-GASHIRA"

Ceramic, unglazed;
h. 17.3, diam. 18.2 cm.
Southeast Asian, 16th century

The *mizusashi*, or fresh-water jar, serves as a container for the clean water used in the tea ceremony. In the tea ceremony, there are both elaborate, ornate utensils and those which are characterized by their simple, unassuming quality. The former were used primarily for formal gatherings in the reception rooms of official residences, while the latter were used in simple, thatched tea huts. These unassuming utensils were not considered coarse or vulgar, rather they were preferred because in them could be found an expression of a new aesthetic sensibility that had emerged after having experienced a surfeit of richness and extravagance.

This unglazed jar of the *Namban* (literally, "Southern Barbarian") type from Southeast Asia is representative of tea utensils that embody this aesthetic of simple harmony. Such objects came to be valued so highly that they were thought to be worth as much as a large castle.

Named "Imo-gashira" (Potato Head), this jar was owned by the leading tea master of the late Muromachi period, Takeno Jōō and later came into the possession of the first Tokugawa shogun, Ieyasu.

167

168. TEA BOWL

Ceramic, white *Temmoku* with gold-bound rim;
h. 6.4, diam. 12.1 cm.
Muromachi period, 15th-16th century

Along with the introduction of the practice of drinking powdered tea, *kensan temmoku* teabowls (see no. 76) began to be imported into Japan in large quantities. Soon, attempts were being made by Japanese potters to produce imitations of these Chinese *Temmoku* bowls. These attempts proved successful, and during the

fifteenth century they were produced in large quantities at kilns in the Seto region. Later, the same potters began to make ash-glazed tea bowls in addition to the iron-glazed *Temmoku* ware. This white *Temmoku* tea bowl was made in the manner of these ash-glazed bowls. Its shape and color deeply impressed tea ceremony devotees, who came to greatly admire it as a rare and treasured object.

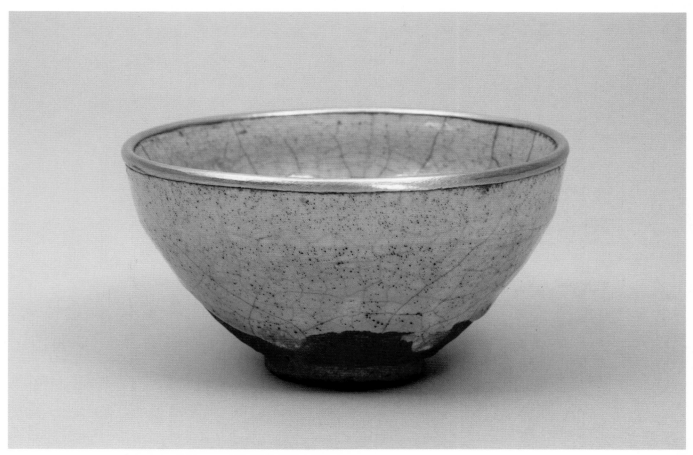

168

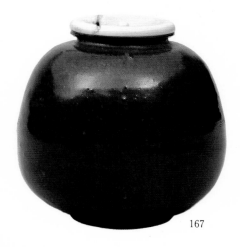

167

167. TEA CADDY, NAMED "AKANEYA-NASU"

Ceramic, iron-glazed; h. 7.4, diam. 8.0 cm.
Chinese, Southern Song period, 12th-13th century

Among tea ceremony utensils, Chinese tea caddies were considered to be exceptionally valuable. Some were even treasured so highly that it was believed an entire province or castle could be sacrificed in order to obtain them. This tea caddy, famed for centuries, is in the form of an aubergine, and is considered to be especially beautiful for the deep, chestnut-

brown color of its iron glaze.

This tea caddy is named after Akaneya Yoshimatsu, a wealthy Sakai merchant who owned it during the second half of the sixteenth century. At that time, the city of Sakai, like Venice, was governed democratically by councils of merchants, and Akaneya was a member of one of these councils.

169

The guests invited to the tea ceremony proceed up this narrow path walking on the stepping stones, cleanse their mouths and wash their hands with the water provided, and enter the tearoom through the small entrance.

169. TEA BOWL, NAMED "Ō-GŌRAI"

Ceramic, Ido type with crackled, buff-grey glaze;
h. 8.5, diam. 14.8 cm.
Korean, Yi period, 16th century

Tea bowls with this type of light, buff-grey glaze, are generally known as Ido tea bowls. They were first brought to Japan from Korea in the second half of the sixteenth century, and soon came to be considered the most desirable bowl for use in the tea ceremony. The sense of serenity and grandeur, along with a certain air of loneliness, evoked by such bowls have made them the objects of deep admiration. These qualities are associated with the sense of *wabi,* an aesthetic principle essential to the tea ceremony.

Named "O-gōrai" or "Great Koryo" after the country of its origin, this bowl was at one time owned by the first Tokugawa shogun, Ieyasu.

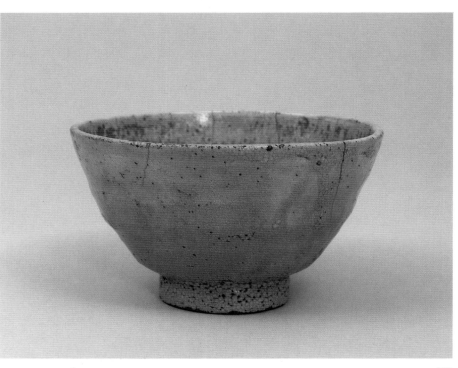

169

170. TEA BOWL, NAMED "FUYUGARE"

Ceramic, black Oribe;
h. 9.2, diam. 10.2cm.
Momoyama period, 16th century

The surface of this cylindrically-shaped tea bowl is divided into black and white glazed portions. The design in the black glazed portion has been made by scraping the surface to reveal the white clay body, while those on the white slip have been applied with iron pigment. The abstract patterns thus created suggest withered trees and grasses in a winter field (hence its name "Fuyugare" or "Bare Winter Field"), and can be said to resemble the paintings of Joan Miro (b. 1893). This piece reflects the originality of the Momoyama period.

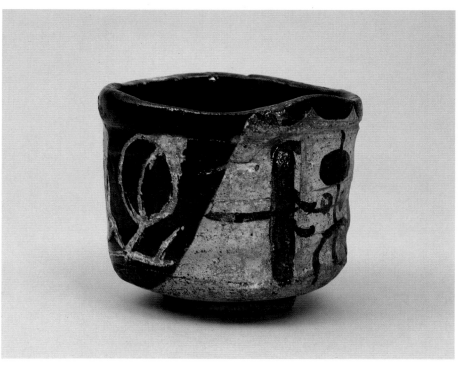

171. WATER JAR, NAMED "SEIKAI"

Ceramic, Ko-Bizen ware;
h. 18.0, diam. 18.2 cm.
Muromachi period, 16th century

This *mizusashi* or fresh-water jar was used to hold the clean water required in the preparation of tea and has the appearance of an ordinary, unglazed jar. Its form derives from that of ceramic jars used by farmers to store hemp seed, and such utilitarian objects appealed to tea ceremony devotees, who adopted them for their use. This piece, however, was made specifically for use as a tea ceremony utensil, and is a typical example of wares produced at the Bizen kilns in the early part of the sixteenth century. Named "Seikai" or "Blue Sea," it was owned by the leading tea master Takeno Jōō.

179

171

179. TEA-LEAF JAR, NAMED "KINKA"

Ceramic with yellowish glaze;
h. 41.5cm.
Chinese, Yuan-early Ming period,
13th-15th century

This piece was made in Southern China and is representative of a type of jar imported in large quantities to Japan from the early fourteenth century. These jars were used for storing leaf tea and came to be viewed as objects of rare value. By the sixteenth century, they were appreciated as objects of art and were seen both in simple, thatched tea huts and the reception rooms of daimyos.

Chinese tea-leaf jars came to be considered important utensils associated closely with the tea ceremony. Every year the family of the Tokugawa shogun despatched a procession to the tea-growing district of Kyoto; the men would carry these jars and have them filled with fresh leaf tea for use by the Tokugawa family. During the journey to and from Kyoto, these processions were assigned a rank equal to that of mid-ranking daimyos.

Named "Kinka" or "Golden Flower," this tea-leaf jar was passed from hand to hand among powerful warlords in the sixteenth century, and subsequently came into the possession of the first Tokugawa shogun, Ieyasu.

173. INCENSE BURNER, NAMED, "SHIRAGIKU"

Ceramic, Longquan celadon with paulownia wood lid;
h. 6.5, diam. 9.1 cm.
Chinese, Southern Song-Yuan period, 12th-13th century

Three rows of raised triple bands circle the body of this celadon incense burner. The piece is supported by a foot situated at the center of the base, so that the three decorative feet attached to the outer edge of the base are suspended slightly above the surface. The lid is made of paulownia wood and is decorated with a design of white chrysanthemums in white and verdigris pigments, in keeping with its name, "Shiragiku" or "White chrysanthemum."

This small incense burner was either placed on a shelf to emit the fragrance of burning incense or held in the palm of the hand to absorb the fragrance at closer range.

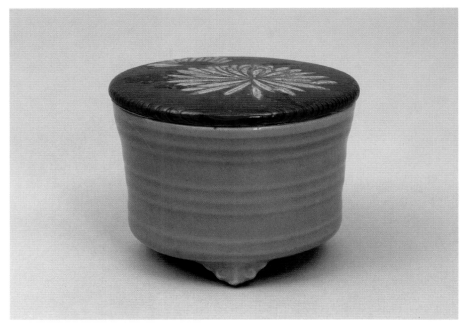

173

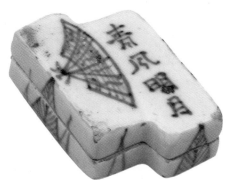

177

177. INCENSE CONTAINER

Design of fan, Chinese characters, and fishing nets in blue and white porcelain;
5.6 × 3.6 × 2.1cm.
Chinese, Ming period, 17th century

178. INCENSE CONTAINER IN THE SHAPE OF A SWAN

Overglaze color on porcelain;
h.13.0 cm.
Dutch, 18th-19th century

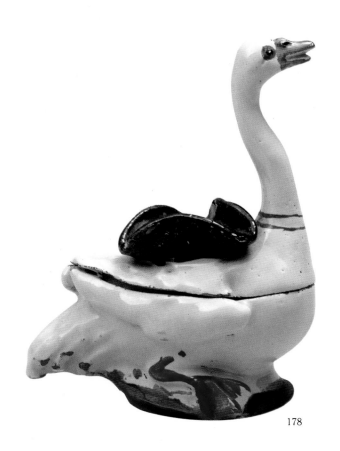

178

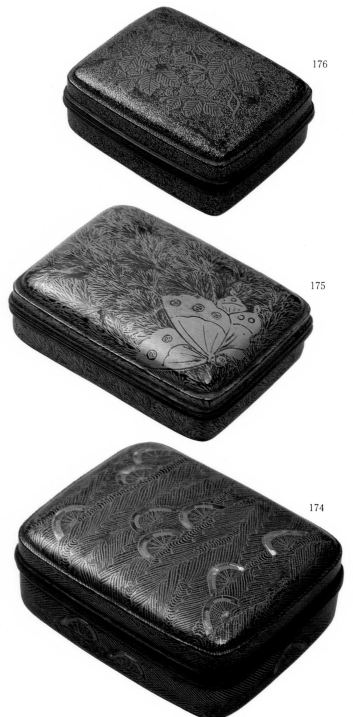

176

176. INCENSE CONTAINER

Design of paulownia tree in *maki-e* on an aventurine lacquer ground;
8.8 × 7.1 × 3.6cm.
Momoyama period, 16th century

175

175. INCENSE CONTAINER

Design of butterfly among hare's-foot ferns in *maki-e* on an aventurine lacquer ground;
7.7 × 6.3 × 3.2cm.
Muromachi period, 15th-16th century

174

174. INCENSE CONTAINER

Design of wheels half submerged in a stream in *maki-e* and inlaid mother-of-pearl on an aventurine lacquer ground;
7.7 × 6.2 × 3.2cm.
Kamakura period, 13th century

In the tea ceremony, incense is burned for the enjoyment of the arriving guests. The small, lidded container for keeping the aromatic wood is called a *kōgō*. Incense was made from the fragrant wood of trees not native to Japan and was thus a sparingly-used, imported commodity with a value equal to that of gold. Consequently, only unusual imported vessels or domestic containers of exceptional aesthetic value and technical accomplishment were considered appropriate for use as *kōgō*. Lacquer and porcelain were the materials most often used in making *kōgō*, although

wood and metal examples are also found.

The design of number 174 is known as *katawaguruma* ("warped wheels"), one of the most popular motifs in the history of Japanese decorative arts. The half-submerged cart wheels that were soaked in the waters of mountain streams to prevent their drying out are arranged in groups of one, two, and three wheels. Inlaid mother-of-pearl and gold *maki-e* combine to produce wheels of considerable variety.

Number 177 was produced in Ming China during the fifteenth century. This

kōgō is in the shape of wooden clappers called *hyōshigi* that were used to keep musical time. Its design includes a fan and four Chinese characters meaning "fresh breeze and bright moon" on the top of the lid with triangular fishing nets along the sides.

Number 178 is notable in that it was produced in Holland, the only European country with which the Tokugawa regime conducted trade after the closing of the country in 1640. But even this contact was severely restricted to only one mission a year and through a single port, Nagasaki.

172. VASE

Ceramic, Longquan celadon;
h. 25.1, diam. 9.4 cm.
Chinese, Southern Song period, 12th-13th
century

This celadon vase was produced at the
Longquan kilns in China. It is represent-
ative of a type of celadon porcelain ware
which the Chinese began to produce in an
attempt to represent jade, a substance held
in particularly high esteem. This vase is
modeled after a type of ancient Chinese
ritual jade called a *zong,* which was first
produced during the late neolithic and early
bronze age of China.

172

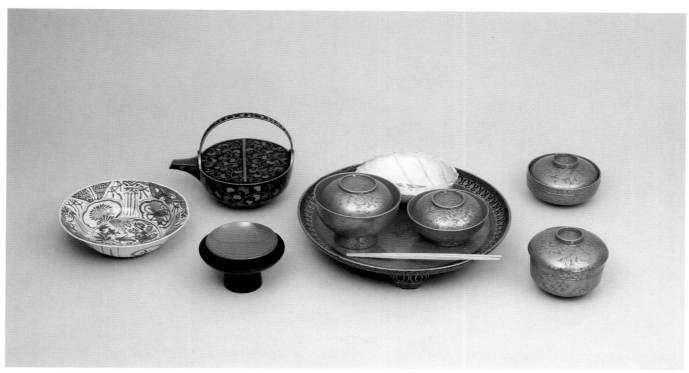

180-185. UTENSILS FOR SERVING THE TEA CEREMONY MEAL (*KAISEKI*)

Three-footed dining tray, set of dining bowls, *mukōzuke* dish, bowl, three *sake* cups and their stand, and *sake* container.
Edo period, 18th-19th century

The tea ceremony is not merely a time for drinking and appreciating high quality teas; it was a distillation of Japanese aesthetics, customs, and etiquette. During the course of the ceremony, rare incense was enjoyed, art objects including the tea utensils themselves, were appreciated and evaluated, and a specially prepared meal was consumed. The contents of this meal, which preceded the serving of thick tea in formal tea ceremonies, depended upon the guests who were in attendance. The meal could range from an exquisitely prepared feast to simple, light fare that would only temporarily satisfy one's hunger. But even these so-called humble meals would be served on the finest lacquer and ceramic vessels, and the utmost care was taken in the preparation of the color and flavor of the food that was as pleasing to the eye as it was to the palate. Developed from the vegetarian menus of Zen monasteries, this meal was known by a number of names, including *cha-kaiseki* or simply *kaiseki*.

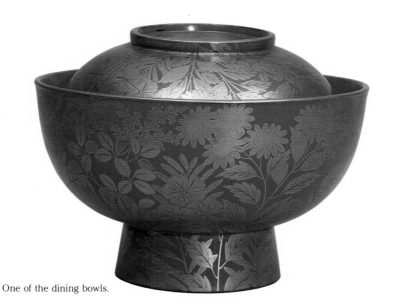

One of the dining bowls.

175

KYŪBI

THE QUEST FOR BEAUTY

PART IV.
THE QUEST FOR BEAUTY

As the atmosphere of the turbulent period of civil war gradually began to diminish, it was natural that the samurai should devote themselves not only to the military arts, but also to learning and the fine arts. The shogun and daimyo, with their unquestioned power, were in a position to assimilate many different types of culture; from the point of view of maintaining the authority of the shogunate, it was essential to adopt elements from the aristocratic culture of the Kyoto court nobility, Chinese scholarship, and the teachings of Confucianism, as well as retain their own samurai culture. Tokugawa Ieyasu laid the foundations of the shogunate on the teachings of Confucianism and Neo-Confucianism. In order to further the organization and policies of the shogunate, Ieyasu recognized that the stability of the spirit and the development of men of talent, in other words the promotion of scholarship and education, were essential for the nation's very basis. He also perceived that a new system of values, order, and morality was necessary for the consolidation of the nation under the shogunate. In line with the policy of the shogunate, the daimyos all adopted Confucianism on the official plane. In contrast, Buddhism was worshipped individually as a private belief. In keeping with Ieyasu's final admonition to excel in the literary as well as the military arts, the successive shoguns and daimyos studied painting and calligraphy from the time of their youth, stimulated and enlightened by the achievements of the Japanese and Chinese artistic heritage. Some of these high-ranking practitioners of the arts produced works that would have done justice to professional artists. As part of the continuation of the cultural heritage from preceding ages, superb art works, such as narrative painting scrolls, paintings mounted as folding screens, and genre paintings, were collected. These, however, were largely confined to the realm of individual, personal interests. The works of art that were handed down for generations in the families of the shogun and daimyo during the Edo period demonstrate the values and aesthetic sensibilities of the Japanese people that are still in evidence today.

RELIGIOUS TENETS AND PHILOSOPHIES

A view of the Jōkō-ji Mausoleum
(Grave of Tokugawa Yoshinao, the first lord of
the Owari Tokugawa family).

With the establishment of the shogunate, along with a growing requirement within the society at large for scholarship, it became evident that there was a need to establish a theoretical basis for the feudal society. With its emphasis on the social order and social position, Confucianism, specifically Neo-Confucianism, was selected as the most suitable set of teachings for the needs of the shogunate.

From the period of the rule of the fifth shogun Tsunayoshi (r. 1680—1709), with the adoption of the policy of civilian administration and the diminishing of the atmosphere of militarism that had prevailed until that time, the shogunate began actively to stress the Confucian teachings. Hayashi Nobuatsu (Hōkō), grandson of the Neo-Confucian scholar Hayashi Razan (1583—1637), was appointed head of the official Confucian college, and his private school was transferred to Yushima in Edo. The teachings of Neo-Confucianism were thus officially adopted. During the Kansei Reform, the stauch Neo-Confucianist Matsudaira Sadanobu (1758—1829) renovated the Confucian college and banned all unprescribed teachings. During the Edo period, Neo-Confucianism served as the orthodox philosophy of the feudal society.

During the rule of the third shogun, Iemitsu, the policy of isolation was implemented, and the Christian teachings proscribed, requiring the Japanese to adhere to the three teachings of Confucianism, Buddhism, and Shintō. After the death of the founder of the shogunate, Ieyasu, the Tendai monk, Tenkai, in keeping with the identification of the indigenous Shintō gods with the deities of Buddhism, had posthumously deified Ieyasu as "Tōshō-Dai-Gongen," an avatar of the Buddha. In the succeeding centuries, the instructions of the deified Ieyasu were invoked when attempting to buttress the structure of the Tokugawa shogunate.

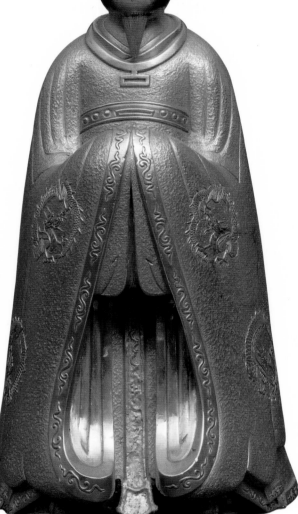

214C

214. THREE CONFUCIAN STATUETTES

A: Confucius, brass covered with pure gold,
 h. 19.3cm.
B: Fu Xi, brass covered with pure gold,
 h. 20.3cm.
C: King Wen, gold, h. 21.1cm.
 Edo period, 17th-18th century

214A

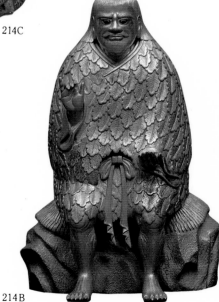

214B

Tokugawa Yoshinao, first lord of Owari and an assiduous student of Confucianism, preceded the shogunate in building a Temple of Confucius in the precincts of Nagoya Castle, enshrining therein statues of sages such as Confucius and the Duke of Zhou. The statuettes of Confucius and Fu Xi in the present group were among those produced at that time; they are made of brass covered with pure gold.

The statue of King Wen is recorded as being one of the five statuettes of Confucian sages commissioned by the civil administrator of the Sado mine, Ōkubo Nagayasu, and made of gold from the same mine. This statuette has been modelled from 2.2 kilograms of pure gold.

179

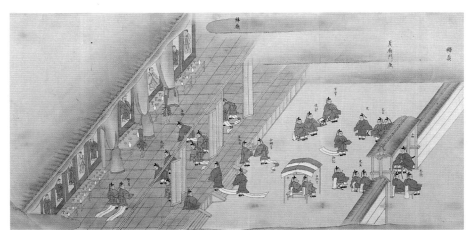

215 (detail)

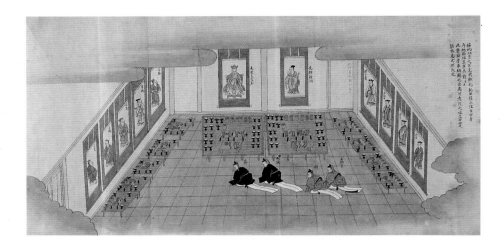

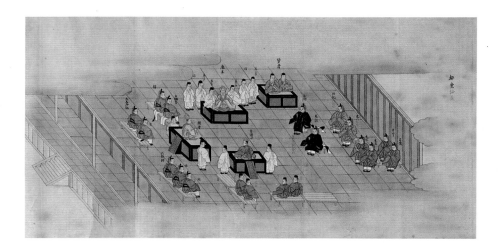

215. SCENES OF A CONFUCIAN FESTIVAL

Handscroll, ink and colors on paper;
41.0 × 993.6cm.
Edo period, Dated in accordance with 1729

The festival, called *Sekiten* (also *Shakuten*), is a formal ceremony observed principally in honor of the Chinese sage Confucius (but which may also include others, such as Yen hui, a favorite disciple of Confucius). Its celebration consists of making offer-ings before the image of the deity, and this festival is held twice a year on the first *hinoto* day (one of the Ten Stems assigned in the lunar monthly calendar) of the second (spring) and eighth (autumn) months respectively. First celebrated in Japan in 701, observance of the festival was on the wane from the Muromachi period onwards. However, it was revived in the Edo period, when it served as a manifestation of the official policy of the shogunate, which had adopted Confucian-ism as the foundation for a disciplined social order. Perhaps the intention of the Tokugawa rulers was to reaffirm as statesmen their commitment to emulate the sages and thus to equal their virtue.

216. THE *FUMON* CHAPTER OF THE *LOTUS SŪTRA*

Handscroll, ink colors, gold, and silver on
decorated paper; 25.1 × 258.5cm.
Heian period, 12th century

The *Lotus Sūtra* (in Sanskrit, the
Saddharma-puṇḍarīka-sūtra; in Japanese,
the *Myōhō-renge-kyō* or the *Hokke-kyō*) is
the Western name for one of the most
important texts in the enormous Buddhist
canon. It was first recorded in India about
the time of Christ and then translated six
times from Sanskrit to Chinese before
making its way to Japan in the sixth
century.

Illustrated here is chapter twenty-five
of this sūtra, which is known by either of
two names, the *Fumon* Chapter or the
Kannon Sūtra (*Kannon-gyō*). It describes
and interprets numerous pious acts of
Kannon Bosatsu (Sanskrit: Avalokiteśvara),
the Buddhist deity of mercy and compas-
sion. In this chapter Kannon comes to the
aid of beings in distress by assuming
thirty-three different forms, depending upon
the nature and circumstances of the person
to be saved. Kannon thus exhibits in this
chapter the "all-sided" (*fumon*) nature of
his mercy and powers of salvation.

In the frontispiece illustration, one of
these merciful acts is depicted in brilliant
colors, a scene where shipwrecked voyagers
are saved from the middle of a tempestuous
sea by the mysterious and all-pervading
power of Kannon. In the top half are
depicted threatening fantastic fish and
dragons and a shipwrecked boat with
baggage strewn overboard in a stormy sea
with high, swirling waves, while in the
lower half travelers rescued by the grace
of Kannon enjoy an undisturbed trip
across tranquil seas.

A variety of paper-decorating techniques
were used to adorn this sūtra. Mica, pieces
of cut gold and silver leaf of varying sizes,
and finely powdered particles of gold and
silver were applied to this paper. The
painting is executed in deep, rich colors
according to the canons of a painting
mode called *Yamato-e* (literally, "Japanese-
style painting").

The text itself is written in black ink in
a restrained but elegant calligraphic style.

Above and below this text are waves in
silver paint which echo those found in the
frontispiece illustration. Many sūtras lavishly
decorated in this manner were produced for
the nobility of the late Heian period
(12th century).

Because this sūtra was stored amidst the
armor, clothing, and other personal
effects of Tokugawa Ieyasu in the
Tōshō-gū Shrine on the grounds of Nagoya
Castle, there is a possibility that this sūtra
too was a part of the bequest of Ieyasu.

217. *KEGON-KYŌ*

Folding book, gold and light colors on
indigo-dyed paper; 31.0 × 475.2cm.
Korean, Koryŏ period, 14th century

The placement of characters written in
gold pigment upon paper stained a deep
blue creates a luminous effects that rivals
the profound theological brilliance of the
concepts expounded in the text. This same
dazzling contrast is achieved in the
frontispiece painting of Birushana-nyorai
finely delineated in delicate gold lines
seated atop a dais preaching to a multitude
of heavenly beings, several of whom have

identifying cartouches. The cover of the
book bears the full title of the sūtra
surrounded by an elaborate design of
arabesques and floral scrools. Birushana-
nyorai (Sanskrit: Vairocana or Mahāvairo-
cana) symbolizes the unknowable first
principle of the universe, the great
generative force, the origin of all other
Buddhas and all states of being. The full
title of this sūtra is *Daihōkōbutsu-kegon-kyō*
(Sanskrit: *Buddha-avataṃsaka-nāma-
mahāvaipulya-sūtra* or the *Expanded sūtra
of the Buddha Adorned with Garlands*).
Commonly known as the *Kegon-kyō*
(Sanskrit: *Avataṃsaka-sūtra*), it is considered

the first discourse of the Buddhist canon
in East Asia, detailing the circumstances
surrounding the Buddha's enlightenment.

Only recently has it been determined
that this folding book is a Korean work of
the fourteenth century during the late
Koryŏ period (918—1392). In the Edo
period it was considered a work of the
Heian period monk, Jie Daishi, who lived
in the tenth century. Also, several
fragments of this sūtra can be found in
large collections of ancient calligraphy
called *tekagami* ("models of calligraphy").

217

218. THE *FUMON* CHAPTER OF THE *LOTUS SŪTRA*

Chiyohime (Reizei-in)
Folding book, ink, gold, and silver on decorated
paper; 29.1 × 569.4cm.
Edo period, 17th century

The *Lotus Sūtra* (see no. 216) is said
to be the last and most perfect of the
sermons of the historical Buddha.
Presented in a form that could be
easily grasped by all, the *Lotus Sūtra*
enjoyed a popularity unrivalled by other
Buddhist texts and exerted a tremendous
influence on Japanese culture.

At the same time, the *Lotus Sūtra* is
unique among Buddhist scriptures in that it
asserts that the attainment of enlighten-
ment was possible for women. In earlier
Buddhist texts, women were excluded from
Buddhahood, and virtuous women had to
be reborn as men before they were eligible
to reach the exalted state. The *Lotus Sūtra*
gained widespread acceptance in the Heian
period, when women at the imperial court

218

figured largely in the cultural achievements
of the time.

Illustrated here is a copy of the *Fumon*
Chapter of the *Lotus Sūtra* written in the
cursive native Japanese script of *hiragana*
by Chiyohime, the daughter of the second
shogun, Iemitsu, and the wife of Tokugawa
Mitsutomo, the second lord of Owari.

Most Buddhist texts were written entirely
in Chinese characters. Chinese characters
were, however, at this time considered the
domain of men and not thought to be a

proper field of study for women. As a
result, in copying Buddhist texts, the native
Japanese *kana* script was at times
employed by women.

Chiyohime's calligraphic style is flowing
and elegant and is complemented by the
paper decoration consisting of autumn
flowers and grasses executed in gold and
silver pigment. This elaborate paper is
further decorated by cut gold and silver leaf
and gold and silver dust.

219. MANIFESTATION OF HACHIMAN IN THE GUISE OF A BUDDHIST MONK

Hanging scroll, ink, colors, and gold on silk;
79.4 × 40.1cm.
Kamakura period, 14th century

This painting served as the personification of the deity in the Hachiman Shrine that stood within the garden of the Owari Tokugawa family's principal residence in Edo.

The Shintō *kami* (god) Hachiman was the deity worshipped by the military class. He was particularly venerated by the Genji clan (the Tokugawa family also had the adopted surname Genji) as its tutelary god (*ujigami*). Hachiman was also traditionally revered as the guardian deity of the Owari Tokugawa family.

The practice of representing the god Hachiman in the form of a Buddhist monk is believed to have originated in about the ninth century. The early sculptural examples at the Tō-ji (Kyoto) and Yakushi-ji (Nara) are well known. In painting, there are no extant works earlier than the thirteenth century. Among the various forms assumed by this deity seen in iconographic drawings, the most common is one in which the image, facing obliquely, is seated on a lotus pedestal. The present painting is the only known example in which Hachiman is in a frontal pose and seated in a chair. The diminutive figure in the lower left of the painting is thought to be Takenouchi no Sukune.

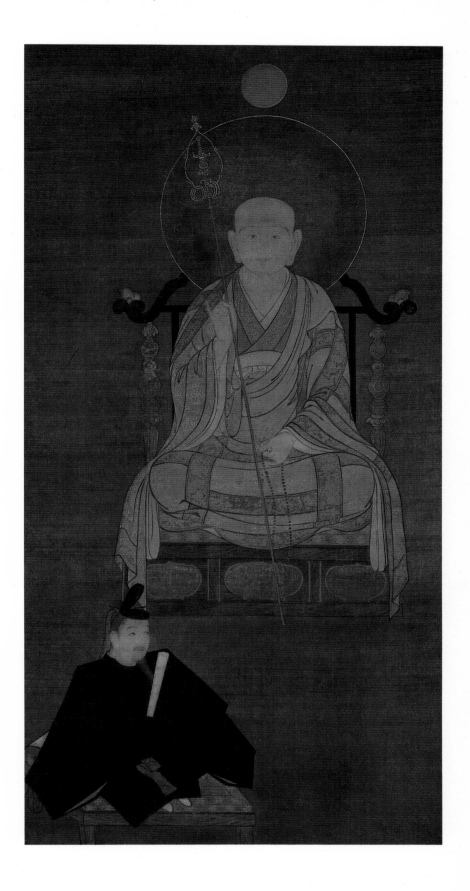

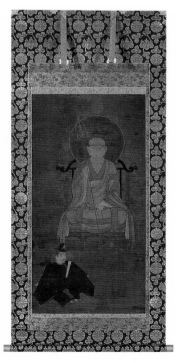

219

220. KASUGA MANDALA

Hanging scroll, ink, colors, gold pigment, and
cut gold leaf (*kirikane*) on silk;
65.1 × 26.7cm.
Kamakura period, 13th-14th century

In the upper portion of the painting is
depicted a commanding view of the pre-
cincts of the Kasuga Shrine with its five
main buildings. An image of Fukūkenzaku
Kannon (Sanskrit: Amoghapāśa, the *honji
butsu* (that is, the original, fundamental
Buddhist form) of Takemikazuchi no Mikoto,
the Shintō deity of the first of the Kasuga
Shrine's sanctuaries, is represented in the
painting's lower portion.

The particular foliate form of the man-
dorla of the Kannon is unusual, and is
recognized as the form adopted in the
principal image enshrined in the Nan'en-dō
of the Kōfuku-ji in Nara. The Kasuga Shrine
and the Kōfuku-ji were constructed as the
tutelary shrine and temple, respectively,
of the Fujiwara clan. The two institutions
were equated and the worship associated
with them was integrated.

The representation of a Shintō shrine
in a landscape setting was established
sometime in the late Heian period (ca. 12th
century). The design was intended to serve
as a means by which the devotee could
worship in front of the shrine without having
to make the actual pilgrimage. Whether or
not the artist had in mind the Shintō con-
cept of "rebirth," he has nonetheless
depicted the new growth and blossoming
cherry trees of spring-time.

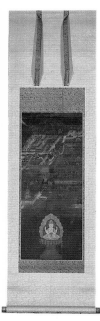

221. THE DEPARTURE FROM KASHIMA

Hanging scroll, ink, colors, and gold on silk;
101.8 × 40.0cm.
Muromachi period, 15th century

The development of the Shintō religion
originated in the indigenous beliefs peculiar
to the Japanese people. From about the
latter half of the eighth century, together
with the rise in popularity of Buddhism,
there evolved an interaction between this
imported religion and the native Shintō.
In time the concept of *honji-suijaku* arose,
according to which Shintō *kami* (gods)
were regarded as provisional embodiments
or avatars of universal Buddhist deities.
The idea was also preached of combined
Shintō-Buddhist practice, in which Shintō
kami and deities of the Buddhist pantheon
were considered as having in essence
a single identity. Paintings were produced
that gave concrete expression to these
doctrines.

This painting illustrates the tradition of
the founding of the Kasuga Shrine at the
foot of Mount Mikasa in Nara. The scene
portrays Takemikazuchi no Mikoto, who
is said to have established himself as a
deity of this shrine. From the Kashima
Shrine in Hitachi no Kuni (in present-day
Ibaragi Prefecture) to Mount Mikasa, this
kami manifested his incarnate form as he
rode on a white deer, accompanied by
two attendants.

Kanō Tan'yū attributed this painting to
an artist who was employed in the painting
workshop of the Kasuga Shrine, where
stereotyped paintings of this type were
produced in large quatities from the
thirteenth through the fifteenth centuries.
The painting here, done around the first
half of the fifteenth century, is one such
example.

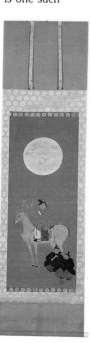

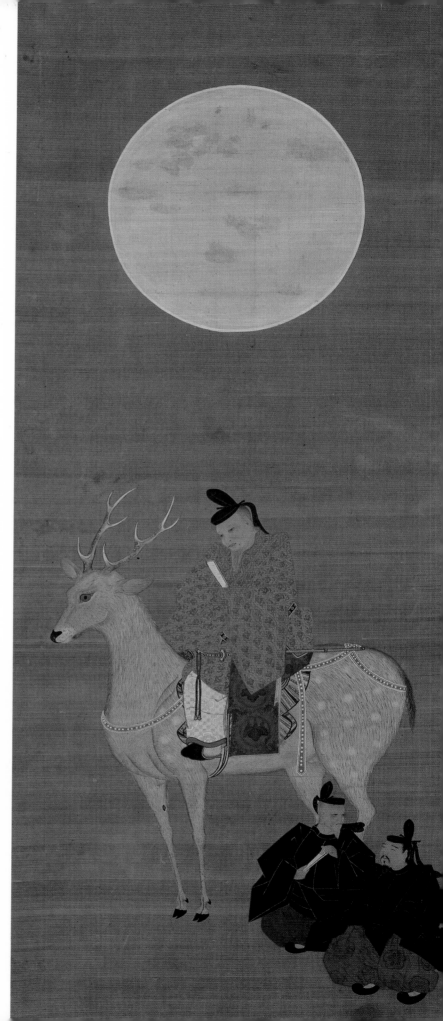

221

THE CULTIVATION OF THE RULING CLASS

The ideal standard for the members of the samurai class was to excel in both the literary and military arts, and and the shogun and daimyo strove to live up to this ideal. Since they were members of the warrior class, they were necessarily required to train in the military arts.

The successive shoguns and daimyos also applied themselves to scholarship, and among them were accomplished scholars such as the fifth shogun Tsunayoshi, who lectured to the daimyos on the Confucian classics. Tokugawa Yoshinao, the first lord of Owari, was also a Confucian scholar of note, and produced a number of treatises on the subject. Aside from Confucian studies, other fields of study included classical Japanese literature, such as the *Kokinwakashū* poetry anthology or the long prose work, *The Tale of Genji*. It was also considered necessary that their accomplishments include a broad knowledge of classical poetic forms, and that they be able to compose poetry as well. The study of painting and calligraphy was also

considered a basic requirement, and lessons began at an early age. Ieyasu studied the calligraphic style of the Heian court noble Fujiwara no Teika (1162—1241), and his painting studies were directed largely by artists of the Kanō School. The tea ceremony was of course included among the necessary accomplishments, since it figured largely in the etiquette governing the receiving of guests. The second shogun Hidetada studied with the tea master Furuta Oribe and Iemitsu was instructed by Kobori Enshū. In addition, Ieyasu patronized the performing art of Nō, and adopted it as the official music-drama of the shogunate. He himself was well-versed enough in the art to perform himself. At the start of every new year the *utai-hajime,* or first Nō-chanting of the year, was conducted and participants were required not only to chant but also to dance.

In this manner, the shogun and daimyo, who formed the uppermost echelon of the ruling administration, were not only political leaders, but also educated men of letters.

187 -189. SU DONGPO; LONG-TAILED COCK ON A BAMBOO STEM; DOVE ON A PLUM BRANCH

Tokugawa Yoshinao (1600—1650; inscriptions)
Tokugawa Mitsutomo (1625—1700, paintings)

3 hanging scrolls (triptych), ink on paper;
138.5 × 39.8cm. each
Edo period, 17th century

These three hanging scrolls are a collaborative work between father and son, Tokugawa Yoshinao and Tokugawa Mitsutomo (the first and the second lords of Owari, respectively), the father adding his inscriptions to the paintings brushed by his son.

Mitsutomo is said to have studied painting with Kanō Tan'yū, and his works display a trained brush manner that is free from amateurishness. Commenting on Mitsutomo's paintings, Edo-period painting histories of the 18th century state that they are "truly excellent" and "refined."

Su Dongpo (1036—1101), the subject of the central painting, was a Chinese literati poet, who also excelled in painting and calligraphy. The triptych form, as seen here, with paintings of birds and flowers flanking a figure painting, had been a traditional combination since the Muromachi period (14th century).

188 187 189

186. FINAL INSTRUCTIONS OF TOKUGAWA YOSHINAO

One of two handscrolls, ink on paper;
36.3 × 151.7 cm.
Edo period, dated Keian 3rd year, 2nd month,
12th day (March 14, 1650)

Tokugawa Yoshinao, the first lord of Owari, died at his Edo residence in 1650 at the age of fifty-one. He wrote a will addressed to his eldest son and successor, Mitsutomo, which was deeply colored by Confucian ethics. The will can be summarized is as follows:
—First and foremost, be loyal to both the ruling shogun, Iemitsu and the memory of his predecessor, Hidetada.
—Do not forget the way of the warrior, its martial discipline and ethical values, as exemplified by the life of *Gongen-sama.*
—Be totally honest and upright and exercise proper discretion at all times.
—The principal duty of the head of a clan is to see into the hearts of his retainers and see through any evil intentions or deeds.

186

190. PORTRAIT OF SAKI NO CHŪSHOŌ (KANEAKIRA SHINNŌ)

Tokugawa Yoshinao (1600—1650)
Hanging scroll, ink and colors on paper;
69.4 × 37.9cm.
Edo period, 17th century

Both the painted figure and the inscription in this scroll are by Tokugawa Yoshinao. Reported to have learned painting from Kanō Tan'yū, Yoshinao apparently made a specialty of figures, and there are a number of works in the neatly ordered, intimate style seen in the present example.

The subject of this painting, Saki no Chūshoō (914—987), was the imperial prince (*Shinno*) Kaneakira, a son of Emperor Daigo. He was reputed to have been a man of extraordinary erudition and talent.

190

191. DANCING HOTEI

Tokugawa Mitsutomo (1625—1700)
Hanging scroll, ink on paper;
32.7 × 55.8cm.
Edo period, 17th century

Paintings of this subject are often entitled "Dancing Hotei," for the simple reason that when Hotei (Chinese: Pudai; "Cloth Bag"), a Chinese Chan monk of the Tang dynasty (618—907), shouldered his staff and sack as he wandered about, it would appear quite as if he were dancing.

Using only ink, the artist has skillfully captured Hotei's "dancing" form by varying the ink tones from light to dark, and by modulating the width of his brushstrokes. The effect is striking, both in Hotei's splendid expression and in the overall composition.

The artist has picked up the idea for his painting from one of the same subject by the Song period Chan painter Liang Kai. Liang's "Dancing Hotei" was one of the articles that belonged to Ieyasu, and after his death was preserved in the treasury of the Owari branch of the Tokugawa family. When Mitsutomo died in 1700, Liang's painting was among his former possessions that were presented to the fifth shogun Tsunayoshi, an dit appears that Mitsutomo had been particularly attached to that work. The painting by Liang Kai is now in the collection of the Kōsetsu Museum in Kobe.

In addition to painting, it is noted that Mitsutomo (the second lord of Owari) excelled in calligraphy and was also adept in the military arts.

192. POMEGRANATE AND PEARS

Tokugawa Muneharu (1696—1764)
Hanging scroll, colors on paper;
41.8 × 28.0cm.
Edo period, 18th century

This painting was executed by the seventh lord of Owari, Tokugawa Muneharu (1696—1764). No background is provided for the pomegranate and pears depicted in the center of the painting surface, the rest of which is mostly a large, blank space. Whereas, technically, the painting is unskillful, it nonetheless possesses a calm dignity befitting the work of a feudal lord.

Possessor of a free, extravagant character, Muneharu adopted policies that went against those of the eighth shogun, Yoshimune. Incurring thereby the latter's displeasure, Muneharu was ordered into retirement. Oddly enough, however, nothing of Muneharu's disposition can be gathered from this or any of his other paintings.

195

193. POEM WRITTEN ON A *TANZAKU*

Tokugawa Yoshinao (1600—1650)
Hanging scroll, ink and gold pigment on oblong decorative paper;
36.6 × 5.8cm.
Edo period, 1st half of the 17th century

Illustrated here is a poem composed and written by Tokugawa Yoshinao, the first lord of Owari. It is written on a *tanzaku*, a long, narrow piece of decorative paper used for writing short poems composed at poetry gatherings.

It is said that "Writing is the man," and this calligraphy is apropriate for an honest person of strict moral character. Most examples of Yoshinao's calligraphic work are written solely in Chinese characters, and works executed in the flowing native Japanese script are few in number.

Gold pigment is used for the depiction of flowering autumn grasses on the decorative paper. This is a summer verse which takes a cuckoo as its subject.

194. POEMS WRITTEN ON *SHIKISHI*

Tokugawa Yoshimichi (1689—1713)
Three square sheets (*shikishi*) mounted as a hanging scroll, ink on decorative paper;
19.0 × 16.6, 15.7 × 15.1, 19.0 × 16.9cm.
Edo period, dated in accordance with 1713

These are specimens of the calligraphy of Tokugawa Yoshimichi (1689—1713), the short-lived fourth lord of Owari. One Chinese poem (left) and two Japanese poems are written on each of three separate paper squares.

These poems are written on the theme of plum blossoms, composed perhaps as Yoshimichi thought longingly of his wife, who was required to reside in faroff Edo.

193

195. POEM WRITTEN ON *KAISHI* PAPER

Tokugawa Munechika (1733—1799)
Hanging scroll, ink on paper; 35.3 × 50.0cm.
Edo period, 18th century

This verse was composed and written by Tokugawa Munechika (1733—1799), the ninth lord of Owari. Reputed to have had a very kind and generous nature and diligent in his scholarly endeavors, Yoshimichi is said to have been a wise ruler who oversaw a revival in the fortunes of the Owari Tokugawa family and its domain. This example of his calligraphy, too, reflects long hours of practice, and is executed in a competent hand that tends to lack an evocative quality. The poem takes a cuckoo (*hototogisu*) on a summer day as its subject.

194

AESTHETIC SENSIBILITIES

Included among the estates of the shogun and daimyo were countless works of art that had been passed down as heirlooms within the family. The most numerous categories include illustrated handscrolls, monochrome ink paintings, paintings on folding and sliding screens, and genre paintings; but there seems to have been only a handful of Buddhist paintings and statuary and *Ukiyo-e.* Successive generations of rulers considered these tangible examples of their cultural heritage to be the ideal of beauty whose appreciation furthered their own cultivation.

Paintings included *Yamato-e,* or paintings in the native Japanese style, which were frequently executed in the illustrated handscroll format and reflected the tastes of the Heian court nobility. Manifesting another set of aesthetic values altogether, the Chinese monochrome ink paintings of the Song and Yuan periods were prized during the period of the Ashikaga shoguns. These Chinese paintings greatly influenced the Japanese Zen monks who also practiced ink painting, beginning a development in Japan that culminated in the works of Sesshū (1420—1506). The aesthetic possibilities opened by ink painting in the Chinese style were further developed by the Kanō school with its fusion of the austere mode of ink painting and the highly polychromed techniques of *Yamato-e.*

The panoramic paintings executed on large surfaces such as sliding and folding screens, as well as genre painting, developed under the patronage of the great generals Oda Nobunaga, Toyotomi Hideyoshi, and Tokugawa Ieyasu. With the advent of the Edo period, the Tokugawa shogunate officially patronized the Kanō School as *goyō-eshi,* a position that passed in hereditary succession within that school of painters. Artists of the Kanō School executed commissions for the shogun and the daimyo, dominating the painting circles of the time and providing the basis for the aesthetic preferences of the ruling class.

196. PORTRAITS OF EMPERORS, REGENTS, AND ADVISORS

Handscroll (one of a set of two), ink and colors on paper; 33.0 × 541.0cm.
Kamakura period, 13th century

This first scroll of a set of two contains portraits depicting fourteen emperors from the middle of the twelfth century to the first half of the thirteenth century, from ex-Emperor Toba downward. The portraits of three emperors and nine other personages in Buddhist monastic garb, together with eleven imperial regents and chief advisors (*kampaku*) from Fujiwara no Tadamichi (1097-1164) onward, comprise the latter scroll.

The facial features are given a realistic interpretation, catching precisely the individual character of each subject. In contrast, the artist shows little interest in the treatment of the robes, notwithstanding a certain amount of variation in their presentation; in conveying a sense of the texture of their material and in the representation of their pleats the painting is less accomplished, even to the point of being merely conventional.

A type of portraiture of emperors and courtiers that sought to achieve a likeness (*nise*) of the subject was popular from the latter half of the twelfth through the thirteenth centuries. The court artists Fujiwara Takanobu and his son, Fujiwara Nobuzane, are particularly eminent representatives of this portrait-painting tradition. Although these paintings have been attributed traditionally to Nobuzane, they are not the work of a single artist, but display instead a mixture of brushwork, indicating the participation of several painters.

196 (detail)

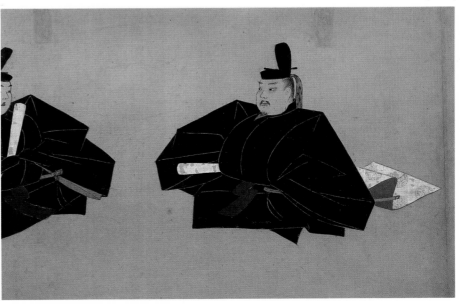

190

197. TALE OF HAIZUMI (HAIZUMI MONOGATARI EMAKI)

2 handscrolls, ink and colors on paper;
33.3 × 503.9cm.
33.3 × 508.1cm.
Kamakura period, 14th century

The tale (*monogatari*) illustrated in this narrative scroll painting (*emaki*) is based on the tragicomic theme of a young woman who mistakenly applied her cosmetics, totally confusing the white paint to put on her face with her black eyebrow paint. The story was well-known among the Japanese people, since it had earlier been included in the *Tsutsumi Chūnagon Monogatari,* a collection of short tales compiled around the beginning of the

eleventh century.

The first scroll, in which the story unfolds in one text portion and two lengths of illustration, depicts a startled monk fleeing at the sight of the blackened face of the girl who has so unwittingly erred in putting on her makeup; her painful realization of the truth leads her, wailing and weeping, to embrace Buddhism. In a single passage of text and illustration, the second scroll continues with a scene of the young woman having her hair clipped to become a nun; finally, mother and daughter together are shown having retreated to a

hermitage in Kitayama (the "Northern Hills" of Kyoto) to live out their days.

This work is noteworthy as belonging to a transitional period marking the shift away from classical *Yamato-e* picture scrolls dealing with courtly themes to scrolls depicting *otogi-zōshi* (short folktales, often parables, and sometimes very humorous).

This scroll contains particularly beautiful depictions of natural scenery in the four seasons. The paintings are, moreover, valuable reference material for the study of the architecture, manners, and customs of the period.

198. TREE PEONIES

Attributed to Sesshu Tōyō (1420-1506)
Pair of eight-fold screens, ink and colors on
gilded paper;
162.9 × 361.0cm. each
Muromachi period, 16th century

On this pair of screens, tree peonies
tossed in a violent wind are set in
contrast to a calm, resplendent display of
these same large flowers at the peak of
their blossom. They are painted in deep,
saturated colors against a ground of gold
leaf. The flowering peony plants are the
sole pictorial elements, placed on a back-
ground altogether devoid of any elements
of setting.

A seal which reads "Tōyō" impressed on
each screen has been responsible for their
attribution to the artist Sesshū (1420—1506).
Among accepted paintings by this master,
however, no other works in this style are
known today. The style and composition
of these screens indeed suggest a date of
production somewhat later than Sesshū.

A style that promoted even greater
compositional simplification within a limited
range of subject matter reached its zenith in
the Momoyama period in the hands of the
Kanō school artists, exemplified by Kanō
Eitoku (1543-1590). These screens appear
to presage this development and, as such,
are valuable works of art.

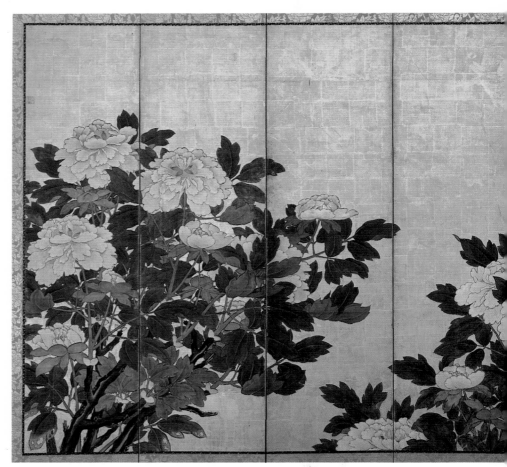

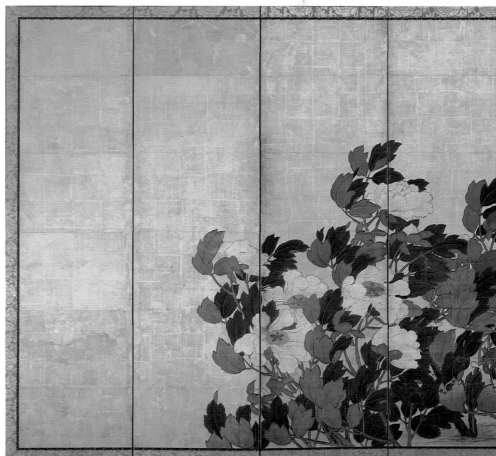

198

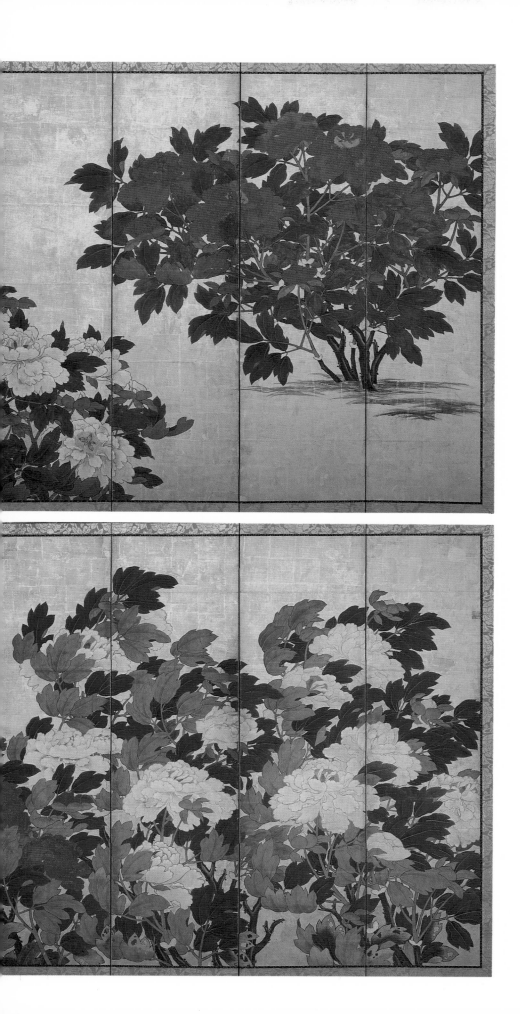

199. BIRDS AND FLOWERS IN THE FOUR SEASONS

Attributed to Kanō Sanraku (1559-1635)
Pair of six-fold screens, ink, colors, and gold
leaf (partially over *gofun*) on paper;
158.4 × 355.6cm. each
Edo period, 17th century

Scenes of birds and water fowl amidst
flowers and trees of the four seasons are
painted in strikingly fresh, rich colors; the
"floating" ground of gold leaf and gilding,
and the effectively arranged lozenge-
figured clouds set in relief sum up the
very meaning of the art of the decorative
screen.

These screens belong to the lineage of
gilt-ground (*kimpeki*) bird-and-flower
screen painting, originated by Kanō
Motonobu (1476-1559), that integrated the
native Japanese style (*Yamato-e*) and the
Chinese-based style (*kanga*). The
decorative composition and the manner in
which the rocks and trees have been
depicted display characteristics belonging
to the artist Kanō Sanraku. Although the
work is unsigned, it is traditionally
credited to Sanraku.

As a child, Kanō Sanraku (1559-1635)
entered Toyotomi Hideyoshi's service as a
page; when his talent in painting was
recognized, he was recommended as a
pupil to Kanō Eitoku (1543-1590) at
Hideyoshi's behest. After Eitoku's death,
he became the preeminent artist of the
Kanō school. He suffered misfortune and
obscurity for a short time due to his
numerous commissions arising from his
close ties with the Toyotomi family; before
long, however, he was received
favorably and patronized by the Tokugawa
family. While being heir to Eitoku's
grandiose style, Sanraku's works
characteristically exhibit this graceful,
decorative compositional treatment of the
painting surface.

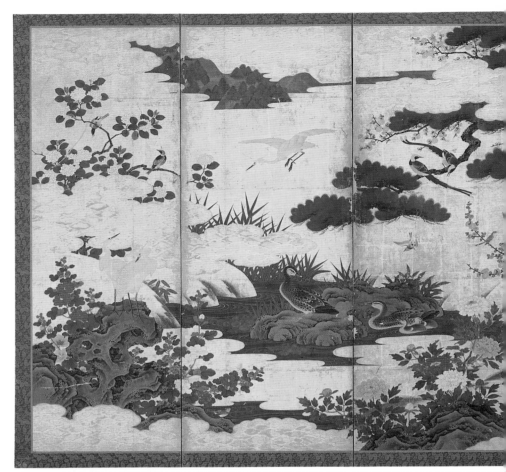

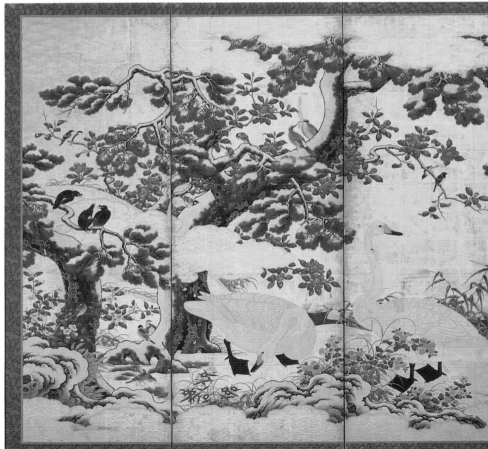

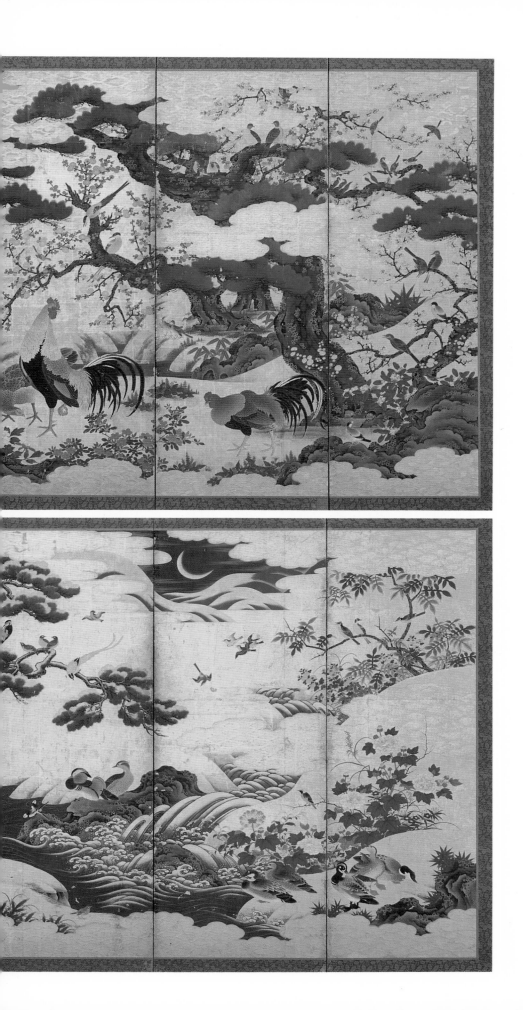

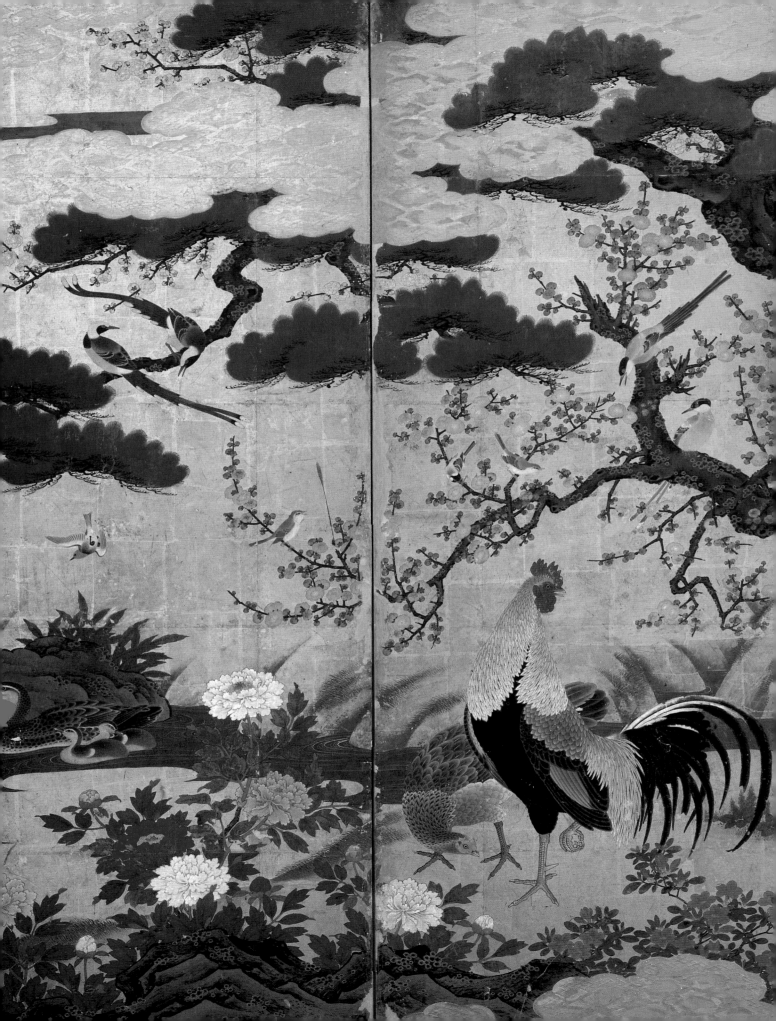

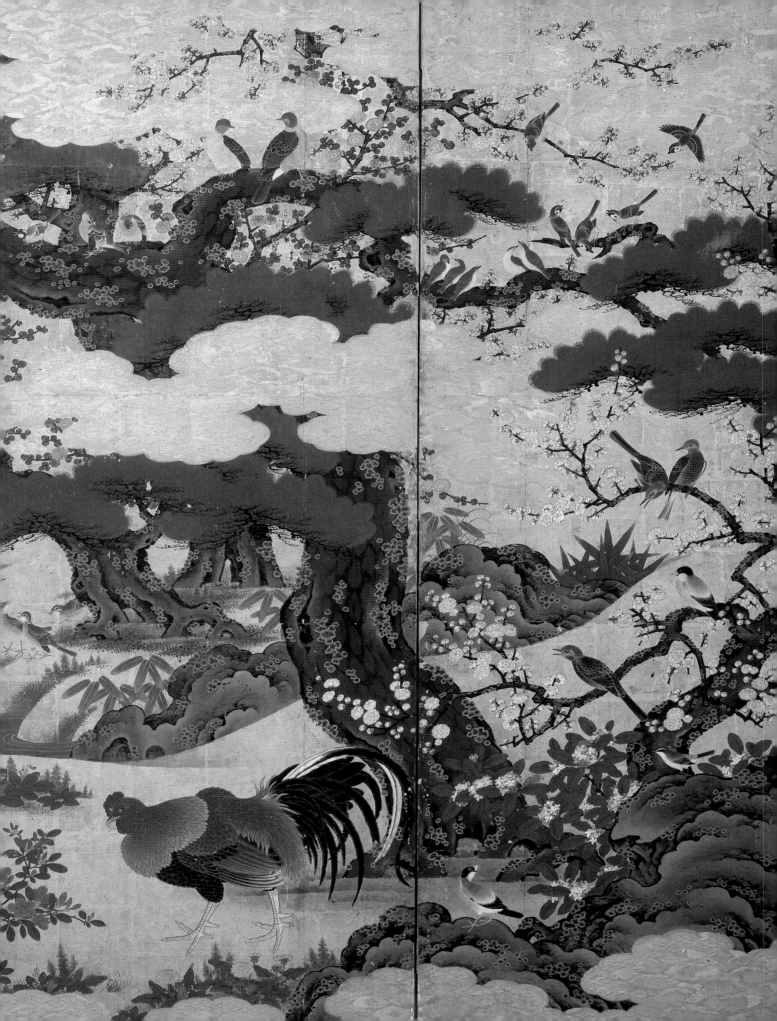

200. ITSUKUSHIMA AND MATSUSHIMA

Tosa Mitsuoki (1617-1691)
Pair of six-fold screens, ink, colors, gold
pigment, and gold leaf on paper;
122.1 × 366.6cm. each
Edo period, 17th century

Itsukushima in Hiroshima Prefecture
and Matsushima located in Miyagi Prefecture
comprise, together with Ama no Hashidate
in Kyoto Prefecture, Japan's three most
famous landscape views. Traditionally
these three particular scenic locales have
been admired and grouped under the label
Nihon sankei ("the three landscapes of
Japan").

In the center of the painting on the right
screen is the main building of the
Itsukushima Shrine, while on the left
screen are depicted the scattered islands
that dot Matsushima Bay. Both scenes are
viewed from a high vantage point over the
sea. Instead of representing pure
landscape, the artist has incorporated
colorful genre elements, amply populating
each picture with visitors enjoying the
sites.

The artist of this work is identified as
Tosa Mitsuoki by the presence of his
signature and seal in the lower, outer
corner of both the left and right screens.
Among the paintings credited to Mitsuoki,
these screens are one of his largest
compositions.

Leading exponent of the painting tradition
termed *Yamato-e* (native-style Japanese,
as distinguished from Chinese-style
painting), the Tosa School was estab-
lished at about the beginning of the
fifteenth century. Its painters were officially
patronized by the imperial court and served
the household of the Ashikaga shogunate,
as well. Responsible for reviving the Tosa
School, which had been languishing since
the latter half of the sixteenth century, Tosa
Mitsuoki (1617-1691), the son of Tosa
Mitsunori (see no. 204), was appointed
director of the official Bureau of Painting
at the court (*Edokoro azukari*). His paintings
are executed with an exquisite delicacy and
an attention ot minute detail that he learned
from Chinese academic-style paintings.

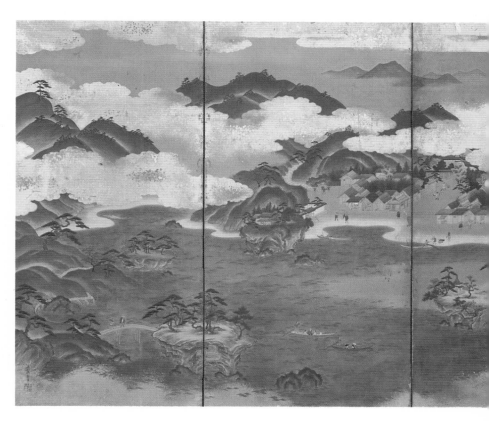

200

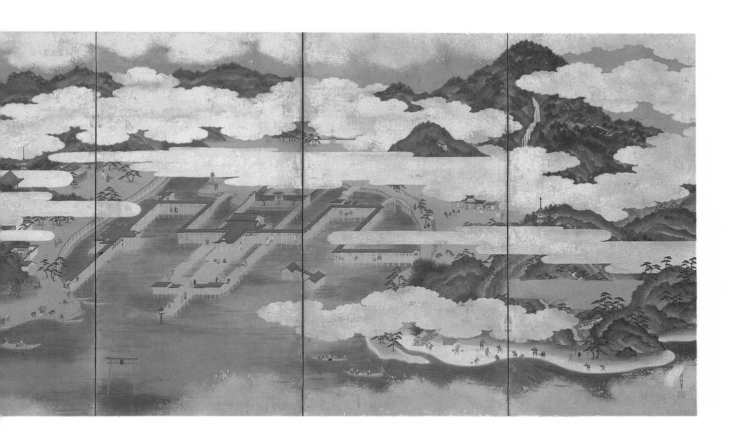

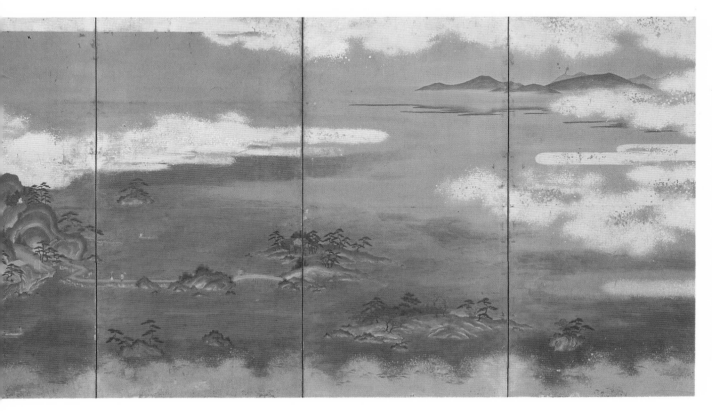

202. SCENES OF RICE CULTIVATION

Kanō Tan'yū (1602—1674)
Pair of six-fold screens, ink and light colors on
paper; 147.2 × 355.6cm. each
Edo period, 17th century

This pair of screens, painted in the genre-style of China, depicts the sequence of rice cultivation through the seasons, from planting to harvesting. Just as with illustrations of sericulture and silk-weaving, this agricultural theme transmitted from China was originally a type of "admonitions picture." Ever since its representation in the sixteenth century on sliding-door panels

(*fusuma*) of the Daisen-in sub-temple of Daitoku-ji in Kyoto, it had become a subject that artists of the Kanō school were fond of painting.

A son of Takanobu (1571—1618) and grandson of Eitoku (1543—1590), the artist of these screens, Kanō Tan'yū, was presented together with his father in audience with the shogun, Ieyasu, in 1612. Not long afterwards, he was appointed an official painter to the shogunate (*goyō-eshi*) and was granted a residence in the capital; thus the status of the Edo branch of the

Kanō school was firmly established. From then on, until the end of the Tokugawa regime in 1868, the Kanō family line continued in unbroken succession, maintaining its dominant position at the center of painting circles.

On the basis of the signature "Tan'yū-sai hitsu," we know that this pair of screens was executed during the period when Tan'yū, between the ages of thirty-four and fifty-nine, was working as a fully mature artist.

202

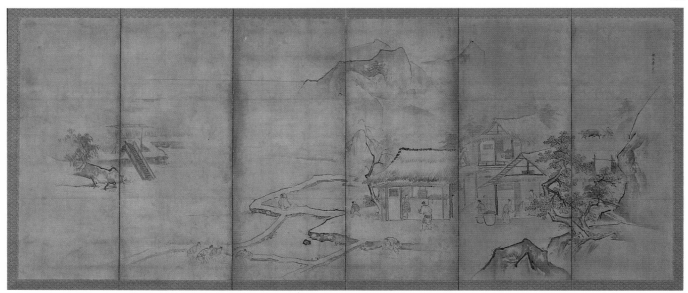

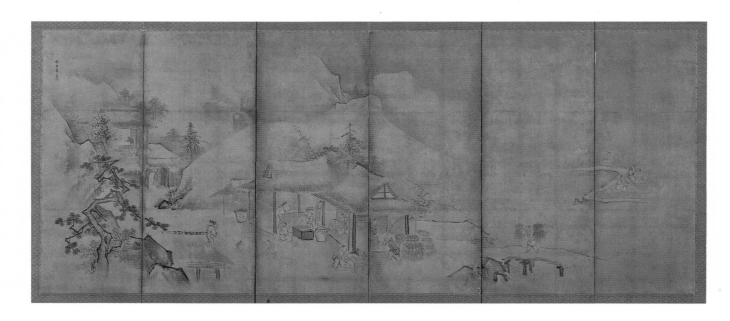

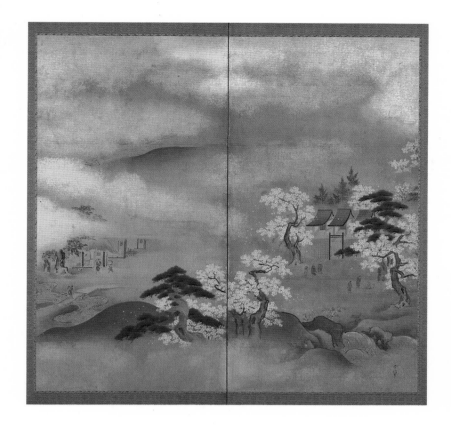

201. VIEWS OF YOSHINO

Kanō Tsunenobu (1636—1713)
Pair of two-fold screens, ink, colors, and
gold-leaf dust on paper; 162.5 × 168.4cm. each
Edo period, 17th century

The scenic landscape of Mount Yoshino in Nara Prefecture has been traditionally famous for its cherry blossoms. It is hardly surprising, therefore, that these screens depict the time when the trees at Yoshino are in full bloom. The artist's attention, however, is not fixed upon the blossoms alone, but encompasses, the various activities of the people gathered under the blossoming trees.

The painter of these screens, Kanō Tsunenobu (1636—1713), succeeded his father Kanō Naonobu (1607—1650), becoming the head of one of the four Edo branches of the Kanō family officially designated painters to the shogunate (oku-eshi). He assimilated the various styles of the school since Tan'yū (1602—1674) and achieved his own unaffected, graceful style well-suited to the period. The style of the present screens is one in which Yamato-e features have been introduced into the Chinese-based manner (kanga) of the Kanō school.

Tokugawa Nariharu, the nineteenth son of the eleventh shogun Ienari (1787—1837), brought this pair of screens with him in 1822 when he succeeded Naritomo (1793—1850), the tenth lord of Owari.

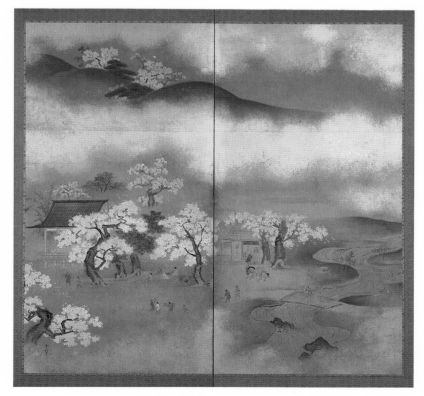

201

Tosa Mitsunori (1583—1638; paintings)
and various calligraphers (text)
Album, ink, colors, gold and silver leaf on
paper; 15.5 × 14.1cm. each
Edo period, 17th century

Sixty leaves of paintings illustrating famous scenes selected from each of the fifty-four chapters of Lady Murasaki's romantic novel, the *Genji monogatari* (*Tale of Genji*), are combined with sixty leaves of accompanying text to form a single album. The illustrations are by Tosa Mitsunori (1583—1638), while each leaf of text is by a different hand, altogether representing the calligraphy of sixty members of the imperial family and the court aristocracy.

Inheriting the style of Tosa Mitsuyoshi (1539—1613), who is reported to have been either his father or his teacher, Mitsunori is considered a master of miniature painting, for the execution of which it is said that he used a magnifying glass, a device newly imported from Europe. In the illustrations for this album, the delineation of details in areas such as the clothing patterns and the household furnishings is exquisitely delicate and minute. If there is a rather excessive display of craftsmanship, the paintings nevertheless preserve a tone of elegant refinement. The *Genji monogatari* (see no.222) has

continued as a subject for Japanese painting from the twelfth century onwards. In the sixteenth and seventeenth centuries, artists of the Tosa school painted many decorative illustrations that came to be used as a part of marriage dowries. With a cover that incorporates a woven design of cranes on damask and metal fittings in the shape of butterflies affixed in the four corners, this album has been bound in a fashion that would make it suitable to ornament the interior of a room.

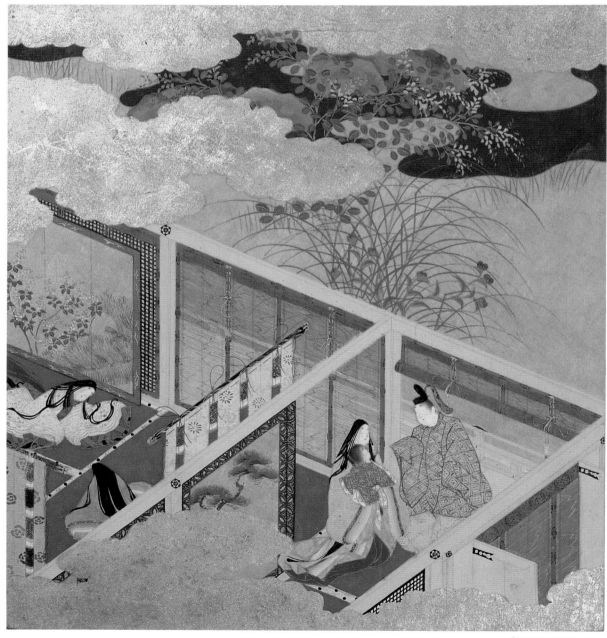

Chapter 18 *Matsukaze*

(cover)

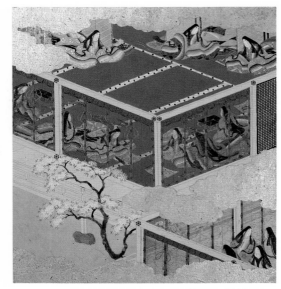
Chapter 17 *E-awase*

Chapter 22 *Tamakazura*

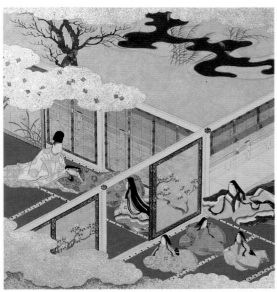
Chapter 5 *Wakamurasaki*

Chapter 11 *Hanachirusato*

Chapter 1 *Kiritsubo*

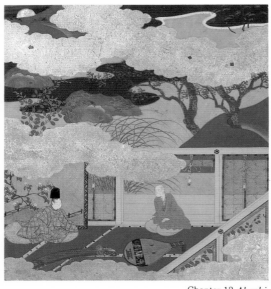
Chapter 13 *Akashi*

203

203. BIRDS AND FLOWERS

Kumashiro Yūhi (1693—1772)
Pair of six-fold screens, ink and colors on silk,
each painting, 162.6 × 50.5cm.
Edo period, 18th century

When the Chinese painter Chin Nanpin
(Shen Quan) visited Japan in 1731, he
brought with him a method of graphically
and precisely transcribing the world of
flowering plants, birds, and animals.
This style was learned by many native
artists and within a short time was widely
practiced in Japan.

Kumashiro Yūhi (1693—1772), the artist
of this work, was a direct pupil of Nanpin.
He was born into a Nagasaki family which
held the hereditary position of *tō-tsūji*, or
Chinese interpreter, and Yūhi, too, became
employed as head of this civil office.

Paintings of this "Nagasaki-school" lineage
are distinguished by vivid, fresh coloring
hitherto unseen in Japanese painting and
new compositional arrangements. This
characteristic sense of color is apparent in
the painting shown here in Yūhi's abundant
use of primary colors and purple; and his
handling of compositional elements on the
picture plane is also distinctive of this
Nanpin-derived style.

Although mounted in the folding screen
format, the paintings do not form a single,
continuous composition; one to a panel,
each is rather regarded as an independent
picture. Screens of this type are known as
oshie-bari byōbu ("pasted-picture folding
screen").

- This screen comes from the personal
effects of Tokugawa Munekatsu, the eighth
lord of Owari.

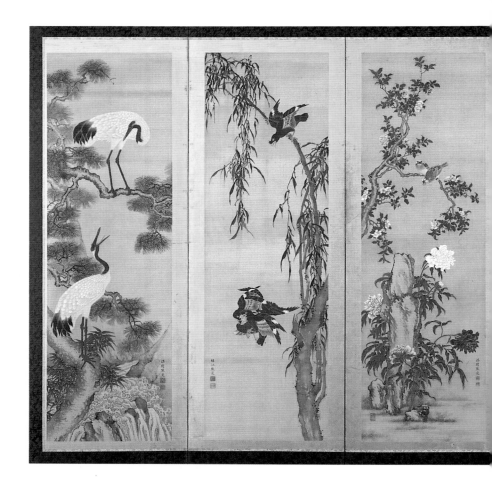

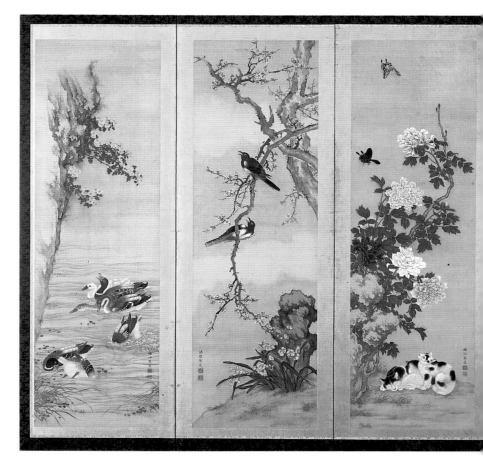

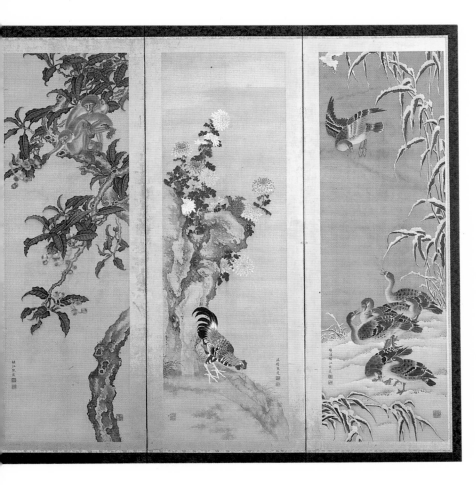

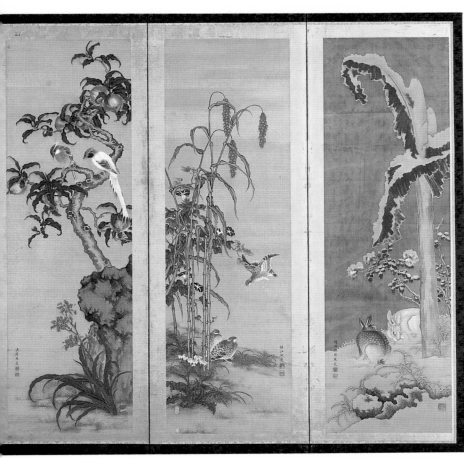

205. UNEME KABUKI

2 handscrolls, ink, colors, gold and silver leaf
on paper; 36.7 × 790.0cm each
Edo period, 17th century

Featuring an extremely gay, flamboyant style of dress, the *Kabuki odori* (Kabuki dance) originated around the start of the seventeenth century by a woman named Izumo no Okuni and quickly leapt into vogue as a new form of public entertainment, spawning a host of imitative types of theater performances. Among these successors to Okuni was Uneme, the leading performer in this set of handscrolls. They illustrate how she established her popularity through her performances staged at the Shijō riverbed amusement quarter of Kyoto. The texts of five varieties of song are followed by illustrations of their accom-panying dances; lastly, there is an encomium paid to Kabuki and a final scene of Uneme dancing in men's dress. However, the scope of the pictures is not limited to the dance performances. Spectators, vendors in front of the theater, and members of the audience within partaking of refreshments are also depicted, lending great interest to these scrolls as informative

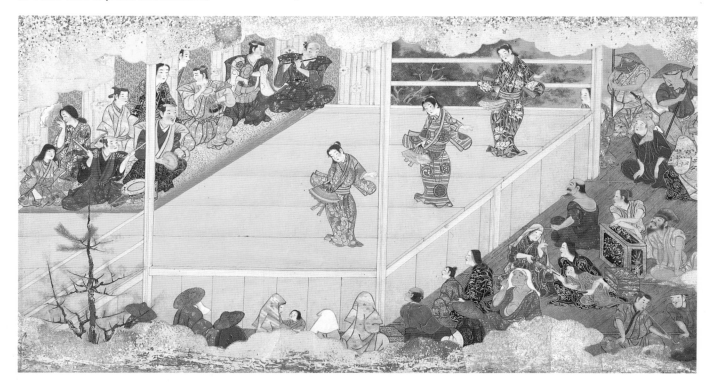

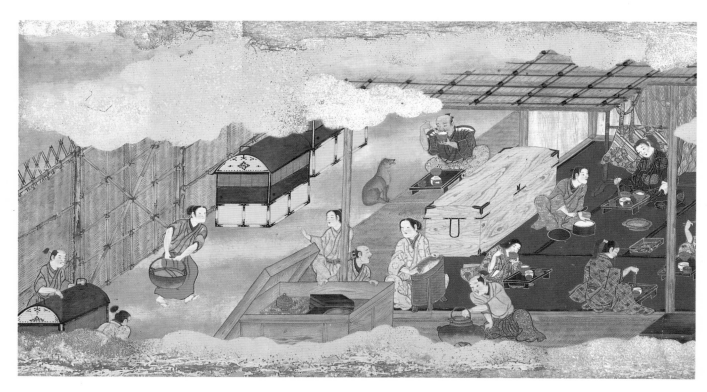

documents of period genre. Portuguese and Dutch visitors to Japan at that time are represented, as well.

Detailed delineation and richly applied colors using decorated paper sprinkled with both dust and flakes of gold and silver for the text passages make these truly sumptuous handscrolls. The artist is not identified, but the painting exhibits stylistic features that are linked to the painter Iwasa Matabei (1578—1650).

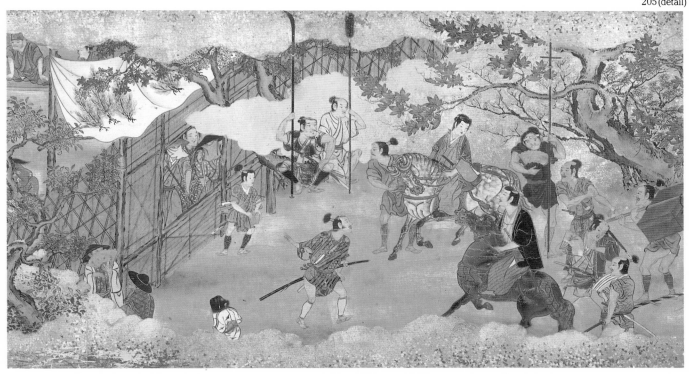

205 (detail)

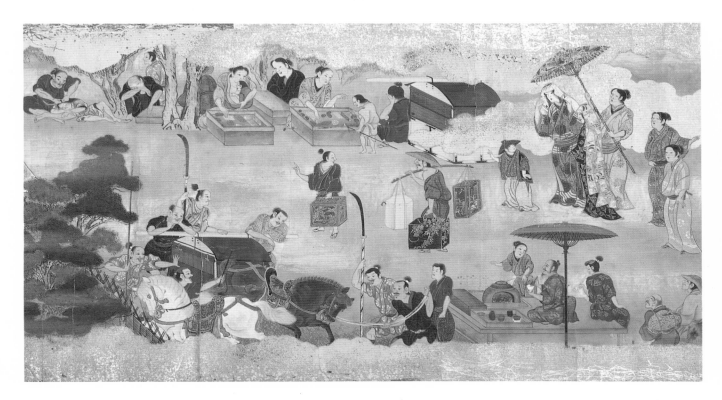

206. PASTIMES AND OBSERVANCES OF THE FOUR SEASONS

Maruyama Okyō (1733—1795)
2 handscrolls, ink and colors on paper;
28.2 × 616.0cm., 28.2 × 561.2cm.
Edo period, 18th century

The four seasons are represented in scenes depicting sites and activities poignantly familiar to the lives of the common folk of Kyoto: blossom-viewing at Arashiyama in springtime, enjoying the evening cool along the Kamo River in summer, performing *Urabon-e odori* (circle dances held during the Buddhist "All Souls' Day" festival) in autumn, and in winter, the bustle and stir of year-end observances in preparation for greeting the New Year. The artist of these two scrolls, Maruyama Ōkyo (1733—1795), has always received a sympathetic popular response with his readily approachable, realistic, and clearly rendered style, and his emphasis on the observation of nature. In the present work, as well, the casual scenes of everyday activities seems bound to stir in the Japanese viewer a warm, lightly nostalgic sentiment. Each of the pictures is preceded by a lengthy explanatory text, written by a renowned Kyoto calligrapher, Takahashi Munenao (1703—1785), who was also the holder of the honorary court title Wakasa no Kami ("Governor of Wakasa").

There are two extant preliminary studies for these scrolls, one in a private collection in Tokyo and the other in the Mrs. Jackson Burke collection in New York. The Tokyo scrolls have a colophon at the end which mentions that the work was presented to the Owari Tokugawa family by the Kujō family, and that the paintings were executed prior to 1777. They belong then to a period when Ōkyo, in his forties, was producing some of this finest works.

206 (detail)

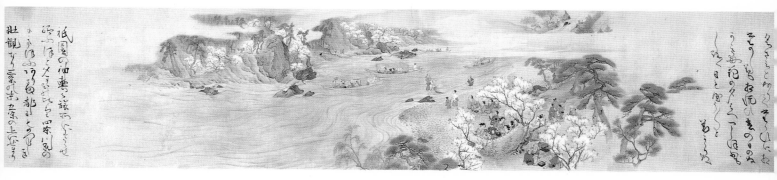

祇園の御輿も旅所に
移らせ給ふと大津絵から四条河原の
ふかほり河原都とうまき
壮觀なり三条の末三条の上通まて

ことしもと釣月をひき
ことのほね石匠ひきものの月のみ
うき海辺の久くりー一日間
しもく日と思くらへ
あつらく

Spring

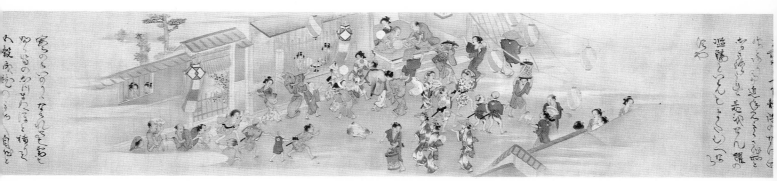

慶雲

Summer

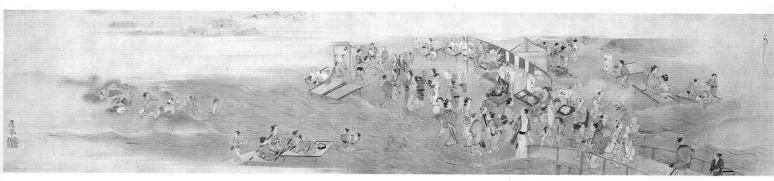

雲のうつりうなれ□らくる富を
とのよのよつかたりたれはと横て
わ穀窓かかしのこきも白宮と

□□□和□ひかへりなみて
いうのらきかなくらる□□□
さく□流きとうまた元浴らる曜の
潺澹となとうくいらは
ふら

慶雲

Autumn

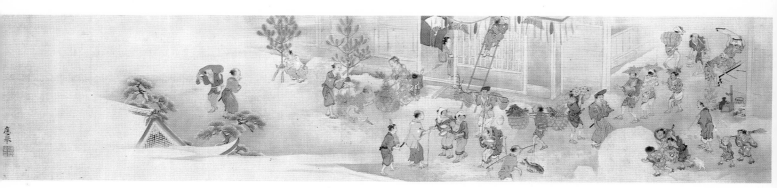

慶雲

Winter

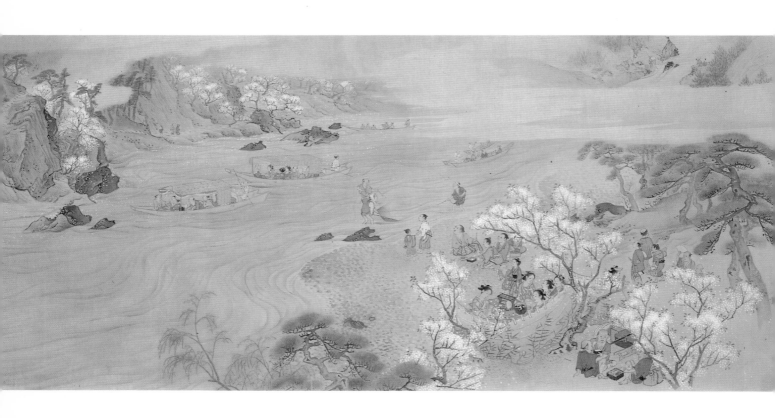

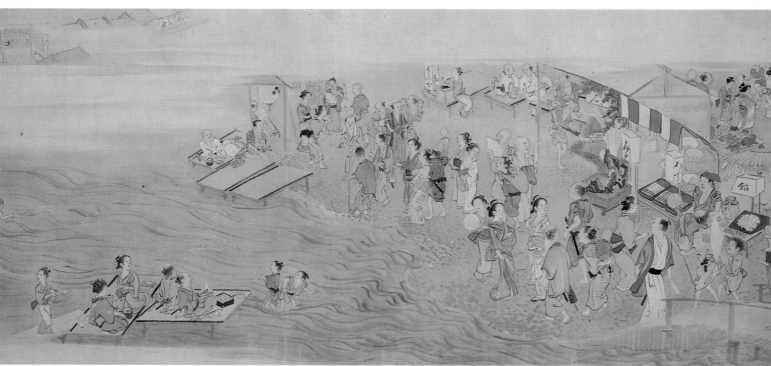

210

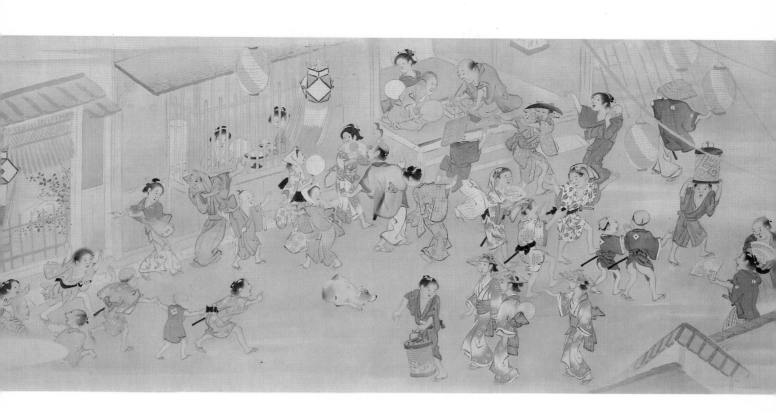

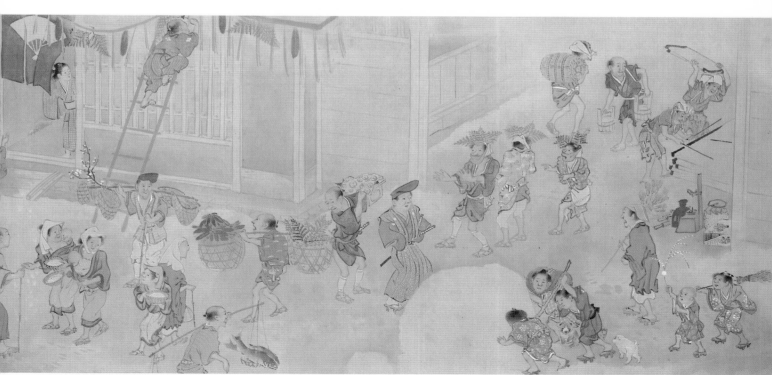

206 (detail)

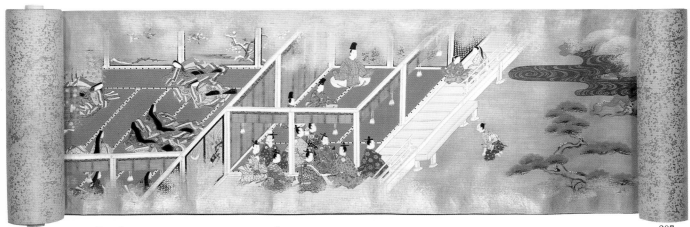

207. *BUNSHŌ ZŌSHI (STORY OF BUNSHŌ)*

Handscroll (one of three), ink, colors, gold
pigment, and gold leaf on paper;
32.0 × 1,553.8cm.
Edo period, 19th century

An *otogi-zōshi*, or folktale, written some-
time around the fifteenth century, the
Bunshō zōshi is a tale of the common
people whose auspicious "rags-to-riches"
theme concerns the acquisition of wealth
and the gaining of high status. The story
is about Bunshō, a servant of the lowest
grade to the high Shintō priest of the grand

shrine Kashima Myōjin. Thinking he would
see what kind of person Bunshō was, the
priest dismissed him from this position.
Bunshō then became a successful salt-
maker. He also prayed at the Kashima
Myōjin shrine and was blessed with two
beautiful daughters. The daughters were
courted far and wide, receiving many
proposals of marriage, so that eventually
the elder sister was wed to the son of an
imperial advisor, and the younger one was
summoned to become a courtlady. The

narrative recounts further that Bunshō, too,
was raised to nobility. Due to the nature
of its theme, many illustrated scrolls of the
Bunshō zōshi were produced as articles for
young women's trousseaux. The present
scroll also served this kind of purpose when,
in 1836, it was brought with Fukuhime, the
daughter of Konoe Motomae, at the time of
her marriage to Tokugawa Nariharu, the
eleventh lord of Owari.

208. RIVER LANDSCAPE WITH ANGLER

Zhang Lu (1464—1538)
Hanging scroll, ink and colors on silk,
131.8 × 75.1cm.
Chinese, Ming period, 16th century

An elderly angler in the company of a
small boy is at rest in his small boat gliding
on the water, his fishing over for the day.
The moon has just risen as evening falls,
and a flock of wild geese is flying off. As is
evident in the treatment of the trees and
rocks, the painting is handled in a
somewhat harsh, rough brush manner,
seemingly alien to the tranquil mood of the
subject matter.

Zhang Lu (1464—1538?), also known by
his *hao*, or sobriquet, Pingshan, with which
he signed his paintings, came from Xiangfu
(Kaifeng) in Henan Province. He was a
follower of Wu Wei (1458—1508) and
excelled in figures and landscapes.
Along with Wu and the master Dai Jin
(1388—1462), Zhang Lu is associated with
the Zhe School of painting. The style
designated by later historians as the Zhe
School formed around the middle of the
fifteenth century, with the majority of its
leading artists hailing from Zhejiang
Province. Works of the school tend to be
characterized by a certain "reckless" quality
in the handling of the brush and an
eccentricity of form.

Zhe School paintings were imported
into Japan in large numbers perhaps due
to the proximity of the coastal trading

208

centers of Zhejiang. In addition to the
paintings by Zhang Lu and Zheng Dianxian
(No. 209) in the present exhibition,
there are works in the Owari Tokugawa
family collection by Wu Wei, Liu Zhun
(active c. 1500), and other Ming Zhe School

masters which testify to the extent of their
appeal in Japan. The large size of both
of the paintings shown here suggests that
they were used to decorate the large
audience hall of the daimyo's residence.

209. THE PATRIARCHS OF THE THREE CREEDS

Attributed to Zheng Dianxian (Zheng Wenlin, active mid-16th century)
Hanging scroll, ink and light colors on silk; 141.8×76.5cm.
Chinese, Ming period, 16th century

Beneath an ancient tree with wildly gnarled branches is gathered a trio of old men—from left to right, they are Lao zi, Sakyamuni, and Confucius, the patriarchs of Taoism, Buddhism, and Confucianism, respectively. Despite the didactic differences among their doctrines, a perception of the identity of their goal fostered the concept of the Unity of the Three Creeds. Widespread in the Song period (960—1279), this principle was illustrated in paintings that are generally referred to as *sankyō-zu.*

The example shown here bears neither an identifying seal nor signature, but the attribution to Zheng Dianxian is supported by its close stylistic affinity with accepted works by him. Painting histories record that he was a native of Min (present Fujian Province) and that his paintings of figure subjects possess a "wild" quality. Little else about him is known. Zheng is usually classed with the group of Zhe School artists who were active around the middle of the sixteenth century, a group disdainfully criticized by contemporary literati as "adherents of the Heterodox, or depraved school, who viciously give free reign to a perverse and wild manner."

209

213

210. BODHIDHARMA CROSSING THE YANGZI ON A REED

Miyamoto Musashi (1582 or 4—1645)
Hanging scroll, ink on paper; 112.4 × 28.2cm.
Edo period, 17th century

The Indian monk Bodhidharma (Japanese: Bodaidaruma or Daruma, for short) was the sixth-century founder of the Chan (Japanese: Zen) sect of Buddhism. The theme of this painting derives from the tradition of Bodhidharma's audience with Emperor Wudi (502—550) of the Chinese state of Liang. The interview was unsuccessful, as the emperor failed to be awakened to the truth of the doctrine; whereupon, Bodhidharma, as portrayed here, took his leave of the Liang state, crossing the Yangzi River on a single reed.

Miyamoto Musashi (1582—1645; as a painter, better known as Niten), who served the daimyo Hosokawa in Kyūshū in the last years of his life, is celebrated in Japanese history as a master swordsman. Although he took up his brush for the sake of personal cultivation and amusement, his paintings display abbreviated brush-work in a manner remarkably accomplished and are suggestive of the style of Liang Kai (active, early 13th century), a Chinese Chan painter of the Southern Song. Bodhidharma seems to have been a favorite subject for Musashi, who specialized in depictions of birds and figure painting and whose deep penetration into the spirit of Zen Buddhism stood him in good stead in mastering "the Way" in swordsmanship. "Knowing the Way in various arts" meant, above all, to Musashi, the goal of realizing their essence in the practice of swordsmanship—for him, swordsmanship, Zen, and painting were, in essence, ultimately one and the same art.

210

211. *KAYŪ KANSHOKU (KUMANO-RUI KAISHI)*

Fujiwara no Kintsune (1171—1244)
Hanging scroll, ink on paper; 30.0 × 53.0cm.
Kamakura period, dated in accordance with 1200

Setting a theme, composing *waka* (a classic Japanese verse form in 31-syllables), and then writing the poems down on *kaishi*, the special paper reserved for such an occasion, constituted the basic format for the poetry-composing parties that flourished around the twelfth century. One famous poetry-gathering was held by Emperor Go-Toba (1180—1239) with the noble members of his entourage while he was on his way to Kumano to conduct a *miyuki* (imperial visit). The paper on which the poems composed on that occasion were written is called *Kumano kaishi* ("Kumano poem-paper"). Although the calligraphic poem exhibited here was not written at the time of the Kumano *miyuki*, the form in which it was written is similar and, hence, has been labeled *Kumano-rui kaishi* ("Kumano-type poem-paper").

This calligraphy, a poem entitled "Kayū kanshoku," was written by Fujiwara no Kintsune (1171—1244) at a poetry gathering held in the year 1200, when he was thirty years old. The poems of five of the other participants, in cluding Emperor Go-Toba, have been preserved. Of aristocratic lineage, Kintsune was given the title of prime minister (*dajō-daijin*) in 1222. Imperial anthologies contain 120 of his poems.

211

214

Attributed to Fujiwara no Kintō (966—1041)
Hanging scroll, ink on decorative paper;
19.8 × 47.3cm.
Heian period, 12th century

This is a fragment of the *Anthology of Poems by Lady Ise (Ise-shū)*, a section of the *Collection of the Thirty-six Immortal Poets (Sanjūrokunin-kashū)* which has been housed since the sixteenth century in the Nishi Hongan-ji in Kyoto. Originally it

formed part of one of the thirty-eight volumes of the latter, but in 1929, two of these volumes, the poems of Lady Ise and the second volume of poems by Ki no Tsurayuki (ca. 868—945 or 6; see no. 213), were cut up and sold. These fragments were named the *Ishiyama-gire* (Ishiyama Fragments) after the site (present day Osaka Castle) where Nishi Hongan-ji was located when this anthology came into the temple's

governor. She served as lady-in-waiting to Fujiwara no Onshi, the consort of Emperor Uda (r. 887—897) and was among the most distinguished poets of the late ninth and early tenth centuries, a time of extraordinary feminine literary activity.

This fragment consists of three joined sheets of paper. Across the right and center sheets is written a long preface to the *Ise-shū*, while two poems alone occupy the third sheet. The calligraphy is said to be the work of Fujiwara no Kintō (966—1041), the compiler of the *Sanjūrokunin-kashū*, but there is no evidence to support this claim. Instead the brushwork is more consistent with the style prevalent in the early twelfth century.

The right sheet has a design of lion roundels and peony arabesques executed in mica on a ground of Chinese white *(gofun)*. Silver and gold pigment was used for the underpainting of birds, grasses, and flowers scattered over all three sheets. Other sections of the anthology used brilliantly colored papers, individually and in collage with papers of more restrained colors, or papers sprinkled with gold or silver dust. A carefully planned work that made use of every available technique and sumptuous materials, the *Sanjūrokunin-kashū* is considered to reflect the apex of the art of Japaneser decorative paper and is important in understanding the highly refined aesthetic sensibility of the Heian aristocracy.

212

possession. Illustrated here are the first three pages of the Ise volume.

Born into the Fujiwara family, the leading political and literary clan of the day, Lady Ise (dates uncertain) was named after the province where her father once served as

213. FRAGMENT OF THE *WAKAN RŌEISHŪ* ANTHOLOGY

Attributed to Fujiwara no Yukinari (972—1027)
Hanging scroll, ink, gold, and silver on paper;
25.9 × 14.3cm.
Heian period, 12th century

This is a fragment of a handscroll of the *Wakan rōeishū (Collection of Japanese and Chinese Poems for Recitation)*, an anthology of some eight hundred poems and excerpts of poems and prose from the corpus of Japanese and Chinese literature. It was compiled by Fujiwara no Kintō (see no. 212) around 1018.

The *Wakan rōeishū* was divided into two volumes, the first organized according to the four seasons with subdivisions for the events and natural phenomena that occurred in each season. The second book was devoted to miscellaneous subjects, beginning with a section on the wind and concluding with love poems and a selection of the poems of Li Po (in Japanese, Ri Haku [699—770]), one of the outstanding poets of the Tang dynasty who was greatly admired in Japan.

213

Illustrated here are one Japanese and two Chinese poems from the summer section of the first book. The specific theme of these three poems is the *koromogae*, and annual event in the early summer when one changes form winter clothes to those of summer.

The calligrapher is traditionally identified as Fujiwara no Yukinari (972—1027), who along with Ki no Tsurayuki and Ono no Tōfū, formed the *sanseki*, the three master calligraphers of the Heian period. The attribution of this fragment to Yukinari cannot be substantiated; it is now presumed to be a work of the twelfth century.

The paper used is an exceedingly rare form of dyed paper with a coarse scattering of gold and silver dust and a horizontal line drawn at both the upper and lower borders. The custom of cutting up books and handscrolls into smaller sections and mounting them as hanging scrolls to be enjoyed as room decorations or centerpieces in the alcove came about in the second half of the sixteenth century and was very popular throughout the Edo period. They were also frequently hung at tea ceremony gatherings.

KAREI

SPLENDOR AND REFINEMENT

PART V.
SPLENDOR AND REFINEMENT

During the century (from 1596 to 1704) that spanned the Keichō era, when the shogunate was established in Edo, the Kan'ei, and Genroku eras, the crafts developed dramatically, and this century saw the flowering of the samurai culture. In particular, the Genroku era (1688—1704), corresponding to the rule of the fifth shogun, Tsunayoshi, marked the zenith of the samurai culture of Edo. The flourishing of the applied arts during this era was made possible by the high standards of craftsmanship that had developed, as well as by the concentration of products from throughout the land in the shogunal capital through the development of an effective distribution system. Against this background, in every facet of daily life, from furnishings to clothing and articles for amusement, a high standard of excellence prevailed. The articles and furnishings of the household of the shogun and daimyo were divided into two principal categories: articles for official use, and those for the private use of the household. The official articles were used in the *shoin* or tea room during the formal reception of guests, with a steward to supervise their care. In contrast, the private effects were reserved for the use of the lord of the castle and his household and relegated to the *oku,* which served as the living quarters for members of the household and their attendants, with guest rooms for private visitors. Many of these objects were owned by the ladies of the household. One of the generalizations that can be made concerning the *omote* and *oku* furnishings is that many of the official articles consisted of Chinese art objects, while the majority of the articles for private use were Japanese objects of aesthetic value. The categories of accessories for the private quarters include ceramics, lacquer, metalwork, textiles, paintings, and calligraphy. The articles selected for this section are centered on objects comprising the wedding trousseau, such as clothing, incense instruments, and articles for amusement. The sumptuous accessories of the private household of the shogun and daimyo are imbued with the power and influence of their owners, as well as an unspoken wish for the eternal prosperity of the line. These articles provide a glimpse of the lives of the people who once owned them.

THE ACCESSORIES OF DAILY LIFE

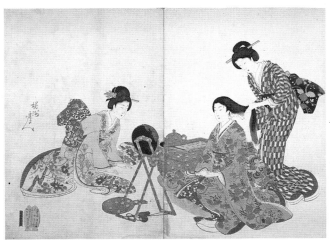

"Ogushiage," from "Chiyoda no Ō-oku,"
by Hashimoto Shūen.

The articles used in the private lives of the shogun,
daimyo, and their families, are called *oku-dōgu*. Everyday
articles are included within this category and were largely
owned by the ladies of the household. Many of the articles for
common, everyday use were made of black lacquer or plain
wood coated with transparent lacquer, but the wear of daily
usage has precluded their preservation and very few exist
today. Most of the household articles that have survived were
objects that had not been subjected to constant use and were
carefully preserved in a storeroom as heirlooms and prized
treasures. The furnishings that are presented here are also of
this nature.

The most sumptuous of the household articles comprised
the trousseaux of the well-born brides, consisting of objects
ornamented with gold and silver *maki-e* lacquer and inlaid
with mother-of-pearl. The wedding trousseaux included
objects that were ostensibly practical, but were in actuality
not used and stored away. For this reason, they are preserved
largely intact. Such elaborate trousseaux were largely
commissioned by the shogun, daimyo, or court nobility, who
spared no efforts to make them as sumptuous as possible in
order not to disgrace their family names. The most
accomplished craftsmen of the day pitted their skills in
producing these objects. Some articles in the trousseau
required as many as three years to produce, and the finest of
materials, techniques, and patterns of design were lavished
on them.

The trousseaux can be categorized into the following large
divisions: writing implements, toiletry articles, utensils for
serving food and drink, tea utensils, incense instruments,
furniture, clothing, and articles for amusement. The objects
shown in the subsequent pages are largely composed of
writing implements, toiletry articles, and serving utensils.

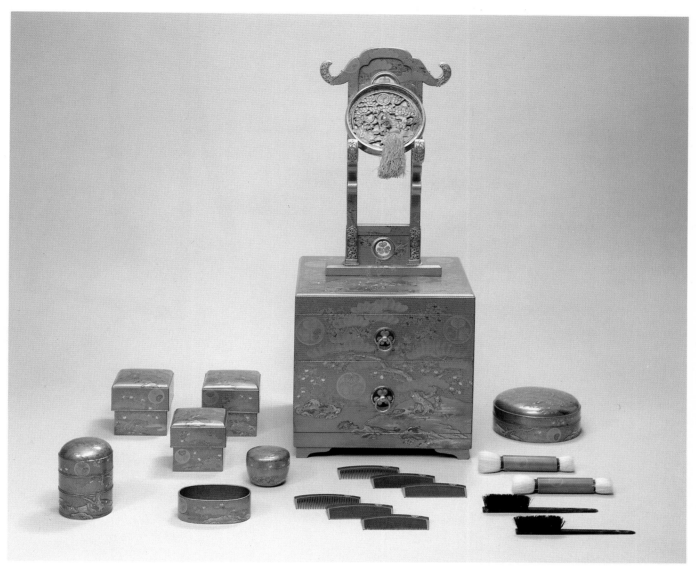

229. DRESSING TABLE AND ACCESSORIES

Design of *aoi* crests scattered among pine and mandarin orange trees in *maki-e* on an aventurine lacquer ground; 27.4 × 27.4 × 65.6cm. Edo period, 18th century

By the beginning of the Edo period (17th century), *kyōdai* (literally "mirror stand") or dressing tables, like the one illustrated here, were the centerpiece of a high-born lady's toilet equipage. A slender mirror support holds a round mirror above a square box with two drawers in which various cosmetics and accessories were stored. *Kyōdai* of this type made their appearance at the end of the Muromachi period (16th century) and became the standard form for dressing tables through-

out the Edo period.

Both of these *kyōdai* display generous amounts of gold and silver dust applied by means of the *maki-e* technique. The design decorating both stands is a landscape featuring pine and mandarin orange trees, both symbols of longevity, with the *aoi* crests of the Tokugawa family deftly scattered throughout. Similar in design and technique, these two objects are attributed to the same lacquer workshop. Both are said to have been used by Hanako-hime, the wife of Tokugawa Muneharu, the seventh lord of Owari.

Many of the articles stored in the dressing table had their own separate cases

decorated with the same motifs that adorned the table itself. Among these smaller accessories were boxes for the mirrors, combs, eyebrow brushes, brushes for cleaning the combs, tiered oil containers, a small basin for the water used in preparing the cosmetics, and small boxes of white face powder and rouge. Number 229 still retains many of its original contents. Unfortunately, aside from the mirror and its case, the water tub, tiered oil container, and rouge box, all the items originally stored in number 231 have been lost.

230. MIRROR STAND (WITH MIRROR AND CASE)

Design of arabesques and scattered *aoi* crests in *maki-e* and inlay on an aventurine lacquer ground; h. 70.1, w. 30.6cm.
Edo period, 19th century

Glass mirrors have been used in Europe for centuries, and their introduction to America even predated the arrival of glass mirrors in Japan in the mid-19th century. Mirrors used in the Edo period and earlier were made of bronze, nickle, and iron with the surface coated by a mixture of mercury and tin that was highly polished to a lustrous finish. On the reverse was cast a design which was often of considerable artistic value.

Mirrors with attached handles that could be picked up and used by hand did not develop until the end of the Muromachi period (16th century). *E-kagami*, as these mirrors were known, were enormously popular and were widely used during the Edo period. The kind of stand shown here is for holding such a mirror. Like the dressing tables in numbers 229 and 231, the placement of a mirror on this stand freed both hands for arranging the hair or applying cosmetics. Collapsible and standing directly upon the floor, this stand is similar to those mentioned in the documents of the Heian period when mirror stands are thought to have first appeared.

This mirror stand displays an overall ground of gold aventurine lacquer upon which are depicted plum blossoms and ivy formed into an arabesque and randomly scattered *aoi* crests, all executed in gold *maki-e* and inlay. These motifs are repeated on the large, trifoliate *aoi* inserted in the place where the mirror is set. This perforated crest is covered with a thin sheet of gold upon which are finely carved plum and ivy arabesques. The lavish decoration applied to this structurally simple piece of household furniture illustrates the level of technical excellence achieved by both lacquer and metal craftsmen of the late Edo period. The box with the large *aoi* crest in *maki-e* in the center of the lid originally held a large and small mirror, both of which are now lost.

230

231

231. DRESSING TABLE AND ACCESSORIES

Design of pine and mandarin orange trees in *maki-e* on an aventurine laquer ground; 27.6 × 27.6 × 64.9cm.
Edo period, 18th century

233. COMB CABINET AND ACCESSORIES

Design of pine, bamboo, and scattered *aoi* crests in gold *maki-e* on an aventurine lacquer ground; 25.0×34.4×35.6cm.
Edo period, 18th century

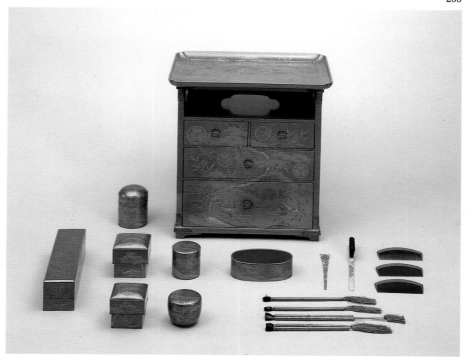

Kushidai (literally, "comb stand") held mainly cosmetic items used in dressing a woman's hair. This comb cabinet has four drawers of different sizes below a broad, rectangular tray where the various cosmetic items are placed when used.

The contents of this comb cabinet include two kinds of combs, one with relatively few teeth (*tokigushi*) and two fine-toothed combs (*sukigushi*); a brush with black bristles used for cleaning these combs; a spatula used for preparing cosmetics; long-stemmed eyebrow brushes; oil containers; a small basin for water used in preparing the cosmetics, boxes for powder and rouge; a razor box; and a box for tooth blackener.

The design and techniques used on this *kushidai* are the same as the basins in numbers 232 and 234, and the box in number 235. There are several objects of this type in the collection of The Tokugawa Art Museum, and it is thought that were made as part of a set of toilet articles for a

bride's wedding trousseau.

There were two other objects, in addition to *kushidai,* used for storing the cosmetic articles needed when arranging one's hair. The *kushibako* ("comb box") strictly served as a container, while the *tabi-kushibako* ("travel comb box"). was taken along as a portable vanity.

235. BOX CONTAINING ACCESSORIES FOR BLACKENING TEETH

Design of pine, bamboo, and scattered *aoi* crests in gold and silver *maki-e* on an aventurine lacquer ground; 40.6×11.1×11.2cm.
Edo period, 18th century

A *watashikane-bako* is a box for keeping the various utensils used in blackening teeth, including the long, thin, narrow brass plate (called a *watashikane*, "stretched across metal") which is placed across the rim of the basin (*mimidarai,* see no. 234). Other articles include the spouted ewer and small bowl, which are used when boiling the stains, and the brush used for applying that stain to the teeth.

A dark liquid made from oxidized iron is placed in the ewer, which is set on the plate above the *mimidarai.* To ensure adherence of this liquid to the teeth, a powder (*fushiko*) is added to the liquid, which is then applied by brush. The *mimidarai* is used for rinsing the mouth during this procedure. The various implements contained in the *watashikane-bako* are normally used with a *mimidarai,* so these two items were usually decorated with the same designs.

Aside from the *watashikane-bako,* there is a box called the *kanebako* for holding the various tooth-staining tools. Shorter and wider than the *watashikane-bako,* this box may have one or two tiers.

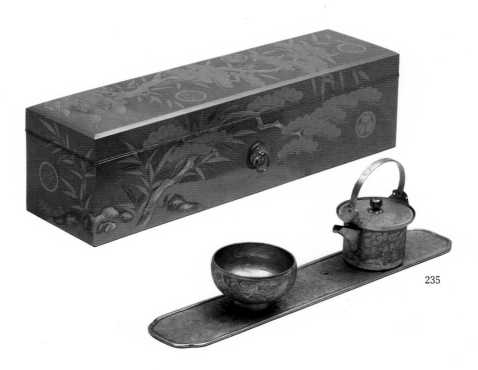

235

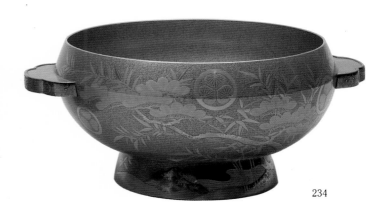

234

234. WATER BASIN AND STAND

Design of pine, bamboo, and scattered *aoi* crests in gold and silver *maki-e* on an aventurine lacquer ground;
Total; h.28.1, diam.26.7cm
Edo period, 18th century

A *mimidarai* (literally, "ear tub") is a small basin that was named after the two short ear-shaped handles. A *mimidarai* is slightly smaller than another basin with

handles, the *tsunodarai*. This term derives from the fact that the four handles on a *tsunodarai* are long and shaped somewhat like horns.

Mimidarai were primarily used to rinse out one's mouth when blackening the teeth, a custom that was practiced among aristocratic Japanese women from ancient times. Male members of the

nobility also blackened their teeth from the latter half of the Heian period. In the Edo period, all married women blackened their teeth, regardless of social standing.

The design on this basin and stand is the same as those in numbers 232, 233, and 235—a riverside landscape of rocks. bamboo, and pine dotted with the *aoi* crests of the Tokugawa family.

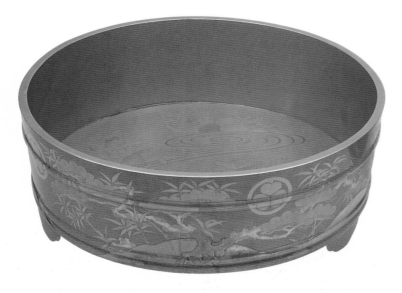
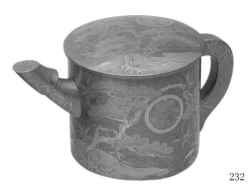

232

232. EWER AND WASH BASIN

Design of pine, bamboo, and scattered *aoi* crests in gold and silver *maki-e* on an aventurine lacquer ground; ewer, h. 22.7, diam. 19.8cm; wash basin, h. 19.7, diam. 52.1cm. Edo period, 18th century

This kind of wash basin is called a *te-arai* (literally, "hand wash") or *ōte-arai* ("ō" meaning "large"). The *te-arai* was, as the name suggests, a water vessel used for washing one's hands.

The ewer (*yutsugi or yutō*) was used in tandem with the wash basin. It is a container for the hot water to be poured into the basin.

Both vessels have their surfaces completely covered with a densely sprinkled aventurine lacquer ground and a design of pine trees, bamboo, and various flowering aquatic grasses growing among the rocks of a swiftly moving

stream, with scattered *aoi* crests in gold and silver *maki-e* accented with cut gold leaf. The interior of the ewer and the interior rim of the wash basin were decorated with only the aventurine lacquer ground. These are two excellent examples of objects from the lavish wedding trousseau of a Tokugawa bride in the middle Edo period (18th century).

222. STORAGE CABINET FOR BOOKS

Design of nandina in gold and silver *maki-e* and cut gold leaf on an aventurine lacquer ground; 26.6 × 40.0 × 31.2cm.
Edo period, 17th—18th century

On the five exterior surfaces of this book-storage cabinet are landscapes of nandina growing along the rocky banks of a stream. Interspersed between these berry-laden bushes are roundels of peonies, chrysanthemums, and Chinese bellflowers. The entire design is executed in gold and silver *maki-e* against a golden aventurine lacquer ground accented with small, cut squares of gold and silver leaf.

This cabinet was made to house a fifty-four volume copy of the most celebrated work of Japanese literature, the *Tale of Genji* (*Genji monogatari*, see no. 204). These volumes were divided among six drawers (two rows of three drawers each) with the names of the various chapters written on the outside of their respective drawers.

The *Tale of Genji* was written by Murasaki Shikibu (ca. 978—ca. 1016), a lady of the court who has been called the world's first female novelist. The work explores the lives and fates of the people of the court of that time with a sensitivity and perception unequalled in early Japanese literature. The pivotal figure in the work is the imperial prince Hikaru Genji.

The *Tale of Genji* gained wide accep-

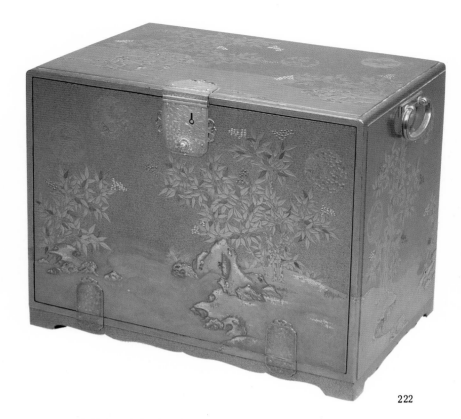

222

tance among the court nobility from the moment of its appearance. Afterwards, it became the standard of excellence to which all subsequent novels aspired, and reading it became a part of the education of members of the upper ranks of society. Furthermore, copies of *Genji* by master

calligraphers of the aristocracy were highly-prized additions to wedding trousseaux. The copy contained in this cabinet was the work of the aristocratic calligrapher, Konoe Motosuke, who died in 1714.

223. DOCUMENT CASE

Design of iris and water grasses along the bank of a stream in *maki-e* on an aventurine lacquer ground; 30.8 × 11.2 × 10.4cm.
Edo period, 18th century

Fubako are elongated, covered cases for the storing of letters, documents, and written petitions to the deities of a temple or shrine. There are two kinds of *fubako*, short ones (as illustrated here) and long ones called *naga-fubako*. The lid of these boxes were secured by knotted cords that were looped through the metal rings on either side of the box. *Fubako* were usually fitted with overlapping lids that provided extra protection for the valuable documents contained within.

The term *fubako* is an abbreviation of the word *fumibako* (literally, "letter case"). No *fubako* have survived from ancient times, but the fact that they are mentioned

in the *Tale of Genji* indicates that they were produced as early as the eleventh century. They came to be widely used from the Muromachi period, and in the Edo period outstanding examples decorated with the elaborate *maki-e*, or inlaid mother-of-pearl, lacquer techniques were being produced in large numbers. Moreover, by this time *fubako* came to be added to the stationery items included in a wedding trousseau, so they became even more lavish in their decoration. This *fubako* is an eighteenth century example of this type of elaborate trousseau item, and is decorated with water grasses and irises that bloom in the summer.

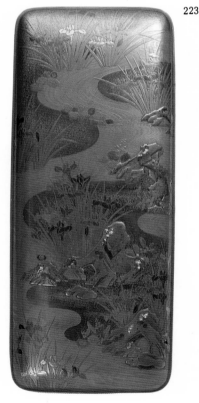

223

223

224. WRITING TABLE

Design of chrysanthemums along a rocky shore in gold and silver *maki-e* on an aventurine lacquer ground; 33.3 × 57.9 × 9.1cm.
Edo period, 17th century

A *bundai* is a small, rectangular desk only about nine centimeters high. In ancient times *bundai* were stands for books or *tanzaku* (see no. 193), and hence the origin of its name which means "stand for a letter." With time *bundai* became smaller and were mainly used for writing, especially at poetry gatherings.

Technically, this writing table was first covered entirely with a sprinkling of gold powder. Atop this the chrysanthemums and rocks were executed in high relief (*taka-maki-e*) using gold and silver powders. Inlays of gold and silver metal (*hyōmon*) were used for the dew and written characters. Before tarnishing, the silver was a gleaming white, which would have produced a dramatic contrast with the gold and been more suitable in illustrating the poem. It is thought that this *bundai* dates from the late sixteenth or early seventeenth century (Momoyama and early Edo periods), when, judging from extent examples, nature motifs composed solely of flowers and grasses were most widely adopted as decorative themes.

224 (seen from above)

224

224

226. BOOKREST

Design of flowers and grasses along the banks
of a stream in gold and silver *maki-e* and inlay
on an aventurine lacquer ground;
28.9 × 70.0 × 52.2cm.
Edo period, 17th—18th century

Kendai were elevated stands for the
placement of books, musical scores or
scripts during performances or simply when
reading. Books placed on a *kendai* come
up to the eye level of someone seated on
the floor.

Depicted on this bookrest is a tranquil
spring scene of thickly blossoming roses
and bamboo grass among the rocks lining
the banks of a swiftly flowing stream.

The design is called *chōshun*, the
"prolonged or enduring spring," because it
communicates the atmosphere of that season.
The entire design was executed in gold
and silver using the techniques of *maki-e*
and inlay to produce an elaborate work
that fully utilizes these decorative techniques.

From the composition of the design
and the free use of *maki-e*, this *kendai* is
thought to have been produced in the
middle Edo period, in the seventeenth
or early eighteenth century.

"Uta-awase," from "Chiyoda no Ō-oku"
by Hashimoto Shūen.

226

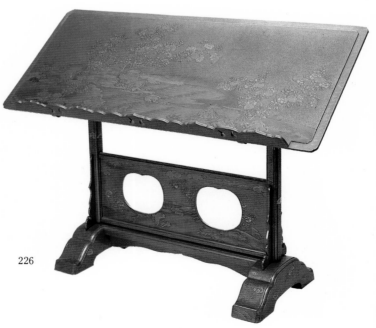

225

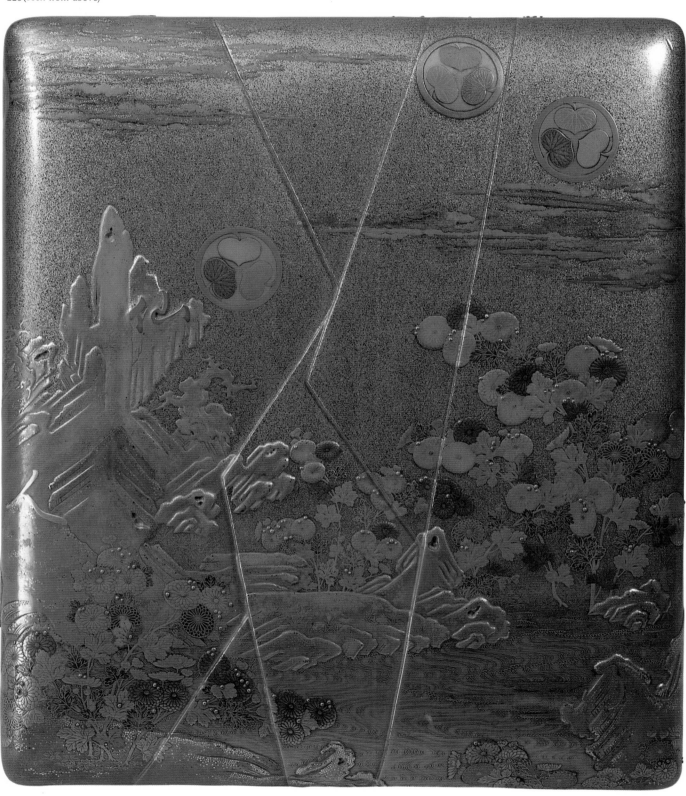

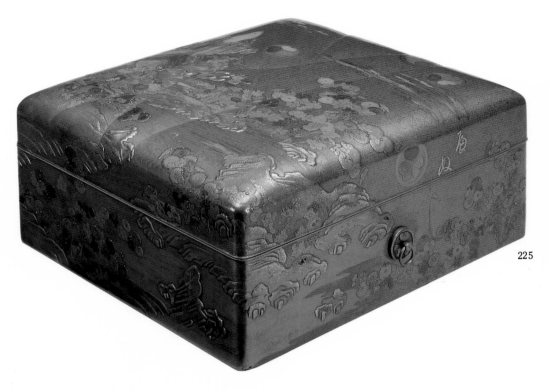

225

225. STATIONERY BOX

Design of chrysanthemums along a rocky shore
with scattered *aoi* crests in gold and silver *maki-e*
and inlay on an aventurine lacquer ground;
42.4 × 36.4 × 18.8cm.
Edo period, 17th century

Ryōshibako are boxes used primarily
for the storage of different types of writing
paper and letters.

Both the design and decorative tech-
niques of this box are similar to those used
on the *bundai* (in number 224). Conse-
quently, it is thought that both objects were
made by the same workshop at about
the same time. Just as inkstone boxes and
writing tables were often produced as a
matched pair from the middle of the
Muromachi period, in the early Edo period
stationery boxes were included with this
set, with all three being decorated with
complementary designs and techniques.
Both this box and the writing table in the
previous entry are highly decorative, but
display strength as well as sumptuousness.

Five *aoi* crests of the Tokugawa family
augment the design of this box. This
motif is continued on the metal fitting on
either side of the box through which the
silk cord that secures the lid is passed.
The ring is mounted on a metal projection
which displays the same chrysanthemum
design seen on the box itself.

227

227. INKSTONE CASE

Design of lions and peonies in *maki-e* on a cinnabar lacquer ground; 23.2 × 22.0 × 4.3cm.
Edo period, 18th—19th century

Until pens were imported in large quantities to Japan from Europe in the nineteenth century, Japanese wrote with brushes. Even today on diplomatic documents, a brush is used when signing.

A *suzuri-bako* is a small case for storing instruments for writing with a brush. The main object kept in this case is the inkstone (*suzuri*). Next in importance are the brushes, the ink stick, and the water dropper (*suiteki*) for holding the water that is mixed with the ink stick to make liquid ink. Other tools include a small paper knife, an awl to use as a paper punch, and tongs for holding the ink stick.

This inkstone case bears a design of lions and peonies in *maki-e* and gold and silver inlay boldly distributed across the entire surface. On the inside of the lid is depicted a dragon among the clouds rising from the midst of the sea.

The original brushes, ink stick, and tongs are unfortunately now lost.

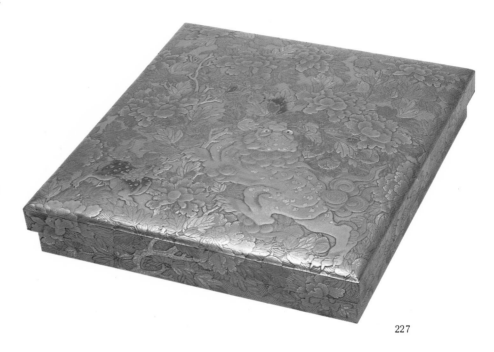

227

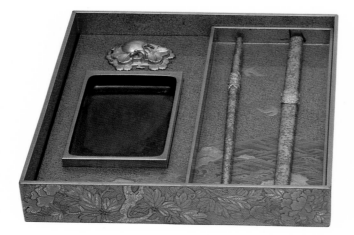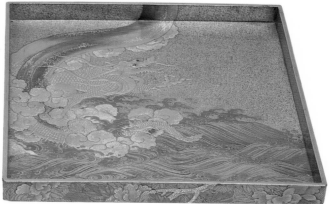

227 (interior)

228. BOX FOR *SHIKISHI*

Design of herons in a mountainous landscape in *maki-e* on an aventurine lacquer ground; 18.4 × 18.4 × 4.5cm.
Edo period, 18th century

This is a box for storing *shikishi* (see no. 201), the thick, square paper used for painting or writing poetry.

On this box are landscapes of the four seasons—the grasses, flowers, birds, and farming activities of each season—densely yet delicately depicted in the traditional technique of silver and gold *maki-e*. As time passed, Edo period *maki-e* objects generally tended to become more ostentatious—mere technical displays as ends in themselves. This *shikishibako*, on the other hand, avoids these excesses and exhibits a dignified, balanced design composition.

The decorative border around the perimeter of the lid demarcates the top of the lid from the sides, thus creating a continuous landscape band around the deep, overlapping sides of the lid, and a scene not unlike a decorative *shikishi* itself in shape, size, and decoration on the top of the lid.

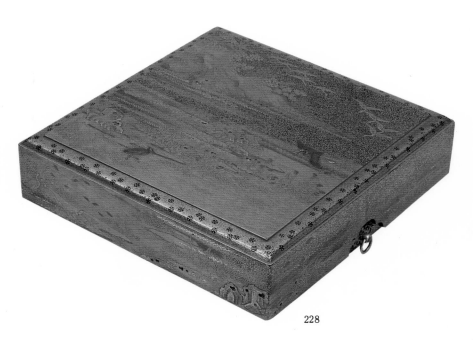

228

228 (interior and reverse of the cover)

236. PICNIC BOX

Design of *yatsuhashi* (eight bridges and irises)
in gold and silver *maki-e* on a black lacquer
ground;
22.1 × 38.0 × 38.0cm.
Edo period, 18th-19th century

A *sagejū* is a kind of picnic box (*bentō bako*) which holds an assortment of food and beverage containers in a light, compact, portable form. Carried from the silver handle attached to the top, this *sagejū* has three compartments and two levels. The largest object included in this *sagejū* is the tiered food box or *jūbako*. Next to it are two silver *sake* bottles decorated with the *aoi* crest of the Tokugawa family. Below these bottles is a

small container. In the upper level there is a compartment for trays and one for a two-tiered container.

The box itself and all its component parts (with the exception of the silver bottles) are coated with black lacquer and decorated with the *yatsuhashi* motif taken from the *Ise monogatari (Tales of Ise)*. A dense sprinkling of gold was used for the edges of the frame and the border of the lid of the *jūbako*. Silver was used

primarily for the iris flowers, while the rest was executed with gold *maki-e*. Irises are a favorite summer flower in Japan and an appropriate motif for this box which was primarily used during the warm months of the year. In addition to *sagejū*, other containers such as *jūbako, hokai* (see no. 237) and *chabentō* were also used for eating outdoors.

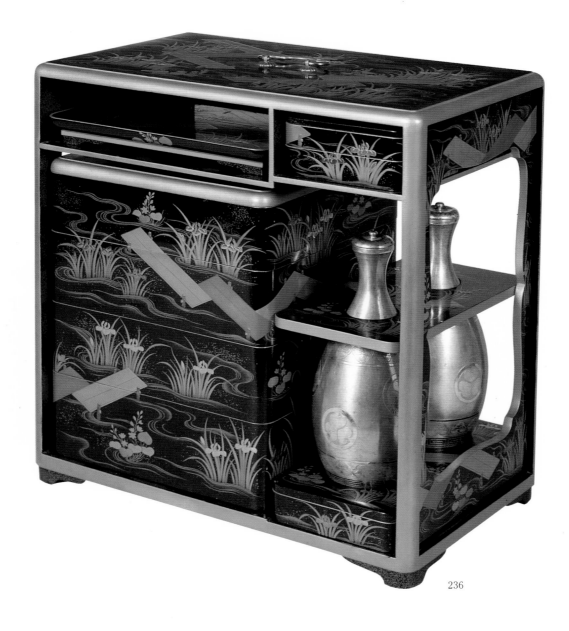

236

238. TIERED FOOD BOX

Design of long-tailed cocks in cherry trees in *maki-e*, and inlay on a black lacquer ground: 25.6 × 24.0 × 43.6cm.
Edo period, 19th century

Completely coated with black lacquer, this *jūbako* is decorated with long-tailed cocks and cherry trees that bloom in the spring. The techniques of *maki-e, hyōmon,* and *kirigane* are skillfully blended in this colorful landscape. Tiered boxes of this type are used for storing and serving food, and consist of two, three, five, or more tiers. This box has five layers which decrease slightly in height from bottom to top. These boxes could separately store the various parts of a meal such as cooked rice, stewed dishes, fish, or raw vegetables without spoiling their individual flavors. Primarily used for picnics or at festivals, *jūbako* were also used in conjunction with *sagejū* (see no. 236) and *chabentō*. The use of these tiered boxes was widespread throughout the populace in the Edo period. Compared to the highly decorated lacquer boxes used by the upper stratum of society, the boxes of the lower classes had simple, unadorned lacquered grounds or a plain wood ground. Even today they are used several times a year in rural areas, but in the cities their use is limited almost entirely to the serving of the New Year's meal.

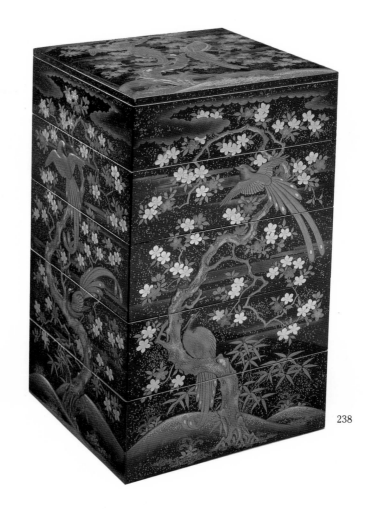
238

237. PORTABLE FOOD BOXES

Design of clematis, arabesques, and scattered *aoi* and paulownia crests in gold and silver *maki-e* on an aventurine lacquer ground; 37.5 × 37.5 × 35.5cm.
Edo period, 19th century

Hokai are containers for carrying food. Like *sagejū* and *jūbako* (see nos. 236 and 238), *hokai* are primarily used outdoors, on picnics or flower and foliage outings. It is thought that the corrugated sides of the vessels were for insulation.

The design on these boxes includes the *aoi* crest of the Tokugawa family and the paulownia crest of the imperial family, along with clematis, a popular summer flower. The composition of the design and the accomplished *maki-e* technique place this pair of boxes among the finest lacquer works of the late Edo period.

237

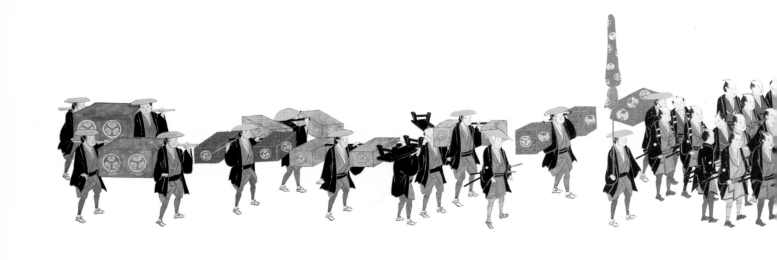

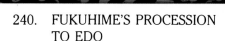

240. FUKUHIME'S PROCESSION TO EDO

Handscroll, colors on paper;
31.1× 1855.6cm.
Edo period, 19th century

This handscroll records the details of the procession from Kyoto to Edo of Fukuhime (also known as Shunkyō-in), the daughter of the court noble Konoe Motosaki, during the latter part of the tenth lunar month of 1836, for her marriage to Tokugawa Nariharu, the eleventh lord of Owari, in the eleventh month of that same year.

The palanquin of Fukuhime is shown surrounded by hundreds of attendants: warriors on foot armed with a pair of long and short swords, mounted warriors, archers, and lancers as well as porters carrying long chests, suits of armor, boxes on long poles, and other wedding furnishings. The identity of the artist who produced this work is not known, but it is believed to be the work of a painter of the Kanō school.

239. PALANQUIN

Design of peonies and arabesque with scattered *aoi* crests in gold and silver *maki-e* on a black lacquer ground; body, 109.4 × 67.3 × 105.4cm.; roof, 133.9 × 106.6cm.; carrying rod, 465.7cm.
Edo period, 19th century

In the Edo period whenever members of the upper classes (nobility, shogun, and daimyo) set out from their residences, whether for short distances or long journeys, they would be conveyed in one of two kinds of vehicles: an oxcart or *gissha* (a small wagon pulled by a single ox) or a palanquin. Illustrated here is an *aoi*-crested palanquin of the most exalted type. Reserved for use by females only, this *norimono* was carried by a long rod, that passed through metal fittings attached to the roof of the riding compartment on the shoulders of six men, three in front and three in back (see no. 240). The palanquin could be entered through two sliding doors on either side, and one rode facing forward with legs tucked underneath. Although the interior seems small and cramped, there was sufficient room for reading and writing and performing small tasks. Furthermore, by sliding the lattices attached to the windows in front and on the side doors, the passenger was able to enjoy the passing scenery.

The entire exterior was coated with black lacquer upon which Tokugawa family crests and an arabesque pattern were decoratively applied using gold and silver *maki-e*. The interior is also lavishly decorated with the auspicious tortoise and foliage painted on the gold leaf that covered the walls, while the ceiling is adorned with a large yet delicately handled *aoi* crest in bright colors. The vehicles used by warriors of low rank and affluent merchants were more modest, either a plain palanquin whose decoration was limited to its black-lacquered surface or a simple woven bamboo vehicle of the same shape.

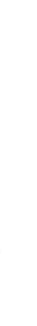

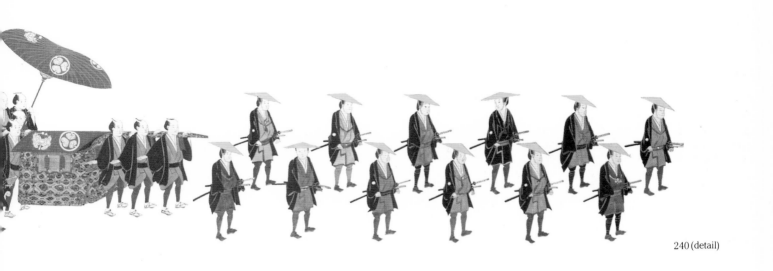

240 (detail)

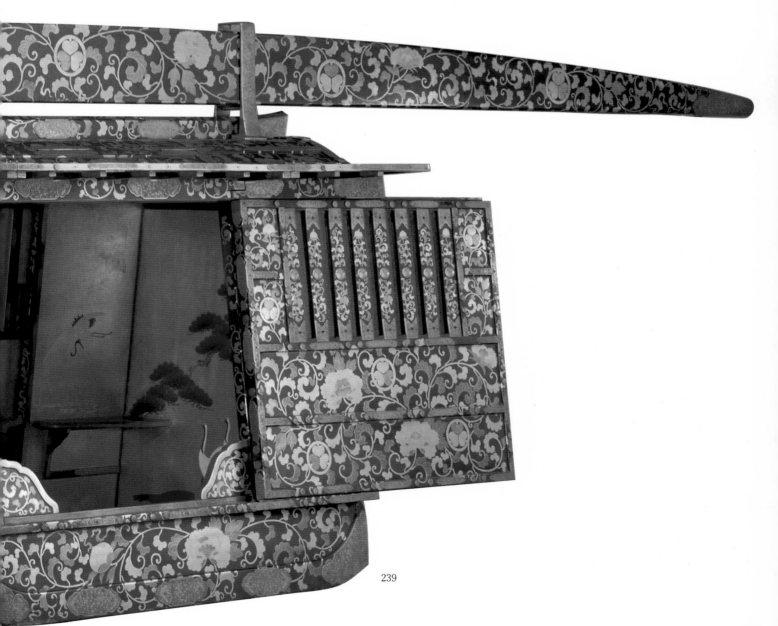

239

233

DRESS

The clothing worn by the shogun or daimyo of the Edo period included garments such as formal court dress for ceremonial occasions, the *kamishimo* that constituted the formal wear of the samurai, and everyday wear such as *haori* jackets, *kosode* robes, *dōfuku, katabira,* and *yukata.* The ladies wore such garments as *kosode, uchikake, katabira,* and *koshimaki.* With the advent of summer, the ladies wore a *kosode* held in place with a sash and draped a *koshimaki* over this. At the onset of winter, the *kosode* was worn underneath an *uchikake.*

During the period, although quality varied greatly, the *kosode* was widely worn, regardless of sex or status. During the first half of the seventeenth century, the *kosode* was tailored with short, deep sleeves, but from the Genroku era onward, the length nearly equaled the width of the sleeves, and the patterns grew increasingly ornate. By the latter half of the eighteenth century, women's *kosode* developed long sleeves that trailed to the ground. These garments were patterned using many and varied techniques of weaving, dyeing, and embroidery. Of these, *nuihaku* was also used for Nō costumes, and dyeing in fine patterns was largely used for garments for ladies of samurai lineage. *Yūzen* dyeing incorporated the previously extant techniques used to produce *ko-mon* (fine patterns) and methods used in *tsujigahana.* With the development of the *yūzen* dyeing technique, even more detailed and elaborately patterned *kosode* were produced.

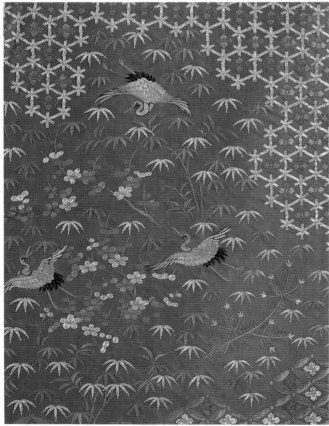

243. *KOSHIMAKI*

Outer robe with designs of auspicious motifs, including pine, bamboo, plum blossoms, cranes, the seven sacred jewels, and hexagonal tortoise-shell pattern in embroidery on a dark brown silk ground;
167.0 × 132.8cm.
Edo period, 19th century

The *koshimaki* was worn over a *kosode* as a kind of wrap. It was worn slipped off the shoulders, wrapped about the waist, and held in place at the hips with an *obi* (sash). By the seventeenth century, the *koshimaki* was being worn by women of the upper classes as formal summer wear.

The designs elaborately embroidered over this finely-tailored women's gown are all traditional Japanese auspicious motifs. They include the pine tree, bamboo, and plum signifying long life and strength, rectitude and resilience, harmony, and happiness; cranes and the tortoise-shell motif symbolizing longevity; and the seven jewels of Buddhism, sometimes identified as gold, silver, lapis lazuli or jade, crystal, coral, agate, and pearl.

243 (detail)

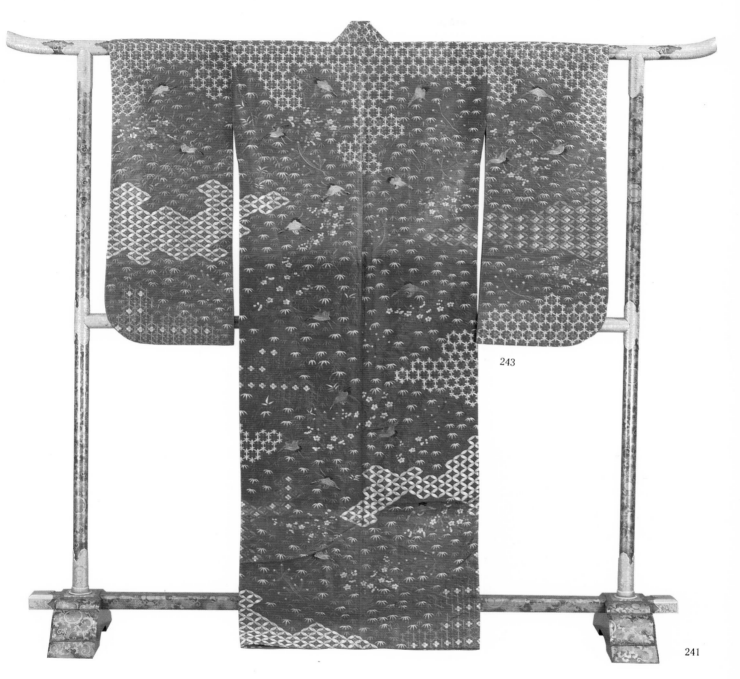

243

241

241. GARMENT RACK

Design of scattered *aoi* and chrysanthemum *fusen* crests in *maki-e* on an unevenly distributed aventurine lacquer ground; 163.9 × 185.7cm.
Edo period, 19th century

An *ikō* is a rack on which garments are draped. In addition to this type of inflexible rack, another variety exists with metal hinges in the middle that allow the rack to be folded in two. Known as *ika* or *mizokake* in ancient times, *ikō* came to be called by its present name from the late

Muromachi period (1st half of the 16th century).

The ground technique used on this garment rack is a variant of the common aventurine lacquer technique, in which the gold powder is unevenly scattered over the surface. A design of scattered *aoi* and stylized chrysanthemum crests is applied atop this ground.

This garment rack is said to have been part of the wedding trousseau of Naohime (also called Teishin-in), the wife of Tokugawa Naritaka, twelfth lord of Owari.

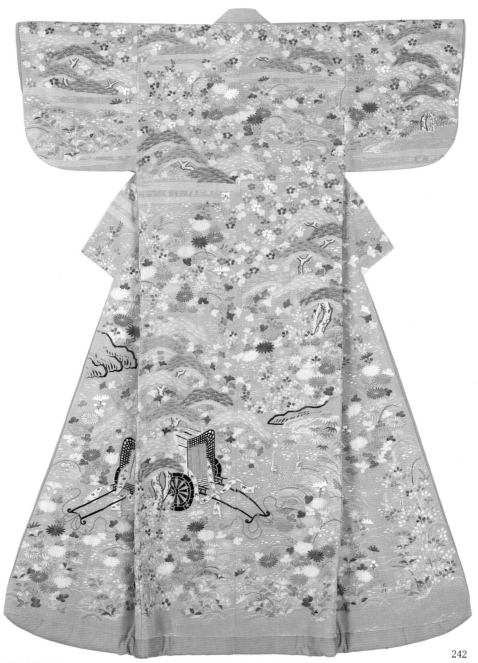

242

242. *WATAIRE-KOSODE*

Cotton-padded inner robe with classical palace scenes dyed and embroidered on a pale blue silk crepe (*chirimen*) ground;
175.7 × 121.2cm.
Edo period, 19th century

The garment called the *kimono* is the national costume of Japan. This garment, when sewn so that the sleeve opening is small, is called a *kosode*. The *kosode* first evolved as a garment in the fifteenth century, but it was not until the seventeenth and eighteenth centuries that it was popularly worn. It was usually worn closed with an *obi* (sash), but long-trained *kosode* such as these two examples were worn slipped on as outer robes, the train trailing behind.

In number 242, a design of classical palace scenes and flowering trees and grasses of the four seasons has been dyed on a pale blue silk crepe ground and accented with embroidery of gold and colored silk threads. This *goshodoki* motif was one of those favored by the women serving at the Kyoto Imperial Palace during the eighteenth and nineteeth centuries. The designs incorporated in the motif may include palace buildings and pavilions, flowering trees and grasses of the four seasons, flowing water, fans, baskets, and ox-drawn carts. *Chirimen* (silk crepe) is a type of fabric in which a strong twisted raw silk weft thread is used in the weaving. When the cloth is then

put in warm water, the threads shrink, creating fine wrinkles in the fabric.

A pattern of flowers and butterflies woven into the white figured-satin ground of number 244 is further embellished with an embroidered design of wisteria, hand-drum skins, and iris. Figured satin (*rinzu*) is a particular type of fabric where glossed threads are used in the weaving so that a shiny textile is produced.

These two *kosode* are said to have been worn by Norihime, the wife of the fourteenth lord of Owari, Tokugawa Yoshikatsu.

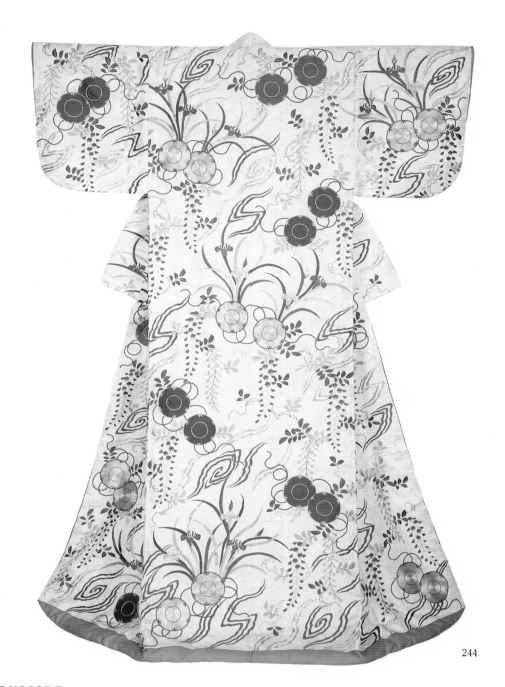

244

244. *WATAIRE-KOSODE*

Cotton-padded inner robe with a design of
hand-drum skins, wisteria, and iris embroidered
on a white figured satin (*rinzu*) ground;
177.3 × 122.4cm.
Edo period, 19th century

245

246

245. *SHIMA-BAORI*

Jacket with splash-pattern (*kasuri*) stripes and *aoi* crest on a light brown abaca (*bashō*) cloth ground;
112.1 × 124.2cm.
Edo period, 17th century

246. *HITOE-BAORI*

Unlined jacket with *aoi* crests on pale yellowish-brown silk tailored in piecing (*tsugiawase*) style;
119.6 × 140.0cm.
Edo period, 17th century

Both of these articles of clothing are *jackets* for summer use, to be worn over *kosode*. The distinctive feature of the *haori* is that there is a gusset inserted at the underarm where the neckband, which has been turned under and continues to the end of the front hem, joins on either side of the underarm. Small loops are provided for a set of short braided cords to serve as a fastener. It is said that the *haori* came into use during the years 1573 to 1591.

The *bashō (abaca)* cloth used in the jacket in number 245 is woven of striped and splash-pattern dyed abaca threads. Because it is woven from coarse twisted fibers, it was probably made for mid-summer use. This *haori* seems very simple at first glance, but, in fact, the composition of the design is very modern in feeling. It is said to have been worn by the third lord of Owari, Tokugawa Tsunanari (d. 1699).

The unlined *haori* in number 246 is composed of an upper portion of knotty silk dupion cacoon threads woven in what is called the *fushito-ori* (knotty silk) weave. In this technique the warp and weft threads are of glossed silk—the weft being pure silk, and the warp also pure silk or dupion cacoon silk. The lower portion of the jacket is in *shijira-ori,* a technique in which slender wrinkles are produced in thin vertical lines across the fabric, or, as in this example, a checkered surface is produced. The two parts are pieced together with a lace net technique. The gussets are wider than in most *haori*, and generally the jacket has a novel feeling to it. This *haori* is said to have been worn by the third shogun, Tokugawa Iemitsu (1604-1651). As the date of manufacture is known, it is treasured as a fine example of the weaving and dyeing art of the time.

247. AWASE-KOSODE

Lined inner robe with a design of *aoi* leaves and *aoi* crests in fawn dappled tie-dyeing on a grass-green figured satin ground (*saya*);
143.3 × 138.6cm.
Edo period, 17th century

This is a lined *kosode* with a thunder-bolt design woven in figured satin and dyed a rich grass green. This style of weaving often employs the key-fret pattern as well as the thunder-bolt design and a plain twill pattern.

This *kosode* has the Tokugawa *aoi* crests at the center-back and sleeves, and also has stylized rendering of the same *aoi* using the dappled tie-dyeing technique for a clear, bright effect.

This *kosode* is said to have been worn by Tokugawa Ieyasu, and has been carefully preserved as such, but on comparison with other robes worn by him, it proved to be both longer and wider, giving rise to speculation about the original attribution. However, the composition of the design is quite remarkable, and it has been suggested that the robe may be one which Ieyasu used as a *Nō-kosode*.

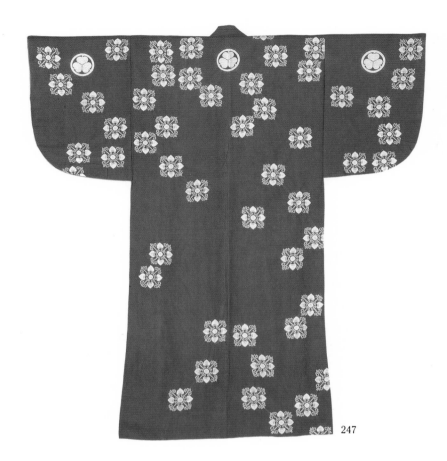

247

248. KATABIRA

Summer robe with *aoi* crests in indigo on a white hemp ground;
137.5 × 127.2cm.
Edo period, 19th century

The *katabira* is one example of a robe worn in the summer. The cloth used is hemp and it has been tailored as an unlined robe. Because the *katabira* was to be worn in the summer, every attempt was made to employ designs that suggested coolness. Hemp was favored because of its excellent ability to absorb moisture, its fast drying properties, and its pleasant feeling against the skin.

This particular *katabira* has the Tokugawa family crest, the trifoliate *aoi*, repeated twice on the front and three times on the back, dyed in indigo. The fourteenth lord of Owari, Tokugawa Yoshikatsu (1824-1883), is said to have worn this refined *katabira*.

248

249

250

249. *YUKATA*

Bathing robe with a resist-dyed design of crabs on a pale blue hemp ground;
133.3 × 139.2cm.
Momoyama period, 16th century

250. *YUKATA*

Bathing robe with a design of a large indigo lattice motif with snow roundels and paulownia crests resist-dyed on a hemp ground;
145.4 × 126.0cm.
Edo period, 17th century

·Today the *yukata* is generally worn in the summer, perhaps after taking a bath, or to enjoy summer festival activities in the cool of the evening. From the sixteenth or seventeenth century, however, the nobility, shogun, daimyo, and high-ranking warriors, all wore the *yukata* for bathing. They wore the garment into the hot water, or afterward to absorb moisutre like a western bathrobe.

The hemp cloth in the robe in number 249 has been resist-dyed a pale blue. The design of crabs in white has also been created by the resist-dye technique. The color of the hemp ground has faded, and so the crab design is not very clear, but remains bold and imaginative. It is an example of a typical *yukata* of the Momoyama period, and is said to have been worn by the first Tokugawa shogun, Ieyasu.

The cloth of number 250 has been resist-dyed so that a large indigo lattice pattern appears on a pale blue ground. The same technique is used to create a design of snow roundels and paulownia crests which alternate on the lattice, with particular care being shown to the use of light and shade. The pattern has almost faded because of exposure to hot water and perspiration, but the beauty of the composition and choice of design are still superb. It is believed to have been worn by the fourth lord of Owari, Tokugawa Yoshimichi.

251. *HAN-KAMISHIMO*

Jacket and ankle-length trousers with a fine pattern of hexagonal tortoise-shells and *hōrai* auspicious motifs and *aoi* on a dark blue hemp ground;
upper garment, 51.5 × 42.4cm;
trousers, 50.0 × 41.5cm.
Edo period, 18th century

252. *NOSHIME*

Inner robe with a lattice-work horizontal band and *aoi* crests on two narrower bands on a blue silk ground;
79.0 × 79.6cm.
Edo period, 18th century

253. *KOMON-KOSODE*

Inner robe with a fine pattern of myriad
treasures and *hōrai* auspicious motifs
surrounding *aoi* crests on horizontal bands on
a pale blue ground;
100.0 × 68.0cm.
Edo period, 17th century

All three pieces are children's formal
wear for ceremonial occasions. The *han-
kamishimo* was formal wear for the
warrior class and consisted of the
kataginu (vest) and *hakama* (trousers).
The *han-kamishimo* in number 251 is
purported to have been made for the
celebration of the *kami-oki* ceremony of
Tokugawa Yoshimichi, fourth lord of
Owari, when he was three years of age.
The etiquette of the time dictated that a
ceremony be held to pray for the longevity
of the child when the child's head was no
longer to be shaved, so that from that point
on, the hair might be dressed. This *han-
kamishimo* is of hemp and has been dyed
dark blue with an overall fine pattern of
hexagonal tortoise-shells. Felicitous
symbols, such as the pine, bamboo, crane,
and tortoise, appear in white along with
the Tokugawa *aoi* crests. The contours of
the figures have been drawn in with ink
and yellow ochre pigment.

The *noshime* in number 252 was the
garment worn with the *han-kamishimo*
(no. 251). The *noshime kosode* was the
formal inner garment of the warrior class
in the Edo period, and was worn first
under the unlined *suo* outer garment, and
then under the *naga-kamishimo* or *han-
kamishimo*. This *noshime* has been cotton-
wadded. The silk has been dyed a bright
blue, and the broad band of white with
lattice-work design classify it as a *dan-

noshime* with crests.

The robe in number 253 was made
specially on the birth of Tokugawa
Tsunanari, who later became the third
lord of Owari, for the celebration of
o-shichiya, the feast on the seventh day
after the birth of a child. It is a lined robe,

the silk ground of pale blue being dyed
with an overall fine pattern of
takarazukushi (myriad treasures).
The auspicious motifs and *aoi* crests are
also in white resist, and black has been
used to outline the elements of the design.

251

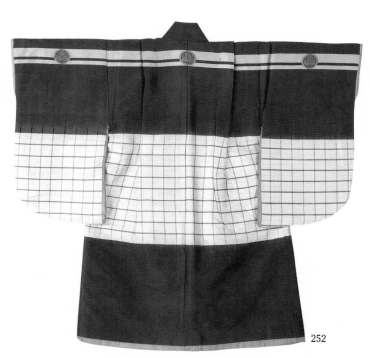

252

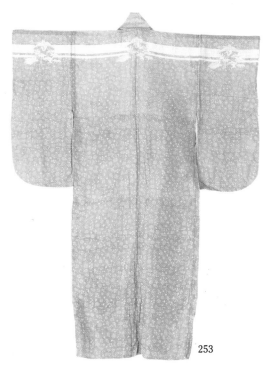

253

241

ACCOMPLISHMENTS AND AMUSEMENTS

The essential accomplishments of a samurai of the Edo period consisted of scholarship and the military arts, including swordsmanship, archery, and horsemanship. Aside from this emphasis, which stemmed from Ieyasu's original instruction to excel in both the literary and military arts, high-ranking members of the samurai class practiced Nō, the tea ceremony, the incense ceremony, flower arrangement, poetry composition, calligraphy, and painting as part of their self-cultivation. Among these latter accomplishments were fields in which the ladies of the household also participated.

The use of incense reached its apex during the Edo period, while at the same time adopting the character of an amusement. For this reason, the incense instruments of the Edo period were designed with that end in mind, resulting in the production of numerous lavish examples. Tokugawa Ieyasu, too, had enjoyed the game of incense identification, collecting frangrant woods toward the end of his life and presenting them to the imperial court or bestowing them on daimyos or retainers as rewards. Fragrant woods and incense instruments were prized in daimyo families as well as in the household of the shogun.

A variety of pastimes and amusements were enjoyed by the shogun and daimyo: the courtly game of "football" played by keeping a ball aloft as long as possible by kicking, sumō wrestling, polo, and horse racing; board games such as go, shōgi, and backgammon; and games such as the matching of shells and card games. The board games of go and shōgi were enjoyed as a form of social interaction among the samurai of high rank, while the ladies derived pleasure from shell-matching and card games.

The Girls' Festival was strictly a women's celebration, occurring on the third day of the third lunar month, and also on the occasion of marriage and the first festival occurring after marriage. The miniature accoutrements for the Girls' Festival were accurate, detailed re-creations of a bride's trousseau in miniature.

254. *KOTO*, NAMED "KOMACHI"·

Small zither with a design of fans scattered in a stream in paulownia wood inlaid with gold, silver, tortoise shell, mother-of-pearl, and ivory; 170.6 × 20.6cm.
Muromachi period, 15th century

The *koto* (also called the *sō*) is a musical instrument of Western origins that came to be used in China in about the eighth century, B.C. The *koto* used at the beginning of the Christian era had five strings, but it is thought that the change to the present-day thirteen string model occurred sometime in the fifth or sixth century, A.D. The transmission of this instrument from China to Japan took place in the Nara period (7th-8th century) when continental culture greatly influenced Japan. So firmly entrenched was this instrument in the culture of that time that when a similar instrument, the native Chinese *kin*, was transmitted to Japan a little later, it was also called a *koto* (or a "seven-stringed *koto*").

The *koto* is played with picks worn on the thumb, index and middle fingers of the right hand. The playing of the *koto* was made a part of the education and training of young girls in households of the Edo period, and it was often included in the wedding trousseau.

The design of open and closed decorative fans scattered about the rushing currents of a stream is found on both ends and along the sides of the zither in number 254, inlaid in gold, silver, tortoise shell, ivory, mother-of-pearl, and ebony. According to an inscription on its reverse discovered during repairs in 1915, this *koto* was made for the daughter of Arima Takazumi (d. 1494), the lord of Hizen, a province in Kyūshū. This *koto* is traditionally said to have been owned by Haruhime, the wife of Tokugawa Yoshinao, the first lord of Owari.

The name of the larger, standard size *koto* (no. 255) comes from a section of the wood grain surface underneath the strings that was thought to resemble the figure of a tiger (in Japanese, *tora*). The design of fans, plum and cherry trees, peonies, aquatic plants, and other flowers found on the ends and sides of this instrument are inlaid in ivory, tortoise shell, and imported woods. It, too, was no doubt the prized possession of the female members of a daimyo household.

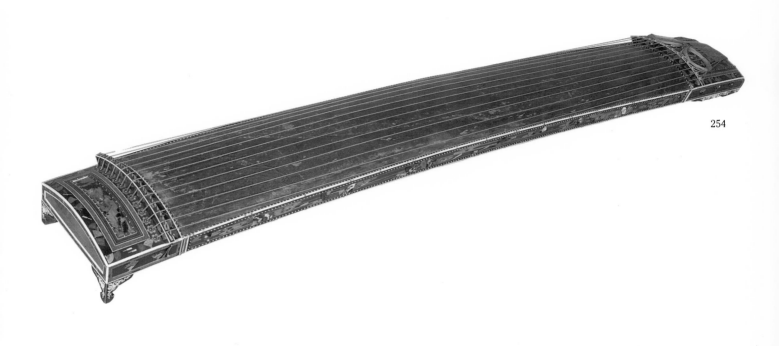

254

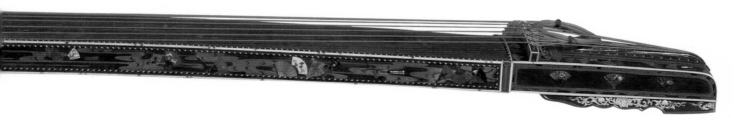

254 *Iso* (side)

Ryūzetsu (detail)

Ryūbi (detail)

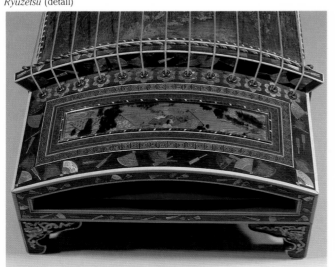

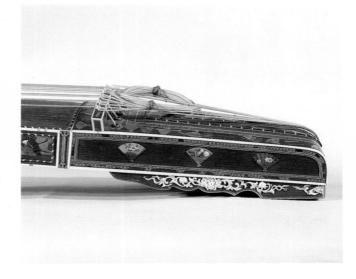

243

255. *KOTO*, NAMED "TORA"

Zither with a design of fans, flowers and grasses in wood inlaid with ivory, tortoise shell, and other woods;
192.7 × 23.2cm.
Muromachi period, 16th century

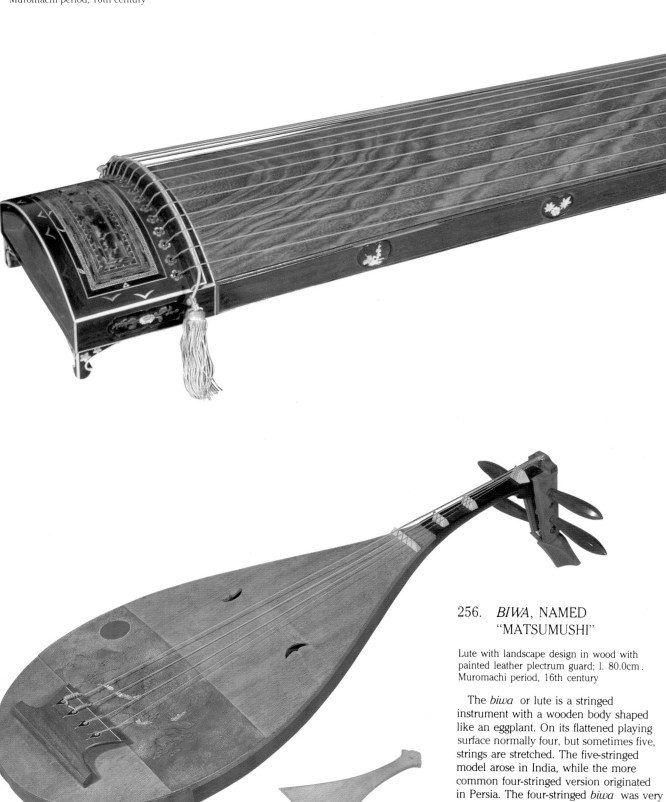

256. *BIWA*, NAMED "MATSUMUSHI"

Lute with landscape design in wood with painted leather plectrum guard; l. 80.0cm.
Muromachi period, 16th century

The *biwa* or lute is a stringed instrument with a wooden body shaped like an eggplant. On its flattened playing surface normally four, but sometimes five, strings are stretched. The five-stringed model arose in India, while the more common four-stringed version originated in Persia. The four-stringed *biwa* was very popular in China from the seventh to the eighth century, at which time it was introduced to Japan.

256

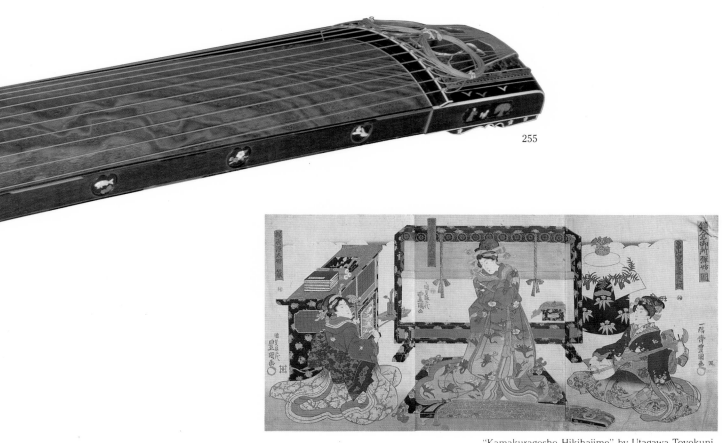

255

"Kamakuragosho Hikihajime" by Utagawa Toyokuni.

257

257. *SHAMISEN*

Design of birds by the shore in *maki-e* on a
black lacquer ground and Chinese quince wood;
l. 96.9cm.
Edo period, 19th century

The plectrum guard of this lute is
leather that was completely covered with
gold pigment and attached to the wooden
body of the lute. Upon this leather is
painted a colorful landscape with soft
washes and gentle outlines. A circular
sheet of *shakudō* (an alloy of copper and
gold) serves as the moon in this scene
dominated by the central waterfall.
Judging from the shape of the instrument
and the style of the landscape on the
plectrum guard, this *biwa* is thought to
have been made in the sixteenth century.

A *shamisen* (or *samisen;* literally,
"strings of three flavors") is a three-
stringed musical instrument with a long
neck and wide, square, wooden body with
swelling sides. Originally a Chinese
instrument, the *shamisen* was introduced
to Japan by way of the Ryūkyū Islands
between 1558 and 1569.

This *shamisen* has the hide of a cat
stretched across a body made of Chinese
quince wood. Chinese woods such as

quince, iron-wood (*tagayasan*), rosewood
(*shitan*), and mulberry were preferred for
the body. Inlay and *maki-e* (as seen here)
were the most popular decorating
techniques.

The *shamisen, koto,* and *biwa* form a
trio of stringed instruments known as the
sankyoku ("three instruments"). This set
was frequently included among the
trousseaux for brides of daimyos.

245

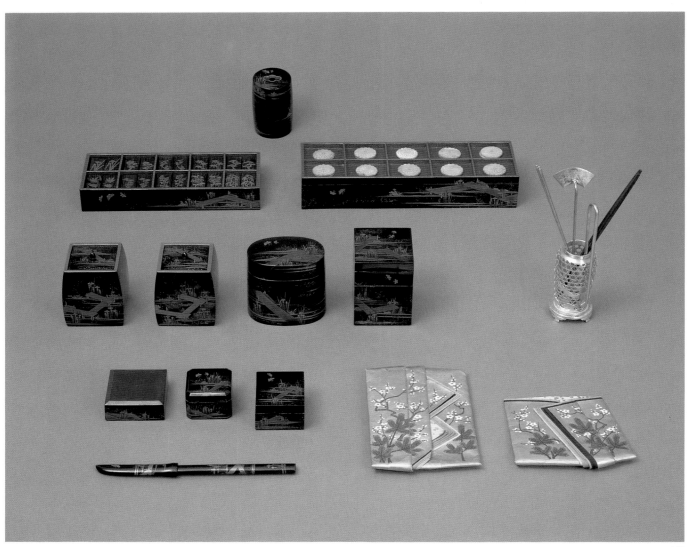

261. *JUSHŪ KŌBAKO*

Box for implements used in incense
identification competition with design of
yatsuhashi motif in gold *maki-e* on a black
lacquer ground;
22.0 × 18.3 × 17.0cm.
Edo period, 19th century

Incense wood was an especially prized
import that was not native to Japan.
Incense was made by burying wood of
especially fragrant trees for many years.
The tree resins from the decayed wood
would harden in the warmth of the earth,
producing the wood used in incense
ceremonies in Japan. From ancient times
incense had been burned before Buddhist
images, to freshen rooms, or to scent
clothes and armor. The adoption of
incense into the realm of amusements did
not occur until the height of the
aristocratic culture of the Heian period
(11th century).

The incense identification game involved
the distinguishing of two or more different
kinds of burning incense. By the end of

the fifteenth century, this game had expanded from a competition limited to recognizing only two types of incense to an elaborate game replete with its own specialized tools. As many as ten people would be challenged to identify a variety of incense. By the beginning of the Edo period (17th century), the incense game had reached the peak of its popularity.

For properly enjoying this game, many types of implements were required. Boxes for holding these various implements (no. 262) were called *kōbako* or *kōdōgubako*, and they contained as many as twenty different utensils and smaller boxes. A smaller box called the *kōdansu* was used to carry them outside the home.

The implements illustrated here are too numerous to mention, but several of the more important ones are the *ginyōban*, the *kofuda*, the *fuda tsutsu*, and the *orisue*. The *ginyōban* is a tray with ten silver-rimmed mica wafers on which the incense wood is placed when it is burned. *Kōfuda* are the "ballots" by which a participant at a competition indicates his guess after whiffing the incense. These tags are deposited into the slot on top of the *orisue* and then placed in one of the paper envelopes (*fuda tsutsu*) until the end of the competition.

Number 261 bears a design based upon one of the most popular novels of the eleventh century, the *Tales of Ise (Ise monogatari)*. The *yatsuhashi* "eight bridges") were located somewhere near Nagoya along the Tōkaidō where a small river branched into eight channels. The irises that bloomed below these bridges inspired the poet to compose a poem about his loneliness and longing for home. This design and that of number 262 are both executed in gold *maki-e* on a black lacquer ground.

Number 261 was produced in the middle of the nineteenth century and was owned by the wife of Tokugawa Yoshiakira, the eighteenth lord of Owari.

261

261(detail)

264. INCENSE TOOLS AND CASE

Design of cherry trees in gold and silver *maki-e* on a wood-grain lacquer ground;
10.5 × 6.5 × 2.4 cm.
Edo period, 19th century

This box (*kōwarigu bako*) holds the various tools used in cutting or splitting the incense wood. So precious was this wood that only a sliver was burned at a time, and even that was saved or given as a memento to the winner of the incense competition. There are large and small varieties of these tools; this group belongs to the large category and includes a saw, hatchet, chisel, mallet, and chopping block.

A special lacquer technique known as *mokume-nuri* ("wood-grain coating") was used for the ground of the storage case. After priming the bare wood surface with a thick mixture of lacquer and clay powder (*sabiurushi*), the main lines of the wood grain were grooved with an auger. The coating of brown lacquer penetrated only the grooved lines, highlighting the grain. The branch of a cherry tree in full bloom is depicted on the top of the lid only. The blossoms are rendered in silver, while the leaves and branches appear in gold *maki-e*. The decoration of the interior of the lid and base is limited to a gold *nashiji* ground. All of the tools, with the exception of the chopping block which is made of a hard wood, are made of steel. Delicate designs of chrysanthemum *arabesques* in gold *maki-e* twine around their wooden handles.

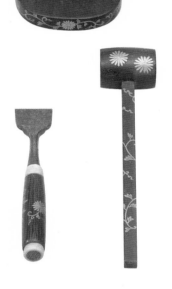
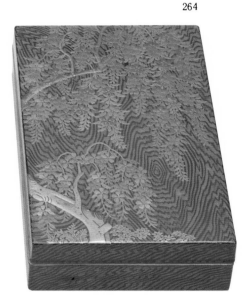

264

265. *JIMBAKO*

Incense box with design of peacock feathers in gold *maki-e* and *aogai* on an aventurine lacquer ground;
11.1 × 16.4 × 11.2 cm.
Edo period, 17th century

There are many kinds of incense boxes such as *kōgō* (incense container), *kasanekōgō* (tiered incense container), and *kōbako* (incense box) that hold a wide variety of incense woods. The incense box known as *jimbako* is used only to store high quality aloeswood.

This box is completely coated with black lacquer upon which a design of stylized peacock feathers is depicted with extraordinary precision and detail. Gold *maki-e* and inlays of shell called *aogai* are the only techniques used.

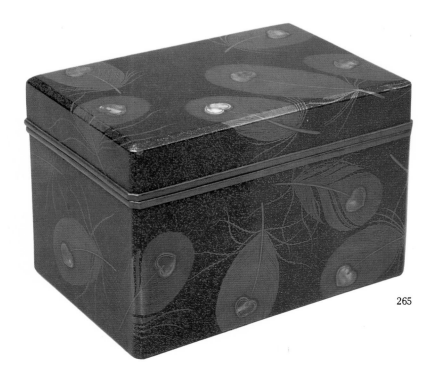

265

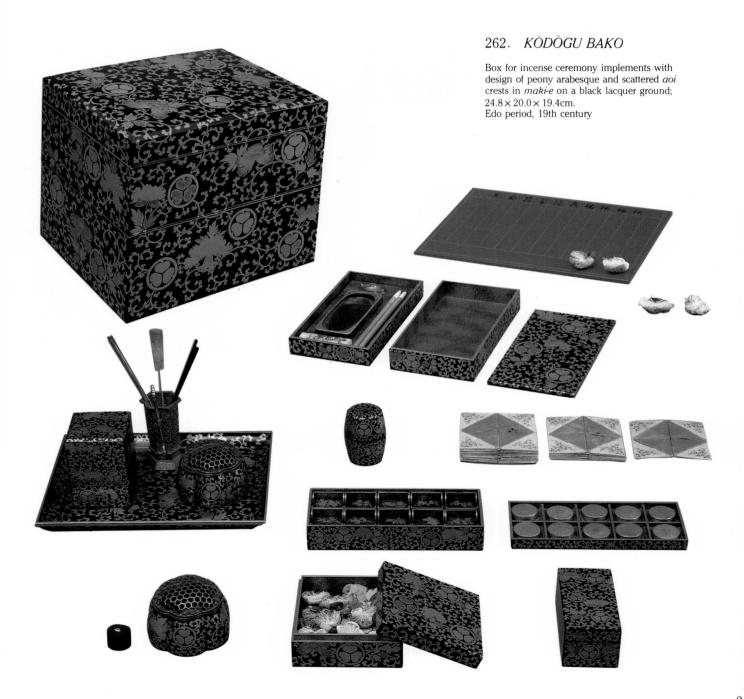

262. *KŌDŌGU BAKO*

Box for incense ceremony implements with
design of peony arabesque and scattered *aoi*
crests in *maki-e* on a black lacquer ground;
24.8 × 20.0 × 19.4cm.
Edo period, 19th century

263. SET OF INCENSE UTENSILS AND THEIR DISPLAY TRAY

Design of *kiku no shiratsuyu* and scattered *aoi* crests in gold and silver *maki-e* on an aventurine lacquer ground;
tray, 28.5 × 40.9 × 4.2cm;
incense container, 9.1 × 7.8 × 4.9cm;
incense burner in blue and white porcelain,
h. 6.4, diam. 8.3cm.
Edo period, 17th century

The various implements displayed on this incense tray are the basic utensils needed in the traditional incense ceremony, including the incense container, where the pieces of fragrant wood are stored before being placed in the incense burner made of porcelain. Although most incense implements were made of lacquer, porcelain examples are by no means rare. The various tools in the silver vase are for tending the fire in the burner. These tools represent a typical set, one that would not be lacking from the reception room of any ranking personage in the Edo period.

The incense container and the tray were made by different hands, but both employ a design based upon the poem entitled "Kiku no Shiratsuyu" (Chrysanthemums in the Dew) that was included in the eighth imperial poetry anthology, the *Shinkokinwakashū*. Both these objects are typical of the many incense utensils made in the seventeenth century when this pastime was at the peak of its popularity.

Among the utensils contained in the silver vase (*kyōjitate*) are a feather to brush away any scattered ash, a sharp, pointed tool for measuring the depth of the ash of the fire, a spatula for shaping the ash mound, metal chopsticks for moving the coals, and a pair of tongs for placing the incense wood and its mica "dish" on the fire (the incense is not to blaze but only smolder).

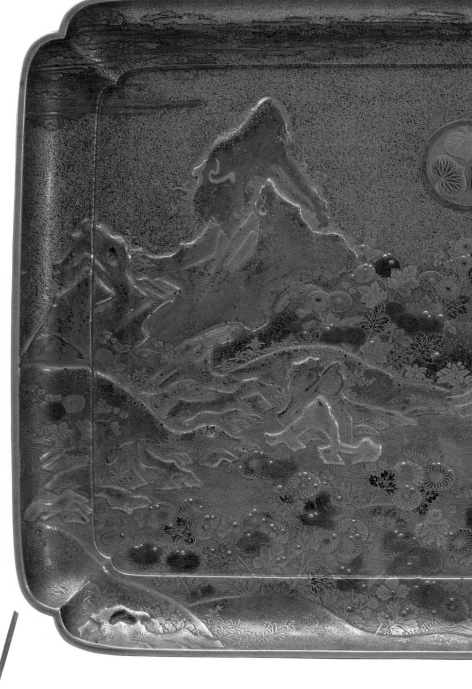

263

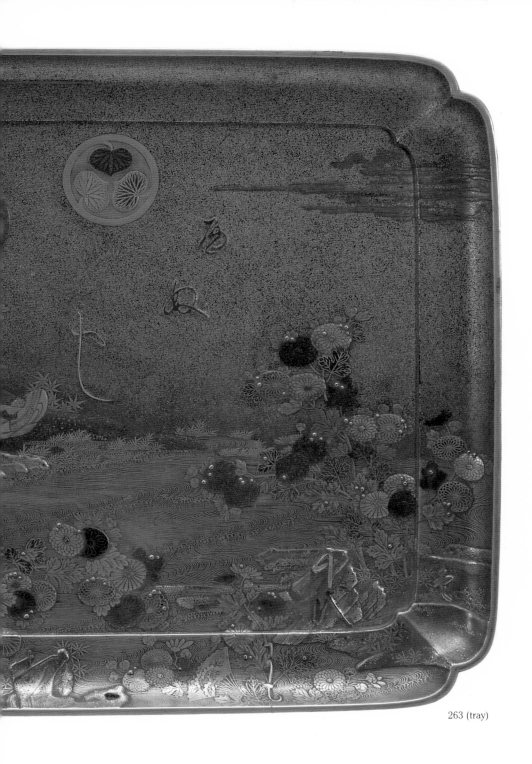

263 (tray)

251

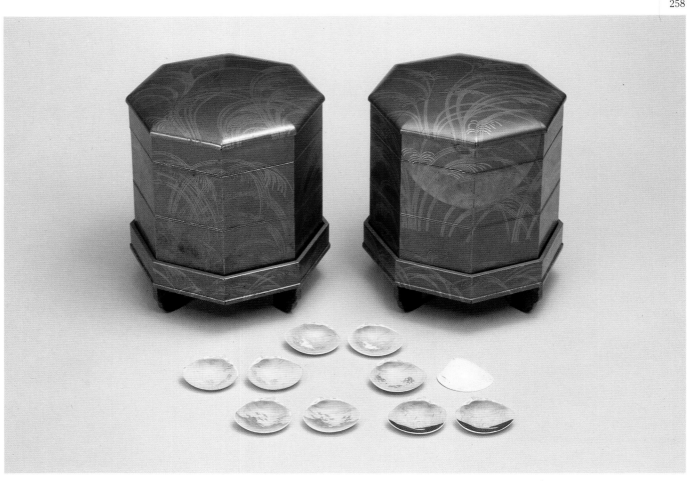

258. *KAIOKE*

Pair of boxes for storing the shells used in the *kai-awase* game with design of the moon and miscanthus grass in gold and silver *maki-e* on an aventurine lacquer ground;
h. with stand, 28.7, l. 22.2, w. 22.2cm.
Muromachi period, 16th century

These paired octagonal containers are called *kaioke* ("shell buckets") and are used for storing the shells used in the game of *kai-awase* ("shell-matching"). Two identical sets of one hundred eighty shells, were required, each with a different miniature painting on its smooth interior. Clam shells that could easily fit into the palm of the hand were preferred. The paintings were taken from a well-known poetry anthology such as the *Kokinwakashū* or a popular work of classical literature like the *Tale of Genji* (see no. 222). One set of shells called the *jigai* was placed face down before the

players, while the shells from the other set the *dashigai* (literally, "played shells") were brought out face up one at a time so that the painting could be seen. The players then tried to find the matching shell from the *jigai* pile by turning over these shells alternately one at a time. The player who discovered the shell's mate would be awarded these shells, and the player with the superior memory and most shells at the end of the game when all the shells had been matched would be declared the winner. This game was particularly popular at New Year's.

Each of these *kaioke* is fitted with a

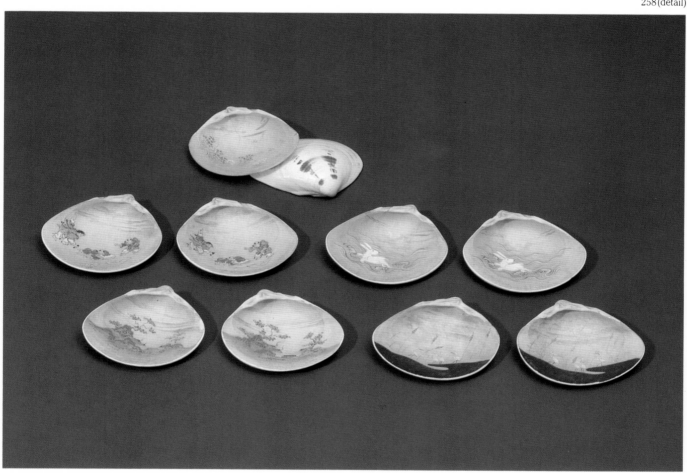

flush-fitting (*inrō-buta*) lid and a four-legged octagonal stand. One would hold the *dashigai*, the other the *jigai*. Each box is a single unit, yet because of the double-ridged lines that circle them, they appear to be stacks of three boxes of different size. Both the forms of the boxes and the rules of the game had become set by the end of the Muromachi period (16th century). Since each shell had only one suitable match among all the other shells, the *kaioke* was an especially valued part of a wedding trousseau as a symbol of feminine morality.

All the examples illustrated here are decorated with *maki-e* lacquer. The design of number 258 is a popular autumn scene probably taken from the *Musashi no kuni* section of the *Tales of Ise* (*Ise monogatari*). This *kaioke* is the earliest of the three illustrated here (nos. 258, 259 and 260), and is an excellent example of the technical accomplishment and evocative quality of lacquer ware produced in the Muromachi period. It is traditionally said to have been used by Okame-no-kata (Sōō-in, see nos. 5 and 6), the mother of Tokugawa Yoshinao, first lord of Owari, and one of the wives of Tokugawa Ieyasu, the first shogun.

Number 259 was used by Jūhime, the wife of Tokugawa Haruyuki, son of Tokugawa Munechika, ninth lord of Owari.

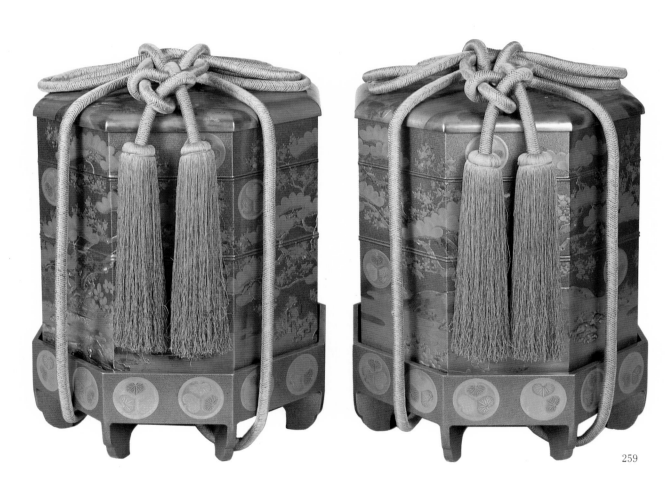

259

259. *KAIOKE*

Design of pine and mandarin orange trees and
scattered *aoi* crests in gold and silver *maki-e* on
an aventurine lacquer ground;
h. with stand, 48.0, l. 39.0, w. 39.0cm.
Edo period, 18th century

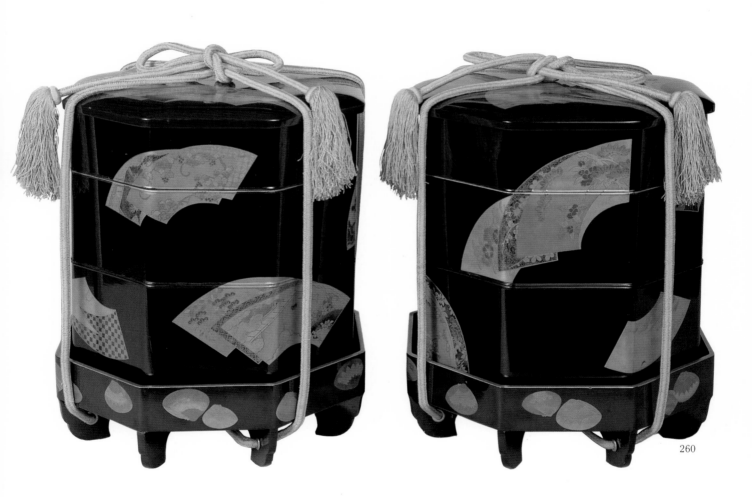

260

260. *KAIOKE*

Design of decorative fans and shells in gold and
silver *maki-e* on a black lacquer ground;
h. with stand, 41.4, l. 34.6, w. 34.6cm.
Edo period, 19th century

271. *HYAKUNIN ISSHU* PLAYING CARDS

One set of two hundred wooden cards with black lacquer box; cards 9.8 × 5.9cm. each; box 11.3 × 15.5 × 18.5cm.
Edo period, 19th century

Although the precise form of the game may differ somewhat, playing cards exist in many cultures. Japanese playing cards, or *karuta* (derived from the Portuguese "carta") are rectangular and are provided with painted illustrations or writing. Most are made of paper, but some rare examples are made of wood.

The first playing cards introduced to Japan were *um sum carta* and so-called *Tenshō Karuta* of the Tenshō era (1573–1592), which had been transmitted by Portuguese mariners. By the early Edo period (beginning of the seventeenth century), playing cards were already being produced in Japan. Later, in the eighteenth and nineteenth centuries, inspired by traditional Japanese pastimes such as *kai-awase* (the shell-matching game), *hana-awase* (floral competitions), and *uta-awase* (poetry contests), Japanese playing cards developed such forms as *uta-garuta*

(poetry cards), *iroha-garuta* (Japanese syllabary cards), *daimyō-garuta*, and *seiyō-garuta* (literally, "western playing cards," and called "torampu" from the word "trump" in the Meiji period and later). With the development of these forms, the playing cards themselves came to be elaborately ornamented.

Hyakunin Isshu playing cards are a form of *utagaruta*. The name *Hyakunin Isshu* derives from the Japanese poetry anthology composed of one hundred poems, each of the poems chosen to represent

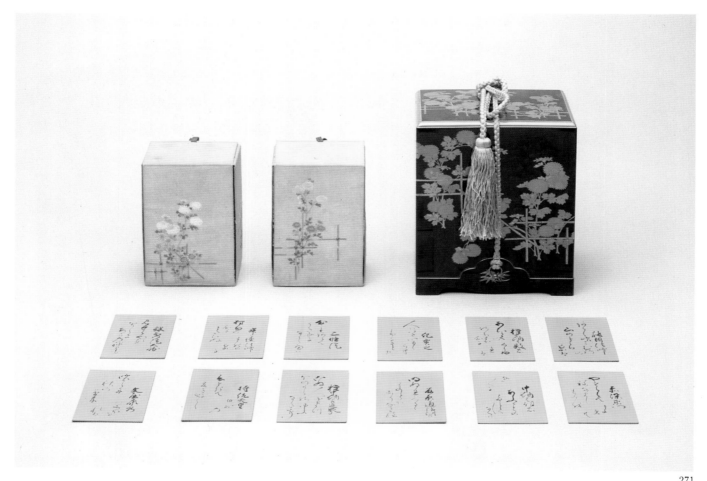

271

the work of one of the hundred famous Japanese classical poets. This anthology was compiled by Fujiwara no Teika (1162-1241), and it is said that his son, Tameie, added to the anthology in later years.

The *Hyakunin Isshu* playing cards included in the present exhibition represent each of the hundred poems of this classical anthology. The set consists of one hundred cards provided for the reader, each bearing the name of one of the poets and the opening line of the corresponding poem; and one hundred cards for the competitors with the closing line of each poem. In this card game, one individual

acting as reader recites the opening line of a poem from the set of cards that he holds, and the competitors vie to select the card with the correct closing line from among the cards of the set scattered in front of them, with the competitor managing to accumulate the most correct cards emerging as the winner.

The container for this set of cards is decorated with a pattern of chrysanthemums and a fence applied in gold and silver *maki-e* technique on a black lacquer ground. This elaborate set of *Hyakunin Isshu* playing cards was produced in accordance with the taste of

the members of a daimyo's personal household.

269. MINIATURE ARCHERY SET

Bow, 59.0cm;
target stand, h. 63.8 w. 33.8cm.;
arrow case, h. 20.9cm.
Edo period, 19th century

Suzume-koyumi is a type of miniature archery set that can be played indoors. Like full-sized archery sets, this one comes equipped with bow, arrows, target, and target stand. *Koyumi* literally means small bow, while *suzume* is the Japanese word for "sparrow," connoting something small and diminutive. Consequently, this *suzume-koyumi* archery set is even smaller than the usual small bow and arrow sets.

This bow is made with sappan wood and its grip wrapped with gold brocade. The target, about twelve centimeters wide, is shot at from a distance of about nine meters. Hung from a large frame, the target is wrapped with gold foil while the bull's eye is marked with black lacquer. The target is stabilized by a gourd-shaped weight which is also wrapped in gold foil. A multi-colored brocade is the border for a damask with a floral pattern, which serves as a backstop for errant shots. The stand supporting this curtain and target is decorated with *aoi* crests in gold *maki-e* on a black lacquer ground. The arrows themselves have a wide safety tip which is also covered with gold foil.

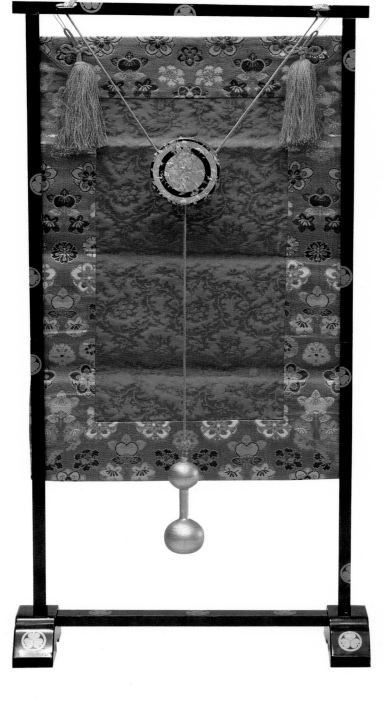

269

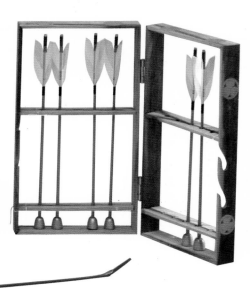

266. *GO* SET

Design of arabesques, chrysanthemum *fusen*
and scattered *aoi* crests in gold *maki-e* on an
unevenly distributed aventurine lacquer ground;
44.5 × 40.9 × 25.8cm.
Edo period, 19th century

267. *SHŌGI* SET

Same as no. 266,
37.3 × 33.9 × 22.1cm.
Edo period, 19th century

A *sugoroku* (Japanese backgammon)
board, combined with *shōgi* and go
boards, forms a group known as the
sanmen (three board games). These *go*
and *shōgi* boards belong to this type of
set, which was a frequent component of a
well-born bride's trousseau in the Edo
period. Both boards and their respective
storage bins are covered with an irregular
sprinkling of gold called *mura-nashiji*.

Two distinctive crests are scattered
among the tightly controlled curves of the
arabesque pattern. One is the *aoi* crest of
the Tokugawa family, while the other is the
chrysanthemum *fusen*. The term *fusen* is
a generic one for all large circular patterns.
Literally "floating lines," *fusen* developed
first in the Kamakura period (13th century)
as a relief design for textiles, but quickly
became a popular motif on other
decorative arts, especially lacquer ware.

Introduced from China in ancient
times, *go* is a game played by two
people with 361 white and black stones.
The stones are played alternately, one at a
time, with the player of higher rank using
the black stones. Each player attempts to
encircle his opponent's stones with his
own. This set contains 180 black and 184
white stones and a pair of matched
containers.

Like *go, shōgi* was originally a game
played only by the nobility. The rules of
the game and the shape of the board had
become standardized by the end of the
Muromachi period, and it is said to have
been one of the favorite pastimes of
Tokugawa Ieyasu, the first shogun. Its
popularity continued into the Edo period
as well.

The *shōgi* board consists of nine rows
of nine rectangles into which the twenty
pieces of each of the two players are
placed. Initially both players have their
pieces arranged in the same way, in three
rows, a row of two pieces placed between
rows of nine, and the object of the game is
to trap the opponent's king.

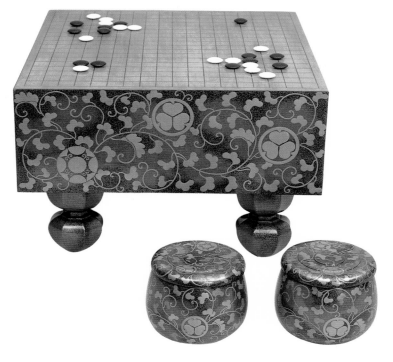

266

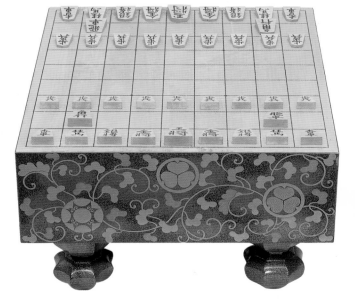

267

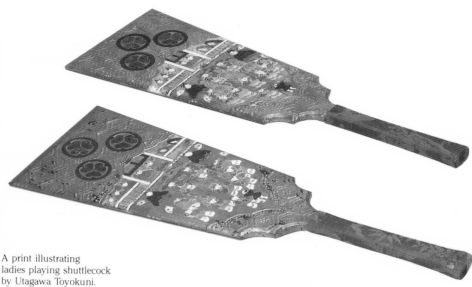

A print illustrating
ladies playing shuttlecock
by Utagawa Toyokuni.

268

268. *HAGOITA*

Pair of battledores with design of *sagichō* New Year's ceremony in gold leaf, paint, and *gofun* on wood;
42.3 × 14.4cm.
Edo period, 19th century

Hanetsuki is a game played by women at New Year's and is similar to the Western game of badminton. *Hanetsuki* is played without a net, however, and can be played alone. A long, narrow, rectangular, board-shaped implement called a *hagoita* is the paddle used in *hanetsuki*.

Documents of the time indicate that *hanetsuki* originated in the Heian period (12th century) as a kind of exorcism,

and only in the Muromachi period (15th century) did it become a form of recreation.

Hagoita usually have a design on the obverse, with the reverse where the shuttlecock is struck left undecorated. These designs are often of birds and flowers or women's customs, although in the Edo period, stage characters from the Kabuki theater were also depicted. Both these paddles are covered on both sides with gold leaf and a thick layer of *gofun,* a white pigment made from either lead white or pulverized oyster shell. The colorful scene depicted in some detail is the *sagichō* ceremony that was

held annually on the fifteenth day of the first lunar month on the grounds of the imperial palace, and in later times in many places throughout the country. Fans, letters, and other documents from the past year and recently displayed New Year's decorations were all burnt on a fire stand made of young bamboo. Since the *hogoita* was one of the items added to this ceremonial fire, *sagichō* (which was performed to ward off disaster and evil in the coming year) was a suitable design for these battledores.

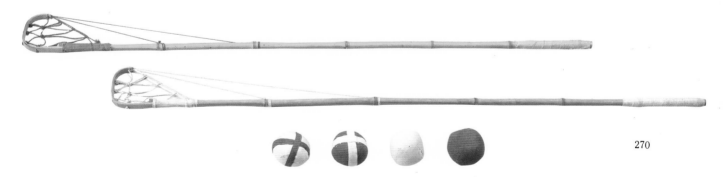

270

270. *GITCHŌ* STICKS AND BALLS

Sticks, 1. 99.0cm. each; balls, diam. 5.5cm. each
Edo period, 19th century

It is said that *gitchō* (literally, "ball-hitting") originated in a ball-and-stick game played by the mounted nomads of Central Asia. This game, which resembles European polo, was transmitted to Japan by way of China.

Gitchō was played either on foot or on horseback, but more commonly on horseback. Two teams vied with each other to toss the ball into the adversary's goal with a scooping motion using a long stick called a *gitchō* (the second character differs from the one used in the name of the game and signifies a cane or stick) consisting of a bamboo rod with red or

white netting attached at the end. During the Edo period, the game of *gitchō* was simplified and constituted one of the New Year's games played by young boys. The present set contains ten sticks and fifty red and white balls each.

259

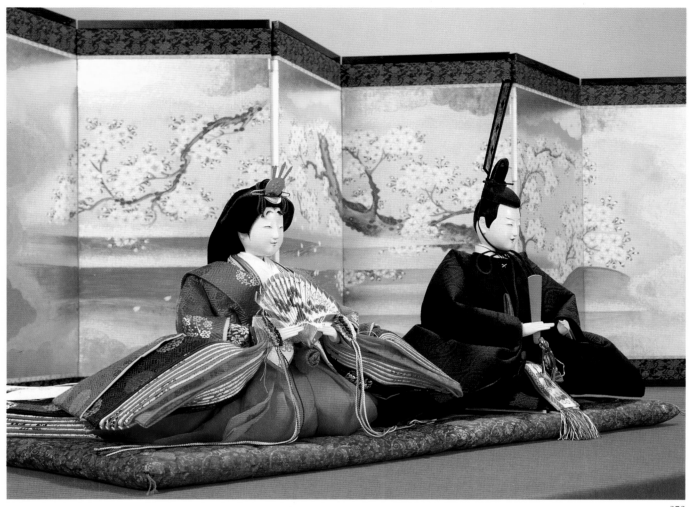

272. SET OF DOLLS AND ACCOUTREMENTS FOR THE GIRLS' FESTIVAL

Including folding screen with cherry blossom
design, coverlet, and candlestands; dolls: male,
h. 29.0cm; female, h. 27.5cm,; screen, h.
46.2cm.; candle stands, 53.6cm. each
Edo period, 19th century

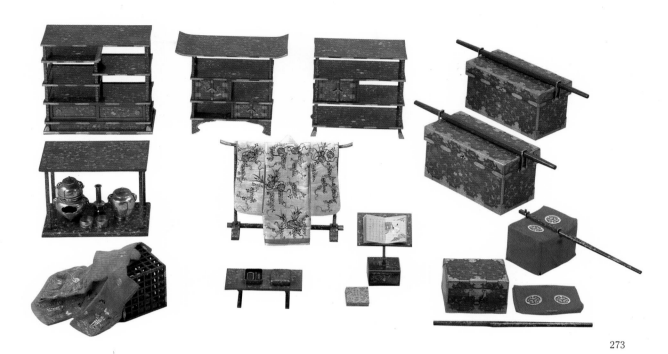

273. MINIATURE ACCOUTREMENTS FOR THE GIRLS' FESTIVAL

Design of pine, bamboo, and plum with arabesques in *maki-e* on an aventurine lacquer ground; Edo period, 18th-19th century

As early as the tenth century in the Heian period, dolls called *hiina-ningyō* were used by members of the aristocracy, who regarded them not as a source of amusement, but rather as substitutes for human beings to which defilements and evil spirits could be transferred. Offerings were made to these dolls, which were sent adrift in a river or the ocean. Although it is not clear when the actual transformation occurred, customs of this nature gradually evolved into the Girls' Festival, held on the third day of the third lunar month to pray for the happiness and growth to maturation of female children. It is believed that the Girls' Festival began to be celebrated on a lavish scale in daimyo households around the late seventeenth century.

White *sake*, diamond-shaped rice cakes, and peach blossoms were offered to the dolls and other accoutrements displayed with the *dairi-bina*, a pair of male and female dolls arrayed in full court dress (the male wearing a *sokutai*, and the female in *jūni-hitoe*). During the Edo period, the Girls' Festival was celebrated not only when a female child reached the first occurrence of the third day of the third lunar month after her birth, but also at the time of marriage and the first festival day following her marriage.

The accoutrements of the Girls' Festival were miniatures of actual household furnishings, including the set of three shelf cabinets (*zushi-dana*, *kuro-dana*, and

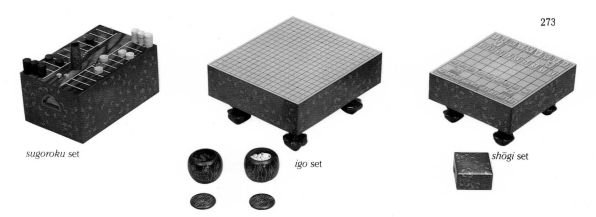

sugoroku set

igo set

shōgi set

273

261

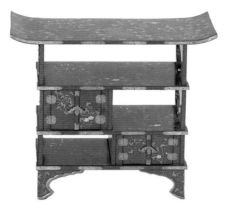

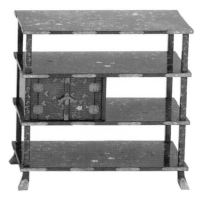

sho-dana *zushi-dana* *kuro-dana*

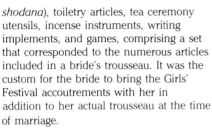

shodana), toiletry articles, tea ceremony utensils, incense instruments, writing implements, and games, comprising a set that corresponded to the numerous articles included in a bride's trousseau. It was the custom for the bride to bring the Girls' Festival accoutrements with her in addition to her actual trousseau at the time of marriage.

A number of complete sets of Girls' Festival accoutrements exist today in the collection of The Tokugawa Art Museum. The articles selected for the present exhibition include only some of the objects from one of these sets, such as the dolls, set of three shelf cabinets, toiletry articles, and tea ceremony utensils. These articles are decorated in *maki-e* lacquer on an aventurine lacquer ground with a design of arabesques and pine, plum, and bamboo, auspicious motifs that frequently appeared on items contained in a bride's trousseau.

set of three shelf cabinets

In the proper arrangement of these accoutrements, incense instruments adorned the *zushi-dana*, toiletry articles were placed on the *kuro-dana*, and a scroll or book was arranged on the *sho-dana*. These so-called three shelf cabinets were placed in the private rooms of the ladies of the household, with the *zushi-dana* and *kuro-dana* situated in the actual living quarters and the *sho-dana* in a receiving room fitted with an alcove.

daisu-kazari

The *daisu* was a piece of furniture intended to display the utensils necessary to prepare and drink powdered tea. Tea ceremony utensils arranged in this manner are called *daisu-kazari*.

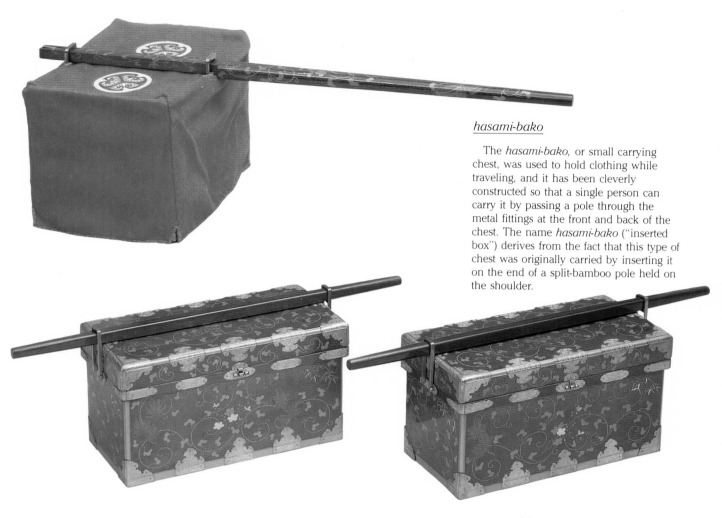

hasami-bako

The *hasami-bako*, or small carrying chest, was used to hold clothing while traveling, and it has been cleverly constructed so that a single person can carry it by passing a pole through the metal fittings at the front and back of the chest. The name *hasami-bako* ("inserted box") derives from the fact that this type of chest was originally carried by inserting it on the end of a split-bamboo pole held on the shoulder.

nagamochi

The *nagamochi,* or long carrying chest, was a large article of furniture intended for the storage of garments, quilts, or other household effects. A pole was passed through the metal fittings on either side of the chest and carried by two people, one at each end.

fusego

The *fusego* was used when perfuming garments with incense: the garment was draped over the latticed box housing the incense burner.

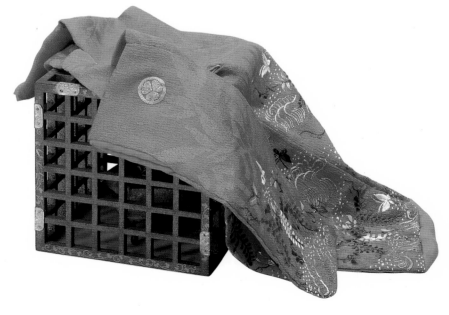

263

CHRONOLOGICAL CHART OF
JAPAN AND CHINA

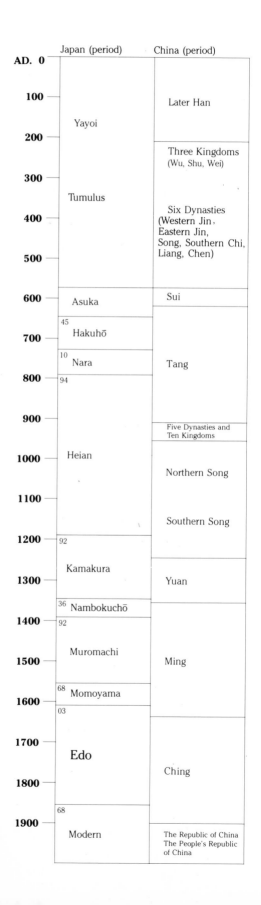

	Japan (period)	China (period)
AD. 0		
100	Yayoi	Later Han
200		
300		Three Kingdoms (Wu, Shu, Wei)
	Tumulus	
400		Six Dynasties (Western Jin, Eastern Jin, Song, Southern Chi, Liang, Chen)
500		
600	Asuka	Sui
	45 Hakuhō	
700		
	10 Nara	Tang
800	94	
900		
		Five Dynasties and Ten Kingdoms
1000	Heian	Northern Song
1100		
		Southern Song
1200	92	
	Kamakura	Yuan
1300		
	36 Nambokuchō	
1400	92	
	Muromachi	Ming
1500		
	68 Momoyama	
1600	03	
1700	Edo	Ching
1800		
	68	
1900	Modern	The Republic of China The People's Republic of China

CHRONOLOGICAL CHART OF THE EDO PERIOD (Main Events)

1603
Ieyasu becomes shogun and establishes Tokugawa Shogunate.

1604
Seventh commemorative celebration at Hōkoku shrine in honor of Hideyoshi.

1606
Construction of Hikone castle by Ii clan.

1608
Ikeda Terumasa rebuilds Himeji castle.

1609
Permission given for Dutch to trade and they establish trading factory at Hirado.

1610
Beginning of the construction of Nagoya castle for Ieyasu.

1611
Permission for Portuguese to resume trade.

1612
Prohibition of Christianity. Permission for Chinese from Ming to trade at Nagasaki.

1613
Expulsion of missionaries and Christians. English establish a trading factory at Hirado.

1614
Completion of Matsumoto castle. Expulsion of Takayama Ukon and other Christians to Manila and Macao. Osaka Winter Campaign.

1615
Osaka Summer Campaign. Downfall of the Toyotomi clan. Ieyasu in uncontested supremacy. Promulgates the Laws of Military Houses (*Buke Sho-hatto*).

1616
Bakufu restricts foreign trade to Nagasaki and Hirado. Death of Ieyasu.

1617
Renewed persecution of Christians. Dutch given trading privileges.

1618
Nagasaki and Hirado opened to trade between British and Japanese.

1619
About sixty Christians burned at the stake in Kyoto.

1620
Beginning of construction of Katsura Rikyū (completed in 1624?).

1622
Kimura Sebastian and fifty-four others executed (Great martyrdom in Nagasaki).

1623
The English close factory in Hirado and leave Japan. Fifty Christians executed in Edo.

1624
Hidetada breaks all relations with Spanish. Kan'ei-ji temple built by Tokugawa Hidetada.

1625
Ni no maru quarters built in Nijō Castle. Production of Hagi pottery begins.

1628
More Christians persecuted in Nagasaki.

1632
Careful search for remaining Christians.

1634
Dejima built at Nagasaki and all foreigners forced to live there. Attempt at forcing Christians to recant by trampling on the crucifix (*fumie*).

1635
All foreign trading ships restricted to Nagasaki by third Sakoku (isolation) edict. All overseas Japanese shipping and travel prohibited. *Sankin-kōtai* system institutionalized.

1636
Kan'ei tsūhō coins minted. Famine occurs throughout Japan.

1637
Shimabara Rebellion breaks out.

1638
Shimabara Rebellion suppressed.

1639
Shogunate orders all daimyo to ban Christianity in their domains. Final Isolation edict. Expulsion of Portuguese.

1640
Other Europeans expelled. Portuguese envoys from Macao beheaded.

1641
Dutch area moved from Hirado and to Dejima in Nagasaki.

1642
Famine throughout Japan.

1647
Portuguese ship visits Nagasaki and demands trade. Shogun refuses.

1649
Promulgation of the Laws and Ordinances of Keian (*Keian Ofuregaki*).

1650
Pilgrimage to Ise-Jingū shrine (*Okagemairi*) grows very popular. Completion of chronology of Japanese history, *Honchō tsugan*.

1651
Revolt of Yui Shōsetsu (*Keian jiken*). Shōsetsu Killed.

1654
Zen priest Ingen arrives in Nagasaki from Ming and founds Ōbaku sect of Zen.

1655
Beginning of the construction of Shūgakuin Rikyū.

1657
Great fire in Edo (Great fire of Meireki).

1658
Execution of 630 Christians by Ōmura Suminaga.

1659
Ingen builds Mampuku-ji temple.

1660
Rise of Mito school of historians under leadership of Tokugawa Mitsukuni to promote National Learning and Shintō studies.

1668
Reconstruction of Ashikaga School.

1673
Great Britain attempts to renew trade relations but fails.

1678
Great earthquake in Edo.

1680
Corrupt administration, great freedom in social mores.

1682
Restriction of various goods because of the rise in prices. Completion of *Kōshoku ichidai otoko* (The Life of an Amorous Man) by Ihara Saikaku.

1684
New calendar (*Jōkyōreki*) adopted. Completion of haiku anthology, *Fuyu no hi* (A Winter Day), by Matsuo Bashō.

1685
Bashō's *Nozarashi kikō* (Exposure in the Fields), and Saikaku's *Kōshoku gonin onna* (Five Women Who Loved Love) and *Kōshoku ichidai onna* (The Life of an Amorous Woman).

1686
Haiku anthology, *Haru no hi* (A Spring Day), by Bashō.

1687
Shōgun Tsunayoshi's "Dog Decrees" laws prohibiting the killing of animals.

1688
Completion of Bashō's *Oi no kobumi* (Manuscript in My Knapsack), and Saikaku's *Nippon eitaigura* (The Japanese Family Storehouse).

1690
E. Kaempfer comes to Japan as physician to Dejima factory.

1691
Haiku anthology, *Sarumino* (The Monkey's Raincoat), by the Bashō School.

1692
Seken mune sanyō (Reckonings That Carry Men Through the World) by Saikaku.

1694
Restoration of Kamo festival. Renku (linked verse in Bashō's style) anthology, *Sumidawara* (A Sack of Charcoal), ed. by Shida Yaba, and *Oku no hosomichi* (The Narrow Road of Oku) by Bashō.

1701
Ogata Kōrin given title of *hokkyō*. Asano Takumi no kami strikes at Kira Kōzukenosuke in Edo castle.

1702
Completion of clan chronology. *Hankanfu*, by Arai Hakuseki. Revised map of all Japan completed.

1703
Jōruri drama, *Sonezaki shinjū*, by Chikamatsu Monzaemon.

1707
Mt. Fuji erupts (eruption of Hōei era).

1709
Abolition of "Dog Decrees." Reaction against laxity of Tsunayoshi's regime. Financial reforms attempted.

1714
Widespread famine. Recoining of gold and silver (*Shōtoku kingin*).

1715
Completion of *Dai Nihonshi* (Great History of Japan) commenced by Mito Mitsukuni. Promulgation of new laws governing Nagasaki trading.

1716
Attempt to strengthen national administration (beginning of Kyōhō reform). Relaxation of edicts against Western Learning.

1720
Jōruri drama, *Shinjū ten no Amijima*, by Chikamatsu.

1721
Regulation of prices charged by rice dealers in Osaka. *Jōruri* drama, *Onna goroshi abura no jigoku*, by Chikamatsu.

1734
Permission given for daimyo to dispatch troops to suppress riots.

1738
Census taken in every province.

1739
Russian ships make several appearances off Mutsu and Awa.

1742
Great floods in Kinki and Kantō regions.

1746
Kabuki drama, *Sugawara denju tenarai kagami*, by Takeda Izumo and others.

1747
Kabuki drama, *Yoshitsune senbonzakura*, by Takeda Izumo.

1748
Kabuki drama, *Kanadehon chūshin-gura*, by Takeda Izumo.

1750
Census taken in every province.

1755
Completion of the manuscript on ideal society, *Shizen shin'eidō*, by Andō Shōeki. Great famine in the Ōu region.

1756
Restrictions on rice dealers in buying up rice to keep prices down.

1758
Outbreak of Hōreki incident.

1765
Nishiki-e form of color print developed by Suzuki Harunobu.

1767
Beginning of the golden age of liberal administrator, Tanuma Okitsugu.

1771
First anatomical dissection of cadaver on executed criminal by Maeno Ryōtaku and others at the execution ground of Kotsukappara.

1774
Publication of text of anatomy. *Kaitai shinsho* (translated Dutch work on medicine and surgery), by Maeno Ryōtaku and Sugita Gempaku.

1776
Ugetsu monogatari (Tales of Rain and the Moon) by Ueda Akinari.

1782
Beginning of great famine of Tenmei era.

1783
Shiba Kōkan begins to produce etchings. Matsudaira Sadanobu attempts economic and social reforms. Growing feeling against shogunate.

1786
Tanuma Okitsugu dismissed.

1787
Matsudaira Sadanobu becomes member of the shogun's council. Completion of the text on political ideas called *Tamakushige* by Motoori Norinaga.

1788
Great fire in Kyoto. Nijō Castle burns.

1790
Prohibition of foreign studies.

1791
American and Russian ships visit Japan but are driven away. Decrees against foreign shipping reissued (~1792).

1792
Hayashi Shihei prosecuted for a military work, *Kaikoku heidan*.

1794
Great fire in Edo. Completion of educational and cultural essay, *Tamakatsuma* by Motoori Norinaga.

1796
Completion of critical study on *Tale of Genji*, *Genji monogatari tama no ogushi*, by Norinaga.

1797
American ship *Eliza* calls at Nagasaki and allowed to trade. Slight relaxation of edicts for a few years, and then strict enforcement.

1798
Completion of the commentary on *Kojiki*, *Kojikiden*, by Norinaga.

1800
Inō Tadataka begins topological and cartographical survey of Ezo (Ōu region and Hokkaidō).

1801
Inō Tadataka ordered to survey Japan's coastline.

1802
Completion of *Tōkaidōchū Hizakurige* (Travels on Foot on the Tōkaidō) by Jippensha Ikku.

1803
American ship visits Nagasaki and demands trade but is refused by shogunate.

1804
Kitagawa Utamaro, painter, punished. Rezanov, Russian diplomat, arrives at Nagasaki and demands trade (rejected in 1805).

1805
Manager of Kanto area instituted.

1808
Discovery of Mamiya Straits. Posthumous publication of poem anthology, *Buson shichibushū*, by Yosa Buson.

1811
Russian naval officer V. Golovnin and others held prisoner in Matsumae (modern Hakodate).

1812
Takataya Kahei, bakufu trader, arrested by Russians.

1814
British ship arrives at Nagasaki. Sir Stamford Raffles sends ship in attempt to trade, is rebuffed. *Nansō satomi hakkenden* (Biographies of Eight Dogs) by Takizawa Bakin.

1815
Publication of *Rangaku kotohajime* (Studies on Western Medicine) by Sugita Genpaku.

1818
Englishman Gordon arrives at Uraga for trade but is rebuffed by the shogunate.

1821
Completion of "Dai-Nihon enkaikōchi-zenzu" (Coastal Map of All Japan) by Inō Tadataka.

1823
P. F. von Siebold comes to Nagasaki.

1825
Expulsion edict against foreign ships. First performance of the Kabuki play, *Tōkaidō Yotsuya kaidan* (Ghost story of Yotsuya on the Tōkaidō), by Tsuruya Namboku.

1831
Peasant uprisings in Chōshū province. Landscape print, "Fugakusanjūrokkei," by Katsushika Hokusai.

1834
Mizuno Tadakuni becomes an elder in shogun's council.

1837
American ship *Morrison* driven away from Edo Bay. Ōshio Heihachirō leads rebellion in Osaka.

1838
Shogunate in financial straits. Peasant uprising in Sado.

1839
Watanabe Kazan, Takano Chōei and others punished for demand opening of Japan to foreign commerce (*Bansha no goku*).

1840
Census taken in every province.

1841
Mizuno Tadakuni begins attempt at economic and political reform (Tempō reforms).

1842
Permission given to supply water and fuel to foreign ships.

1844
French ship visits Ryūkyūs for trade.

1846
American warships come to Uraga and demand trade.

1852
Publication of Kobayashi Issa's poems, *Oragaharu* (The Year of My Life).

1853
Commodore Matthew Perry arrives with Black Ships off Uraga. Russian Admiral Putyatin arrives in Nagasaki.

1854
Perry returns. Treaties of Amity and Commerce concluded with America, England, and Russia.

1855
Great earthquake in Edo (*Ansei no daijishin*). Treaties of Amity and Commerce with France and Holland.

1856
Townsend Harris comes to Shimoda as consul-general of United States.

1858
Treaty of Amity and Commerce with U.S.A. Suppression of *Sonnō-jōi* (Revere the emperor, expel the barbarian) movement.

1859
Kanagawa, Nagasaki, and Hakodate opened to foreign trade with Russia, France, Britain, Holland, and America. Yoshida Shōin and others executed.

1860
Ii Naosuke assassinated by 17 samurai of Mito fief (*Sakuradamongai no hen*).

1864
Allied fleets of four countries fire on Shimonoseki in Chōshū province (War of Shimoneseki). Chōshū clan submits to shogunate.

1866
Conclusion of military alliance between Satsuma and Chōshū clans.

1867
Imperial rule replaces shogunate. Armed conflict between shogunate troops and loyalists. Feudalism abolished.

1868
Edo renamed Tokyo. Battle of Toba-Fushimi near Kyoto.

Source: Shigehisa Yamasaki, ed. *Chronological Table of Japanese Art*. Tokyo: Geishinsha, 1981

THE SHOGUNS AND SUCCESSIVE GENERATIONS OF
THE TOKUGAWA FAMILY OF OWARI

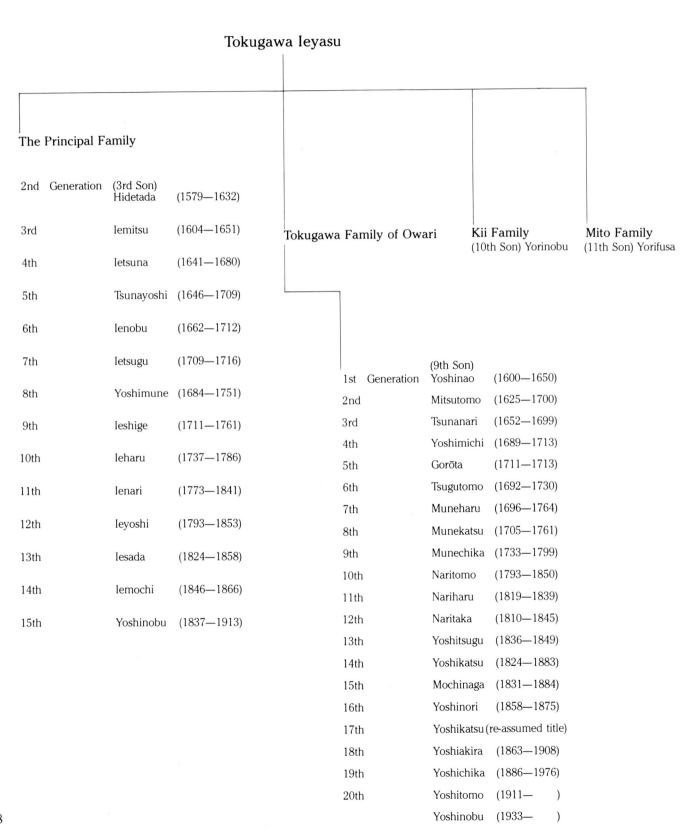

Tokugawa Ieyasu

The Principal Family

2nd Generation	(3rd Son) Hidetada	(1579—1632)	
3rd	Iemitsu	(1604—1651)	
4th	Ietsuna	(1641—1680)	
5th	Tsunayoshi	(1646—1709)	
6th	Ienobu	(1662—1712)	
7th	Ietsugu	(1709—1716)	
8th	Yoshimune	(1684—1751)	
9th	Ieshige	(1711—1761)	
10th	Ieharu	(1737—1786)	
11th	Ienari	(1773—1841)	
12th	Ieyoshi	(1793—1853)	
13th	Iesada	(1824—1858)	
14th	Iemochi	(1846—1866)	
15th	Yoshinobu	(1837—1913)	

Tokugawa Family of Owari

Kii Family
(10th Son) Yorinobu

Mito Family
(11th Son) Yorifusa

1st Generation	(9th Son) Yoshinao	(1600—1650)	
2nd	Mitsutomo	(1625—1700)	
3rd	Tsunanari	(1652—1699)	
4th	Yoshimichi	(1689—1713)	
5th	Gorōta	(1711—1713)	
6th	Tsugutomo	(1692—1730)	
7th	Muneharu	(1696—1764)	
8th	Munekatsu	(1705—1761)	
9th	Munechika	(1733—1799)	
10th	Naritomo	(1793—1850)	
11th	Nariharu	(1819—1839)	
12th	Naritaka	(1810—1845)	
13th	Yoshitsugu	(1836—1849)	
14th	Yoshikatsu	(1824—1883)	
15th	Mochinaga	(1831—1884)	
16th	Yoshinori	(1858—1875)	
17th	Yoshikatsu (re-assumed title)		
18th	Yoshiakira	(1863—1908)	
19th	Yoshichika	(1886—1976)	
20th	Yoshitomo	(1911—)	
	Yoshinobu	(1933—)	

源家正嫡武門稱梁
興新里跡出参州郷
威風大振徳澤益彰
於句無致不招歸降
有仁有智克宗克剖
一統祥業萬年永昌

3. PORTRAIT OF TOKUGAWA IEYASU AT THE BATTLE OF NAGAKUTE

Kanō Yasunobu
Hanging scroll, ink and colors on silk;
44.5 × 65.8cm.
Edo period, 17th century

2. PORTRAIT OF TOKUGAWA IEYASU

Tokugawa Yoshinao
Hanging scroll, ink and colors on
paper; 56.4 × 33.5cm.
Edo period, 17th century

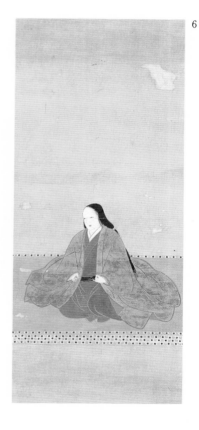

4. PORTRAIT OF TOKUGAWA YOSHINAO

Sakurai Seikō
Hanging scroll, ink, colors, and gold on
paper; 142.4 × 70.3cm.
1937 copy of Edo-period original
formerly owned by Shōjō-ji, Nagoya

6. PORTRAIT OF SŌŌ-IN

Sakurai Seikō
Hanging scroll, ink and colors on silk;
80.6 × 34.1cm.
1936 copy of Edo period original owned
by Seiryō-an, Kyoto

5. PORTRAIT OF SŌŌ-IN

Kanō Tansetsu
Hanging scroll, colors, on paper; 34.5 × 50.2cm.
Edo period, 17th century

7. GENEALOGY OF THE TOKUGAWA FAMILY

Brocade-bound folding book, ink on
gold leaf and paper; 33.0 × 1,711.0cm.
Box, gold and silver *maki-e* on an
aventurine lacquer ground;
Edo period, 17th century

GLOSSARY

aoi

Generally speaking, the *aoi* family of plants corresponds to the mallow family, and the term is frequently seen translated as "hollyhock." When used in referring to family crests, however, the name *aoi* serves as an abbreviation for the *futaba-aoi*, which belongs to the birthwort family (*uma no suzukusa*), and is more accurately translated as "wild ginger." Since the term "hollyhock" has achieved widespread, if mistaken, acceptance when referring to the *aoi* crest of the Tokugawa family, rather than using the less well-known "wild-ginger," the term has been left in its original Japanese form to avoid confusion. Also, the precise form of the *aoi* crest used by the Tokugawa family has varied from generation to generation, and the form adopted in the illustrations in this catalog represents the most well-known variant.

chōshitsu

Carved lacquer. A generic term used to encompass the numerous carved lacquer techniques, in which layers of lacquer are applied to a thickness of three to seven millimeters, then carved with a design in relief. Spiral patterns (*guri*), carved cinnabar lacquer (*tsuishu*), and carved black lacquer (*tsuikoku*) belong within this category.

daishō

Literally, "large and small," the term refers to a pair of swords, usually consisting of a *katana* and a *wakizashi*. The custom of wearing a pair of swords, one long and one short, began during the late Momoyama period, and the practice was codified in the Edo period, limiting the wearing of the pair to members of the samurai class and regulating the types of mountings that could be used by samurai of different ranks.

emaki

Illustrated handscrolls usually of a narrative character. Most Japanese *emaki* extant today date from the twelfth century or later.

fusuma

Sliding screens covered with thick paper on both sides and frequently decorated with paintings or calligraphy. They were used as partitions to divide a large interior space into smaller units.

guri See *chōshitsu*.

hakama See *kamishimo*.

hatamoto

Literally, "bannermen." In the Edo period, those retainers under the direct command of the shogun whose income was less than ten thousand but more than five hundred *koku* of rice.

hyōmon

Developed in China, this technique used in decorating lacquer was popular in the Nara period in Japan, when it was called *heidatsu*. During the Heian period, the technique was called *kanagai*. A thin sheet of metal was cut into the desired shape and then affixed onto the lacquer surface. Several subsequently applied layers of lacquer covered the total surface, including the metal appliques, which were revealed by removing the lacquer overlay and polishing the entire surface with charcoal.

inrō

Literally, "seal caddy." A container originally designed to store and protect seals. This form later developed into the miniature medicine containers of the same name that were worn suspended from the waistband by men during the Edo period.

iro-e

In metalwork, especially sword furniture, used both as a specific term signifying the soldering of thin sheets of precious metal, such as gold or silver, onto the ground metal, and also as a generic term that includes decorative metalwork techniques such as inlay and overlay in which other metals are applied to the ground metal, regardless of the specific technique.

jimbaori

Campaign vests worn over armor from the beginning of the Sengoku period onward. Early examples were designed to afford the greatest protection against cold or inclement weather during actual campaigns, but Edo period *jimbaori* were largely decorative overgarments worn on outdoor occasions.

jūni-hitoe

Formal women's costume consisting of numerous layers of unlined robes worn over an upper garment and skirt by high-ranking ladies of the imperial court.

kaiseki

A light meal served before the presentation of thick tea (*koi-cha*) in formal tea ceremonies. Developed from the vegetarian menus of Zen monasteries, the term which literally means "longing for the stone" originated from the custom of using a heated stone as a pocket warmer. Just as the stone helped one endure the bitter cold of winter, this light meal served to assuage one's hunger before the presentation of tea in the climax of the tea ceremony.

kami

Shintō deity, including apotheosized heroes or ancestors and impressive natural phenomena. An *uji-gami* is the tutelary deity of a family or clan.

kamishimo

Literally, "upper and lower." A garment of two parts designed to be worn together and reserved for members of the samurai class during the Edo period. The upper garment consisted of a sleeveless, broad-shouldered *kataginu* that was tucked into the *hakama* or trousers, which could be either ankle-length for performing daily official duties or extending beyond the feet to trail behind as required for important formal functions.

kaō

Elaborate seal, primarily handwritten,

that served as the signature of an individual. Generally divided into the two types used by the court nobility and the samurai class, respectively, the term is usually seen translated as "monogram" or "cipher."

kataginu See kamishimo.

katana

A long, curved sword blade measuring over sixty centimeters in length, mounted to be thrust into the sash of the wearer with the cutting edge facing upward. To differentiate an unmounted katana from a tachi, the inscription is always placed on the side that is meant to face outward when worn.

kiji-maki-e

Lacquer technique in which a maki-e design is placed directly on the bare wood surface to emphasize the natural pattern of the wood grain. The design is frequently produced by placing a lead sheet perforated with an openwork pattern on the wood surface and applying lacquer to the openwork areas. Gold powder is then sprinkled on the wet lacquer, and the lead sheet is removed after the lacquer has dried. Although practiced as early as the Heian period, this technique was not widely used until the end of the Edo period.

kōgai

Sword fitting. Implement shaped like a paper knife that was originally used to arrange the hair. Not provided with a tempered blade, it was fitted flush against the scabbard on the outside of the sheath on the side away from the wearer. With the kozuka and menuki, it formed a set called mi-tokoro-mono.

kōgō

A small, lidded container used for storing the aromatic wood that was burned as incense. Usually made of lacquer or ceramic, wood and metal containers were also used. Since the aromatic wood was highly prized, the containers in which it was placed were

of commensurate aesthetic value and technical accomplishment.

kosode

A kimono with narrow hand openings. Used as an outer garment during the Momoyama period, a version with large, more markedly rectangular sleeves was popularly worn during the Edo period. Usually wrapped tightly about the body and secured with an obi, long-trained kosode were also worn as loose, flowing outer robes.

kozuka

Sword fitting. The handle of a small knife whose tempered blade measured about twelve centimeters in length. Placed flush against the scabbard on the inside of the sheath, with the kogai and menuki it formed a set called mi-tokoro-mono.

maki-e

Lacquer decorating technique in which fine, powdery filings of precious metal are scattered on a design first drawn in lacquer. The ground may be either lacquered or plain wood (see kiji-maki-e). The technique originated during the Heian period and can be largely divided into the categories of togidashi-makie (polished maki-e) in which a further coating of transparent or black lacquer is applied over the flat, dried and powdered surface and polished with charcoal to reveal the design, hira-maki-e (flat maki-e) in which the sprinkled powders are applied directly on the smooth lacquered surface, and taka-maki-e (high relief maki-e) where the metallic powders are applied on a lacquer surface molded with relief designs.

menuki

Sword fittings. Decorations affixed on both sides of the hilt that developed from the ornamental heads of pegs passing through the hilt to secure the blade. With the kozuka and kōgai, they formed a set called mi-tokoro-mono

mi-tokoro-mono

Set of sword fittings consisting of

kozuka, kōgai, and menuki that adorned the mountings used by samurai of high rank. Correctly fitted mountings used by the shogun, daimyo, and hatamoto were provided with mi-tokoro-mono produced by the Gotō family of metalworkers.

monogatari

A narrative account or long prose literary work such as a novel or historical tale, frequently adopted for illustration in the handscroll or folding book format.

nanako

Literally, "fish-roe." A metalwork technique in which fine, closely packed granulation is produced using a round-headed chisel. First seen in Japan during the early Nara period, the technique was used in metalwork of subsequent periods.

nashi-ji

Literally, "pear-skin ground." A lacquer ground technique in which fine metallic powder is sprinkled onto a lacquered surface. Once dry, a coat of transparent or other lacquer is applied and polished lightly, leaving the powder well-imbedded. The sparkling, stippled effect produced is reminiscent of the skin of a Japanese pear, hence the term nashi-ji. Originating during the Kamakura period, the technique was widely used in its many variations in subsequent periods.

noshime

An inner robe worn under the kamishimo or hitatare whose nomenclature derives from the smooth, lustrous fabric woven with a raw warp and a glossed weft.

obi

A band or sash. Small, narrow bands (kazura-obi) were used to secure the wig of a Nō actor in a female role, while long sashes of varying widths (koshi-obi) were wound around the waist or hips to fasten the garment securely in place.

otogi-zōshi

Short folk-tales, sometimes resembling fairy tales, that served to relay moral precepts. These tales were especially popular during the Muromachi period.

raden

Inlaid mother-of-pearl. Practiced in Japan since the Nara period, this technique involved the imbedding of thin, flat pieces of shell onto a surface by coating the entire surface with lacquer and scraping away the lacquer that obscured the pieces of shell.
The surface would then be polished until perfectly smooth.

sankin-kōtai

A system instituted by the Edo shogunate in which the daimyos and certain *hatamoto* were forced to spend every other year in Edo accompanied by a set number of retainers determined by the relative incomes of their fiefs. During their period of attendance in Edo, they were required to pay homage to the shogun. This system necessitated the maintenance of a substantial Edo residence in addition to their residences in their home feudatories. The exact period of attendance in Edo was codified in 1635 for the non-hereditary vassals (*tozama daimyō*), while the attendance period of the hereditary Tokugawa vassals (*fudai daimyō*) was regulated in 1642.

shakudō

An alloy of copper and a small amount of gold (4—7%) finished by chemical means to produce a glossy dark blue-black shade on the surface.

shikishi

Writing paper, generally square, whose size was later standardized to 19.4 by 17.0 centimeters for large *shikishi*, and 18.2 by 16.0 centimeters for small ones. Similar in thickness to cardboard, their surfaces were decorated with a variety of colors and designs. Their principal use was as formal, decorative paper for the writing of short poems.

shoin

A writing alcove or the study room in which this alcove was located. Also, the style of residential architecture that originated in the Muromachi period and was widely adopted in the Momoyama and Edo periods for residences of members of the samurai class, guest halls of temples, and Zen abbot's quarters. This style of architecture is characterized by the appearance of a *tokonoma*, staggered shelves, writing alcove, and ornamental doors all often arranged on a raised platform area (*jōdan no ma*), and the incorporation of sliding screens and *tatami* flooring, among other elements.

suzuri

An inkstone. Used for making and storing liquid ink, a small amount of water was poured into the depression and the ink stick was rubbed along the abrasive surface moistened with water. Made of porcelain, tile, metal, or stone, the most common material used was shale, preferably from Anhui and Guangdong provinces in China, whose shale was considered to be of the highest quality.

tachi

Long, curved sword blade measuring sixty centimeters in length mounted to be slung from the sash with the cutting edge facing downward. To differentiate an unmounted *tachi* from a *katana,* the inscription is always placed on the side that is meant to face outward when worn.

tanzaku

Oblong formal decorative writing paper for either *tanka* or *haiku* poems. Usually about 35 by 6 centimeters, the surface was often elaborately decorated.

Temmoku

Lustrous, black-glazed stoneware bowls whose name derives from the Tian-mu mountains in Zhejiang province in China, which is supposed to have been the source of the first bowl of this type brought back to Japan by a Buddhist monk sometime during the Kamakura period. The different varieties of mottled glaze, such as "oil-spot" or "hare's-fur" provide one of the principal points of appreciation.

tokonoma

Although originally a raised floor or bench, from the Momoyama period onward this term designated an alcove with a raised floorboard used for the display of hanging scrolls and articles such as vases, incense burners, and candle stands.

tsuikoku See *chōshitsu.*

tsuishu See *chōshitsu.*

wabi

An aesthetic quality that embodies the simplicity associated with poverty, while at the same time transcending that state. The aesthetic values of *wabi* are manifested in the form of the tea ceremony perfected by Sen no Rikyū, in which host and guest shed the trappings of rank and enjoyed tea in a humble thatched hut using simple, unpretentious utensils.

wakizashi

A smaller version of the *katana,* measuring more than thirty and less than sixty centimeters in length, of the Muromachi period or later. Forming a *daishō* pair with the *katana,* the use of this pair of swords was strictly reserved for members of the samurai class.

Yamato-e

So-called "Japanese-style painting," as opposed to painting in the Chinese manner. At first used to connote paintings treating native Japanese themes, the term was later used to designate paintings executed in the highly polychromed, detailed style of paintings on Japanese themes produced during the Heian period.

INDEX (List of Exhibits)

277

CT831228